Victorian Photography and Literary Nostalgia

Victorian Photography
and
Literary Nostalgia

HELEN GROTH

OXFORD
UNIVERSITY PRESS

OXFORD
UNIVERSITY PRESS

Great Clarendon Street, Oxford OX2 6DP

Oxford University Press is a department of the University of Oxford.
It furthers the University's objective of excellence in research, scholarship,
and education by publishing worldwide in

Oxford New York

Auckland Bangkok Buenos Aires Cape Town Chennai
Dar es Salaam Delhi Hong Kong Istanbul Karachi Kolkata
Kuala Lumpur Madrid Melbourne Mexico City Mumbai Nairobi
São Paulo Shanghai Taipei Tokyo Toronto

Oxford is a registered trade mark of Oxford University Press
in the UK and in certain other countries

Published in the United States
by Oxford University Press Inc., New York

© Helen Groth 2003

The moral rights of the author have been asserted
Database right Oxford University Press (maker)

First published 2003

British Library Cataloguing in Publication Data
Data available

Library of Congress Cataloging in Publication Data
Data available

ISBN 0–19–925624–1

1 3 5 7 9 10 8 6 4 2

Typeset by Graphicraft Limited, Hong Kong
Printed in Great Britain
on acid-free paper by
Biddles Ltd,
Guildford and King's Lynn

That the Photograph is 'modern,' mingled with our noisiest everyday life, does not keep it from having an enigmatic point of actuality, a strange stasis, the stasis of an *arrest* . . .

Roland Barthes, *Camera Lucida*, 91.

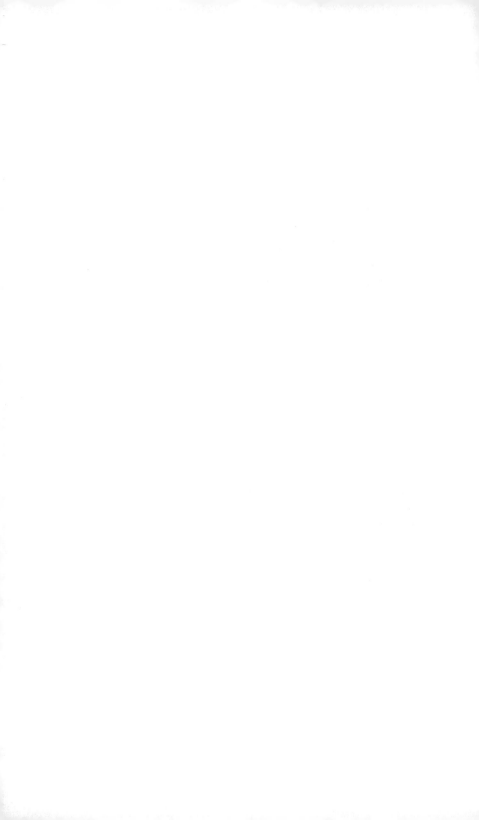

Acknowledgements

THIS BOOK HAS evolved slowly into its present form. Inspired by my reading of the growing body of work on nineteenth-century visual culture, and in particular, the work of Kate Flint, Geoff Batchen, and Jonathan Crary, this project has gradually expanded its solely literary focus into an interdisciplinary consideration of the impact of photography on nineteenth-century literary culture. Along the way I have accumulated many debts that I can only acknowledge but never begin to repay. Traces remain of the doctoral dissertation undertaken at King's College, University of Cambridge, and supervised by Dame Gillian Beer, whose sustained support over the years and ground-breaking research has provided much-needed inspiration and encouragement. My profound debt to Kate Flint also dates from the early years of my graduate study. Kate has been unfailing in her generosity and support, and this book would not have been written without her guidance and example. It is also difficult to sum up in a few words my deep appreciation of Margaret Harris who has been an invaluable mentor and friend throughout many years of uncertainty. I would also like to thank the Australian Research Council for awarding me with a three-year fellowship without which this project would not have been possible. The Research Institute of Humanities and Social Sciences at the University of Sydney also provided invaluable funding and assistance during the tenure of my fellowship in the Department of English at the University of Sydney. The assistance of archivists and librarians at the British Library, Cambridge University Library, the Harry Ransom Resource Centre, University of Texas, in particular Linda Briscoe Myers, and at the New York Public Library have been equally invaluable. I would also like to thank the English Department at Macquarie University, and in particular, Virginia Blain, Peter Goodall, and John Stephens for their support and encouragement. In addition, I owe a considerable debt to the editors of the journals *Victorian Literature and Culture*, *Nineteenth Century Contexts*, *Textual Practice*, and *Victorian Poetry* for providing me

with the opportunity to publish early versions of parts of some of the chapters that appear here.

I have also been inspired and encouraged in many different ways by numerous friends and colleagues. I would like to thank Susan Conley, Matthew Gibney, Sam Glover, Jenny Gribble, Syd Hickman, Lucinda Holdforth, Julian Holland, Melissa Lane, Natalya Lusty, Simon Petch, Rachel Potter, Nina Puren, Clara Tuite, Penny Van Toorn, and Lyndan Warner. I would especially like to thank Michele Pierson, whose friendship and encouragement over the years has made the impossible seem possible. I also owe so much to family and friends who have provided a much-needed anchor over the years, in particular Carol Adamson, Jackie Schiller, and Peter O'Shea. Finally, there are two women to whom I would like to dedicate this book, my mother Joan and my aunt Cynthia. Both, in their very different ways, made it possible for me to pursue a decidedly eccentric and obsessive path with confidence and passion. This book is for them.

H. G.

Contents

List of Illustrations

CHAPTER ONE

Introduction

My dearest Miss Mitford, do you know anything about that
wonderful invention of the day, called the Daguerrotype?
[*sic*]—that is, have you seen any portraits produced by means
of it? Think of a man sitting down in the sun & leaving his fac-
simile in all its full completion of outline & shadow, stedfast
[*sic*] on a plate, at the end of a minute & a half!! The Mesmeric
disembodiment of spirits strikes one as a degree less marvellous.
And several of these wonderful portraits . . . like engravings—
only exquisite and delicate beyond the work of graver—have
I seen lately—longing to have such a memorial of every Being
dear to me in the world. It is not merely the likeness which is
precious in such cases but the association, & the sense of near-
ness involved in the thing . . . the fact of the very shadow of the
person lying there fixed for ever!—It is the very sanctification
of portraits I think—and it is not at all monstrous in me to
say what my brothers cry out against so vehemently, . . . that
I would rather have such a memorial of one I dearly loved, than
the noblest Artist's work ever produced.

Elizabeth Barrett Browning to Mary Russell Mitford[1]

After seeing her first daguerreotypes in 1843 Elizabeth Barrett
Browning wrote in excitement to her friend Mary Russell Mitford.
Trying to capture the wonder she felt in words she reached for the
analogy of mesmerism. Inspired by the idea of the spirit of a sitter
caught forever on a metal plate, she transformed a simple portrait
into an uncanny likeness, a ghostlike figure summoned from beyond
the grave by the necromantic art of the daguerreotypist. For a

[1] Elizabeth Barrett Browning to Mary Russell Mitford, 7 December 1843. *The
Letters of Elizabeth Barrett Browning to Mary Russell Mitford 1836–1854*,
ed. Meredith B. Raymond and Mary Rose Sullivan (Winfield, Kan.: Armstrong
Browning Library of Baylor University, The Browning Institute, Wedgestone Press,
and Wellesley College, 1983), ii. 357–8.

moment time stood still and something had shifted in Barrett Browning's perception of the world. Suddenly the limits of what could be thought and imagined in the present and the future had widened to take account of otherwise forgotten faces, moments, lives, and scenes. Viewed through the lens of Barrett Browning's excitement, Daguerre's marvellous images extended the possibilities of memory to include the literal preservation of an infinite number of isolated fragments of time.

This book traces the various ways in which this desire to arrest time was taken up by writers, photographers, publishers, and consumers in the decades immediately following the invention of photography. Recent critical work on the relationship between nineteenth-century realism and photography has focused much-needed critical attention on the ways in which the invention of photography complicated the always troubled distinction between illusion and truth, realism and romance in the Victorian period.[2] But the impact of photography on the nostalgic construction of Victorian literary culture, both then and now, still remains to be explored. The early experiments with photographing the lives and works of poets that the following chapters analyse may seem bereft of uncanny visual effects, white clad pre-pubescent girls, or 'authentic' insights into past rituals of everyday life. Yet their assimilation of the photographic image into overtly literary rhetoric and forms reveals the various ways in which photography contributed to the emergence of new publishing practices that encouraged the association of reading literature with a self-consciously modern sense of cultural nostalgia and conservation.[3] This may seem, at first, to be profoundly antithetical to both photography's democratizing effects and the work of poets who actively resisted the impact of modernity on traditional arts and lives, yet this odd formal cohabitation was relatively successful. The conflation of poetry with an idealized notion of tradition was, in effect, the symbolic currency of all those in the business of selling poetry to a wider audience through popular forms such as the gift books, travel

[2] The recent work of Jennifer Green-Lewis and Nancy Armstrong exemplify this critical emphasis. Jennifer Green-Lewis, *Framing the Victorians: Photography and the Culture of Realism* (Ithaca, NY: Cornell University Press, 1996) and Nancy Armstrong, *Fiction in the Age of Photography: The Legacy of British Realism* (Cambridge, Mass.: Harvard University Press, 1999).

[3] Raymond Williams, *Keywords: A Vocabulary of Culture and Society* (London: Fontana, 1976), 87–93.

guides, magic lantern shows, working men's editions of verse, celebrity portraits, memorabilia, and mementos that are the subjects of this book. Indeed, one of the less palatable aspects of these often blatantly commercial forms for the literary historian is their unapologetic bowdlerization of the poetic text to amplify its nostalgic effects. Yet this is also where their critical interest and historical significance lies. Rather than simply conforming to the Victorian liberal elite's grim prognoses about the deleterious impact of public opinion on the sacred liberty of writers and artists to individual expression, these forms enact and illuminate the proliferation, as much as the standardization, of forms of visual and literary experience in a rapidly expanding and diverse cultural field. Increasingly dependent upon a productive coexistence of literature and the marketplace, the contours of this field were mapped and reinforced by the energetic interplay between the resistance and inevitable complicity of those writers and artists who ensured its ongoing vitality.[4] For despite the anxieties of critics such as Carlyle, Mill, Arnold, Ruskin, and others, the rapid expansion of middlebrow tastes and fashions played a crucial role in shaping the ways in which Victorian literary and cultural values were forged and promulgated. This is particularly apparent in the instances of photographic mediation and marketing of literary texts that will be covered here. As Patricia Anderson's extensive study of the printed image and the transformation of nineteenth-century popular culture has shown, illustration played a pivotal role in the growing literacy of the lower middle and working classes.[5] And while the novelty of photographic illustration would not find its way to an extended market until the final decades of the century, the struggle that began in the 1860s to reproduce photographs in increasingly affordable forms indicates a strong collective desire to realize that possibility.

One of the challenges for Victorian publishers was to market photographic illustration as a unique form, a fragment of time

[4] This phrasing is drawn from the cultural polemic of John Stuart Mill, 'On Liberty', *On Liberty and Other Essays* (New York: Oxford University Press, 1991), 5–128.

[5] Patricia Anderson, *The Printed Image and the Transformation of Popular Culture 1790–1860* (Oxford: Clarendon Press, 1991). See also, Richard Altick, *The English Common Reader* (Chicago: University of Chicago Press, 1957); William M. Ivins, *Prints and Visual Communication* (Cambridge, Mass.: MIT Press, 1969); Geoffrey Wakeman, *Victorian Book Illustration: The Technical Revolution* (Newton Abbot: David & Charles, 1973).

forever caught on the photographer's plate, to echo Barrett Browning's words. This is where verse fragments by famous poets were particularly helpful. Poetry, or strategically placed poetic references, provided a sequence and a legitimizing aesthetic tradition, transforming otherwise unremarkable landscape photographs or street scenes into collectible mementos. A relatively late example of this technique is Baccio Bandinelli's image of an old bookstall at the base of the statue of Giovanni de' Medici, which was framed by a fragment from Browning's *The Ring and The Book* (see Fig. 1).

Published in a volume devoted to tracing the influence of Florence on the poetry of both Brownings, this painstakingly literal matching of image and text demonstrates the nexus between close reading and nostalgia that photographic illustration encouraged.[6] The American author of this volume, Anna Benneson McMahan enthusiastically consigned her subjects to sepia but in the process she also drew attention to how their work could invest the contemporary tourist's experience of the streets of Florence with a sense of lived history. The trade in books taking place in Bandinelli's photograph nicely reinforces this impression, offering readers a slice of Florentine street life that they could easily re-enact if they chose to mirror McMahan's own commerce with the past. Practically demonstrating the pleasures and advantages of reading and buying books, Browning's poetry functions in this context as an associative trigger and a sign of a history to be uncovered by the dedicated curiosity of the would-be literary tourist on vacation, whether literally or imaginatively. McMahan thus assured her readers that they too could enter into a cultural exchange of words and ideas that would provide a still point in the midst of the chaos and change of their everyday lives.

The interest in isolating and resequencing authentic insights into past times that shapes McMahan's volume has also informed the growing interest in Victorian photography over the last three decades, as Raphael Samuel and more recently, Jennifer Green-Lewis have observed.[7] Correspondingly, there has been an interest in

[6] Anna Benneson McMahan (ed.), *Florence in the Poetry of the Brownings. Being a Selection of the Poems of Robert and Elizabeth Barrett Browning which have to do with the History, the Scenery and the Art of Florence*, with over 60 full page illustrations from photographs (Chicago: A. C. McClurg, 1904), 10.

[7] Raphael Samuel, *Theatres of Memory* (London: Verso, 1994), i. 337; Jennifer Green-Lewis, 'At Home in the Nineteenth Century: Photography, Nostalgia, and the Will to Authenticity', *Victorian Afterlife. Postmodern Culture Rewrites the Nineteenth Century* (Minneapolis: University of Minnesota Press, 2000), 29–48.

OLD book-stall at base of Statue of Giovanni de' Medici, by Baccio Bandinelli.

" *Baccio's marble, — ay, the basement ledge*
O' the pedestal where sits and menaces
John of the Black Bands with the upright spear. "
— The Ring and the Book, p. 164

1. Baccio Bandinelli, Old Book Stall at the Base of the Statue of
Giovanni de' Medici

accounting not only for the impact of photography on Victorian memory practices, but also in tracing the often negative ideological implications of the photographic reproduction of standardized versions of different cultures and histories.[8] Yet, as Green-Lewis astutely notes, the intrinsic nostalgia that drives our own appetite for insights into a culture that photography has made so familiar and available to us demands a form of cultural analysis that moves beyond conventional academic treatments that dismiss nostalgia itself as a regressive and politically suspect 'combination of poor history and narcissistic imaginings'.[9] In contrast, as Susan Stewart's provocative work on longing has demonstrated, nostalgia is a constitutive part of the process of reading, viewing, and imagining our own relation to both the past and the present.[10] And this retrospective sense of ourselves is as intimately tied to photography for us, as it was for Victorians. Rather than claiming authority, nostalgia works variously and dynamically to uncover, evoke, and familiarize the past. In its post-Kantian sense, nostalgia gave a name to the perennial longing and regret for lost youth that was readily assimilated into nineteenth-century conceptions of personality as a retrospective recovery of emotions.[11] Nostalgia also took on multiple forms in Victorian literary culture from the commercialized kitsch of the literary souvenir to a recursive story-telling mode that either resisted or resolved into myth and cliché.

It is the latter sin, as Isobel Armstrong has argued in her extensive study of Victorian poetry and politics, that modernist and contemporary critics have accused Victorian poets of committing: 'the major critical and theoretical movements of the twentieth century have been virtually silent about Victorian poetry. As the stranded remnants of high bourgeois liberalism, the poets have been

[8] One of the many recent examples of a Foucauldian approach to photographic forms of social surveillance is Suren Lalvani, *Photography, Vision, and the Production of Modern Bodies* (New York: State University of New York Press, 1996).

[9] Green-Lewis, 'At Home in the Nineteenth Century', 44–5.

[10] Susan Stewart, *On Longing: Narrative of the Miniature, the Gigantic, the Souvenir, the Collection* (Durham, NC: Duke University Press, 1993).

[11] Richard Sennett, *The Fall of Public Man* (London: Faber & Faber, 1986), 152. Jean Starobinski's seminal genealogy of nostalgia outlines the impact of Kant's shift of the sense of nostalgia as a pathological form of homesickness to the more psychological conception outlined in *Anthropologie in pragmatischer Hinsicht* (1798). There Kant argued that rather than registering a longing for place and for home, with which the nostalgic subject was inevitably disappointed, nostalgia recognized the sad reality that one could never turn back the clock and recover lost youth; Jean Starobinski, 'The Idea of Nostalgia', *Diogenes*, 54 (1966), 81–103.

consigned to sepia.'[12] The nostalgic preoccupations of a poet such as Tennyson and the photographers he inspired, for example, have come to epitomize the anachronistic excesses of Victorian poetry and art-photography.[13] And yet, paradoxically, it was in the process of 'consigning themselves to sepia' that Victorian poets, photographers, and publishers alike came to terms with their own modernity. In the context of this debate, Armstrong's use of a photographic analogy to describe the selective memory of twentieth-century critics is telling. Echoing both Victorian and contemporary associations of photography with the more pathological aspects of nostalgia—the entropy of forgetting or the appropriative sequencing of a museal sensibility—Armstrong's analogy demonstrates photography's continuing symbolic force as a critical device that illuminates the profound connections between nostalgia and literary discourse.[14]

Contrary to the contemporary critical priority given to literary realism as a register of the radical transformation of mimetic conventions in the nineteenth century, Victorian poetry and poetics were preoccupied with extending the temporal limits of language in a culture where keeping time had begun to assume its modern regimental contours. Haunted by what they perceived as modernity's seduction by the ephemeral, Victorian poets looked for signs of the eternal amidst the transient forms of historical time, and it is here that the parallel between Victorian poetry and the primitive practice and conception of photography begins to emerge. Early attempts to describe the experience of looking at a photograph or the machinery of photography shared this longing to take a moment out of time. Abstracted from the material conditions of its production, the photographic image appeared to manifest the mimetic ideal of the arrested moment rendered transparent by the observer's gaze; a temporal concept to which Victorian poets, such as Tennyson, Barrett Browning, Browning, and Dante Gabriel Rossetti were struggling to give

[12] Isobel Armstrong, *Victorian Poetry: Poetry, Poetics, and Politics* (London: Routledge, 1993), 1. Armstrong's point in full is: 'So the major critical and theoretical movements of the twentieth century have been virtually silent about Victorian poetry. As the stranded remnants of high bourgeois liberalism, the poets have been consigned to sepia.'

[13] See Woolf and Fry's critical assessment of Cameron and her milieu in *Victorian Photographs of Famous Men and Fair Women by Julia Margaret Cameron. With Introductions by Virginia Woolf and Roger Fry* (London: Hogarth Press, 1926).

[14] The term 'museal sensibility' is used by Andreas Huyssen in 'Monument and Memory in a Postmodern Age', *Yale Journal of Criticism*, 6/2 (1993), 253.

linguistic form. Intensifying this affinity, many early photographers, particularly those who circulated in a similar cultural milieu to Tennyson or Pre-Raphaelites such as Dante Gabriel Rossetti and John Everett Millais, drew upon an iconographic repertoire that recalled the legendary faces, narratives, and ivy-covered ruins that filled the landscape of the poetry and paintings of both their peers and Romantic precursors.

Extending beyond these artistic circles, commercial photographers found a market for their images of medieval ruins, the Lake District, or the wilds of Scotland and Wales amongst entrepreneurial photographic publishers. A predominantly English phenomenon, the photographically illustrated anthologies of verse that began to appear in the 1860s returned the images of this first generation of photographers to their literary and cultural sources in a format that, like McMahan's photographic treatment of the Brownings, encouraged the consumer not only to read, but to re-enact Wordsworth's reflective wanderings through the Lake District or Scott's mythic encounters with the ancient inhabitants of the Scottish Border.

Moving behind the lens, in early reviews, essays, and manuals devoted to photography as both an art and a growing industry, poets such as Tennyson and Wordsworth were held up as aesthetic models. Likewise, in photographically illustrated books and later photographic magic lantern shows the consumer was invited to move back and forth between the literary past and the immediate present of their own aesthetic experience; an overtly time-conscious hermeneutics facilitated by a synthesis of photograph and text or, in the latter's case, projected image and scripted oral performance. Rather than being the antithesis of a poetic sensibility that saw itself in perpetual flight from modernity therefore, these experimental illustrative ventures assimilated the idea of photography into the more consoling form of existing aesthetic paradigms. The anxieties inspired by one of modernity's iconic inventions were thus tempered by the familiarizing dynamics of discursive analogy and literary sequencing.

This rhetorical domestication of the novelty of photography is exemplified by the following review of the fifth exhibition of the London Photographic Society, published in the *Athenaeum* in 1858. Here the critic reads two photographs as if they were poems, drawing upon what would have been familiar poetic associations to the predominantly urban cognoscenti who attended such events:

To lump together some scraps of nature in a faint hope to preserve some organic unity in a more than usually heterogeneous Exhibition, we may mention with admiration Messrs. Ross & Thomson's somewhat murky and tragic *Brambles, Wild Hops, and Ferns* (100), and their *Nettles, Foxglove and Dock-leaves* (263). It is like reading Keats and Tennyson to look at the soft, white, velvet hair of the poisonous, veined nettle-leaves, green and rank, huddling up in a dark guilty mass to hide where the murdered child was buried, while the bee sings round the white diadems of their beguiling flowers as if nothing was wrong and earth was still a Paradise. How the wild hops, vine-like, cling and twine,—how the hooked bramble, with its square red stalk, trails and spreads.[15]

Not content to marvel at the uncanny verisimilitude of two simply titled studies of characteristically English plant life, the reviewer transforms them into stylized Pre-Raphaelite landscapes.[16] Post-lapsarian resonances give a sinister edge to the description of the 'dark guilty mass' of poisonous and clinging vegetation that entangles references to Tennyson and Keats. Thoughts of discovering a corpse in the lush undergrowth of these fragments of an English garden suggests that nature is no longer the 'nestling green for poets made' celebrated in poems such as Keats' *I Stood Tip-Toe on a Little Hill*, from which this reviewer lifts the sensuous images of 'sweet buds' crowned by 'starry diadems' of dew, buzzing bees, and the 'noiseless noise among the leaves'.[17] This is a landscape more suited to the Gothic melodrama of Tennyson's *Maud*, with its macabre opening memory of a body long since found in a 'ghastly pit' dripping with the 'silent horror of blood'.[18] Thus, as was so often the case in early photographic reviews, the photographic image was turned into something other than itself by the analogic sensibility of the critic. More concerned with tracing the various symbolic resonances that blurred the line between the natural and the cultural, the symbolic and the real, this reviewer transformed a relatively unambitious exhibition of the work of the London Photographic Society's membership into a catalyst for dreams, literary analogies, and metaphors

[15] 'Photographic Society', *Athenaeum* (29 May 1858), 692.
[16] Michael Bartram, *The Pre-Raphaelite Camera: Aspects of Victorian Photography* (London: Weidenfeld & Nicolson, 1985).
[17] John Keats, *Poems* (London: Everyman's Library, 1974), 3–8.
[18] All references to Tennyson's poems, other than when specified, will be according to Christopher Ricks (ed.), *The Poems of Tennyson*, 3 vols. (Harlow: Longman, 1987).

that countered the irreducible contingency of photography with the eternalizing rhetoric of a shared poetic repertoire.

That looking at a photograph should inspire thoughts of death and murder recalls Barthes' observation that the ascendancy of 'this image which produces Death while trying to preserve life' corresponded with the decline of religious rites of memorialization and the constant political turmoil of 'revolutions, contestations, assassinations, explosions, in short, of impatiences, of everything which denies ripening'.[19] Death, Barthes suggests, must be somewhere in a society and if it is no longer comfortably enshrined in religious practices and traditions it will inevitably find a secular manifestation. But as the above review suggests, Victorians did not simply relinquish the hold of the sacred in the face of the new, nor did they unambiguously correlate photography with the rise of a distracted secular modern sensibility. As the readers of Tennyson's *In Memoriam* knew only too well, the anxieties induced by the speaker's vision of his age drowning in a sea of blood spilt in the interests of political and industrial revolution were appeased by his refusal of the inevitability of evolutionary paradigms and the ultimate resolution, no matter how tenuous, of his crisis of faith. What this review reveals therefore is just how amenable photography was to being assimilated into Victorian cultural narratives that were equally concerned with forging patterns of kinship, relation, and continuity, as they were with recording the inevitable decline and struggle of those whose time had run out.

As Barrett Browning's response to the daguerreotype exemplifies, thoughts of death were also inseparable from thoughts of immortalizing a moment in time 'forever on a metal plate'. There was something strange, yet familiar, about these new images that inspired analogies with mesmerism and other necromantic materializations of the spirit. That they so often consisted of haunting likenesses of familiar faces and scenes further eased their transition into a well-established rhetoric of memorialization. Barrett Browning may have succumbed to the magical lure of the photographic image like a willing subject surrendering to the power of a mesmerist's gaze, but she did so in the interests of thickening the connective tissue of memory —her only armour against what she saw as modernity's culture of forgetting. As she wrote to Mitford, she began to mourn anew for

[19] Roland Barthes, *Camera Lucida: Reflections on Photography* (New York: Hill & Wang, 1998), 92–4.

those who had lived and died before the invention of photography; a loss that induced a longing 'to have such a memorial of every Being dear to me in the world'. This choice of words reveals how precarious she felt her own relation was to the world she inhabited. Never fully surrendering to the seductions of the new, Barrett Browning continually found herself looking back in an effort to understand the dramatic cultural, technological, and political transformations that were taking place around her. This historical inclination was integral to her understanding of her poetic vocation, but it was also a sensibility she shared with many of her contemporaries. In a variety of contexts ranging from the emerging disciplines of psychology and sociology to the seemingly diverse fields of geology, anthropology, philology, and physiology, the desire to trace the development of present forms back through time increasingly shaped the contours of intellectual enquiry. Historicism, as Maurice Mandelbaum has argued, pervaded Victorian cultural life recasting the phenomenal world in terms of the belief that 'an adequate understanding of the nature of any phenomenon and an adequate assessment of its value' were only to be gained through 'considering it in terms of the place which it occupied and the role which it played within a process of development'.[20] One manifestation of this epistemological shift has been described by Foucault as a move away from eighteenth-century paradigms of classifying the order of nature towards the study of processes of evolutionary transformation and the search for genealogical explanations of the present.[21] It was no longer enough to look and record the characteristics of a face, an artefact, or a species. To see and to write increasingly meant to decode and decipher secret histories encrypted just beneath the surface of the visible.

Much has been written about photography's place in this history of nineteenth-century interrogations of the limits of memory and perception. Often the announcement of photography's invention in 1839 is described in terms of an epistemic rupture. The year 1839 marks the date when 'the inventory started', to quote Susan Sontag, 'since then just about everything has been photographed' by an insatiable 'photographing eye' that has left us with the grandiose delusion 'that we can hold the whole world in our heads—as an anthology of

[20] Maurice Mandelbaum, *History, Man and Reason: A Study of Nineteenth-Century Thought* (Baltimore: Johns Hopkins University Press, 1974), 42.

[21] Michel Foucault, *The Order of Things: An Archaeology of the Human Sciences* (London: Routledge, 1989).

images'.[22] Photography, in the words of Walter Benjamin, revealed 'the physiognomic aspects of visual worlds which dwell in the smallest things, meaningful yet covert enough to find a hiding place in waking dreams'.[23] After 1839, according to Roland Barthes, the privilege of seeing 'oneself (differently from in a mirror): on the scale of History' was no longer confined to those who could afford a painted miniature. There had been a revolution in ways of seeing that required 'a History of Looking' to take account of 'the *disturbance* (to civilization) which this new action causes'.[24] Integral to that 'History of Looking' for Barthes was a division of 'the history of the world' into a time before 'the advent of the photograph' when history was understood 'in the form of myth' and a present in which the events of the past could be authenticated with 'an evidential power' that countered the agency of individual memory.[25]

This rhetoric of epistemic rupture is also not confined to twentieth-century theorizations of the cultural impact of photography. Whilst promoting the advantages of his version of the stereoscope, which sold in the millions in the 1860s, the then famous nineteenth-century man of science Sir David Brewster was similarly inspired to speculate about the possibility of compiling a photographic 'history of the world':

The truths of nature are fixed at one instant of time; the self-delineated landscape is embalmed amid the co-existing events of the physical and social world. If the sun shines, his rays throw their gilding on the picture. If the rain-shower falls, the earth and the trees glisten with its reflections. If the wind blows, the partially obliterated foliage will display the extent of its agitation. The objects of still life, too, give reality and animation to the scene. The streets display their stationary chariots, the esplanade its military array, and the market-place its colloquial groups, while the fields are studded with the forms and attitudes of animal life. The incidents of time and the forms of space are thus simultaneously recorded, and every picture from the sober palette of the sun becomes an authentic chapter in the history of the world.[26]

Brewster seized upon the idea of the photographic image as a fixed 'instant of time' that revealed all to the spellbound observer.

[22] Susan Sontag, *On Photography* (New York: Anchor Books, 1990), 3.

[23] Walter Benjamin, 'A Small History of Photography', in *One-Way Street*, trans. Edmund Jephcott and Kingsley Shorter (London: Verso, 1979), 243.

[24] Barthes, *Camera Lucida*, 12. [25] Ibid. 87.

[26] David Brewster, *The Stereoscope: Its History, Theory and Construction* (London: John Murray, 1856), 179.

Like Barrett Browning he saw a future where no moment need be forgotten. The incidental scenes of everyday life could now become authentic chapters in a truly comprehensive 'history of the world'. One of the more compelling aspects of Brewster's description is his evident fascination with the idea of suspended animation. Rather than signifying the death of the represented, his images of glistening wind-blown leaves and convivial street scenes teeter on the verge of motion. Time may stand still for a moment, but only long enough for Brewster to find the words to transform the invention of photography into what Frederic Jameson has called a 'telltale instant', a rupture or event after which history would never be the same again.[27]

Amidst these varying accounts of image-haunted minds a distinctive profile of a modern observer begins to emerge, an observer whose 'waking dreams' now extended far beyond the realms of his or her lived experience. More recently, literary historians have started to consider the impact of this technologically enhanced visual imagination on the culture of Victorian realism. Nancy Armstrong describes literary realism as 'fiction's anticipation of and reaction to the sudden proliferation of transparent and reproducible images that marks the mid-Victorian period'; a literary response that she argues was accompanied by the emergence of a visually literate readership that deployed these images differentially as a means 'of classifying both things and people'.[28] Alternatively, Jennifer Green-Lewis has emphasized the formative role the rapid circulation of photographic images played in Victorian interrogations of the 'increasingly unstable distinctions between romance and realism'; a discursive analysis that illuminates the complex and various significations of photography, as both a magical device and an empirical technique in Victorian modes of storytelling.[29] Extending this critical interrogation of the phenomenology of photographic perception still further, Lindsay Smith has suggestively analysed photography's intersection with what she describes as the Pre-Raphaelite 'desire to draw attention to the physiological basis of sight' and to move beyond 'a simple acceptance of the metaphorical dominance of the visual sense'.[30]

[27] Frederic Jameson, *Post-Modernism, or, the Cultural Logic of Late Capitalism* (Durham, NC: Duke University Press, 1991), 9.

[28] Armstrong, *Fiction in the Age of Photography*, 4.

[29] Green-Lewis, *Framing the Victorians*, 6.

[30] Lindsay Smith, *Victorian Photography, Painting, and Poetry: The Enigma of Visibility in Ruskin, Morris, and the Pre-Raphaelites* (Cambridge: Cambridge University Press, 1995), 2.

Inflecting, if only implicitly, the various historical arguments of these and other recent studies of Victorian visual culture has been Jonathan Crary's influential analysis of the transformation of nineteenth-century models of vision in *Techniques of the Observer*.[31] While Crary's historical assumptions may have been the subject of intense and often polarized debate over the last decade, his work remains a crucial reference point in studies of Victorian visual culture for precisely that reason, and this book is no exception to that rule.[32] Whether one agrees with Crary or not, one of the strengths of his work is its analysis of the ways in which optical instruments, such as the stereoscope or photography, provide a crucial point of access into nineteenth-century figurations of the visible. As he rightly observes, these optical devices and the discourse they generated survive as the materialization of a shared repertoire of visual techniques that slowly, yet fundamentally, reconfigured the ways in which Victorians in general interacted with the world around them. More contentiously, however, Crary argues that a new kind of observer took shape in the nineteenth century as a result of profound epistemic shifts in the discourses of psychology, physiology, and optical technology. He suggests that this moment in the history of the philosophy of perception is the 'moment when the visible escapes from the timeless order of the camera obscura' only to become enslaved by another visual regime lodged in 'the unstable physiology and temporality of the human body'.[33] No longer tethered to a referent, the perceptual process itself becomes the focus of new disciplinary techniques designed to manage and standardize the visual experience of the observer. In this context photography, like new technologies such as the stereoscope, the phenakistoscope, and the kaleidoscope, contributed to 'a radical abstraction and reconstruction of optical experience'.[34] Crary suggests therefore, that even though photography may bear a superficial resemblance to the realist devices of more traditional visual arts, 'the vast systemic rupture of which photography is a part renders such similarities insignificant'.[35]

[31] Jonathan Crary, *Techniques of the Observer: On Vision and Modernity in the Nineteenth Century* (Cambridge, Mass.: MIT Press, 1992).

[32] W. J. T. Mitchell provides an extensive critique of Crary's work in *Picture Theory: Essays on Verbal and Visual Representation* (Chicago: University Of Chicago Press, 1994), 19–24. [33] Crary, *Techniques of the Observer*, 70.

[34] Ibid. 9. [35] Ibid. 13.

But, as critics such as W. J. T. Mitchell have been quick to point out, such a broad theorization of nineteenth-century visual practices runs the risk of homogenizing patterns of cultural consumption.[36] Clearly the rapid rise in the circulation of commercial photographic images played its part in the standardization of visual imagery and of visual experience in the nineteenth century. What is not so clear is the extent to which new visual technologies, such as the photograph and the stereoscope, were deployed coercively to homogenize and discipline the visual field of the modern observer. Crary himself characterizes the temporality of modern perceptual models as intrinsically unstable, and it is in the individual, contextual, and physiological variations that this comment implies that the space for alternative intersections between memory, representation, and vision emerge. For while the extensive archives of Victorian psychiatric, police, and ethnographic photographs undoubtedly demonstrate how quickly photography was assimilated into the various surveillance apparatuses of the medical, scientific, and legal establishments, the sheer proliferation of photographic images in the first forty years after its invention suggests that there are multiple and entangled histories of experimentation, adaptation, and mediation yet to be unravelled. A trace of these alternative histories of reception and adaptation remains in the form of the Victorian photographically illustrated book, and another survives in personal documents such as Barrett Browning's letter, both of which capture the irreducible particularity of Victorian conceptions of photographic time and the variety of perceptual experiences that new visual technologies made available to nineteenth-century observers. In both these cultural forms the relationship between observer and image is by no means constant or analogous. When a Victorian consumer purchased a photographically illustrated volume of Wordsworth's poetry, his or her experience of photography was mediated through poems that, to use Raphael Samuel's words, were self-consciously 'built on time's ruins'.[37] In this context the reader's response to the image was undoubtedly guided by the context in which the book was read, given that volumes such as these were variously marketed as gift books, travel guides, and serious literary anthologies. In contrast, Barrett Browning's letter to Mitford registers a very different

[36] Mitchell, *Picture Theory*, 19–24. [37] Samuel, *Theatres of Memory*, i. p. ix.

response to photography reflecting the novelty of the daguerreotype and the photographic portrait more generally in the early 1840s, while foreshadowing her own enthusiastic participation in the practice and the subsequent reproduction of her favourite photographic portraits in posthumously published collections of her works in both England and America.

Too often the history of photography and the aesthetic and logistical demands of the museum exhibition space have extracted nineteenth-century photographs from the series or the book where they originally appeared; a textual context which, as Carol Armstrong has recently observed, contributed substantially to the conception of the broader cultural significance of photography in the first four decades after its invention.[38] Likewise, there has been an abstraction of the emergence of an increasingly time-conscious poetics from the visual culture from which it drew its images and ideas, and of the figure of the Victorian poet from a history of photographic self-presentation that forged new patterns of consumption and memorialization. One familiar instance of the latter is the countless portraits of Victorian poets that survive, testifying to the nineteenth-century fascination with the face as the transparent boundary between public and private selves, presence and absence. Informed by the widely disseminated principles of Physiognomy, and later Phrenology, most Victorians subscribed to a greater or lesser degree to the belief that the contours of the face revealed a secret history that no amount of sophistry could mask. The invention of photography only amplified and mystified the metaphysics of presence that underpinned this equation of sight with insight. Looking out from the frontispieces of early photographically illustrated books, or from the millions of postcard-size portraits that consumers could assemble into their own portrait books, the faces of Tennyson, Barrett Browning, Robert Browning, and many others injected a commemorative note into the reading experience. Visually incarnating the spirit of the sitter, they haunted these volumes with dreams of immortality, dreams that emanated as much from the writer's desire to be remembered as from the consumer's desire to possess the ultimate memorial of a great poetic mind. Although portraits had long graced the frontispieces of literary works, photographs offered

[38] Carol Armstrong, *Scenes in a Library: Reading the Photograph in the Book, 1843–1875* (Cambridge, Mass.: MIT Press, 1998), 3.

an unprecedented sense of intimacy and contact with the author; an effect that was amplified by the reader now being able to share in the experience of being photographed. Owing to the rapid commercialization of photographic portraiture, taking up one's place in history was no longer confined to the famous or the powerful, as Lewis Carroll's satire of Victorian portrait photography, *Hiawatha's Photographing*, somewhat wistfully acknowledged.[39] But while this widespread cultural phenomenon may have been a source of anxiety and disappointment for Carroll, who responded by taking up the conventional position of the alienated artist struggling for autonomy amidst the undiscriminating desires of the crowd, it suggests a shared preoccupation with possessing a permanent record of one's existence—a sign of continuity set against a backdrop of perceived transience and perpetual revolution.

The following chapters form a series of case studies that take various examples of photographic illustration of the work of nineteenth-century poets as their subject. Beginning with an analysis of early photographic reviewing cultures and the first photographically illustrated verse anthologies to be published in England, each chapter then traces the permutations of literary and cultural nostalgia that the work of poets such as Wordsworth, Scott, Barrett Browning, Tennyson, and lesser-known poets such as Augusta Webster and Agnes Mary Frances Robinson inspired in Victorian photographers, publishers, and critics alike. What unites these very different case studies is the acute sense of belatedness that haunts Victorian literary culture and poetry in particular. Poetry as an idea emerges from these various illustrated texts as an ideal of tradition, a repository of cultural memory, a time-keeping device, and as a means of deferral and deceleration in the midst of the flux and chaos of modern life. Demonstrating a characteristically Victorian interest in the affinities between image and word, these volumes variously manifest an openness to new forms and generic combinations that refused the formal distinctions and conventions that their modernist successors would insist upon. Closer in sensibility to the adaptive and nostalgic preoccupations of postmodern culture, Victorian experiments with the photographic mediation of literary texts offered new perspectives on familiar narratives and new techniques for rewriting the self and

[39] Lewis Carroll, *Phantasmagoria and Other Poems* (London: Macmillan, 1911), 66–77.

its relation to the past and present.[40] That these experiments met with mixed success suggests just how provisional and exploratory they were. Yet the qualified nature of their success by no means diminishes their historical significance as evidence of the fascination with new ways of exploring and extending the boundaries of imaginative experience that photography inspired. For those who first encountered a photograph or daguerreotype, the time and space of representation appeared to transform before their eyes. And even if the cultural implications of this transformation were not always consoling, nor the economic benefits of experimenting with its illustrative potential invariably remunerative, the history of reading and spectatorship that emerges out of these early literary framings of photography provides an insight into the increasingly sophisticated relationship between image and text that developed in the latter half of the nineteenth century, and in the century that followed. To fix a moment, a famous face or favourite literary scene, to arrest time, in effect, in the face of the relentless pace of history, would become an increasingly seductive prospect in an era when advances in transport and communication were pressing against the limits of what the mind could take in at a glance.

[40] Barbara Maria Stafford's recent observations on the analogic structure of the Internet and Hypermedia, for example, emphasize the seemingly infinite creative combinations produced by new technological configurations; *Visual Analogy: Consciousness and the Art of Connecting* (Cambridge, Mass.: MIT Press, 1999), 82–3.

CHAPTER TWO

Nostalgia and Poetic Idylls in Early Victorian Photographic Discourse

There is a poetry of photography as there is of painting and literature.

Peter Henry Emerson[1]

It is well for the onward traveller occasionally to pause and review the ground over which he has traversed: to stop and reflect—

'And gaze upon the distant vale below:'

to 'look before and after,' and see whither leads the path he is pursuing . . . The above should be the attitude to photography. It is long since crossed the *pons asinorum*, and entered the broad champaign which lies stretched before it. It remains to be seen whether it will ever climb the fabled mount or penetrate the charmed circle so jealously guarded, and be welcomed as an equal, instead of being coldly received as a *parvenu* or intruder.

Stephen Thompson[2]

Early nineteenth-century photographic reviewing practices were diverse and numerous. Reflecting the speed with which photography

[1] Cited in Lucien Goldsmith and Weston J. Naef, *The Truthful Lens: A Survey of the Photographically Illustrated Books 1844–1914* (New York: The Grolier Club, 1980), 9. This ideal of photography is expanded upon in Peter Henry Emerson's treatise *Naturalistic Photography for Students of the Art* (London, 1889) and Nancy Newhall, *Peter Henry Emerson: The Fight for Photography as a Fine Art* (New York: Aperture, 1975).

[2] Stephen Thompson, 'The Commercial Aspects of Photography', *British Journal of Photography* (1 November 1862), 406–7 (406).

was embraced on both sides of the Atlantic, periodicals, journals, newspapers, and almanacs allow us to chart not only the early reception of photography but also the emergence of a new critical language forged out of the desire to account for both the excitement and anxiety that photography inspired in its critics, enthusiasts, and practitioners alike. The need to define and adapt photography to a variety of social, political, scientific, and cultural uses and contexts characterized publications addressed to photographic societies, professionals, and interested amateurs. These included the *British Journal of Photography*, the *Journal of the Photographic Society of London*, the *Philadelphia Photographer*, the *Photographic Art Journal*, the *Photographic News*, the *Photographic Times*, and the *Photographic World*, as well as review essays, announcements, and photographic illustrations which began to appear in periodicals, newspapers, and the illustrated press.[3] As one might expect, given the varied nature of this literature, it is impossible to extrapolate a single and defining idea of photography from these sources. Rather, what emerges from immersing oneself in nineteenth-century photographic discourse is its contradictory, inconsistent, and assimilative nature. Given the literary concerns of this project, however, as well as the considerable scholarship that has already charted the history of photography, an account of the complexity of early photographic culture will not be attempted here. Instead, this chapter will focus on the particular ways in which early photographic discourse takes up and adapts an idea of poetry to legitimate and reflect on photography's relation and contribution to Victorian culture. Beginning with a close analysis of the rhetorical strategies of particular reviewers, the focus of the chapter will then broaden out to consider the conceptual implications of the nostalgic idea of poetry and culture that shapes these reviews and early illustrated volumes that take either poets or poetry as their subject. The latter began to appear in the early 1860s, starting with anthologies such as William Morris Grundy's *Sunshine in the Country* and continuing through the next decades, as

[3] Other periodicals, journals, and magazines, such as the *Cornhill*, from which this chapter's epigraph is taken, *Century Magazine*, *Eclectic Review*, *Harper's New Monthly Magazine*, which will be the focus of the final chapter of this study, and the *Art Union*, later the *Art Journal*, also help us to chart the early convergence of the idea of photography with the idea of poetry. For further examples see William S. Johnson, *Nineteenth-Century Photography: An Annotated Bibliography 1839–1879* (Boston, Mass.: G. K. Hall, 1990).

the following chapters will discuss, in a variety of forms, ranging from photographic frontispieces in collected works to ornamental editions of Cowper, Wordsworth, Scott, Tennyson, Keble, Barrett Browning, and other poets of the period.[4] Mary Warner Marien argues in *Photography and Its Critics* that when 'photography is viewed as a multifaceted social idea, vested in the practice of but not limited to image making, the oft-made distinction between photographic document and photographic art can be transcended'.[5] This approach to early ideas of photography is a crucial one for this project, and one that should not be confused with the more familiar and pervasive contention that, to quote John Tagg:

Photography as such has no identity. Its status as a technology varies with the power relations that invest it. Its nature as a practice depends on the institutions and agents that define it and set it to work. Its function as a mode of cultural production is tied to definite conditions of existence, and its products are meaningful and legible only within the particular currencies they have. Its history has no unity. It is a flickering across a field of institutional spaces. It is the field we must study, not photography as such.[6]

Tagg's thesis is particularly appealing to a literary scholar venturing into the unknown terrain of early photographic literature. But to return to Mary Warner Marien's formulation, the challenge is rather to maintain and expand on the multiple facets of Victorian ideas about photography, whilst also transcending too rigid a distinction between what is said about or as a result of photography and the practice of image-making itself. Too often either the photographic or literary aspect of the project gets lost or compromised in literary studies that have drawn on Victorian ideas of photography, a difficulty that this study has tried to resolve through the selection of cultural forms that maintain, or struggle to maintain, that balance for themselves.[7]

[4] William Morris Grundy, *Sunshine in the Country: A Book of Rural Poetry Embellished with Photographs from Nature* (London: Richard Griffin, 1861).

[5] Mary Warner Marien, *Photography and Its Critics: A Cultural History 1839–1900* (Cambridge: Cambridge University Press, 1997), p. xiii.

[6] John Tagg, 'Evidence, Truth and Order: Photographic Records and the Growth of the State' (1984), in *The Burden of Representation: Essays on Photographies and Histories* (London: Macmillan, 1988), 63.

[7] Two exemplary exceptions to this rule are the work of Jennifer Green-Lewis and Lindsay Smith.

THE ART OF PHOTOGRAPHIC CONVERSATION

Early photographic reviews have provided a rich source of curious phrases and superstitious legends that have become stock phrases in recent accounts of the early reception of photography, and for good reason. It is hard to resist reproducing tales and phrases that were intentionally designed to entertain and delight the readers of early histories of the mysterious origins of photography. All too willing to believe in the photographer's magical powers, readers unfamiliar with the art, as well as more informed amateurs and cognoscenti, delighted in these tales, as we do, enjoying the pleasures and escapism of nostalgic reinvention. One of the many histories that has got lost in the rush to theorize these more seductive and popular photographic analogies and metaphors, however, is the far less appealing, yet characteristically earnest, style of much Victorian photographic reviewing. Disappointingly free of wild speculation and fanciful anecdote, many of these reviews provide slim pickings for critics in search of signs of wonder and cinematic auguries. Yet, for those interested in the intersections between photographic and literary practice in this period, and its implications for how we continue to narrate the past and engage with resulting literary formations, the yield is both rich and nuanced. The sheer variety of this archive encourages a survey-style analysis. Yet this approach risks reproducing the method of strategic culling often applied to early photographic reviews in their more conventional role as a stage-setting device. The next section will provide a detailed analysis of how one early photographic critic experimented with the idea of poetry on multiple levels—as an ideal aesthetic, an anti-industrial cultural tradition, an analogous image-making device, and as the unmediated materialization of a moment taken out of time.

Stephen Thompson, who was a regular contributor to the *British Journal of Photography*, prefaced an essay on photographic portraiture, which he submitted to the journal in 1862, with a history that extended back to when 'the Greek maiden made the first essay in portrait painting by endeavouring to trace the shadow of her lover on the wall' and forward through 'the centuries intervening that poetic myth and the photographic era'.[8] This brief ambitious genealogy included three portraits from 'the photographic era', Tennyson's

[8] Stephen Thompson, 'On Portraits and Portraiture', *British Journal of Photography* (15 January 1862), 21–2 (21). Thompson (1830?–93) was a photographer who produced pictorial albums of views, as well as a prolific reviewer.

'Margaret', 'Lilian', and 'The Gardener's Daughter'. To further illustrate his point, Thompson also included a lengthy citation from 'The Gardener's Daughter', which, he effused, was 'painted in words as only the true artist can paint':

> She stood—
> A single stream of all her soft brown hair
> Pour'd on one side: the shadow of the flowers ·
> Stole all the golden gloss, and, wavering
> Lovingly lower, trembled on her waist—
> Ah! happy shade!—and still went wavering down—
> * * * * *half* light, *half* shade,
> She stood—a sight to make an old man young.

Transfixed by nostalgia, the speaker lingers over every curve of 'his' gardener's daughter in this fairy-tale version of finding love, a muse and domestic harmony embodied in the form of a working-class woman exchanged between two urban, middle-class, male friends.[9] The perfect antidote to the painter's block that has plagued the poem's speaker, this moment, as the recursive form of the poem implies, has been and will be endlessly replayed for his and our viewing pleasure.

Although it would be tempting at this point to explore the implications of the configuration of homosocial desire that 'The Gardener's Daughter' typifies, as Eve Sedgwick has so ably done in her critique of 'The Princess', it is the role this fragment plays in Thompson's review that is of concern here.[10] Proving himself the ideal reader, Thompson chooses to reproduce Tennyson's lingering gaze as it follows the contours of Rose's body, a visual pleasure that he invites his reader's to share and adapt to their own Tennysonian-style portraits, as so many did.[11] Tennyson's naïve erotic fantasy also imports a model of

[9] In his notes for the poem Christopher Ricks provides its biographical background: 'The poem brings together Tennyson's friendship for Hallam (the narrator's Eustace) and Hallam's love for Tennyson's sister Emily (Eustace's Juliet).' Ricks, *Poems*, 507.

[10] Eve Sedgwick's reading of the dynamics of male homosocial desire in Tennyson's poetry is implicit here. See Eve Kosofsky Sedgwick, *Between Men: English Literature and Male Homosocial Desire* (New York: Columbia University Press, 1985), 118–33.

[11] Oskar Rejlander and Henry Peach Robinson are the more famous practitioners of this Tennysonian style. Robinson also substantiated his claims for photography as an art with reference to the poet's work in treatise, such as his *Letter on Landscape Photography* (New York: Scovill Manufacturing Co., 1888). There he equated 'poetic' with 'original genius . . . that mysterious something beyond the border line of hard fact which is felt more than seen in a picture', suggesting that the need for originality had become all the more urgent in 'this age of imitation' when anything 'absolutely new seems to be almost impossible' (19–20). He then used an illustration of Tennyson's *The Brook* as an example of how this ideal of originality and poetic inspiration could be practically achieved (35).

inspiration into Thompson's grafting of photographic practice onto the more familiar forms of poetry and painting. The idea of poetry in this context takes the form of a romantic ideal of creativity, an inherently nostalgic concept that privileges originality, whilst, paradoxically, emphasizing the dynamics of reproduction itself. To quote Thompson: 'Every stroke telling—clothing the dry bones with flesh and blood until they become a living, breathing reality. Yes! for, after all, the ideal is the only real: things that are seen and patent to the senses pass away and are not.' This mystification of the process of poetic-making resonates with the then common ideal of photography as autography, a natural magic that brought the past to life, capturing every detail, and transcending the limitations of hand or machine. Pygmalion-like, the body comes to life through the process of reproduction while reminding us of just how quickly early photographic discourse, even in its most high-minded incarnations, could slide into occult and supernatural associations. In the broader context of the review, however, these associations are enlisted to remove photography from its technological provenance, to stress its natural or poetic, rather than mechanical origins. For Thompson, the comparison with Tennyson reinforces the idea of photography as a shared 'natural' language with the power to capture and express not only human emotion, but also an ideal of human progress; an aspiration he shared with many of his peers, as will become more apparent in subsequent chapters.

Thompson's isolation of the poetic fragment to exemplify the ideal made real also demonstrates the appeal of the disassociative aspects of poetic description to early photographers. By framing a moment or scene, taking it out of time in effect, poetic vignettes such as Tennyson's portrait of Rose, or, alternatively, a picturesque landscape by Wordsworth or a gothic detail from one of Scott's early verse narratives, provided a legitimizing gloss on photography's defamiliarizing effects and a scripted response to images that emulated such ideals. Moreover, analogies between poetic and photographic perception suited the mythic sense of unmediated vision that legitimated these illustrative practices. As an ideal of truth and transparency, poetry invested photography with a sense of order and permanence, even if the stabilizing effects of such idealism were only ever tenuously maintained. For never far from the surface was a profound sense of epistemic unease that prompted a corresponding stress on the recuperative benefits of endless returns and reviewings,

of which the adaptation of the medievalized Englishness of Tennyson's portraits is only one of many instances.[12] Inside the privileged institutional and social milieus of urban photographic societies it was far easier to forget or, alternatively, filter the outside world through exoticized images of the past that elicited wonder and pleasure, rather than guilt and an uneasy sense of implication.[13]

Yet this desire to intellectualize and abstract photography from its technological origins did not prevent Thompson from celebrating its democratizing aspects, or demanding the maintenance of high standards in the rapidly expanding area of commercial portraiture. This stance is exemplified in the epigraph for this chapter, which is taken from another of Thompson's essays on the commercial aspects of photography. Combining aesthetic aspiration with an enthusiastic populism, Thompson refused the conventional condemnation of mass-produced imagery. Integral to this approach was a pointed interest in how consumers made use of photography in their everyday lives. Expanding out from his reflections on Tennyson's portrait, for example, Thompson turned his focus to his audience's experience of posing for portraits, offering advice on how to master the process and accounting for the often disappointing outcomes:

Portraits by photography are generally considered *uncertain*, which is not surprising when we consider how chameleon-like are the flitting aspects of the human face. A passing thought—an 'airy nothing'—will throw a shadow over the countenance at the critical moment and later the whole expression. Then there are always particular aspects under which *those at home* like you best, which may not have been caught. Sitters should always remember that the photographer cannot, like the painter, work up a particular expression; and yet, it is in those happy evanescent gleams of individuality of expression that photography is so great—far outstripping the most gifted pencil of the loftiest genius.

Notably, this passage assumes a shared conception of photography's destabilizing effects, stressing its uncertainty and unreliability, rather than its verifying powers. Yet it also registers a fascination with the

[12] Tom Gunning, 'Phantom Images and Modern Manifestations: Spirit Photography, Magic Theater, Trick Films, and Photography's Uncanny', in Patrice Petro (ed.), *Fugitive Images: From Photography to Video* (Bloomington: Indiana University Press, 1995), 42–71 (43).
[13] Grace Seiberling provides a detailed account of amateurism and the culture of these photographic societies in *Amateurs, Photography, and the Mid-Victorian Imagination* (Chicago: University of Chicago Press, 1986).

variability of expression that gestures towards a more profound shift in concepts of the self and facial expression that goes beyond prosaic advice and conventional physiognomic syllogisms, suggesting something more akin to what Richard Sennett describes as 'secular immanence'.[14] Sennett defines this concept as a belief in immanent meaning in the world, which he argues shaped nineteenth-century notions of personality, and that we also find in the expressive theory of Duchenne de Bologne and Darwin's influential photographic studies of the human face in motion.[15] Sennett contends that as 'the gods fled, immediacy of sensation and perception grew more important; phenomena came to seem real in and of themselves as immediate experience. People in turn were disposed to make more and more of differences in the immediate impressions they made upon each other, to see these differences, indeed, as the very basis of social existence.'[16] The lack of control any one individual could have over the variety of emotions that the ever-changing circumstances of interpersonal communication and life conditions produced therefore meant that the individual's capacity to recollect and master the past took on a new urgency. Accordingly, Sennett argues that longing and nostalgia acquire a distinctively nineteenth-century psychological sense, what Jean Starobinski would call a post-Kantian understanding of the self as in perpetual mourning for a lost youth that is necessarily and constitutively out of reach. The resulting sense of personality in Sennett's account is thus increasingly tethered to a mythic sense of the local, the particular, to family and childhood memories of hearth and home that, theoretically, gave meaning and depth to the insubstantiality and transience of present experience.

Yet, while Thompson's interest in perceived differences and the recollective powers of the camera accords with Sennett's theorization of the increasingly nostalgic articulation of nineteenth-century concepts of personality, his enthusiasm for photography's potential to produce new forms of sociability and cultural memory presents a far more optimistic vision than that which underlies Sennett's ultimately declinist conclusions about the diminished quality of public and

[14] Sennett, *The Fall of Public Man*, 150–3.
[15] A translation of Duchenne's lesser-known, yet deeply influential study has recently been published, see G. B. Duchenne de Boulogne, *The Mechanism of Human Facial Expression*, ed. and trans R. Andrew Cuthbertson (Cambridge: Cambridge University Press, 1990). [16] Sennett, *The Fall of Public Man*, 151–2.

private life in the second half of the nineteenth century. Take, for example, Thompson's celebratory genealogy of the photographic portrait. Although it might seem provocative to cite this deliberately light journalistic account alongside Sennett's rigorous sociological analysis, the point here is to demonstrate the need to take seriously the elements of play and pleasure, as well as anxiety and melancholia, that characterized Victorian reflections on the social and psychological impact of powerful new technologies such as photography. This spirit of fun and excitement by no means cancels out fears for the present or future; what it does is to illuminate the creative influence photography had on those who chose to tell stories and make sense of the world for the ever-expanding readership of amateur journals, popular science, and, of course, photographically illustrated books:

It is curious to reflect how little in past ages mankind knew of their contemporaries. The form and features of many of those who 'moved the world' were so utterly unknown to those who lived in the same period as they are to us. The men of mark of our own age are as familiar to us as 'household words'. [Yet] we have really no idea of what our race was like before the times of the Reformation. What we see could not possibly be 'likenesses' because they simply are not humanity. Not until Holbein's time did we begin to see what men and women were. What our early Henry's and Edwards were like—we cannot know: they are buried in the night of art, like the brave who lived before the time of Agamemnon.

We sometimes hear people question whether portraits by photography will continue to be as popular as they are. We might as reasonably ask whether railways will continue to be popular, and whether we shall not go back to the slow coaching days. So long as the affections and passions last, it must be popular: so long as people marry and are given in marriage—as long as friendship, love, heroism, genius, and goodness are attributes of humanity —so long will there be a demand for the fruits of photography.

What further distinguishes Thompson's chronology is its implicit assimilation of Tennyson's portraiture into a history of photographic portraiture, while simultaneously providing a cultural rationale for the gradual appearance of photographic portraits in anthologies of verse and editions of the work of poets such as Tennyson and Barrett Browning. Applied to these publishing formats, Thompson's notion of the photographic portrait's extraordinary revelatory powers reinforces Romantic ideals of unmediated vision, whilst transforming the act of reading itself into a process of cultural conservation.

The inherently progressive nature of Thompson's defence of photography also has significant resonances with letters and essays that began appearing at this time in photographic journals calling for the foundation of England's first national photographic portrait gallery. Only a year later, one of Thompson's contemporaries, Lachlan Maclachlan, would address the readers of the *British Journal of Photography* in the following impassioned terms:

PHOTOGRAPHY stands in the foremost rank as a great civiliser; it enters into every grade of society, from the Queen on the throne to the peasant in his humble cottage . . . the artist avails himself of its wondrous powers, as does also the architect; and the lecturer employs it with the magic lantern as the means of showing instantly to his audience places that, with the most eloquent tongue he would be utterly unable to describe. He can place before us scenes from the Holy Land; and as we gaze at their wondrous and sublime grandeur, we become lost in amazement and forget that we are not looking at the realities. The grotesque pagodas of China, and the wonderful temples of India, are made to pass before our view as if by enchantment; but the likenesses of those who erected and inhabited them no one can conceive. Alas! man, noble man, for whom all things were created, has passed into oblivion, whilst the works of his hands remain. . . . This should not be. Photography has conferred upon us many blessings, but the greatest of all is its wonderful power of delineating the human form.[17]

While the evangelical style of MacLachlan's celebration of the civilizing potential of the photographic portrait may be crude and imperialistic, the contrast with Thompson's more expressive conception of what photography reveals about the human face is worth remarking. What fascinates Maclachlan is the stasis of the image, its monumentalizing and verifying properties, in contrast to Thompson's interest in the instability and infinite variability of the photographic portrait. While these differences may be subtle, they exemplify the complexity, rather than the standardization of a new photographic hermeneutics. Maclachlan conforms to the more commonplace repertoire of Lavaterian physiognomy, which as Jennifer Green-Lewis argues, became a 'hermeneutic staple of literally hundreds of Victorian novels in which moral substance can be identified in the features of the protagonists', a 'tidy mutual affirmation' which

[17] Lachlan MacLachlan, 'A National Photographic Portrait Gallery', *British Journal of Photography* (15 August 1863), 333.

she contextualizes through an analysis of Victorian photographs of the insane.[18] But what this chapter is more concerned to unravel are the issues arising from a comment Green-Lewis makes in a brief reference to Joseph Turnley's *Language of the Eye*.[19] Published in 1856, this volume was described by a reviewer in the *Art-Journal* as uniting 'Poetry, Philosophy, and Science' through a combination of fragments from Burns, Byron, Coleridge, Dante, Shakespeare, and Spenser with accompanying portraits.[20] Assessing the purpose and reception of the volume, Green-Lewis describes the *Language of the Eye* as a manual that assumed a common descriptive repertoire; a shared visual literacy, which she uses to elaborate and historicize the reception of the extraordinary images produced in the context of Victorian diagnoses of mental illness. There are, however, as many differences as there are affinities between these various permutations of physiognomic description. Turnley, Thompson, Maclachlan, and many of their peers located their variations on physiognomic analyses as part of a self-consciously educative exercise, which was ultimately far less systematically oppressive than the supposedly therapeutic uses to which photographic portraiture was put by early alienists.[21] The sheer diversity of forms of photographic portraiture that Maclachlan lists, for example, is evidence of the creative and multiple uses to which photography was already being adapted by the 1860s. Likewise, Thompson's fluid movement from poetic exegesis to helpful hints on how to pose demonstrates the inherent malleability of the portrait as an idea and practice in early photographic discourse.

A further critical framework authorizing Thompson's fascination with photographing the face and expressive affect was the more familiar Romantic individualism of Carlylean hero-worship. By invoking Tennyson's voice to reinforce the originality of photographic portraiture, Thompson strategically emphasized essence over

[18] Green-Lewis, *Framing the Victorians*, 153.

[19] Joseph Turnley, *The Language of the Eye: The Importance and Dignity of the Eye as Indicative of General Character, Female Beauty, and Manly Genius* (London, 1856).

[20] This review appeared on the cover of the volume and is cited in Green-Lewis, *Framing the Victorians*, 153.

[21] Many of these images are reproduced in Sander Gilman (ed.), *The Face of Madness: Hugh W. Diamond and the Origin of Psychiatric Photography* (New York: Bruner/Mazel, 1976).

reproduction and raised the utopian possibility of maintaining what Walter Benjamin would describe as aura. This emphasis then conveniently translated into an unabashed manipulation of the conventions of class emulation in his subsequent discussion of commercial portraiture, giving expression to a 'charismatic ideology' that had similarly fuelled the seemingly insatiable Victorian appetite for *cartes de visite* portraits of exemplary authority figures.[22] With the advent of accessible commercial photographic studios, the average consumer could pay a few shillings to perform in front of the camera, an unprecedented accessibility to portraiture which, in turn, produced a new gestural repertoire of poses and theatrical backdrops and a critical backlash with which many of Thompson's readers would have agreed. Aptly, given this chapter's concerns, some chose poetry to voice their horror. Lewis Carroll, for example, adapted the metre of Longfellow's popular *The Song of Hiawatha*, to deflate the industry's worst excesses.[23] Turning Longfellow's sentimental indigenous hero into an ill-fated photographer with artistic aspirations, Carroll's parody also wittily exposed the prosodic and ethical limitations of the original which had recently received an equally merciless handling by *Punch*:[24]

> All the family in order
> Sat before him for their pictures:
> Each in turn, as he was taken,
> Volunteered his own suggestions,
> His ingenious suggestions.
>
> First the Governor, the Father:
> He suggested velvet curtains
> Looped about a massy pillar;

[22] Pierre Bourdieu, 'The Production of Belief: Contribution to an Economy of Symbolic Goods', *The Field of Cultural Production: Essays on Art and Literature*, ed. Randal Johnson (New York: Columbia University Press, 1993), 74–6.

[23] Carroll, *Phantasmagoria and Other Poems*, 66–77.

[24] The satire in *Punch*, reproduced below, has interesting resonances with Carroll's text. The complete version is reproduced in Frank E. Huggett, *Victorian England As Seen by Punch* (London: Sidgwick and Jackson, 1978), 13: 'Should you ask me, What's its nature? | Ask me, What's the kind of poem? | . . . | I should answer, I should tell you, | 'Tis a poem in this metre, | And embalming the traditions, | Fables, rites, and superstitions, | Legends, charms, and ceremonials | Of the various tribes of Indians, | From the land of the Ojibways, | From the land of the Dacotahs, | From the mountains, moors, and fenlands, | Where the heron, the Shuh-shuh-gar, | Finds its sugar in the rushes: | From the fast-decaying nations, | Which our gentle UNCLE SAMUEL | Is improving, very smartly, | From the face of all creation, | Off the face of all creation.'

2. Arthur B. Frost engraving from Lewis Carroll's 'Hiawatha's Photographing'

> And the corner of a table,
> Of a rosewood dining table.
> He would hold a scroll of something,
> Hold it firmly in his left-hand;
> He would keep his right-hand buried
> (Like Napoleon) in his waistcoat;
> He would contemplate the distance
> With a look of pensive meaning,
> As of ducks that die in tempests.
>
> Grand, heroic was the notion:
> Yet the picture failed entirely:
> Failed, because he moved a little,
> Moved, because he couldn't help it.

The poem takes the reader through the failure of each family portrait, before the oppressed photographer finally accepts his fate, takes a group portrait, a favoured form of Carroll's when photographing adults, and vanishes from the scene, although not without a final cry of defiance:

> But my Hiawatha's patience,
> His politeness and his patience,
> Unaccountably had vanished,
> And he left that happy party.
> Neither did he leave them slowly,
> With the calm deliberation,
> The intense deliberation
> Of a photographic artist:
> But he left them in a hurry,
> Left them in a mighty hurry,
> Stating that he would not stand it,
> Stating in emphatic language
> What he'd be before he'd stand it.
> Hurriedly he packed his boxes:
> Hurriedly the porter trundled
> On a barrow all his boxes:
> Hurriedly he took his ticket:
> Hurriedly the train received him:
> Thus departed Hiawatha.

Longfellow's jingling metre further intensifies Carroll's barbed words. Unabashedly elitist, this poem barely veils Carroll's own packing-up of his signature rosewood camera in protest against the commercialization of the art he had practised since boyhood as

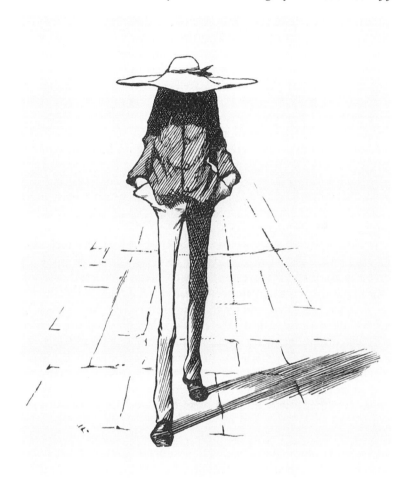

3. Arthur B. Frost engraving from Lewis Carroll's 'Hiawatha's Photographing'

an impassioned amateur.[25] But Carroll's fixation on the horrifying spectacle of his bourgeois subjects dressing above themselves in an effort to disguise their true station also intersects with the inherent instability of photographic portraiture that interested Thompson. The possibility of manipulating well-established conventions of dressing and presenting the body is a source of anxiety for Carroll here that goes beyond questions of bad taste and the excesses of vanity. A deeply felt aversion to the corruption of photography as a mediator of truth pervades the poem reflecting the inherent romanticism of Carroll's own photographic practice; a romanticism that, as many have argued, had its most disturbing and contentious outlet in his own forays into dressing up the children of his friends in an effort to capture 'the essence of childhood', to use Carol Mavor's phrase.[26]

It was, however, the commercial photograph as spectacle and its ready assimilation into a rapidly growing culture of publicity that was the cause for gravest concern to Carroll. Yet despite the outrage of the aggrieved narrator of *Hiawatha's Photographing*, there is an undeniably creative and playful dimension to the poses struck by his socially aspiring sitters. Not only do they dress up themselves, they also invent imaginary interiors, albeit with the formulaic props of the photographer's studio. In a transparent enactment of the social and physical mobility that the trade in celebrity photographs and portrait books encouraged, sitters create a new identity for themselves that briefly liberates them from the boundaries of their prosaic everyday lives and identities. In the magic, timeless zone of Hiawatha's photographic studio, they can become politicians, artists, and fashion plates. So, while seeming to exemplify what Leo Braudy has described as an internalization of the dynamics of advertising as part of the formation of a self-consciously modern civic culture, a process in which the portrait played an integral part, Carroll's characters also enact the liberty and pleasure that that process could involve—dressing up, striking poses, and briefly indulging in delusions of grandeur. In this way, Hiawatha's hapless sitters conform to the pattern of the marvellous menagerie of absurd characters that

[25] S. F. Spira describes Carroll's fascination with and purchase of Ottewill's Double Folding Camera in his essay on 'Carroll's Camera', *History of Photography*, 8 (July–September 1984), 175–7.
[26] Carol Mavor, *Pleasures Taken: Performances of Sexuality and Loss in Victorian Photographs* (Durham, NC: Duke University Press, 1995), 29.

populates Carroll's œuvre more generally. They take on a life of their own, even if Hiawatha ultimately thwarts their self-delusions by refusing to produce the photographic mementos they desire. Instead, he leaves behind a lifeless group portrait—one of Carroll's favoured forms for photographing adults and children who did not capture his imagination. The costs of pleasure in this case are deemed too high by Carroll, a moral judgement that returns us to Braudy's analysis of the ideological implications and counter-arguments generated by the increasing nineteenth-century compulsion to 'lure allegiance through the eye' in the form of portraits that enacted a 'willingness to face the public in order to be recognized and to be identified'.[27] Glamour and fashion were central to this new gestural public style. As were sensational figures such as Byron, the ultimate incarnation of the poet as celebrity, as both Braudy and Andrew Elfenbein (in *Byron and the Victorians*, 1995) have argued. Creating the precedent for the profitable relation between gossip and celebrity portraiture, a symbiosis that will be explored later in the context of the emergence of celebrity interviews and late nineteenth-century photojournalism, the excesses of Byron's fame also generated a counter-discourse of fame that privileged memory over immediate influence and power. What James Eli Adams has described as the 'disembodied subjectivity' of Carlylean 'savage depth' and 'wild sincerity' was assumed to be the antithesis of the corrupted surface display of the dandiacal body.[28] Deeply nostalgic in style and spirit, this high Victorian redescription of fame as a form of saintly heroism encouraged public performances of heroic withdrawal. And yet this new gestural repertoire was simply that, a stylistic device which as the careers of poets such as Tennyson reveal, veiled a more knowing and successful orchestration of the nexus between publicity and publication.[29]

In fact, the emphasis on virtue and moral character in the titles of Victorian volumes of celebrity portraits and *cartes de visite* exemplifies the happy marriage of commerce with the cult of heroworship sanctified by Carlyle and others. The successful portraitist Augustus

[27] Leo Braudy, *The Frenzy of Renown: Fame and Its History* (Oxford: Oxford University Press, 1986), 399.

[28] James Eli Adams, 'The Hero as Spectacle: Carlyle and the Persistence of Dandyism', in Carol T. Christ and John O. Jordan (eds.), *Victorian Literature and the Victorian Visual Imagination* (Berkeley: University of California Press, 1995), 218.

[29] Alan Sinfield discusses Tennyson's manipulation of publicity and publication in *Alfred Tennyson* (Oxford: Basil Blackwell, 1986).

Lovell Reeve, for example, lured potential consumers in with aspirational titles such as *Portraits of Men of Eminence in Literature, Science, Art with Biographic Memoirs*.[30] Similar titles reinforcing the nexus of national mythmaking and hero worship were John Mayall's *New Series of Photographic Portraits of Eminent and Illustrious Persons*, Edward Walford's *Representative Men in Literature, Science and Art*, and Maull and Polyblank's *Photographic Portraits of Living Celebrities*, which included biographical portraits also penned by Walford.[31] These collections were typically published in monthly parts, often with details on the back of each number that outlined price and format variations, as well as instructions for consumers interested in having their own portraits taken in the manner of their favourite celebrity. In the case of Maull and Polyblank they advertised basic 8 × 6 inch portraits for 10s. 6d., with the price increasing depending on the number of figures represented or whether the portraits were produced in stereoscopic form or tinted by hand. There were also helpful suggestions on what to wear to enhance the visual effect of one's portrait, dark silks and satins were recommended 'for Ladies', and black rather than lighter tones of velvet and brocade.

Photographs of painted portraits of dead literary celebrities also proliferated, with volumes devoted to Shakespeare and his birthplace far outnumbering all others.[32] Fluidly combining photographs of

[30] Augustus Lovell Reeve, *Portraits of Men of Eminence in Literature, Science, and Art, with Biographic Memoirs* (London: Lovell Reeve, 1863–4), vols. i–ii. A further four volumes were published by A. W. Bennett between 1865 and 1867.

[31] John Mayall, *New Series of Photographic Portraits of Eminent and Illustrious Persons* (London: Mavor & Son, 1864); Edward Walford, *Representative Men in Literature, Science and Art* (London: A. W. Bennett, 1868), including twenty portrait photos, 9 × 6 cm., by Ernest Edwards; *Photographic Portraits of Living Celebrities*, executed by Maull and Polyblank with Biographical Notices by E. Walford—later scholar of Balliol College and fellow of the Genealogical and Historical Society of Great Britain (London: Messrs Maull & Polyblank, 1859).

[32] Some examples of this astonishing output include: J. Hain Friswell, *Life Portraits of William Shakespeare*, including eight photographs and one photographic vignette (London: Sampson Low, Son & Marston, 1861); John Mounteney Jephson, *Shakespeare: His Birthplace, Home and Grave; a Pilgrimage to Stratford on Avon in the Autumn of 1863, with Photographic Illustrations by Ernest Edwards* (London: Lovell Reeve, 1864); *The Shakespeare Gallery; a Reproduction for the Tercentenary Anniversary of the Poet's Birth, MDCCCLXIV* (London: L. Booth & S. Ayling, 1864) which included ninety-four mounted collodion photographs after Boydell's engravings of Shakespeare subjects, a frontispiece and small round title page of a commemorative relief; Howard Staunton (ed.), *Memorials of Shakespeare; Comprising the Poet's Will* (London: Day & Son, 1864)—which included two mounted photos by Preston of engraved portraits of Shakespeare; Charles and Mary Lamb, *Tales from Shakespeare*, with twelve illustrations in permanent photography from the Boydell Gallery (London: Bickers, 1876).

painted portraits of the dead and the living these volumes both narrated and memorialized 'the great tradition' of English poetry. Joseph Gostwick's *English Poets*, an American publication, exemplifies this canonizing format.[33] The author of handbooks on German poets and American literature, Gostwick combined potted histories of the 'great' poetic traditions of the world with an interest in the educative potential of photography as a mass-produced illustrative form. Further legitimating this synthesis of image of text, Gostick prefaced his biographical profiles of Shakespeare, Milton, Addison, Pope, Goldsmith, Burns, Wordsworth, Scott, Byron, Shelley, Longfellow, and Tennyson with a long meditation on the distinction between 'modern' and traditional aesthetic forms. This meditation began with a discussion of Lessing's distinction between poetry and painting that conveniently emphasized poetry's narrative and historical properties, before expanding into a celebration of Shelley's disregard for formal distinctions that allowed him to 'see and feel, in a moment'.[34] Gostwick then incorporated what he called Shelley's 'unitive imagination' into his defence of an ideal of poetic creation with the power to capture human life 'viewed as a whole, and with respect to the past, the present, and the future'. While photography as a historical form materializes the body of events, he argued that poetry revealed 'feelings, thoughts, hopes, desires—the germs of far-distant events'.[35]

Gostwick's volume epitomizes the idealism that Stephen Thompson endorses in his previously mentioned essay on the importance of maintaining aesthetic standards in commercial photography. Published in the same year as his genealogy of photographic portraiture, this essay was more splenetic and sociological in its elaboration of the already stratified commerce in photographs:

Photographers—or rather those practising photography—may, with tolerable ease, be pretty nearly reduced to *three* classes. To begin with the lowest: there is the class which has been justly termed by the journals and daily press 'the photographic nuisance'—the Arabs, the Pariahs of the profession, who prey on the garbage, and infest the reputable quarters of the metropolis and great provincial cities in daily increasing numbers—coarse, vulgar rogues who 'hold out' in filthy dens, backed by an *entourage* of tawdry finery and

[33] Joseph Gostwick, *English Poets*, twelve essays illustrated by nine photographs after paintings (New York: Appleton, 1875). [34] Ibid. 7.
[35] Ibid. 7–11.

atrocious specimens, yet attended by an even still lower variety of human species—the touter or doorsman. Ruffianism and blackguardism may there be found in its most repulsive phase. . . . It is pleasant to turn from this dismal spectacle to another class—the regular professional photographers in both portraiture and landscape art—who have no more *affinity* with either of the others than the regular medical practitioner has with quacks and charlatans. It may be said they number in their ranks men of the highest attainments, governed by refined principles of honour and integrity. . . . It is to them and to distinguished amateurs that we owe the past progress and present position of photography in this country. Each and all of them can tell of years of weary labour, and perseverance amidst mortifying failures, when the photographic highway was not so well macadamized as it now is. In them have the bewildered aspirant and the dainty *dilettanti* ever found willing guides; and the services they have rendered to science, art, education, and civilization are almost incalculable.[36]

The space Thompson devotes to vilifying the charlatanism and blackguardism of street and fairground photographers barely veils the unease that his aggressively maintained class system registers. Reflecting the proliferation of photographic practices, Thompson's essay demonstrates the full spectrum of photography's contradictory discursive articulations, as both a sign of progress and decline, dehumanizing mechanization and civilization, unbridled commerce and aesthetic integrity, reproducibility and romantic originality. As Mary Warner Marien observes, by the 1850s and 1860s photography concurrently 'symbolized progressive and regressive change *and* a stillpoint within change'.[37]

Yet, in the midst of this discursive chaos poetry provided a model of temporal succession and duration that eased the destabilizing effects of the rapid transitions that Thompson's essay charts. Turning away from the filth and vulgarity of the city, poetic references and frameworks anachronized the dynamics of photographic affect, providing a ready-made mythologizing framework to soften the focus of change and a practical demonstration of photography's civilizing effects. This is the balance that early photographically illustrated books that took poetry and poets as their subject tried to maintain; an aspiration, which Thompson, who was an early advocate of the civilizing potential of photographically illustrated

[36] Thompson, 'The Commercial Aspects of Photography', 406. The emphases in this passage are Thompson's own.
[37] Warner Marien, *Photography and Its Critics*, 47.

books, would promote enthusiastically.[38] William Samuel Wright's *The Loved Haunts of Cowper; the Photographic Remembrancer of Olney and Weston; Being Photographs of Buildings and Rural Scenes Immortalized by the Poet; with Historical and Descriptive Sketches* is typical of this genre of photographic illustration.[39] Published in 1867, Wright introduced his volume with the following promotional words:

This work is the first of the kind that has appeared; there have been pleasing and interesting works with many plates which are now out of print, but never a book of Photographs; and it is well known that the faithfulness of a photographic picture is unequalled; I hope the present work therefore will in every way be found to answer to the title given to it, for by turning over its pages, when we may be far away from the reality, we bring to remembrance all the varied scenes around which such a charm has been thrown, and can 'to the loved haunt return' again and again, knowing that we are enjoying photographic faithfulness; and while we view them as in a mirror, our fancy can easily picture the poet roving amidst their quiet beauty, or entering one of those buildings so often frequented for his sake. Thus to view them must be exceedingly pleasing to those admirers also, who are never likely to visit this poetic ground. Time has removed many of the scenes, but thanks are due to the Artists of the past for handing down to us good drawings of them. . . . They are authentic, as are also the portraits introduced here.

Setting aside the author's own claims to fame, and his omission of any reference to precursors such as William Morris Grundy's more humble *Sunshine in the Country* (1861), this preface encourages a photographically enhanced intimacy between reader and poet. Photographs even obviate the need to touch and wander on the 'poetic ground' made sacred by the memory of Cowper's poetic sentiments. In this context each image is intended to materialize and guide the recurring cycles of repeat readings or revisitings that assigned the reader a central role in the survival of Cowper's vision, whilst at the same time promoting a deeply anachronistic image of

[38] Thompson's positive reception of William and Mary Howitt's Wordsworthian-style *Ruined Abbeys and Castles of Great Britain* will be discussed in the following chapter.
[39] *The Loved Haunts of Cowper; the Photographic Remembrancer of Olney and Weston; Being Photographs of Buildings and Rural Scenes Immortalized by the Poet; with Historical and Descriptive Sketches* (compiled and published by William Samuel Wright, 1867). This volume contained eighteen photographs, one of which is a heliotype portrait of Cowper, ten views, and seven reproductions of various portraits and prints.

rural England. Adding to this manufactured illusion of timelessness, fragments from Cowper's devotional verse invested Wright's hopes for the civilizing influence of the volume with the authority of a sacred mission. Framing the following citation, for example, Wright's sentimental reflections imagine a world suffused with Cowper's inspirational pastoral vision: 'The writings of Cowper have thrown around Olney and Weston a charm, which like a brightening rainbow, will increase its effect, as knowledge and religion shed their benign influence more copiously over the world:'

> 'Tis now become a history little known,
> that once we call'd the pastoral house our own.
> Short-lived possession! but the record fair,
> that memory keeps of all thy kindness there,
> Still outlives many a storm, that has effaced
> a thousand other themes less deeply traced.[40]

These lines celebrate a secret history that only a local would know; a private familial association that authorizes the speaker's historical claim on the landscape that Wright then passes on to his consumers. Each photograph that follows, to return to the volume's preface, is then constructed as an authentic trace, not only of Cowper's life, but of a time prior to the industrialized present when social relations were simpler and a collective memory of local family histories was an integral part of cultural life. This nostalgic message was, of course, not unique to Wright's volume. Rather, what emerges here is merely one of many instances of the ways in which early photographers and publishers enlisted poetry to serve not only aesthetic but pointedly didactic ends. Familiarity with the works and lives of the great and the good is constructed as a mark of civility, of personal virtue and integrity, cultural values that are explicitly opposed to the prevailing philistinism of Victorian culture. Reflecting the necessary disavowal that drove the production of this belief, the modernity of the photographic image was effaced in the interests of enshrining and cementing the impression of a common aesthetic experience and shared literary tradition.

The didactic purpose of Wright's volume becomes even more explicit in an illustrative sequence that frames the reproduction of the epitaph inscribed on Cowper's tomb, an elegiac device intended

[40] Wright, *The Loved Haunts of Cowper*, 11.

to draw the reader into the familiar and intimate mourning ritual of visiting the grave of a loved one:

> In memory of
> WILLIAN COWPER, ESQ.
> BORN IN HERTFORDSHIRE 1731
> Buried in the church, 1800
>
> Ye, who with warmth the public triumph feel
> Of talents dignified by sacred zeal,
> Here to devotion's bard, devoutly just,
> Pay your fond tribute due to Cowper's dust!
> England, exulting in his spotless fame,
> Ranks, with her dearest sons, his fav'rite name;
> Sense, fancy, wit, suffice not all to raise
> So clear a title to affection's praise;
> His highest honours to the heart belong,
> His virtues form the magic of his song.

Wright's decision to reproduce Cowper's epitaph conforms to Leo Braudy's account of the characteristically Victorian transformation of celebrity into a vehicle of cultural memory and cohesion.[41] Echoing the memorializing style of contemporary volumes of celebrity photographs, Wright invites his readers to fixate on the literal connection between the poet's corpse and the corpus that survives him. This self-conscious act of mourning then merges into the carefully styled gestural repertoire of literary pilgrimage in the subsequent images of Cowper's summer house. Interweaving fragments from *The Task* with passages of celebratory description, the accompanying text outlines the history and extent of the pilgrimages to this sacred site, informing readers that the walls and ceilings of the summer house 'like Shakespeare's House at Stratford-on-Avon, are literally covered with signatures of visitors, many being the names of persons of note from great distances'. These included enamoured fans, such as Abraham and Mary Logan who had, according to their pencilled inscription, travelled four thousand miles in 1839 and a Miss Jane Taylor who visited on 7 December 1857 and left the following epitaph behind:

> Where Cowper wrote, what meaner hand shall try?
> Yet to his loved remains we breathe a sigh.

[41] Braudy, *The Frenzy of Renown*, 15–16.

4. William Samuel Wright, Cowper's 'Summer House'

Inspired by her surroundings Jane Taylor's inscription memorializes her personal connection to Cowper's 'loved remains'; a connection that Wright further dignifies by reproducing it alongside Cowper's own and illustrating both with a close-up photograph of the site.

Yet despite Wright's democratizing intentions, a linguistic elitism underlies his fusion of poetry and photography to create what John Guillory has described as a reception-scenario characterised by the reader's pleased recognition that 'this is my truth', which further reinforces the subliminal recognition that 'this is my language'.[42] This process of linguistic assimilation is reinforced by the inherently citational style of Wright's volume and illustrated verse anthologies,

[42] John Guillory, *Cultural Capital: The Problem of Literary Canon Formation* (Chicago: University of Chicago Press, 1993), 92.

such as William Morris Grundy's *Sunshine in the Country*, which will be the critical focus of the remainder of this chapter. Carefully organized around the idea of the illuminating fragment, these volumes constructed a sequence of moments of identification in which the contours of self and community were made visible to the reader/observer in a form that implicitly promoted the civilizing potential of the marriage of traditional arts with the modern wonders of photographic mediation.

PHOTOGRAPHIC AND LITERARY GEMS

According to Helmut Gernsheim, Grundy's volume is the first photographically illustrated verse anthology ever to be published.[43] The number in the edition is unknown, but the majority of photographically illustrated books issued at this time were in limited editions of no more than three hundred copies. One of the exceptions to this rule was, however, the Howitts's *The Ruined Abbeys and Castles of Great Britain* series which is the subject of the next chapter. This series was issued in exceptionally large editions of just over one hundred and sixty thousand copies per volume.[44] In contrast, Grundy's volume, with its elaborate red and gilt morocco binding, was an elegant literary fetish clearly designed for the gift book market.[45] Yet despite its elegant packaging, the advertising and title of *Sunshine in the Country* still recalled the more humble touristic provenance of its twenty albumen stereographs. Grundy's images had originally appeared as a series of stereo-pairs under the title *Rural England* and little is known about the role Grundy played in the preparation of

[43] Helmut Gernsheim, *Incunabula of British Photographic Literature: A Bibliography of British Photographic Literature 1839–75* (London: Scolar Press, 1984).

[44] The exact number in the edition of the first and second volumes in the series was 162,000 and 214,000 according to Gernsheim. In addition, some books were published in two editions. The more expensive version contained more or larger format prints than its cheaper form. Publishers also produced presentation copies for the author which included extra prints. Gernsheim, *Incunabula*, 8. My research has revealed two variant editions of Grundy's volume. The volume held in the collection of the New York Public Library contains a frontispiece depicting boys reading in a glade. This frontispiece is absent from the volume held in the Gernsheim Collection at the Harry Ransom Research Centre, University of Texas, Austin.

[45] For example, the inscription inside the cover of the volume in the Gernsheim collection reads 'Elizabeth Ashurst, a birthday present, December 11, 1863'.

Sunshine in the Country. Grundy, who was a well-regarded photographer from Sutton Coldfield, died shortly after the volume was published. What is known is that *Sunshine in the Country* was one of the harbingers of what Weston Naef has called the 'golden age of photographic book illustration' which resulted in the conversion to photography of a number of well-known artist-illustrators, including Francis Frith, John Thomson, Adolphe Smith, Thomas Annan, and ongoing experimentations with the medium by pictorialists, such as Peach Robinson and the ambitious naturalism of P. H. Emerson.[46]

What distinguished *Sunshine in the Country* in the eyes of its Victorian reviewers, as one delighted critic in the *Art-Journal* observed, was the effective marriage of poem and photograph: 'The poet leads you, by the charm of his melodious utterance, and the photograph wins you to loiter on your way in contemplation of the truth which the sunshine shows.'[47] Emphasizing the poet's guiding role, this critic constructs poetic time as progressive and sequential, in contrast to photographic time, which slows the rhythms of poetic time down to a loitering pace, giving the reader time to uncover the truth of what he or she has seen. The appeal of Grundy's photographs to this critic primarily resides therefore, in their power to reveal what lurks just beneath the surface of the visible and the translation of such

[46] Naef, *The Truthful Lens*, 10. According to Naef and Goldsmith, the number of books illustrated with photographs prior to the introduction of half-tone processes in the 1880s numbered close to 4,000 titles. This figure included volumes containing only frontispiece portraits. Francis Frith was one of the first highly regarded illustrators to embrace photography, resulting in his exquisite volume *Egypt and Palestine Photographed and Described* (1858–9). He also illustrated an edition of Longfellow's *Hyperion: A Romance* (1865) and the more lighthearted *The Gossiping Photographer at Hastings* (1864). Then on the strength of the sales of his deluxe albums, stereotype sets, exhibition prints, and illustrated bibles, Frith established his phenomenally successful photographic-printing firm in Reigate, Devonshire. Rivalling the success of the French photographic printing company Blancquart-Evrard, Frith's firm prospered until 1971 when it finally closed its doors. See Bill Jay, *Victorian Cameraman, Francis Frith's Views of Rural England* (Newton Abbott: David & Charles, 1973), and Derek Wilson, *Francis Frith's Travels: A Photographic Journey through Victorian England* (London: J. M. Dent, 1985). Weston Naef describes the similarly adventurous and entrepreneurial efforts of early photographers such as Smith and Annan in *The Truthful Lens*, 33 ff. Annan's well-known photographs of the Glaswegian slums are seminal examples of early social-realist photography.

[47] Review of William Morris Grundy, *Sunshine in the Country: A Book of Rural Poetry Embellished with Photographs from Nature, The Art-Journal* (1 February 1861), 48. Photographs of engravings, however, had appeared in volumes of poems from as early as 1855 in an edition of Horace, and of Virgil (1858), and in Joseph Turnley's *Reveries of Affection* (1863). In these instances photographic illustrations assumed a functional rather than an aesthetic role; Naef, *The Truthful Lens*, 33.

discoveries into generalizable instances of a shared aesthetic sensibility. The mobility of the reader, in both a symbolic and literal sense, is also assumed, reinforcing the volume's appeal to those in search of the timeless pleasures of rural England as an antidote to the exigencies of modern urban life.

Grundy's volume matched photographs of deserted rural villages, haystacks, apiaries, and picturesque landscapes with an eclectic list of poets including John Gay, John Clare, Samuel Rogers, Charlotte Smith, Mary Howitt, Felicia Hemans, John Keats, Adelaide Proctor, Henry Wadsworth Longfellow, Alexander Pope, and Thomas Gray. Each poem introduced the reader to an aspect of country life to emulate, from the wholesome traditions of angling, hunting, and walking, to the peaceful life of simple country folk living out their days in time to the rhythms of the seasons. Photographs designed to bring the 'sunshine' of the country quite literally into the home of the curious reader then echoed this guiding chorus of voices. Grundy's photographs also subtly modulated the emphasis of many of the poems, tethering their more abstract reflections to material cultural practices. In the case of Samuel Roger's 'The Bee', a photograph of an apiarist offers an alternative reading of the poem's anthropomorphic identification with the bee's mystical powers of sight. Grundy shifts the focus of Roger's poem away from the poet and onto the apiarist, ultimately transforming the illustrative sequence into a celebration of the survival of archaic rustic traditions and the role of the photographer and poet as their God-ordained conservators:

> Hark! the bee winds her small but mellow horn,
> Blithe to salute the sunny smile of morn,
> O'er thymy downs she bends her busy course,
> And many a stream allures her to its source.
> 'Tis noon, 'tis night. That eye so finely wrought,
> Beyond the reach of sense, the soar of thought,
> Now vainly asks the scenes she left behind,
> Its orb so full, its vision so confined!
> Who guides the patient pilgrim to her cell?
> Who bids her soul with conscious triumph swell?
> With conscious truth retrace the mazy clue
> Of varied scents, that charm'd her as she flew?
> Hail, memory, hail! thy universal reign
> Guards the least link of being's glorious chain.[48]

[48] Grundy, *Sunshine in the Country*, 14.

5. William Morris Grundy, 'The Bee'

Staged as a stolen glimpse into the everyday activities of the api-
arist, Grundy's image also exemplifies the mixture of performance
and ethnographic curiosity that characterizes many early photographs
of the English countryside. Yet the ultimate intention is to reinforce
the identification between poet and reader by creating a sense of
immediacy through the construction of a similar scene to that which
had inspired Rogers to pen his encomium to the bee's supernatural
gifts; an illusory moment of recognition designed to affirm the con-
sumer's sense of visual control over the scene and the rural traditions
it celebrated.

This mixture of visual omniscience and curiosity also shapes
the illustration of Mary Howitt's 'Little Streams'. In this sequence
photographs were embedded into the body of the text to animate

Howitt's idyllic description of a series of small streams that wend
their way through a sun-bathed meadow and a conventionally
picturesque village:

> Little streams are light and shadow,
> Flowing through the pasture meadow —
> Flowing by the green way-side,
> Through the forest dim and wild,
> By the cottage, by the hall,
> By the ruin'd abbey still,
> Turning here and there a mill,
> Down in valleys green and lowly,
> Murmuring not and gliding slowly,
> Up in mountain-hollows wild,
> Fretting like a peevish child;
> Through the hamlet, where all day

6. William Morris Grundy, 'Little Streams'

> In their waves the children play;
> Running west, or running east,
> Doing good to man and beast —
> Always giving, weary never,
> Little streams, I love you ever.[49]

Grundy's images invest Howitt's mawkish sentiment with a timeless quality that celebrates the continuity of tradition, whilst simultaneously promoting the attractions of photographic verisimilitude. Proving the error of Ruskin's misrecognition of photography as a mechanical usurpation of 'human labor regulated by design,' this sequence is typical of the dialogic nature of early photographic illustration.[50] Far from usurping traditional illustrative practices, volumes such as Grundy's exemplify the struggle of early photographers to be assimilated into established cultural and discursive networks, through their celebration of craft and traditional forms of rural labour, a celebratory descriptive mode that also intersected with the burgeoning popular interest in folk culture in mid-Victorian England. Thus, as Nancy Armstrong has convincingly argued, rather than inuring the Victorian public to the traditions of country life, regional photographers such as Grundy only intensified curiosity in folk traditions by providing urban consumers with a steady flow of images of rural dwellers that promoted a mythic sense of fragments of rural and regional life as anachronistic survivals; a selective representation which often had destructive economic and ideological effects.[51] One such effect was the production of a fluid rhetorical fusion of ethnographic description and literary nostalgia, which in turn was well suited to the packaging of photographs and poetry into volumes that promoted an ultimately conservative narrative of the material and spiritual progress of the nation. In this context Grundy's decision to illustrate Crabbe's 'The Village' exemplifies the inherent ambiguities and strategic forgetting that sometimes characterized early photographic practice.[52]

By foregrounding the tourist's experience of the village, Grundy reproduces the stylistic anachronisms of the pastoral that Crabbe's

[49] Grundy, *Sunshine in the Country*, 57.

[50] John Ruskin, *The Works of John Ruskin*, ed. E. T. Cook and Alexander Wedderburn (London: George Allen, 1903–12), xx. 165.

[51] Armstrong argues along these lines in *Fiction in the Age of Photography*, 188.

[52] Grundy, *Sunshine in the Country*, 77.

7. William Morris Grundy, 'The Village'

poem condemned. Any trace of active labour has been removed from
the scene, leaving behind aesthetically pleasing piles of firewood and
thatching. Privileging the urban observer as the disinterested witness
to the village's survival, Grundy's image encourages passive appre-
ciation, in contrast to the active ethical engagement that Crabbe
had demanded from his readers. An emissary from another world,
Grundy's tourist appears to be waiting for the local inhabitants to
issue forth from their thatched cottages and introduce him to the
charms of their rural existence; a paternalistic impression further
amplified by the anachronistic adaptation of an eighteenth-century
image of rural life to frame and authorize the leisurely altruistic sens-
ibility of the Victorian literary tourist.

Like the reviewing cultures that promoted the idea of photography as poetic, therefore, volumes such as *The Loved Haunts of Cowper* and *Sunshine in the Country* combined the mutually reinforcing rhetorics of altruistic nostalgia and cultural progressivism, strategically alternating their generic alignment depending on the terms of the argument and the audience addressed. This nexus between photographic and poetic idealism was intimately connected to the Victorian preoccupation with the interdependence of the material and the spiritual. In this context, identifying and stressing photography's poetic qualities legitimized a productive reciprocity between art and technology that was as creative and experimental as it was nostalgic and conservative. What is important to stress in conclusion, however, is how an idea of poetry as tradition becomes frozen in time in the rush to embrace iconic modern inventions, such as photography. Photography's power to provide the first truly comprehensive and accessible historical record inspired advocates such as Thompson, Maclachlan, and Wright to visionary statements about the enlightenment of the masses and to equally optimistic combinations of literary and photographic forms, a positive embrace of photography's cultural impact which was, of course, by no means uniform. One need only read Baudelaire's familiar splenetic response to the daguerreotype as one of the more evil incarnations of the rise of an undiscriminating mass visual culture to find a dissenting voice in the midst of this approving chorus.[53] And there were many English voices that were equally declinist in their prognoses of the cultural impact of mechanically produced art and what Sainte-Beuve decried as 'industrial literature'.[54] The well-known critic Francis Turner Palgrave, for example, vehemently argued in the pages of the *Quarterly Review*:

Steam-engine and furnace, the steel plate, the roller, the press, the Daguerreotype, the Voltaic battery, and the lens, are the antagonist principles of art; and so long as they are permitted to rule, so long must art be prevented from ever taking root again in the affections of mankind. It may

[53] Baudelaire's negative reaction to the Daguerreotype has been the subject of many seminal studies of both the poet and early photography; however, Marina Warner Marien's analysis of the reception context of Baudelaire's salon essay is possibly the most relevant to this discussion of photographic reviewing in *Photography and Its Critics*, 64–6.

[54] C.-A. Sainte-Beuve, 'De la litterature industrielle', *Portraits Contemporains* (Paris, 1889), ii. 434; cited in Warner Marien, *Photography and Its Critics*, 65.

continue to afford enjoyment to those who are severed in spirit from the multitude: but the masses will be quite easy without it.[55]

This version of mass false consciousness as the antithesis of an enlightened elite stresses the alienating effects of new technologies, revealing how fluidly these new inventions could move from being naturalized agents of social cohesion to signs of the dehumanizing automatism of mass consumption. The purpose of this study, however, is not to supplant such negative accounts with a more utopian version of events, but rather, to explore the suppressed affinities that exist between Palgrave's nihilistic view of photography and the responses of optimists such as Thompson, Wright, and Grundy. What binds these divergent views together is a similar conception of art, and by implication poetry, as a form of slowing down time. Performing the distinctively modern role of timekeeper, the idea of poetry as a device for animating the spirit of the past was a compelling and pervasive one. Post-Romantic in its preoccupation with natural genesis and inherently comparative in its stress on the affinity between distinct forms, early photographic discourse clarified and intensified what was at stake for those who believed in the civilizing power of art. While this point has been made in the context of Victorian art photography, particularly in the context of the Pre-Raphaelite stylings of Oskar Rejlander, Henry Peach Robinson, and Julia Margaret Cameron, the adaptation of this poetic ideal to suit unapologetically commercial forms needs to be considered in greater depth. Theorized by Thompson and realized by Wright and Grundy, as well as by more entrepreneurial photographic publishers, such as A. W. Bennett and George Washington Wilson, who will be subjects of the following chapters, this balance of commerce and idealism suggests that many of the enlightened elite that Palgrave vigorously separates from the unenlightened masses were more interested in engagement than resigned seclusion, even if their interest in market share sometimes outweighed their desire to enlighten the consumer.

Wordsworthian Afterlives and Photographic Nostalgia

Thus we may seek our picture-thoughts in those so peacefully suggested by the gentle undulation of sunny acclivities and shadowy hollows over which the ghostly images of the passing clouds seem to glide so smoothly on their way . . . or we may seek the leading idea in the broad gleam of sunlight which brings out prominently from the midst of an otherwise cloud-shadowed scene some scrap of picturesque beauty in the foreground and middle distance, or from the ghostly mystery which steals upward with the gathering mist, giving a wild, strange grandeur to the shadowy mountain forms, and filling our lonely minds with the awful immensity of that hazy, illimitable space into which all about us appears to be so swiftly and so silently disappearing . . . Thus, in effects of light, effects of season, effects of air, effects of mist, effects of cloud, effects of the count-less accidents of torrent, tempest, and passing rain, &c., or the equally numerous incidents of human interest, we may seek the thoughts and sentiments we need to make our sun-pictures worthy of the most ambitious of our aspirations. Only let us see Truth, and so perfect our appliances that there will be no difficulty in grasping the most refined and subtle of its expressions, and then our art shall speedily rise into the highest rank, and be readily welcomed as the worthy equal of the loftiest in some of their most ambitious reachings. For this end we are all needed—the theoretical, the practical, the experimental, the artistic, the scientific, and the mechanical; and there is so much promise in what we *have* done through combined action in societies, and in such pages as I am now writing for, that despair or despondency appears to me little short of criminal.

Alfred H. Wall, 'An Artist's Letters to a Young Photographer'[1]

[1] Alfred. H. Wall, 'An Artist's Letters to a Young Photographer. On Landscape. Sentiment (continued)—The False and the Ugly versus The True and The Beautiful in Art—On the Various Kinds of Expression Peculiar to Various Scenes, &c.—How To Look At Nature', *British Journal of Photography* (15 February 1862), 68–70 (69).

Wall's letters to young photographers were published as a series in the *British Journal of Photography* in 1862. As the above fragment demonstrates, each letter outlined a detailed compositional methodology combined with a resoundingly optimistic defence of the artistic value of photography across a wide spectrum of practices and institutional spaces. Profoundly influenced by the cultural ideals that he saw embodied in the poetry of Wordsworth and the aesthetics of Ruskin, Wall peppered his letters with numerous citations from both, while vigorously promoting his theory that the future of photography in all its diverse forms depended on the education of a new generation of photographers. Wall insisted that taking a photograph was both a creative and an intellectual process that had a limitless, yet untapped potential to transform the way observers and practitioners alike translated the world around them into memorable images. Given the number of Wordsworthian-style photographs that were produced at this time we can assume that others shared Wall's belief in the affinity between literary and photographic affect. It was also not long before entrepreneurial publishers saw the profits to be made from sequencing this growing collection of images into photographically illustrated anthologies of Wordsworth's poems and guides to the picturesque views that had inspired them.

Like Wright and Grundy's volumes, these books form part of the gradual assimilation of the photographic image into the printed page in the first four decades after its invention. But as Wall's fighting words suggest, this was not always a fluid process or a positively embraced one. For the most part these experimental fusions of photographic and literary texts were as indifferently received by Victorians, as they have been by twentieth-century critics. An exception to this rule in the latter case is Carol Armstrong who has recently argued that engaging with this traditionally overlooked aspect of the early reception of photography requires 'a new form of criticism'— a form of photographic *explication de texte* involving the close reading of images alongside texts in their original publishing format.[2] Armstrong proposes a pointedly 'Barthesian' methodology in an effort to move away from grander narratives of epistemological rupture, or equally abstracting transformations of the photographic image into an unambiguous icon of the ascendancy of a standardizing realist aesthetic in the age of mechanical reproduction. This stress on close reading also informs this chapter's engagement with early

[2] Armstrong, *Scenes in a Library*, 3–6.

photographically illustrated books. But in contrast to Armstrong's more structuralist approach, the primary concern here will be to locate the Victorian photographic illustration of Wordsworth in the context of the cultural anxieties about time and modernity that haunted these volumes.

In his study of what he describes as the nineteenth-century 'memory crisis', Richard Terdiman argues that the spectacular rupture of traditional patterns of cultural inheritance and exchange set in motion by the French Revolution generated new modes of recollecting the past.[3] He suggests that these new forms of memory registered an increasing struggle to integrate past and present experience that translated into a pervasive and disciplined obsession with the past in a diverse range of media and institutional contexts.[4] This sensibility is very much in evidence in the photographic illustration of Wordsworth's post-Revolutionary reflections in the early 1860s, where anxieties about cultural memory are sometimes explicitly addressed in framing prefaces or conclusions, or more subtly, through the sequencing of photographs that overlayed already nostalgic poems with a new, highly self-conscious recollective apparatus. The resulting intensification of focus on the ethical, as well as the aesthetic convergence of memory and perception, reflects a decidedly post-Romantic desire to manage and sequence the visible world. And yet this will to order still fails to exorcize the more profound fear of losing hold on time during a period increasingly preoccupied by the perception that history itself was taking place at a speed beyond the grasp of any individual's capacity to see or remember. This failure is particularly evident when the combination of Romantic topographical verse and picturesque landscape photographs translates into an explicitly conservative nostalgia that, as Nancy Armstrong has argued, contributes to the erasure of the local and regional traditions which these volumes were ostensibly attempting to preserve and enshrine.[5] But this was not always the case. Photography's nostalgic effects were also enlisted in less systematic or programmatic ways to focus the reader's attention on the easily forgotten minutiae of a particular moment in time, the details that Wall so evocatively lingers over to convey the contingencies and varieties of visual experience.

[3] Richard Terdiman, *Present Past: Modernity and the Memory Crisis* (Ithaca, NY: Cornell University Press, 1993), 4. [4] Ibid. 4.

[5] Armstrong, *Fiction in the Age of Photography*, esp. ch. 4.

INSTRUCTIVE RECOLLECTIONS

In an exemplary instance of the assimilation of photography into an explicitly conservative nostalgic aesthetics, William and Mary Howitt concluded the first volume of their successful series *Ruined Abbeys and Castles of Great Britain* with this historical reminder:

> Whilst recalling for a moment the past glories of these memorials of a van-ished condition of human society in these islands, we have felt strongly, not only the fragmental beauty of their remains, but the lessons and the encour-agements they can afford us . . . there come to us whispers of retribution and of the profound purposes of Providence. In no country besides our own, do we meet with such numbers of the graceful skeletons and fractured bones of the once proud forms of papal greatness. We are so accustomed to regard these with the eye of poetry and pictorial effect, that we almost forget at times the stupendous power of which they are signs, and of the great conflict and victory of which they preserve the remembrance.[6]

Here the Protestant ideology of the Quaker Howitts is all too clear. Remembering is a political as well as an aesthetic act. In this case it involves the reader in a restorative process, which affirms the ascendancy of England's Protestant elite. But memory also involves attuning one's ear to the retributive whisperings of the past, auguries that, if left unheard, might lead to future repetitions of past sins. These warnings bear the unmistakable imprint of imperial anxiety. Haunted by the spectres of the Crimean War and the Indian Mutiny, the need to find new ways of legitimating and perpetuating existing power structures and traditions was particularly pressing in the early 1860s when the Howitts's series was first published. To say, there-fore, that their volume promoted a strategically selective version of the past is in many ways to state the obvious. Their efforts to establish continuities between the present and a historical moment when internal religious and political discord was brutally suppressed quite literally enacts the dynamics of invented tradition outlined by

[6] Mary and William Howitt, *Ruined Abbeys and Castles of Great Britain*, Photographic Illustrations by Francis Bedford, Russell Sedgfield, George Washington Wilson, Roger Fenton and others (London: A. W. Bennett, 1862), i. There was also a second volume solely authored/collated by William Howitt and published by A. W. Bennett in 1864, as well as separate, cheaper pocket volumes extracted from the original series with titles such as *The Wye: Its Ruined Abbeys and Castles* (London: A. W. Bennett, 1863).

Hobsbawm and others.[7] Confronted with the increasing instability of the present, the Howitts responded by insisting that the progress of the nation itself depended upon the ritualized remembrance of particular defining events; events that, unsurprisingly, consolidated and legitimated the hegemony of the present political and cultural order. Viewed from this perspective, the Howitts's relatively large editions of aestheticized fragments of English rural life effaced the present in the interests of enshrining the traces of a more authentic Britain to legitimate the progressive cultural narrative they were promoting. It would, however, as Nicholas Thomas's work on the anachronistic ethnographic construction of Pacific cultures has shown, be a mistake to overstate the role played by the colonizing aesthetics of these provisional illustrative forms.[8] Rather, these volumes form part of an entangled history of cultural mediation, of encounters, resistances, and self-conscious reinventions that resonate on multiple social, aesthetic, and political levels; a cultural history that exceeds and complicates the impact of any one literary genre or cultural form, no matter how ubiquitous or hegemonic its intent or deployment.[9]

The unusual scale of the first edition of the Howitts's series, which numbered 162,214, an ambitious quantity given the novelty of the publishing format, is most likely a sign of the volume's legibility within a well-established tradition of Wordsworthian-style guides to the Lake District, including Wordsworth's own.[10] Over a decade

[7] Eric Hobsbawm and Terence Ranger (eds.), *The Invention of Tradition* (Cambridge: Cambridge University Press, 1992).

[8] Nicholas Thomas, *Entangled Objects: Exchange, Material Culture and Colonialism in the Pacific* (Cambridge, Mass.: Harvard University Press, 1991).

[9] In her debate with the work of Michael Hechter, for example, Linda Colley argues that Great Britain did not simply emerge out of a blending of regional or older national cultures, nor as the result of an English core 'imposing its cultural and political hegemony on a helpless and defrauded Celtic Periphery'. Colley contends that this historical interpretation overlooks the formative place regional and national differences played and continue to play in the forging of the myth of a unified British nation. Linda Colley, *Britons: Forging the Nation 1707–1837* (London: Pimlico, 1992), 6. Michael Hechter himself acknowledges this point in the context of his original construction of Scottish culture as marginalized in the introduction to his recently revised edition of *Internal Colonialism: The Celtic Fringe in British National Development, 1536–1966* (1975; New Brunswick: Transaction Books, 1999), p. xix.

[10] According to Helmut Gernsheim, a more typical edition for a book of this kind would have numbered 300 copies or less. Helmut Gernsheim, *Incunabula of British Photographic Literature: A Bibliography of British Photographic Literature, 1839–75, and British Books Illustrated with Original Photographs* (London: Scolar Press, 1984), 8.

after his death, references to Wordsworth's poetry abounded in poems, novels, tourist guides, weekly sermons, criticism, private study guides, and school textbooks. And as the Howitts's deferential volume exemplifies, the Wordsworth who was being enshrined as a national treasure in the middle decades of the century was a figure unblemished by the more contentious aspects of his political and personal history. Focusing only on the edited highlights of the poet's youth and later years, this mythic Victorian Wordsworth was a paragon of Protestant conservative radicalism and humanitarianism; a selective memory assisted by the decorous approach of his official biographer and the limited circulation of *The Prelude*, which would not be generally available until 1892 when its copyright had lapsed.[11] During these years it was the Wordsworth of *The Excursion*, *Tintern Abbey*, and popular volumes such as *Yarrow Revisited* that were much remembered and quoted.[12] Moreover, as Stephen Gill has demonstrated in his extensive analysis of the Victorian reception of Wordsworth, any philosophical or political ambiguities were further diluted or resolved by an Anglo-Christian aesthetics that prioritized consolation and moral seriousness over political or semiotic ambiguity.[13]

And yet, it was precisely these ambiguities and complexities that ensured the infinite adaptability of Wordsworth's unorthodox and idiosyncratic vision to a wide variety of causes and discourses ranging from the theological to the scientific. Victorian readers, for example, would not have thought it out of place to find Wordsworth cited in a work of popular science, after the success of volumes such as Gideon Mantrell's *The Wonders of Geology* (1838).[14] This often densely argued scientific text, written by a distinguished scientist and Fellow of the Royal Society, went through ten editions and concluded with the following lines from *Tintern Abbey*:

[11] The author of the *Memoirs of William Wordsworth*, published in 1851, was the respectable and cautious Dr Christopher Wordsworth, the poet's nephew and the Canon of Westminster.

[12] *Yarrow Revisited* was published in 1835 and was the first of Wordsworth's publications to sell well.

[13] Stephen Gill also discusses other Victorian efforts to illustrate photographically Wordsworth's poetry in *Wordsworth and the Victorians* (Oxford: Clarendon Press, 1998).

[14] Gideon Mantrell, *The Wonders of Geology*, 2 vols. (London, 1839) ii. 679–80. The edition discussed here is the revised version for the 1838 edition that replaced a citation of Felicia Hemans's *To the Poet Wordsworth* with the citation from *Tintern Abbey*.

> From joy to joy: for she can so inform
> The mind that is within us, so impress
> With quietness and beauty, and so feed
> With lofty thoughts, that neither evil tongues,
> Rash judgments, nor the sneers of selfish men,
> Nor greetings where no kindness is, nor all
> The dreary intercourse of daily life,
> Shall e'er prevail against us, or disturb
> Our cheerful faith, that all which we behold
> Is full of blessings. (126–35)

In this context, Mantrell's citations of Wordsworth's resounding hymn to nature assured his readers of his belief that no matter how disquieting the implications of even the most profound geological upheavals, nothing could undermine the greater Christian truth that Wordsworth's famous lines impressed upon his readers.

Victorian pedagogic discourse thus effectively transformed Wordsworth's aesthetics into a standardized affective repertoire; an association increasingly underpinned by the extensive reproduction of Wordsworth's poetry in school textbooks.[15] By reducing Wordsworth's verse to prosaic exercises in grammatical analysis and sentence formation, these volumes entrenched the association of his poetry with the acquisition of what Coleridge described in his critique of the preface to the *Lyrical Ballads* as the *lingua communis* —the standardized or ordinary language of the predominantly urban educated middle classes. Furthermore, the context for this critique, which was Coleridge's well-known objection to Wordsworth's assertion that his poems were written in a 'selection of language really used by men', also helps to explain the continuing appeal of Wordsworth to writers of works of popular science, as well as to the defenders of photography's civilizing potential. Coleridge objected to Wordsworth's claim that his poetry reflected the simplicity of rustic speech, arguing instead that such a claim disavowed its fundamental urbanity.[16] This much discussed insight, as John Guillory has

[15] Ian Michael discusses the pedagogic reduction of poetry to grammatical exercises and to serve the needs of the newly established system of public examinations in *The Teaching of English: From the Sixteenth Century to 1870* (Cambridge: Cambridge University Press, 1987); Stephen Gill cites the instances of the Reverends H. G. Robinson and C. H. Bromby's presentation of Wordsworth's lines as opportunities for grammatical analysis and analytical syntax in *Wordsworth and the Victorians*, 86.

[16] Samuel Taylor Coleridge, *Biographia Literaria*, ed. George Watson (New York: Dutton, 1971), bk. XVII.

argued, identified the logical crux of Wordsworth's argument as a principle of purification, or distinction designed to smooth out the discordant vulgarisms of provincial speech or local dialects.[17] As Coleridge insisted, Wordsworth's 'ordinary' language merely reproduced the standard vernacular of an educated Londoner, a linguistic centrism that understandably appealed to predominantly middle-class urban advocates of self-culture who wrote about and recommended pilgrimages to Wordsworth's Lake District as an instructive leisure activity. Even Wordsworth's elevation of the poetic sensibility as the superior translator of the 'essential passions' of the common man could easily be moulded to suit the aspirational rhetoric of Wordsworthians such as the Howitts.[18] While speaking in a language rife with Wordsworthian citations, enlisted as a mark of their own refined literary taste, these writers celebrated the common traditions that they assumed united their audience, while insisting upon the difference between poetic diction and the everyday language of their guidebook prose by pausing reverentially to recite long passages from the poems. An added advantage of these long citations moreover was the implication that Wordsworth's language defied paraphrase, a respectful gesture that conveniently elevated the cultural claims of the Howitts's derivative framing reflections on the Lake District's various picturesque attractions.

It is, however, within the particular context of the well-entrenched conventions of Romantic tourism that the distinctiveness of texts such as those of the Howitts truly emerges.[19] For while it could be argued that the archaeological preoccupation with local detail that photographic illustration encouraged was a throwback to the more impersonal encyclopedic style of eighteenth-century travel literature, in practice, the presence of photographs took the focus on the individual experience of the tourist, one of the definitive characteristics of Romantic travel literature, on to a new level of self-reflexivity.[20]

[17] Guillory, *Cultural Capital*, 127.

[18] William Wordsworth, 'Preface 1800 version (with 1802 variants)', *Lyrical Ballads: The Text of the 1798 Edition with the Additional 1800 Poems and the Prefaces*, ed. R. L. Brett and A. R. Jones (London: Routledge, 1991), 245.

[19] James Buzard provides an extensive cultural history of this literature in *The Beaten Track: European Tourism, Literature, and the Ways to 'Culture' 1800–1918* (Oxford: Clarendon Press, 1993).

[20] John Glendening describes this transition in his discussion of literary tours of Scotland, including William and Dorothy Wordsworth's *Memorials of a Tour in Scotland, 1803*, in *The High Road: Romantic Tourism, Scotland, and Literature 1720–1820* (London: Macmillan, 1997).

Indeed this heightened self-consciousness was integral to the promotion of the novelty of these volumes in the early years of their production, as the preface to another photographically illustrated volume published in the same year by the Howitts's publisher, A. W. Bennett, demonstrates. After reinforcing his personal connection to both the poet and his own 'native country of Cumberland and Westmoreland', Bennett offered his audience the following suggestions on how to mould their literary pilgrimages to the contours of the topographical itinerary that his volume maps:

> By this arrangement it is believed that not only will the Reader be able, with the assistance of the Photographic illustrations, which have been taken by Mr T. Ogle, specially for this work, to appreciate the more fully Wordsworth's wonderfully true descriptions of the beauties of nature; but the Tourist will have the additional pleasure of identifying with his own favourite spot any of the Poet's verses which refer especially to it.[21]

This attempt to aestheticize photography's evidentiary power could be interpreted as yet another instance of the conservatism of Victorian literary nostalgia. But Bennett's instructions are more nuanced than they first appear. To begin with, Bennett is not only inviting his readers to view, in the words of his title, *Our English Lakes, Mountains and Waterfalls. As Seen by William Wordsworth*, he is also encouraging them to make distinctions between different types of photographic and literary experience. At the level of the marketplace, this translated into a simple distinction between commodities. Depending on their needs and taste, consumers could now purchase a mass-produced volume such as the Howitts's, which featured negatives from commercial archives taken by photographers of note. Or, alternatively, they could invest in a more luxurious gift edition illustrated by art-photographs that they would find nowhere else. Also implicit in this branding of particular aesthetic experiences was an effort to modernize Wordsworth's vision, to bring it up to date with the contemporary everyday lives of Victorian readers by encouraging them to incorporate their own memories into the

[21] Bennett in William Wordsworth, *Our English Lakes, Mountains, and Waterfalls; as Seen by William Wordsworth*; with photographic illustrations by Thomas Ogle, 4th edn. (London: A. W. Bennett, 1862), n.p. Illustrated with thirteen albumen prints by Thomas Ogle. A second edition was published in 1867, followed by a third in 1868, and a fourth published by Provost and Co. in 1870. Some of these later editions contained different views.

sequence of images and poems that followed; a flattering suggestion that promoted the sequencing of personal memories into an aesthetic order as the primary function of the volume. In this context Wordsworth's poetry combined with Ogle's photographs to produce an amplification of the sensual pleasure of the reader in which the rhetorical and aural aspects of Wordsworth's language were marginalized in an effort to intensify its visual and mnemonic impact.

A similar self-consciousness characterized the experimentation with photographically extending the limits of poetic perception in the Howitts's volume. But in their case confident claims are qualified by uneasy references to the medium's novelty. There is, for example, an evident insecurity in the Howitts's promotion of photography as a more rigorous way of looking and remembering that pushed beyond the aesthetic limits of Romantic poetry and picturesque pictorial effect. For if, as the Howitts suggested, photography had the potential to move beyond the 'pleasant fictions' of familiar visual codes and literary mnemonic devices, their volume's own dependence on the poetry of Wordsworth and others suggested otherwise.[22] Indeed, the fractured and skeletal remains of Romantic poetry encompass and synchronize their volume's episodic structure. The ultimate message of their volume, as they acknowledged in their preface, was that photography was a new form that could not stand alone for precisely that reason. For while it may have surpassed the 'caprices and deficiencies' of engraving by presenting the reader with 'a genuine presentment of the object under consideration', its cultural value still depended upon an authorizing text and 'yet to be improvements' to be made to the art. To use their own words, their volume was merely 'a step in the right direction' towards the cultural legitimation of photography as a means of authenticating and expanding the scope of the literary experience of modern consumers, an aesthetic dynamic that was still incomplete and thus inherently semantically unstable. In these volumes, as Bennett's introduction to his Wordsworth reader also exemplifies, the emphasis has shifted from the author to the reader, from production to consumption, and more importantly, in the context of this argument, from isolated images to illustrative sequences that reflected on the elusive nature of time. While ostensibly worshipping at the shrine of Wordsworth the poetic visionary, these volumes thus intensified, while memorializing, the reader's

[22] Mary and William Howitt, *Ruined Abbeys and Castles of Great Britain*, i. n.p.

individual experience. The value of Wordsworth's poetry in this con-
text therefore lies in its power to literally regulate the mnemonic
capacities of the consumer; a cultural revaluation which ironically
enlists the poetry of one of the most vehement critics of modern visual
technologies as a consecrating device.[23]

One of Wordsworth's more explicit condemnations of the early
signs of a growing mass visual culture occurs in the seventh book
of *The Prelude*, where he recalled wandering through the streets
of London as a young man fresh from Cambridge. In the process of
surrendering to the memory of London's attractions, however, he
finds himself distracted once more by the kaleidoscopic array of
images that had inundated his senses:

> At leisure let us view, from day to day,
> As they present themselves, the Spectacles
> Within doors, troops of wild Beasts, birds and beasts
> Of every nature, from all climes convened;
> And, next to these, those mimic sights that ape
> The absolute presence of reality,
> Expressing, as in mirror, sea and land,
> And what earth is, and what she had to shew;
> I do not here allude to subtlest craft,
> By means refin'd attaining purest ends,
> But imitations fondly made in plain
> Confession of man's weakness, and his loves.
> Whether the Painter fashioning a work
> To Nature's circumambient scenery,
> And with his greedy pencil taking in
> A whole horizon on all sides, with power,
> Like that of Angels or commission'd Spirits
> Plant us on some lofty Pinnacle,
> Or in a Ship on Waters, with a world
> Of life, and life-like mockery, to East,
> To West, beneath, behind us, and before:
> Of more mechanic Artist represent
> By scale exact, in Model, wood or clay,
> From shading colours also borrowing help.
> Some miniature of famous spots and things

[23] William Galperin analyses this tension in Wordsworth's poetry and its ongoing
implications for the Romantic strains in contemporary cinematic practice in *The
Return of the Visible in British Romanticism* (Baltimore, Md.: Johns Hopkins
University Press, 1993).

Domestic, or the boast of foreign Realms;
. . .
And high upon the steep, that mouldering Fane
The Temple of the Sibyl, every tree
Through all the landscape, tuft, stone, scratch minute,
And every Cottage, lurking in the rocks,
All that the Traveller sees when he is there.[24]

The sheer excess of this description of the popular attractions that London had to offer, from the various menageries, fairs, and freak shows, to the grandiose expanse of Barker's Panorama, reveals the uncanny hold the spectacular continued to have over Wordsworth's imagination. For while the poem's speaker condemns 'those mimic sights that ape | The absolute presence of reality', he dwells at length on the illusionistic effects of the Panorama, in particular, inadvertently echoing the promotional rhetoric that typically accompanied such spectacles.[25]

Wordsworth was, of course, not alone in his contradictory fascination with the vulgar world of popular spectacle. His criticism of the illusionistic distractions that spectacles such as the diorama and panorama offered to the consumer echoed those of the nineteenth-century academic establishment in both England and France. John Constable, Eugene Delacroix, and others had argued, in the words of Constable's critique of the diorama, that even though the 'spectator is in a dark chamber, and it is very pleasing and has great illusion. [Yet] it is without the pale of art, because the object is deception. Art pleases by reminding not deceiving.'[26] Constable's artistic vigilance, like Wordsworth's, was motivated by an interest in maintaining a

[24] William Wordsworth, *The Prelude or Growth of a Poet's Mind* (1805), ed. Ernest de Selincourt (Oxford: Oxford University Press, 1970), 111–12.
[25] Richard Altick provides a fulsome account of the promotion and reception of Barker's Panorama in *The Shows of London* (Cambridge, Mass.: Belknap Press, 1978).
[26] Cited in Angela Miller, 'The Panorama, the Cinema, and the Emergence of the Spectacular', *Wide Angle*, 18 (April 1996), 34–69 (44). Of course, not all intellectuals of this time reacted to the artful deceptions of the Diorama in such a negative fashion. Baudelaire, for example, saw a greater truth in its blatant illusionism: 'I long for the return of the dioramas whose enormous, crude magic subjects me to the spell of a useful illusion. I prefer looking at the backdrop paintings of the stage where I find my favourite dreams treated with consummate skill and tragic concision. Those things, so completely false, are for that very reason much closer to the truth, whereas the majority of our landscape painters are liars, precisely because they fail to lie.' Cited in Walter Benjamin, 'On Some Motifs in Baudelaire', *Illuminations*, ed. Hannah Arendt (London: Fontana Press, 1992), 187.

hierarchy of aesthetic experience. Yet this mutual concern paralleled attempts to produce or maintain attentiveness in human subjects, which, as Jonathan Crary argues, was generated by, and in turn generated, cultural phenomena such as the panorama, photography, and later, cinema.[27] In Constable's account, the thin line between distraction and attention, illusion and art disappears in front of the eyes of the transfixed observer, despite the distinctions that he and his peers wished to maintain. Conversely, only a few decades later, Ruskin would celebrate and emphasize the same features that both Wordsworth and Constable had condemned. Praising the panorama as an 'educational institution of the highest and purest value', Ruskin argued that it 'ought to have been supported by the government as one of the most beneficial school instruments in London'.[28] Where Constable and Wordsworth saw deceptive illusion, Ruskin saw the power to hold the attention of the observer for long enough to shape his or her aesthetic sensibility. More tellingly still, Ruskin's profoundly Wordsworthian didacticism further illuminates the disavowed interdependency of spectacular effect and instruction in Wordsworth's œuvre more generally; an interdependency that unwittingly foreshadowed the form that future photographic illustrations of his work would take, where miniature panoramic views were intended to hold the attention of the reader by bringing Wordsworth's words to life.

Reading Wordsworth's poetry against the grain was, however, as Stephen Gill has demonstrated, a Victorian pastime in itself. But of particular interest here are the techniques that Victorian photographers enlisted to elide Wordsworth's verse with a newly visual sense of the dynamics of memory at both an individual and cultural level. This is again effectively exemplified by Alfred H. Wall's letter to a young photographer, where this abridged fragment from *Tintern Abbey* was enlisted to reinforce a defence of photography's cultural value:[29]

[27] Jonathan Crary, *Suspensions of Perception: Attention, Spectacle and Modern Culture* (Cambridge, Mass.: MIT Press, 1999), 49.

[28] Ruskin, *The Works of John Ruskin*, xxiv. 117. This positive response also characterized Ruskin's early recognition of the didactic potential of photographic slides discussed in the previous chapter.

[29] Walter Benjamin, 'A Small History of Photography', *One-Way Street*, trans. Edmund Jephcott and Kingsley Shorter (London: Verso, 1979), 243.

> . . . Nature never did betray
> The heart that loved her; 'tis her privilege,
> Through all the years of this our life, to lead
> From joy to joy: for so she can inform
> The mind that is within us, so impress
> With quietness and beauty, and so feed
> With lofty thought, that neither evil tongues,
> Rash judgments, nor the sneers of selfish men
> Shall e'er prevail against us, or disturb
> Our cheerful faith, that which we behold
> Is full of blessings.[30]

The political context for the desire for refuge that these lines express is a matter of indifference to Wall, although the general sentiment of turning away from the city towards the beauties of nature suits his purpose. Similarly overlooked are the poem's dialectical oscillations from certainty to doubt that leave no refuge intact, including nature where the speaker still finds himself haunted by thoughts of betrayal. As Stuart Curran notes, everything 'Wordsworth celebrates must be eroded, either by the temporal process so insistent in its intrusions on the poem or by the mind's inability to discover a singular perspective to which it can honestly adhere and through which it can render this contention into harmony.'[31] Wall detects no such internal tensions. He simply reads against the grain of the poem in the interest of adapting it to familiarize his readers with a new set of mnemonic and visual practices. Wordsworth's Platonic quest for eternal images is thus enlisted by Wall to encourage his readers to think of taking photographs as a form of isolating unique moments from an infinity of otherwise forgettable images. To focus in other words on moments that reveal what typically eludes the grasp of the casual observer.

Describing landscapes infused with sentiment awaiting the insight of the photographer's educated eye, Wall's instructions resonate suggestively with Benjamin's celebration of the camera's power to reveal 'the physiognomic aspects of visual worlds which dwell in the

[30] In Stephen Gill's edition of the poem, the final lines vary from Wall's citation: 'Rash judgments, nor the sneers of selfish men, | Nor greetings where no kindness is, nor all | The dreary intercourse of life, | Shall e'er prevail against us, or disturb'. William Wordsworth, *Poems*, ed. Stephen Gill (Oxford: Oxford University Press, 1984), 135.

[31] Stuart Curran, *Poetic Form and British Romanticism* (Oxford: Oxford University Press, 1986), 77.

smallest of things, meaningful yet covert enough to find a hiding place in waking dreams'.[32] But Wall's stress on photography's revelatory powers also draws attention to a fundamental flaw in Benjamin's familiar historical argument about Victorian photographs, exemplifying how at ease many Victorians were with a very literary or textual conception of photography. In the process of drawing attention to the nuances of light, detail, and time that can be captured by an eye educated by a working knowledge of poetic associations and picturesque effects, Wall's instructions acknowledge that even the tiniest 'spark of contingency, of the Here and Now' that a particular photograph may generate can only be recognized as such through a lens forged from a synthesis of borrowed codes:

Throughout all nature—in every season of the year and in every hour of the day—we see the sentiment of each scene continually varying. The light and the shade is full of expression . . . and the misty exhalations of early morn and dewy eve, with their long sweeping shadows and low-lying streams of yellow and orange light, have, like the broad glare of grey cool brilliancy of mid-day, their own peculiar sentiments appealing to their own scale of mental associations and human feelings. To seek out these, in their more powerful manifestations, in spots, and at times, powerfully imbued with harmonising and according qualities, is our chief business, then, as landscape photographers. To examine natural scenes with such views as these we need that cultivation of mind and eye which I have before urged the importance of, and such must be earnestly sought and carefully secured by all who would become photographic *artists* in something more than name. Thousands have toiled up mountains and hills without bearing away a single memory of aught beside the time occupied in the ascent, and the effect of the same upon their feet and legs; and, standing at length upon the topmost level of their cloud-piercing heights, have only thought how far and how much they can see, without hearing one of those solemn though still small voices speaking to their nobler passions, or seeing those glorious ministers of love and beauty which lie before their mental eyes, pointing 'through nature up to nature's God!' Just so thousands have gazed upon scenes of the most wondrous beauty, and seen nothing but a village called so-and-so, by such-and-such a river, near what's-the-name-wood.[33]

This passage could be read as a simple exercise in cultural distinction, which on one level it undoubtedly is. But the nuances of Wall's

[32] Benjamin, 'A Small History of Photography', 243.
[33] Wall, 'An Artist's Letter to a Young Photographer. On Landscape. Sentiment (continued)', 69.

interest in synthesizing Wordsworth's poetry and photographic pictorialism as an antidote to the reifying effects and collective amnesia of mass cultural tourism are worth considering in greater depth. Wall seems to be entertaining the possible co-existence of a unique and lasting copy with the infinite reproducibility of a commodity.[34] By describing the untapped potential of the mass of tourists who were carving their way insensibly through the Lake District by foot, brought thither on the railway networks that Wordsworth had so vehemently opposed, Wall includes them in his vision of a new, yet intrinsically cultic, way of seeing forged from a detailed archiving of visual impressions. Recalling Brewster's image of a new generation busily collecting and remembering every detail of the world around them, Wall reminds his readers that now no view nor action need go unrecorded. And while this may sound very similar to the reifying effects of the Victorian tourist's voracious appetite to see, know, and collect, what emerges from Wall's interest in cultivating a taste for nuances and details and Brewster's stress on the intricate play of light and form that distinguishes one moment from another is the possibility of an accessible sequence of unique moments that should not be simply reduced to yet another instance of the homogenizing effects of the serial reproduction of isolated images of objects stripped bare of their aura.

Bennett's 'Wordsworth Reader' could be interpreted as an effort to realize such a possibility, in contrast to the Howitts's more explicit, and thus inevitably problematic efforts to guide their readers' internalization of Wordsworthian mnemonic techniques. Illustrated by the prominent photographer Thomas Ogle Bennett's volume included the substantial reproduction of Wordsworth's verse and, initially, a facsimile of the poet's signature on the frontispiece. The intended purpose was to produce a serious literary text, rather than an exercise in genteel cultural tourism. In fact, Bennett's aesthetic aspirations for the volume led him to cross the line in the eyes of both Wordsworth's heirs and Moxon, Wordsworth's official publisher, resulting in a Chancery Court injunction ordering the removal of the signature

[34] Geoff Batchen argues that the photographic desire to fix images in the Romantic aesthetics that prefigures and resonates with rhetoric such as Wall's was inherently predatory and acquisitive, in *Burning with Desire: The Conception of Photography* (Cambridge, Mass.: MIT Press, 1997), 94.

and renegotiated use of the copyright verse.[35] Yet despite these minor setbacks, Bennett was the ultimate winner of this struggle, securing the right to publish his volume as an authorized 'Selection from Wordsworth's Poetical Writings' and four subsequent editions from which he made a modest profit. This fraught history also gives an additional ironic edge to Bennett's transparent efforts to legitimize his volume by stressing his personal relationship with the poet. In a further effort to consecrate the volume, he had reproduced a facsimile of lines that he claimed were written on his visit to Rydal four years prior to the poet's death; a shamelessly self-promotional gesture given the contested nature of the volume's provenance.

The distinction between Bennett's reader and the conversational tone of the Howitts's volume is particularly apparent in the dialogue that framed the Howitts's description of Tintern. At this point in the text the narrative voice assumes the guise of a gentlemanly lettered peripatetic who engages a hapless cotton spinner from Derbyshire in conversation and then finds himself enlisted as a somewhat unwilling guide who leads the way to Tintern. This sequence serves as a parable of how to move beyond the undiscriminating exclamations of wonder of the 'hundreds of thousands of visitors who now come by rail', a didactic interlude that nicely echoes Wall's instructions to young photographers. But this dialogue also draws attention to the paradoxes inherent in such self-conscious efforts to conserve 'the

[35] The Copyright Act of 1842 stated that copyright applied for forty-two years from the date of publication, or until seven years after the author's death. This time frame was especially difficult for Wordsworth's executors given that the majority of Wordsworth's most popular poetry had been published prior to 1807. In an attempt to circumvent this problem Wordsworth himself had initially signed an agreement in 1836 with the publishers Edward Moxon and Co. giving them exclusive rights to all his published and unpublished work. His executors subsequently renegotiated this agreement in 1856 and again in 1877. According to this contract, Moxon alone could publish the complete poetical works until 1892. But in the end this deal proved to be less advantageous than it had at first appeared, since after 1857—seven years after the poet's death—the majority of Wordsworth's poems, including the *Lyrical Ballads*, *The Excursion*, and the 1807 poems, were already in the public domain. When he had initially approached Wordsworth's son William for permission to reproduce verse that was still under copyright, Bennett was fully aware of the Wordsworths' tenuous hold on their father's literary legacy and manipulated the situation to his advantage. The flurry of correspondence that this case generated reveals that the more naïve Wordsworths were no match for the unscrupulous Bennett. At first he refused to remove the offending signature and the poems that were still under copyright. Only after he was threatened on 22 December 1864 by a Chancery injunction to prevent the sale of his book did he agree to remove the material.

memories of people and events that made the whole sacred ground'.[36] For no matter how distinctive each moment in an illustrative sequence was, efforts to align them on a single temporal continuum or locate them in an infinitely extendable present tense inevitably drew attention to the troubling opacity of the past, whether one possessed the poetic insight to recognize that fact as a form of cultural death or not. And so, as Barthes poignantly observed, 'while trying to preserve life' of a particular chapter in their nation's literary and political past the Howitts's volume merely confirmed the obsolescence of both.[37]

In the Howitts's plot the cotton spinner from Derbyshire symbolizes the collective amnesia of the modern consumer. A child of industry, he is an overweight, indiscriminate character who speaks in commonplaces that benignly suppress or efface distinctions. A stranger to the manly vigour and romantic sensibility that the narrator exemplifies, he had intended to view the Lake District's charms from the comfort of a carriage window. But his greatest sin is to be insensible to the history of the sacred ground on which he walks. Attracted, like thousands of others, to the natural beauty of the district, he remains unaware of the historical significance of Tintern, which he would have simply passed by, if not for the worthy efforts of the Howitts's trusty narrator who goads this 'neophyte in peripatetics' into action with the timely reminder that 'By not walking you make yourself heavy and lose one of the finest enjoyments in life.'[38] But this sequence does not simply envelope the banalities of the present in the profundities of the past through a collage of Russell Sedgfield's photographs, Wordsworth's poem, which is recited at length by the narrator, and a guidebook-style potted history of the Abbey's history. The fact that the narrator has to force these things on his intractable, yet convivial, companion, who continues to respond in a manner that indicates that the deeper cultural message which the Howitts wish to impart has fallen largely on deaf ears, registers an awareness of the inherent inadequacy of their deeply Romantic valorization of past traditions. The continuing divergence of the narrator and his interlocutor's perspectives exemplify what Richard Terdiman has identified as the two principal disorders

[36] Mary and William Howitt, *Ruined Abbeys and Castles*, 7–8.
[37] Barthes, *Camera Lucida*, 92.
[38] Mary and William Howitt, *Ruined Abbeys and Castles*, 19.

around which nineteenth-century anxieties about memory crystallized. Put simply, one either suffered from 'too little memory' or 'too much'. Weighed down by the burden of the significance of Tintern, the Howitts enlisted photography and poetry to communicate with those readers, who, like the cotton spinner, fell outside the restricted cultural field in which they moved. But their efforts at popularizing ekphrastic description in this instance dissolve into the leaden opacity of nostalgic prose. Ironically, William Howitt's more conventional exercise in literary homage, *Homes and Haunts of the Most Eminent British Poets*, was far more inclusive in its attitude to those 'tourists and hunters of the picturesque', gently reminding the reclusive Laureate that the voracious curiosity of his public was a sign of his continuing cultural relevance.[39] One reason, of course, for the more interactive possibilities offered by this earlier volume was that the Laureate was still alive to actually register the effects of the 'ever swinging censer of the flattery of public curiosity tossing at his door'. But another difference lay in the introduction of photographs to the apparatus of literary pilgrimage, an addition that inadvertently widened the already considerable historical and cultural gulf between Wordsworth and those who now lived amidst 'the din | of towns and cities' from which the poet himself had fled over half a century before.

 In the light of this failure to maintain and enshrine a historical continuity between England's medieval past and industrial present, the collage-like style of the Howitts's volume becomes more significant. For as the playful tone of the above dialogic sequence suggests, the text is characterized by a mixture of registers, a style that was inherently resistant to any single coherent narrative or ideological message. There were simply too many voices simultaneously in play: at one point working through performative example, at another through poetic recitation, and on still another level through photographic images that generated their own conflicting stories about the desire for contact and the melancholia intrinsic to the effort to souvenir a particular moment or view. This is exemplified by the first image in the Tintern sequence by Russell Sedgfield, a picturesque view taken from Chapel Hill, which on one level simply illustrates the Howitts's descriptive topographical prose.

[39] William Howitt, *Homes and Haunts of the Most Eminent British Poets*, 2 vols. (London, 1847), ii. 289. Interestingly, this profile also ends by praising the railway's democratizing effects (290–1).

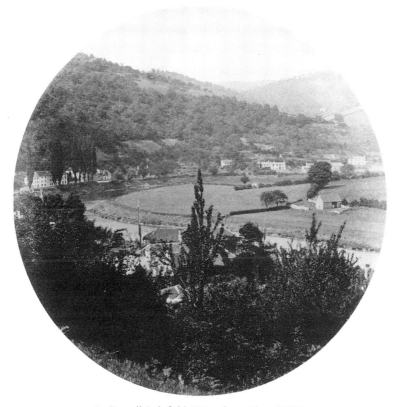

8. Russell Sedgfield, 'View from Chapel Hill'

In this context the image enacts the trajectory of the male narrator looking down at the valley below, a distancing aesthetic further amplified by the cropping of the image creating the effect of a telescopic window opening out in the midst of the page. At this point it is also important to remember the tactile aspects of this viewing experience. Sedgfield's image is not located in a conventional exhibition space, but in an intimate, privately owned, yet eminently transportable, material form that could be held, as well as drawn back and forth, towards and away from the observer's eye. Similarly, the volume's elegant gilt binding reminds us of its role as a domestic artefact that needed to be distinguished from the other volumes on the crowded shelf of the library of its intended middle-class owners.

And yet despite these connotations of intimacy, and the Howitts's popularizing intentions, the prevailing dynamic that results from Sedgfield's view is one of exclusion, both at the level of composition, where the reader's implied location in the foreground seems far removed from the scene below, and at the level of the pictorial frame, where the aesthetic cropping of the image draws attention to what is excluded from the frame and thus to the failure to achieve the illusion of proximity that its form initially promises. The observer is effectively immobilized and the visual field compressed in such a way that it leaves no doubt as to why the popularity of the exaggerated depth and focus of the stereoscopic view so dramatically outstripped the visual attractions offered by the photographically illustrated book.

The second image in the sequence, however, has an entirely different effect and purpose. Taken in the grounds of the Abbey, it focuses the observer's gaze on architectural details, an emphasis reinforced by the title 'West Door and Window' and textual cues that signal a shift from the sublime overview to the particularities of the beautiful. Not surprisingly, given the Howitts's formulaic rehearsal of Romantic topoi, this shift is also marked by the introduction of a female observer into the frame, although it would be a mistake to overstate the conceptual significance of this substitution, given the leisurely stance and fashionable attire of the woman in question. The masculine persona that the narrative voice has assumed is sustained here, as is a model of hardy peripatetics from which the genteel woman tourist in the frame, as well as Mary Howitt herself, would have been excluded.[40] Significantly, this construction of the female as a passive mirror of the male narrator's and, by implication, the reader's perceptual acculturation also parallels Dorothy's role as silenced auditor and effaced collaborator who, to quote Anne Mellor, guarantees 'the truth of the poet's development and perceptions'.[41]

But the prevailing impression of the synthesis of image and text in this instance is of a self-conscious exercise in connoisseurship; an emphasis not lost on the volume's reviewers. Stephen Thompson's review in the *British Journal of Photography*, for example, singled out Sedgfield's images and those of George Washington Wilson in a

[40] Anne D. Wallace discusses the gendering of Victorian peripatetics in *Walking, Literature, and English Culture: The Origins and Uses of Peripatetics in the Nineteenth Century* (Oxford: Clarendon, 1993), esp. 29–30.

[41] Anne K. Mellor, *Romanticism and Gender* (London: Routledge, 1993), 19.

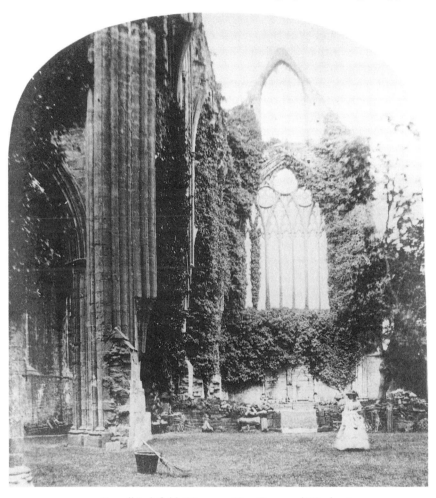

9. Russell Sedgfield, 'Tintern—West Door and Window'

defence of the volume's innovative techniques. Thompson also provided a model of how one should cultivate an eye for reading photographs that, like Wall's, resonates with Benjamin's conception of photography's revelation of the secrets of visual phenomena. And yet, like Wall, Thompson invokes this notion in the context of photographs that are heavily framed by historical exegesis and poetic text. His review, like the photographically illustrated books it promotes, thus reveals the inherent flaws in Benjamin's own nostalgic reconstruction of those photographs from 'our grandfather's day'. And it is here that the significance of the practice and reception of these photographic illustrations for literary history lies. For, in contrast to Benjamin's claim for the luminous authenticity of Victorian photographs, they were from the very beginning framed by often clichéd commentary designed not only to inspire 'verbal associations in the viewer', but more importantly to promote photography's unique capacity to turn 'all life's relationships into literature'.[42] That is the attraction that Bennett stresses in his introduction to *Our English Lakes, Mountains and Waterfalls. As Seen by William Wordsworth*, the sequencing of personal memories into a time-conscious visual syntax by a new generation of reader/observers; a positive embrace of photography's literary effects, moreover, that contrasts dramatically with Benjamin's declinist vision of the medium's fall from innocence into the language of captions and exegetic description.

This effect is given one of its most evocative realizations in the final illustrative sequence in *Our English Lakes, Mountains and Waterfalls*, which combines a photograph of 'Wordsworth's Tomb in Grasmere Churchyard' with a complete citation of *Intimations on Immortality. From Recollections of Early Childhood*. Shot in close-up, the visual stress of the photograph is on the epitaph on the gravestone that simply records the names William and Mary. Confronting in its brevity this simple inscription returns the reader to the Wordsworthian corpus for consolation and substance, a return cued by Bennett's full citation of Wordsworth's ode. This recursive hermeneutic sets off a range of visual effects and conceptual associations. For instance, it registers Bennett's aesthetic aspirations for the volume in its reproduction of the traditional editorial sequencing of the poem, which after its first publication in 1807 was positioned at the conclusion of

[42] Benjamin, 'A Small History of Photography', 256–7.

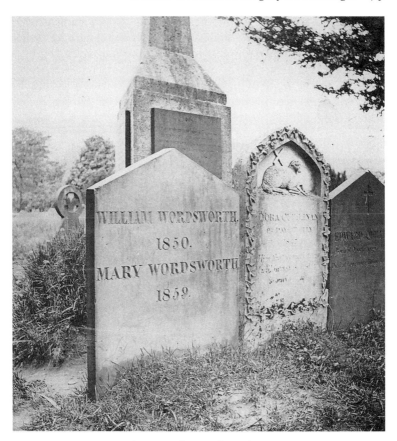

10. Thomas Ogle, Wordsworth's Grave

subsequent editions.[43] But in the specific context of this illustrative sequence, it extends the moment of encounter between the observer and Wordsworth's epitaph, quite literally in the sense of making the reader pause to read, as well as poetically, through what Alan Liu describes as the alternation 'between pastoral and prophetic, elegiac and hymnal' which the Immortality Ode epitomizes.[44] Furthermore, read alongside Wordsworth's consignment of the arc of birth, life,

[43] The Immortality Ode was also distinguished typographically in later editions of the poems.

[44] Alan Liu, *Wordsworth: The Sense of History* (Stanford, Calif.: Stanford University Press, 1989), 383.

and death to a realm of forgetting where the 'Soul's immensity' is inaccessible to all but the Philosopher-Poet, the failure of Ogle's photograph to summon the presence of the dead inadvertently proves the poem's argument.[45] Poem and photograph taken together, therefore, 'sound the death of history', to quote Liu, whilst asserting the prophetic powers of the poet. This is not quite what Barthes meant when he argued that the source of photography's astonishment was that it was 'without future' and blocked the memory by filling 'the sight by force'.[46] Yet it exemplifies the ways in which the dynamics of illustration poses problems for the narratives of epistemic rupture that have traditionally characterized the history of the early reception of photography. In this instance, rather than posing a counter-memory that desecrates the possibility of separating one's real memories from photographic memories in which 'nothing can be refused or transformed', the interplay between photograph and poem exposes the wilful idealism of the concept of authentic memory for all those who lived out their lives in the realm of forgetting. Ogle's photograph is transformed by Wordsworth's prophetic yet hauntingly ambiguous words, just as Wordsworth's poem is transformed by Ogle's photograph into a mnemonic device that facilitates a moment of cultural recognition, whilst reinforcing a hierarchy of sensibility.

In *Camera Lucida* Barthes makes a developmental distinction between the anthropological place of death in societies who remembered through the ritually consecrated form of the monument, and modern societies where the experience of death and memory has been flattened into the alienated and alienating form of the photograph:

Earlier societies managed so that memory, the substitute for life, was eternal and that at least the thing which spoke Death should itself be immortal: this was the Monument. But by making the (mortal) Photograph into the general and somehow natural witness of 'what has been,' modern society has renounced the Monument. A paradox: the same century invented History and Photography. But History is a memory fabricated according to positive formulas, a pure intellectual discourse that abolishes mythic Time; and the Photograph is a certain but fugitive testimony; so that everything, today,

[45] Wordsworth, *Intimations of Immortality: From Recollections of Early Childhood*, in *Our Lakes, Mountains and Waterfalls. As Seen by William Wordsworth*, 183. [46] Barthes, *Camera Lucida*, 90, 91.

prepares our race for this importance: to be no longer able to conceive *duration*, affectively or symbolically.[47]

Yet this interpretation depends upon the possibility of maintaining the integrity of discursive and cultural forms within a linear succession that presumes, as Foucault has argued, that the world was 'made to be read by man'.[48] Yet only the smallest amount of pressure applied to the clarity of the distinctions Barthes makes and the logic of his account collapses into ambiguity. For example, rather than signifying the demise of the monument, Bennett's volume and Ogle's photograph of Wordsworth's grave, in particular, exemplify the reciprocity between these two memorializing forms in Victorian culture. This is equally true in the context of photographically illustrated books devoted to literary figures where graves and monuments were featured as frontispieces, or, as in the case of this volume, as the ultimate destination on a cultural pilgrimage. Furthermore, the reproduction of Wordsworth's ode alongside Ogle's photograph implies the continuing symbolic force of the Platonic idea of duration. Although composed prior to the invention of photography, Wordsworth's poem exemplifies the inherently syncretic ways in which new cultural forms adapt, yet sustain, descriptive rhetorics and familiar mythologies. Referring to his use of this particular Platonic fiction, Wordsworth observed: 'a pre-existent state has entered into the popular creed of many nations; and, among all persons acquainted with classic literature, is known as an ingredient of Platonic philosophy . . . I took hold of the notion of pre-existence as having sufficient foundation in humanity for authorizing me to make for my purpose the best use of it I could as a Poet.'[49] Here Wordsworth makes it clear that the Platonic notion of anamnesis is merely a creative tool that he takes up and uses to achieve his aesthetic ends; a strategy that implicates his work in what Heidegger would call a 'ready-made' world of concepts and practices that precedes and contextualizes any claim to originality.[50] Similarly,

[47] Ibid. 93.

[48] Michel Foucault, *L'Ordre de Discours* (Paris: Gallimard, 1971), cited in Donald Bouchard, Introduction, *Language, Counter-Memory, Practice: Selected Essays and Interviews by Michel Foucault* (Ithaca, NY: Cornell University Press, 1977), 17.

[49] Cited in *William Wordsworth*, ed. Stephen Gill, The Oxford Authors (Oxford: Oxford University Press, 1984), 714.

[50] Martin Heidegger, *Being and Time*, trans. John Macquarie and Edward Robinson (Oxford: Basil Blackwell, 1962), 41–9, 78–82, 279–304, 456–86.

Bennett makes use of Wordsworth's Platonic meditations to create the illusion of a collective memory that maximizes the affective impact of a visit to the poet's humble grave. In this context the poem is transformed into a rhetorical incarnation of the photographic desire to amplify and extend the potential significance of a single moment of time in the interests of making a new generation of Wordsworthians feel.

Paradoxically, Barthes's own compelling reading of Alexander Gardner's 1865 portrait of Lewis Payne on Death Row exemplifies why the 'essence' of photography can never be isolated from the cultural associations that shape its reception. Confronted by the beauty of the photograph and the soon-to-be-hanged man's uncannily handsome face, Barthes' reading enacts Benjamin's notion of photography's power to turn life into literature.[51] The dual aspects of the *punctum*—'he is going to die'—'This will be and has been'—captures the photograph's generative and inextricable place in precisely the process of fictional or poetic elaboration from which Barthes was trying to separate it by speaking of the photograph as 'the instance of reality' that exists apart from any textual elaboration. This is a fundamental paradox in Barthes's conception, which Carol Armstrong has astutely noted is further intensified by the fact that *Camera Lucida* is itself not only a photographically illustrated book, but a book that returns again and again to the haunting, intensely literary, associations that nineteenth-century photographs generate. Yet, to some extent Barthes's own uneasy awareness of the theoretical failure of *Camera Lucida* to develop a systematic analysis of the photographic sign is the source of its success. His critical legacy ultimately taking the form of what Armstrong evocatively describes as a 'vestigial archaeology', a creative critical practice that draws out the contingencies and resonances of the fragmentary and the particular and refuses the necessary occlusions of the general overview or official history.[52]

Potential failure also haunts Bennett's own efforts to make his readers feel. Like the Howitts's ultimate failure to make the cotton spinner from Derbyshire listen, the decision to conclude his Wordsworth Reader on such a resoundingly prophetic note is tinged with melancholic anxiety. Indeed, the solemnizing of a visit to

[51] Barthes, *Camera Lucida*, 95–6.
[52] Ibid. 110; Armstrong, *Scenes in a Library*, 8.

Wordsworth's grave with a recitation of a poem, which many Victorians found ambiguous at best, recalls Arnold's melancholic reflections intoned over Wordsworth's grave in 'Memorial Verses':

> Wordsworth has gone from us—and ye,
> Ah, may ye feel his voice as we.
> He too upon a wintry clime
> Had fallen—on this iron time
> Of doubts, disputes, distractions, fears.
> He found us when the age had bound
> Our souls in its benumbing round:
> . . .
> Others will strengthen us to bear—
> But who, ah! Who will make us feel?
> . . .
> Keep fresh the grass upon his grave,
> O Rotha, with thy living wave!
> Sing him thy best! For few or none
> Hears thy voice right, now he is gone.[53]

Both Arnold's poem and Bennett's book transform a visit to the Lake District into a visit to the graveyard of poetry. Life in an age benumbed by 'doubts, disputes, distractions, fears' only seems to confirm the association of poetry with nostalgic melancholia. But Arnold's diagnosis of the death of feeling in 'this iron time' is of course prematurely apocalyptic. It fails to take into account how at home his own generation would feel amongst the well-tended graves of the cemetery itself. When Benjamin observes of one of David Octavius Hill's photographs taken in Edinburgh Greyfriars cemetery that his subjects seem peculiarly at home there and that the cemetery itself resembled 'an interior, a separate closed-off space where the gravestones propped against gable walls rise up from the grass, hollowed out like chimney pieces, with inscriptions instead of flames', he captures the intimacy and the vitality of a distinctively Victorian culture of mourning, of which photography and poetry were such integral and generative aspects.[54] In a decade characterized by the spectacular grief of Victoria—who publicly avowed her attachment to Tennyson's *In Memoriam*, published a year after Arnold's

[53] Matthew, Arnold, 'The Buried Life', in Walter E. Houghton and G. Robert Stange (eds.), *Victorian Poetry and Poetics* (New York: Houghton Mifflin, 1968), 446–7.

[54] Benjamin, *One-Way Street*, 244–5.

'Memorial Verses'—memorials and monuments proliferated. As Adrienne Munich remarks, everything Albert liked, touched, and designed was transformed into a sacred relic and Victoria's only public actions throughout most of the 1860s revolved around the building of memorials to her beloved Albert, that she believed should be numberless.[55] Such excesses were entirely legible to her subjects who were themselves steeped in their own elaborate ritualizations of death; a common preoccupation which inspired and was in turn inspired by the mass production and consumption of mementos such as hair rings, mourning portraits, and the ever-popular photographs of dead children. The pleasure of possessing these fetishized objects, whose relative value was determined by their inextricable link to the corpse of the loved one, domesticated a traumatic event, bringing it home through a self-conscious mystification of the ties that bound the past to the present. In this cultural context both Bennett's Wordsworth Reader and the Howitts's volume can be read as exemplifying a new hermeneutics that mirrored the recursive dynamics of mourning; a hermeneutics preoccupied with authenticity, yet haunted by the spectre of inevitable loss. Rather than detaching Wordsworth's poetry from the tradition that ensured its cult value therefore, photographic illustration illuminated the aesthetic paradoxes and ideological tensions involved in the promotion and circulation of a self-consciously Romantic aesthetics far beyond the restricted cultural field of those who, to invoke Arnold, had the requisite taste to 'hear his voice right'.

[55] Adrienne Munich, *Queen Victoria's Secrets* (New York: Columbia University Press, 1996), 83.

CHAPTER FOUR

Scott, Technology, and Nostalgic Reinvention

Brick walls we pass between, passed so at once
That for the suddenness I cannot know
Or what, or where begun, or where at end.
Sometimes a station in grey quiet; whence,
With a short gathered champing of pent sound,
We are let out upon the air again.
Pauses of water soon, at intervals,
That has the sky in it;—the reflexes
O' the trees move towards the bank as we go by,
Leaving the water's surface plain. I now
Lie back and close my eyes a space; for they
Smart from the open forwardness of thought
Fronting the wind.

 Dante Gabriel Rossetti, 'A Trip to Paris and Belgium'[1]

Inspired by a journey between London and Folkestone, Dante Gabriel Rossetti's evocative words describe the annihilation of time and space typically associated with the experience of train travel in the 1850s. The observer perceives the landscape as it is filtered through the 'machine ensemble' of the railway journey, to use Wolfgang Schivelbusch's term; a perceptual dynamic that registers the fracturing of the traditional mimetic relationship between travel and landscape.[2] No longer able to keep up with the rush of visual images, the poem's speaker closes his eyes as he struggles to transform the shock of sensual inundation into the unity of poetic

[1] Dante Gabriel Rossetti, 'A Trip to Paris and Belgium', in *The Essential Rossetti*, ed. John Hollander (New York: Ecco Press, 1970), 115–25.
[2] Wolfgang Schivelbusch, *The Railway Journey: Trains and Travel in the 19th Century* (Oxford: Basil Blackwell, 1977), 27.

reflection; a simple gesture that resists the tremendous technical discipline, which, Schivelbusch argues, signalled the 'end of free play between the individual elements' of the transport experience.[3] Yet, at the same time, the poetry itself derives its energy and inspiration from the train's careening force, registering the opening up of a new space for imaginative free play and rhythmic consolations in the midst of the relentless teleological drive of railway time. A reflection on the epistemological impact of 'the machine ensemble' of the railway journey thus becomes a space for poetry. But it is a space forged from the creative interplay between technology and poetry, rather than from a conservative resistance to modernity. There is an element of sensual abandon in Rossetti's verse that eludes the more regressive aspects of nostalgia, whilst at the same time mobilizing a characteristically nostalgic will to arrest time and isolate a moment of authentic experience from the overwhelming elisions of technological affect. This nexus of nostalgic desire with poetic affect resonates with the photographic illustration of Cowper, Wordsworth, and others discussed thus far, as well as with the illustration of Scott's poetical works which this chapter will consider. Here, however, an analysis of the cultural politics of nostalgia will be combined with a closer consideration of the ways in which the 'machine ensemble' of the apparatus of the photographically illustrated book and the later photographic lantern show reproduced the imaginative interplay between shock and duration experienced by Rossetti's train traveller. In this self consciously modern poetics of travel, the convergence of photographs and poetry transforms fragmentary impressions garnered at speed into a form that insists on poetry as an interior private space where continuity can be maintained through an active, yet creative, resistance to the arbitrary efficiency of modern timetables and travel assemblages; a poetic form that is inseparable from the material conditions that are the ultimate source of its inspiration.

The illustrative work of the prominent Scottish photographer George Washington Wilson, whose career began in the 1860s with the reproduction of his negatives in photographically illustrated books and then expanded into the mass production of lantern shows, resonates with Rossetti's suggestive convergence of nostalgia, technology, and poetry. Although Wilson's aesthetic agenda differed

[3] Wolfgang Schivelbusch, *The Railway Journey: Trains and Travel in the 19th Century*, 28.

radically from Rossetti's, the work of both men exemplifies the emergence of a new cultural poetics that transformed poetry itself into a metaphor for cultural duration in Bergson's sense of *durée*—the continuity of becoming. In *Creative Evolution* Bergson used a photographic analogy to describe the invidious aspects of the division of time into successive instants. He observed that we 'take snapshots, as it were, of the passing reality', a compulsion to solidify time that is the antithesis of the fundamental indivisibility of movement that, for Bergson, was the genesis of creativity and knowledge.[4] What concerned Bergson was the need to recognize the artificial fragmentation involved in our sense of the past as a series of externally related recollections, not unlike a collection of photographs. As Genevieve Lloyd argues: 'Bergson sees past and present as coexisting, not as a result of their very nature. The past is "preserved" not because mind is able to counter the flight of the present into nonexistence, but because it is only through an illusion that we think of the past as separate from the present at all.'[5] Integral to the virtual coexistence of the present and the past for Bergson is an erosion of the alignment of perception with the present and memory with the past. In practice, he argued, 'we perceive only the past, the pure present being the invisible progress of the past gnawing into the future'.[6] By invoking the name of photography as the antithesis of this more authentic conception of the relation between time and perception, however, Bergson involves himself in a conceptual and rhetorical paradox which has encouraged his critics to identify resemblances between his notion of duration and the dynamics of photography he constructs as its antithesis; an unsurprising response given that, as Geoff Batchen astutely notes, the recognition of the 'ability to bring past and present together in one visual experience' was quickly seized upon by photography's earliest nineteenth-century commentators as one of the defining characteristics of the new medium. Walter Benjamin, for example, strategically entangled Bergson's ideas with the rhetoric of photography to demonstrate this point. Describing Bergson's efforts to shut out the 'blinding age of industrial capitalism' as misguided

[4] Henri Bergson, *Creative Evolution*, trans. Arthur Mitchell (London: Macmillan, 1913), 202.

[5] Genevieve Lloyd, *Being in Time: Selves and Narrators in Philosophy and Literature* (London: Routledge, 1993), 101.

[6] Henri Bergson, *Matter and Memory*, trans. Nancy M. Paul and W. Scott Palmer (New York: Zone Books, 1991), 194.

7

disavowal, Benjamin redescribes Bergson's conception of duration as akin to a form of photographic nostalgia in which spontaneous after-images are fixed and translated into permanent records.[8] What Benjamin's reading effectively does therefore, is to insist upon the recognition of the interdependency of the ideal and material conditions of perception, an insistence which one could argue was already implicit in Bergson's own recognition of the illusory and culturally determined nature of arbitrary distinctions between past, present, and future. The particular relevance of this critical exchange for this project, however, is that Benjamin's sceptical reading of Bergson's notion of duration exemplifies the sustained nature of the epistemological and cultural tensions that continue to haunt debates about the relation between perception and technologically mediated experience; tensions which can be traced back to Rossetti's early dramatization of the accelerated past–present tense of train travel and forward through George Washington Wilson's attempts infinitely to extend the past tense of his audiences through the photographic illustration of Scott's narrative poems. In Wilson's photographic mediations of Scott's work, the idea of poetry resembles the retrospective synthetic formation of after-images Bergson describes, which in turn mystifies the photographs selected to transform the abstract experience of poetic memory into a fixed image. Both image and text are then drawn into a nostalgic dynamic in which the distance between objects and places contracts and the scope of the domestic consumption of the English middle-class home expands to take in the view; a cultural dynamic that draws a further constellation of political, economic, and social issues into the mix.

In 1862 Wilson provided the frontispiece for an edition of Scott's *The Lady of the Lake* published by A. W. Bennett.[9] The photograph, which had been part of a popular stereoscopic series in a previous incarnation, was of Scott's tomb at Dryburgh. As was so often the case with Wilson's images, this photograph places the visual emphasis on the dynamics of approach. The darkness of the foreground framed

 [8] Walter Benjamin, *Charles Baudelaire: A Lyric Poet in the Era of High Capitalism* (London: Verso, 1997), 111.

 [9] Sir Walter Scott, Bart. *The Lady of the Lake*, illustrated by George Washington Wilson and Thomas Ogle (London: A. W. Bennett, 1862). All further references to the poem are to this edition. There was another edition in 1863 from which the illustrations in this book are taken. Wilson was also involved in a further edition that he illustrated jointly with Birket Foster and John Gilbert, which was published by the Scottish publishers A & C Black in 1866.

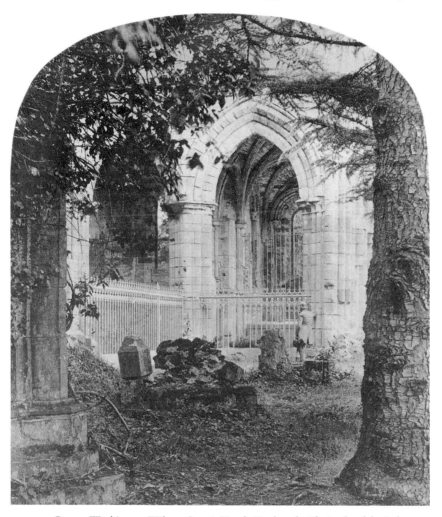

11. George Washington Wilson, Scott's Tomb, Dryburgh, *The Lady of the Lake*

by tree and monument contrasts with the illuminated church façade. Recalling the recessive illusion created by the stereoscope, the observer is drawn into the image towards the light and the figure standing respectfully before Scott's tomb. Back to camera he sees what the observer on the other side of the frame cannot. Yet his posture implies unsated curiosity as he stands looking in at what he can see but cannot touch. The cropping of the image also recalls the isolating dynamics of the stereoscopic apparatus encouraging the observer to banish the immediate surrounds from the viewing experience and move into the visual field; the complete reverse, as Rosalind Krauss has observed, of 'the visual meandering experienced in the museum gallery as one's eyes wander from picture to picture and to surrounding space'. This effect was precisely the one Wilson intended to achieve: 'I am never satisfied unless I can get the objects comprehended, even in a stereoscope-sized plate, to compose in such a manner that the eye, in looking at it shall be led insensibly around the picture, and at last find rest upon the most interesting spot, without having any desire to know what the neighbouring scenery looks like.'[10]

In a manner similar to the viewing dynamics that characterized the photographic illustration of Wordsworth, the emphasis here is on isolated private viewing and intimacy as the observer implicitly draws the book back and forth scanning the image for details and alternately focusing on foreground and background. In theory, the act of perceiving endlessly repeats the tourist's movement through space towards the monument. Yet this effect is achieved by suspending that movement—the observer on the other side of the frame literally never gets to Scott's tomb. The present of the viewing experience is always in the process of becoming past—caught in a state of suspension that implies the endless returns of literary pilgrimage itself. Wilson's frontispiece thus becomes a visual distillation of what the volume is intended to achieve, the opening up of a space for the infinite recession of cultural memory between the point of origin and the final destination of the Victorian reader's nostalgic desire. Read in this context, Scott's poem gives narrative sequence to the infinite deferral that Wilson's photograph enacts. The reader moves into the poem and the familiar landscape it invokes through Wilson's image,

[10] Rosalind Krauss, 'Photography's Discursive Spaces', in *The Originality of the Avant-Garde and Other Modernist Myths* (Cambridge, Mass.: MIT Press, 1986), 137. George Washington Wilson, 'A Voice from the Hills. Mr Wilson at Home', *British Journal of Photography* (16 September 1864), 375.

turning the page to find out what happens next in a story that most had heard many times before; a story where the significance lay in the telling and retelling, not in the arrival at an undisclosed destination.

That *The Lady of the Lake* should have appealed to photographers is consistent with its publication history. Shattering 'all records for the sale of poetry', it inspired an internal tourist trade that radically transformed the Trossachs and Scotland more generally into a site where Scott's romantic ethnographic sensibility could be re-enacted in the guise of instructive leisure.[11] Taking Scott's problematic quest for an authentic cultural encounter with his Scottish heritage as their guide, English middle-class tourists set out to see a Scotland that never existed for themselves. The real in this context was easily set aside in favour of pleasure and nostalgia, much as it had been for Scott when he weighed up the limitations of his knowledge of Celtic manners:

I have had for some time thoughts of writing a Highland poem . . . giving as far as I can a real picture of what that enthusiastic race actually were before the destruction of their patriarchal government. It is true I have not quite the same facilities as in describing Border manners where I am . . . more at home. But to balance my comparative deficiency in knowledge of Celtic manners . . . I have from my youth delighted in all the highland traditions which I could pick up from the old Jacobites who used to frequent my father's house.[12]

James Buzard has described the ideologically fraught mix of idealism and complicity that characterizes this poetic aspiration as a defining aspect of what he calls Scott's fictional auto-ethnography.[13] For Buzard this is most clearly demonstrated in Scott's ambiguous response to Macpherson's Ossian forgeries. Divided between literary appreciation and a desire for an authentic translation of primary documents, it is the former that ultimately prevails. As he wrote to Anna Seward, 'the question of authenticity' ought not to be confounded with that of literary merit.[14]

This tension between cultural authenticity and poetic licence haunts *The Lady of the Lake*, as it had done *The Lay of the Last Minstrel*, the latter of which began with the following defence:

[11] The phrase 'Shattered all records' is from Edgar Johnson's *Sir Walter Scott: The Great Unknown* (New York: Macmillan, 1970), 335.

[12] Sir Walter Scott, Bart. *The Letters of Sir Walter Scott*, ed. H. J. C. Grierson, 12 vols. (London: Constable, 1932–7), i. 324.

[13] James Buzard, 'Translation and Tourism: Scott's *Waverley* and the Rendering of Culture', *Yale Journal of Criticism*, 8/2 (1995), 31.

[14] Scott, *The Letters of Sir Walter Scott*, i. 320–4, 347.

The Poem, now offered to the Public, is intended to illustrate the customs and manners that anciently prevailed on the Borders of England and Scotland. The inhabitants living in a state partly pastoral and partly warlike, and combining habits of constant depredation with the influence of a rude spirit of chivalry were often engaged in scenes highly susceptible to poetical ornament. As the description of scenery and manners was more the object of the Author than a combined and regular narrative, the plan of the Ancient Metrical Romance was adopted, which allows greater latitude in this respect, than would be consistent with the dignity of a regular poem. The same model offered other facilities, as it permits an occasional alteration of measure, which, in some degree authorises the change of rhythm in the text. The machinery, also, adopted from popular belief, would have seemed puerile in a Poem which did not partake of the rudeness of the old Ballad, or Metrical Romance.

For these reasons, the Poem was put into the mouth of an ancient Minstrel, the last of the race, who, as he is supposed to have survived the Revolution, might have caught somewhat of the refinement of modern poetry, without losing the simplicity of his original model. The date of the Tale itself is about the middle of the sixteenth century, when most of the personages actually flourished. The time occupied by the action is Three Nights and Three Days.[15]

The expansive form of the metrical romance thus becomes a device for deferral, allowing for descriptive digressions that are in the end far more important than completing the narrative arc of the poem in the allotted time of three days and three nights. A similar interpenetration of linear and digressive chronologies shapes *The Lady of the Lake* which is briefly located in time and space with the following prefatory cues: 'The Scene of the following Poem is laid chiefly in the vicinity of Loch Katrine, in the Western Highlands of Perthshire. The time of Action includes Six Days, and the transactions of each Day occupy a Canto.' Both poems also exemplify the risks of balancing patriotism and commerce. As Michael Gamer has argued, Scott's sentimental Highland types provided his readers with the techniques for embalming the cultural differences that he had hoped they would protect from 'daily melting and dissolving into those of her sister and ally'.[16] Haunted by the spectre of invasion generated by the prolonged war with France, Scott's ultimate concern was to promote an ideology of British unity. But the price of Scott's appeal to the tastes

[15] Sir Walter Scott, *The Lay of the Last Minstrel*, illustrated by twelve photographs by Russell Sedgfield (London: Provost, 1872), p. i.

[16] Michael C. Gamer, 'Marketing a Masculine Romance: Scott, Antiquarianism and the Gothic', *Studies in Romanticism* (Winter 1993), 523–49 (530); Sir Walter Scott, Bart. *Minstrelsy of the Scottish Border*, ed. T. F. Henderson, 4 vols. (Edinburgh: William Blackwood & Sons, 1902), i. 175.

and fears of English readers, as many contemporary critics have noted, was the disappearance behind the far more seductive and marketable types of gothic romance of precisely those cultural manners and customs he desired to preserve. Although, as James Buzard argues, 'to consider Scott's translation as "anglicization" is not to suggest that it seeks the wholesale domestication of the alien, the production of a uniform "English" culture for Britain.'[17] For at the same time as Scott welcomed the entanglement of Scottish and English cultures, his resistance to 'the lowering and grinding down' of 'all those peculiarities which distinguished us as Scotsmen' became all the more urgent.[18]

Exacerbating the destabilizing effects of these ideological and generic tensions was a critical climate that was deeply hostile to the irregularities and excesses of Gothic Romance. In exemplary style, after reading *The Lady of the Lake*, Coleridge expressed his contempt in a letter to Wordsworth:

The first business must be, a vast string of patronymics, and names of Mountains, Rivers, &c... Secondly, all the nomenclature of Gothic Architecture, of Heraldry, of Arms, of Hunting, & Falconry ... Stout Substantives, if only they are strung together, and some attention is paid to the sound of the words—for no one attempts to understand the meaning, which would indeed snap the charm ... For the rest, whatever suits Mrs Radcliffe, i.e., in the Fable, and the Dramatis Personae, will do for the Poem, with this advantage, that however thread-bare in the Romance Shelves of the circulating Library it is to be taken as quite new as soon as told in rhyme—it need not be half as interesting—& the Ghost may be a Ghost, or may be explained— or both may take place in the same poem.[19]

Recoiling from what he saw as a decline of literary taste into the feminized economy of sentimental kitsch and circulating libraries, Coleridge criticized Scott's popular verse narratives on the same grounds that Wilson would embrace them. For the latter the mass reading scene Coleridge invokes as an aesthetic nightmare was a fantasy of untapped commercial potential—a pre-established domestic economy that he intended to expand to suit the Victorian market for tourist literature. His illustrations and lantern shows were never intended for elite audiences. They were, instead, part of a broader

[17] Buzard, 'Translation and Tourism', 36–7.

[18] Cited in Alexander M. Ross, *The Imprint of the Picturesque on Nineteenth Century Fiction* (Waterloo: Wilfred Laurier University Press, 1986), 59.

[19] Samuel Taylor Coleridge, *Collected Letters*, ed. Earl Leslie Griggs, 6 vols. (Oxford: Oxford University Press, 1956–71), iii. 294–5.

transformation of landscape into popular culture, which poems such as *The Lady of the Lake* had set in motion, and the expansion of railway networks had realized on an unprecedented scale. If the railroad had the power to create a new national geography that mirrored the contracted space of the Victorian middle-class home, as many feared it would, Wilson intended to provide the slide show that entertained those who now gathered around this radically expanded English domestic hearth.[20]

The Lady of the Lake takes place in a temporal fold into which James V rides in quest of a legendary stag only to find himself entangled in a romance plot in which he briefly falls in love with Ellen Douglas, the love interest of the leader of the rebel Clan Alpine, Rhoderick Dhu. This doomed love triangle inevitably leads to battle and a resolution that not only frees James to return to the Lowlands, but also liberates Ellen and the Highlands from the ravages of rebellion. The none too subtle political subtext of this plot of course being the ease with which cultural differences can be resolved when the common goal is the preservation of domestic peace and future prosperity. But there is a further temporal dimension to the plot that this brief outline occludes, which is the affective power of the poem's often elaborately picturesque moments. It is this aspect of the poem that appealed to Wilson when it came to providing images for the 1866 edition of the poem that he co-illustrated with the well-known illustrators Birket Foster and John Gilbert.[21] The list of Wilson's

[20] An article published in the *Quarterly Review* in 1839 envisaged 'the gradual annihilation, approaching almost to the final extinction, of that space and of those distances which have hitherto been supposed unalterably to separate the various nations of the globe. For instance, supposing that railroads, even at our present simmering rate of travelling, were to be suddenly established all over England, the whole population of the country would, speaking metaphorically, at once advance *en masse*, and place their chairs nearer to the fireside of their metropolis by two-thirds of the time which now separates them from it; they would also sit nearer to one another by two-thirds of the time which now respectively alienate them. If the rate were to be sufficiently accelerated, this process would be repeated; our harbours, our dock-yards, our towns, the whole of our rural population, would again not only draw nearer to each other by two-thirds, but all would proportionally approach the national hearth. As distances were thus annihilated, the surface of our country would, as it were, shrivel in size until it became not much bigger than one immense city.' *Quarterly Review*, 63 (1839), 22. Cited in Schivelbusch, *The Railway Journey*, 41–2.

[21] Catherine Gordon provides the illustrative context for this volume in 'The Illustration of Sir Walter Scott: Nineteenth-Century Enthusiasm and Adaptation', *Journal of the Warburg and Courtauld Institutes*, 34 (1971), 297–317.

photographs for this edition reads like a standard Victorian tourist itinerary—1. A scene in the Trossachs; 2. Loch Katrine; 3. Benvenue from Loch Katrine; 4. The Silver Strand, Loch Katrine; 5. The Boat House at Loch Katrine; 4. Fall at Inversnaid; 5. Loch Achray; 6. Pass of Ballach-nam-do; 7. Stirling Castle from Cemetery. This affinity is strengthened after a quick perusal of the list of the publishers of the volume, Adam and Charles Black, which included numerous mass-produced tourist guides to Scotland.[22] In addition, the delegation of topographical illustration to Wilson and narrative realization to Birket and Foster reinforces the alignment of photography with the commercial side of the volume and engraving with the more aesthetic realization of Scott's poetic vision. Wilson's photographs were, in effect, intended to draw the consumer into the visual field Scott's picturesque interludes evoked, whilst Birket and Foster's images had a more propulsive function animating the narrative with dramatic realizations of climactic moments in the plot.

Illustrating James's first sight of Ellen Douglas rowing across Lake Katrine from Ellen's Isle, for example, Wilson's photograph of 'The Silver Strand, Loch Katrine' took as its subtitle the couplet 'The beach of pebbles bright as snow | The boat had touch'd this silver strand' from these lines:

> From underneath an aged oak,
> That slanted from the islet rock,
> A damsel guider of its way,
> A little skiff shot to the bay,
> That round the promontory steep
> Led its deep line in graceful sweep,
> Eddying, in almost viewless wave,
> The weeping willow-twig to lave,
> And kiss, with whispering sound and slow,
> The beach of pebbles bright as snow.
> The boat had touch'd this silver strand,
> And stood conceal'd amide the brake,
> To view this Lady of the Lake.[23]

[22] Adam and Charles Black, *Black's Picturesque Tourist of Scotland* (Edinburgh, 1844); *Black's Picturesque Guide to Scotland* (Edinburgh, 1852, 1868, 1876, 1892); *Black's Picturesque Guide to the Trossachs* (Edinburgh, 1866).
[23] Scott, *The Lady of the Lake*, 106–7.

This scene enacts what Alan Liu describes as the immobilizing effects of picturesque description: 'The picturesque bars desire from its beautiful object even as it carefully maintains the object in sight.'[24] Each line not so subtly amplifies the erotic impact on James of this first sight of Ellen through an emphasis on intricacies of form and sound that veil what they purport to illuminate—a technique that Uvedale Price explicitly outlined in his *Essays on the Picturesque*:

According to the idea I have formed of it, intricacy in landscape might be defined [as], *that disposition of objects, which, by a partial and uncertain concealment, excites and nourishes curiosity*. . . . Many persons, who take little concern in the intricacy of oaks, beeches, and thorns, may feel the effects of partial concealment in more interesting objects, and may have experienced how differently the passions are moved by an open licentious display of beauties, and by the unguarded disorder which sometimes escapes the care of modesty, and which coquetry so successfully imitates.[25]

Here the pleasures of arrested desire facilitate a process of symbolic possession that we see enacted in Scott's self-conscious invention of a national myth of Scottish beauty; a metamorphosis reinforced and memorialized by the renaming of Ellen as 'The Lady of the Lake'. As she steps out of the boat onto the silver strand Ellen enters the realm of the iconic. She symbolizes the inalienable beauty of Loch Katrine and of Scotland more generally. Yet the irony of this moment is that Scott's translation of this embodiment of the essence of Scottish beauty into a rhetorical effect simultaneously mirrors and catalyses the alienating effects of commodification that ensured the endless circulation of the myth of Lady of the Lake in and far beyond the Victorian cultural marketplace.

What then are we to make of Wilson's photograph of 'The Silver Strand, Loch Katrine'? Ellen is nowhere to be seen. Despite Ellen's absence, the photographer—and, by implication, the tourist—have been drawn here by that iconic moment when she first stepped out onto the silver strand; an association Wilson strengthens by the arrangement of the visual field. Expanding a moment of poetic description through the recessive dynamic of photographic perspective, the observer's eye scans the strand in search of Ellen's discarded

[24] Liu, *Wordsworth. The Sense of History*, 63.

[25] Uvedale Price, *Essays on the Picturesque, As Compared with the Sublime and the Beautiful; and, on the Use of Studying Pictures, for the Purpose of Improving Real Landscape*, 3 vols. (London, 1810), i. 22.

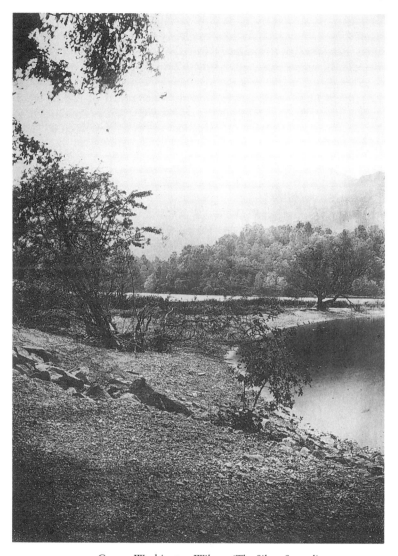

12. George Washington Wilson, 'The Silver Strand'

skiff from the foreground pebbles around the curve of the beach lapped by waves turned silver by the combination of light, movement, and the focal limitations of the camera and the collodion process. In its stereoscopic form this recessive effect would have been amplified by the isolation of the viewing apparatus, but here the cropping and mounting of the image in the midst of Scott's poem has a similar effect, cutting out the surrounding scenery and drawing the observer into the landscape through the descriptive apparatus of Wilson's picturesque technique. All these visual effects combine to create the sense of re-enactment that the observer physically registers through the process of scanning the image for signs of Ellen's presence before moving on towards the vanishing point where the Loch disappears into a mist of trees and light. Here memory and perception merge in the sense of Bergson's *durée*—the literary past 'gnawing into the future' of the observer's encounter with Scotland's invented traditions. The perceptual traversal of the intricate details of Wilson's landscape induces the illusion of a temporal dilation that also recalls Rossetti's withdrawal into himself on the train from London to Folkestone. Wilson's photographs likewise shut out the surrounding objects, producing an effect not too dissimilar to the one Oliver Wendell Holmes enthusiastically attributed to the stereoscope: 'At least the shutting out of surrounding objects, and the concentration of the whole attention which is a consequence of this, produce a dream-like exultation in which we seem to leave the body behind us and sail away into one strange scene after another, like disembodied spirits.'[26]

Wilson's compositional technique, like the disembodying effects of the stereoscope, alienates in the interests of holding the attention of the observer. Taking his cues from Scott's picturesque isolation of intricate details, Wilson created a visual experience that he hoped would manage and intensify the way the observer inhabited the extended moment created from the convergence of photographic and poetic time. This mixture of modalities—of sight and sound— emphasizes the original sense of perception as a 'catching' or 'taking captive', which as Jonathan Crary has observed was self-consciously

[26] Oliver Wendell Holmes, 'Sun-Painting and Sun-Sculpture', *Atlantic Monthly*, VIII (July 1861), 14–15; see also Holmes's essays 'The Stereoscope and the Stereograph', *Atlantic Monthly*, III (June 1859), 738–48, and 'Doings of the Sunbeam', *Atlantic Monthly*, XII (July 1863), 1–15.

restored in the nineteenth century.[27] Although, as the work of John Barrell and others amply demonstrates, this restoration occurs far earlier than the late nineteenth century as Crary argues.[28] Crary's observation that 'attention becomes a specifically modern problem only because of the *historical* obliteration of the possibility of thinking the idea of presence in perception', however, does resonate with the interplay between absence and presence that Wilson's marriage of photography and poetry exemplifies.[29] The underlying destabilization of the foundations of perception that this implies is particularly appropriate to Wilson's manipulation of photographic affect. Always conscious of the felt absence that photography induced, Wilson minimized the resulting sense of alienation by carefully sequencing images to manufacture the illusion of presence. Just as Crary argues therefore, the technological reconfiguration of the grounds of perceptual experience inspires a new constellation of compensatory hermeneutic and mnemonic practices, of which Wilson's work is a particularly illuminating manifestation. To quote Crary: 'attention is the means by which an individual observer can transcend those subjective limitations and make perception *its own*, and attention is at the same time a means by which a perceiver becomes open to control and annexation by external agencies'.[30]

The external organization of the conditions of perception and their internalization as subjective compositional process also has more general cultural implications in the case of Wilson's illustration of Scott's poetry. By self-consciously editing out the broader context of his images Wilson perpetuated a strategically selective cultural memory that reproduced political and economic inequities—not the least of which was the visual reinforcement of the divergence of urban and rural life that was a particularly invidious aspect of the industrialization of Scotland. Wilson's illustration of Scott never allowed his readers to forget that they were reading a survival from another era, even if he was only too willing to let them forget the exigencies that now characterized the lives of many of those who inhabited, or had been forcibly removed, from the Highlands that Scott's historical

[27] Crary, *Suspensions of Perception*, 3.
[28] Simon Pugh's seminal collection of essays on landscape and power, which includes Barrell's work, exemplifies this well-established critical position, see Simon Pugh (ed.), *Reading Landscape: Country—City—Capital* (Manchester: Manchester University Press, 1990). [29] Crary, *Suspensions of Perception*, 3.
[30] Ibid. 4.

reinventions had transformed into the stuff of legend.[31] Wilson, who was Scottish by birth and based his successful business in Edinburgh, also shared Scott's conservative politics and nostalgic belief in the resolving and pacifying force of tradition in contemporary Scottish culture. An unabashed Anglophile, he promoted himself as the 'Photographer to the Queen in Scotland' after his photographs of Victoria at Balmoral found favour with the monarch herself.[32] This was an especially profitable connection given that Victoria's promotion of her Scottish ancestry and love of Scotland played such a pivotal role in the dramatic expansion of the tourist trade from which Wilson would increasingly earn his living.

Fortunately for Wilson, Victoria and Albert's heavily promoted tour of Scotland in 1842 and subsequent publication of Victoria's *Leaves from the Journal of Our Life in the Highlands from 1848 to 1861* explicitly assimilated Scotland and Scottish history into the domestic apparatus of the royal household. Victoria's description of their progress resembled a ritualized taking of possession of territory willingly surrendered to her by charming medievalized subjects who joyfully embraced the feudal hierarchy that sanctioned her rule:

The firing of the guns, the cheering of the great crowd, the picturesqueness of the dresses, the beauty of the surrounding country, with its rich background of wooded hills, altogether formed one of the finest scenes imaginable. It seemed as if a great chieftain in olden feudal times was receiving his sovereign. It was princely and romantic . . . After dinner the gardens were most splendidly illuminated—a whole chain of lamps along the railings, and on the ground was written in lamps, 'Welcome Victoria—Albert'.[33]

Transformed into a medieval pleasure-garden, Scotland exists in a feudalized present in this passage, a self-conscious domestication,

[31] Michael Hechter provides a detailed account of the consequences of industrialization for the cultural integrity of the Celtic fringe in *Internal Colonialism*, esp. ch. 5. However, the classic account of Scott's role in inventing the Highland tradition of Scotland is Hugh Trevor Roper's essay on 'The Invention of Tradition: The Highland Tradition of Scotland', in *The Invention of Tradition*, 15–43.

[32] After Washington Wilson submitted his photographs to Victoria in 1857, from which she selected both large 10 × 8 inch images and stereoscopic views, he added the title of 'Photographer to the Queen' and the royal coat of arms to his business card. Victoria subsequently wrote to Wilson after her first expedition to Glen Feshie and Grantown in September 1860 requesting further images of the Highlands. Roger Taylor describes this exchange in *George Washington Wilson: Artist and Photographer 1832–93* (Aberdeen: Aberdeen University Press, 1981), 36–40.

[33] Queen Victoria, *Leaves from the Journal of Our Life in the Highlands from 1848 to 1861*, ed. Arthur Helps (New York: Harper & Bros., 1868), 38–9.

which, as Adrienne Munich has observed, 'can be viewed as another colonising masquerade, where territory retrospectively' affirms ancestry; a self-conscious cultural nostalgia, furthermore, that was explicitly identified with Scott.[34] In a poem commissioned to commemorate the royal visit, James D. Howie reinforced this point describing Victoria's progress as a transfer of power from one deity to another:

> In days of old, to Caledonia's shores
> Queens young and beautiful, but never one
> Excelling thee in aught, Victoria dear!
> For thou art good as young, beauteous as meek,
> Modest as royal, merciful as just,
> Cheerful as dignified,—uniting all
> The qualities for which we most praise queens,
> . . .
> A sculptured column to her minstrel hoar,
> Whose Caledonian lyre entranced a world,
> She paused, and dropped a consecrated tear
> To genius, grandeur, and Sir Walter Scott![35]

Easing this symbolic transference of power, Scott's works provided the iconography that cloaked Victoria's domestic appropriation of Scotland with authority. Scott's popularization of Highland attire provided the manly accoutrements that legitimated her husband's masculinity in the eyes of her subjects who still distrusted him as a decadent European intruder, while poems, such as *The Lady of Lake*, provided models of manly pursuit symbolized by the opening hunt for the 'Monarch of the Glen' that led James to his ultimate quarry—the restoration of domestic peace to Scotland—a quarry which Victoria was determined would be synonymous with her and Albert's rule.

In 1857 Wilson had submitted a selection of Scottish vistas to Victoria, which led to further requests, a continuing correspondence which in some cases suggested locations for future views and resulted in the popular family portraits taken at Balmoral that contributed substantially to his rising photographic reputation. It was, however, through the extensive sale of his cabinet views and stereoscopic

[34] Munich, *Queen Victoria's Secrets*, 39.
[35] James D. Howie, MD, *The Queen in Scotland, A Descriptive Poem* (Edinburgh: Q. Dalrymple, 1842), 4–5, 14. Cited in Munich, *Queen Victoria's Secrets*, 38.

cards that Wilson made his name as an innovative leader in the photographic trade. As one reviewer in the *Photographic News* observed: 'It is quite certain that one barrier to the extensive circulation of photographs as works of art has arisen from a certain difficulty as to the proper mode of keeping them.' Acknowledging the irrefutable place photography had assumed in the majority of middle-class homes, this critic then praised Wilson for pioneering a new market-friendly form of photographic display and exchange: 'Photographs of a size, then, capable of preservation in albums are likely to become favourites with the public, and hence we conceive that Mr Wilson in issuing this series will originate a style.'[36] The emphasis on the expansion of the Victorian domestic interior is telling here and accords with Wilson's conception of his enterprise as providing views of Scotland taken from places unknown or beyond the reach of the average tourist's capacity or desire to move beyond the comfort zone of their carriage or parlour:

The difficulty in finding suitable foreground is also increased by the circumstance that I have to study popular taste as well as my own, and must try not only to get a pleasing picture of a place, but one also that can be recognised by the public; and the public is not much given to scrambling to out-of-the-way places where a superb view may be had of a celebrated spot, if it can see it tolerably well from the Queen's highway.[37]

Likewise, the photographic expansion of the urban middle-class domestic interior that Wilson and his reviewer describes resonates with the disruption of the traditional mimetic relationship between landscape and travel that Rossetti's poem enacts. Implicit in Wilson's description of going on ahead to get views is the contraction of space between one vantage point and another. Wilson's photographs obviated the need for such travails and with it a subjective sense of space traversed. Different cultural and national geographies effectively concertina into a series of cabinet views available for display in an English middle-class family photograph album. Each view registers a different and unique perspective that opens out from within the confines of the capacious form of an album or illustrated book. Distinguished from other forms of domestic decoration, such as the

[36] Review of Photographic Publications, *The Photographic News* (8 August 1862), 375.

[37] George Washington Wilson, 'A Voice from the Hills: Mr Wilson at Home', *British Journal of Photography* (16 September 1864), 375.

framed portrait, this new form of filing, cataloguing, and sequencing contained the seeds of new forms of storytelling and memory that seemed to hand over authorial agency to the reader/observer. And as Wilson's comments reveal, that was precisely his intent—to guide the observer's eye insensibly around the visual field until it rested on the point of interest—which in the case of the photograph (Fig. 12) of 'The Silver Strand, Loch Katrine' was Ellen's absent bark.

Photographic technique in this context becomes a visual sleight of hand that loosens the moorings of traditional notions of authorship. Not only does Wilson's image personalize the consumer's visual appropriation of the topography of Loch Katrine, it also reconfigures Scott's scene as an eminently marketable mediating device that verifies and legitimates the individual observer's personal memories and literary associations. Accompanying the contraction of space that modern machine ensembles such as railways and photography made possible, therefore, is an accompanying stress on interiority that we find in Rossetti's poem. The necessity of diffusing the shocks and traumas of modern living through the strategic expansion of reflective time that can only be appreciated in a state of arrest, seated in an armchair where one can take the time to linger over a view and recite the appropriate accompanying verse. And this reading experience is what Wilson's books and lantern shows were designed to facilitate by mirroring the spatial expansion railway travel had made possible in a miniaturized and eminently portable form that, while seeming to put the observer in the driver's seat, deftly took hold of the controls.

DREAMLIKE TRAVELLING

> Dreamlike travelling on the railroad. The
> towns which I pass between Philadelphia and
> New York make no distinct impression. They are like
> pictures on a wall.
>
> Emerson, *Journals*, 7 February 1843[38]

Here Emerson describes a loss of perceptual distinction as he watches Philadelphia and New York speed by in a blur. The landscape on the other side of the glass flits by at a velocity that can be ordered only

[38] Cited in Schivelbusch, *The Railway Journey*, 57.

retrospectively into a visual sequence 'like pictures on a wall'. This nostalgic sequencing captures the function Wilson intended his books and lantern shows to serve. By encouraging consumers to return to landscapes that might have eluded their fatigued attention the first time around, Wilson's images restored details to the space between observer and landscape that the modern pace of travel erased. The 'unique' experience he offered his consumers was, in many ways, like a therapeutic form of animated stasis which restored singularity and sequence to the impressionistic transience Emerson describes. Also, in addition to effectively mirroring Scott's forging of narrative continuities from historical and ethnographic *bricolage* Wilson's books and lantern shows reflected a sophisticated grasp of contemporary photographic practices. The lantern shows, in particular, were innovative in their narrative sequencing of photographic slides, a practice that took hold only in the 1870s and 1880s after the novelty of simply seeing projected photographic images had diminished.

Registering the initial shock these projected photographic images induced, one publicist wrote in the late 1860s: 'Stereoscopic Pictures are placed before us which are the exquisite shadows of the photograph, freighted with all the minute details of the subject as it really exists, not a flat monochromatic shadow, but a rounded, glowing picture, thrown into splendid relief with all its marvelous accuracy magnified, all its tints preserved, and the whole character, subtle and sublime of the existing thing itself'.[39] Here a single image is enough to inspire wonder in the observer, a response that initially encouraged a discontinuous exhibition format designed to intensify the reality effect of the photographic image—its power to shock, in other words. As Charles Musser notes: 'The shift from painted image to photography was one aspect of the complex transformation of screen practice occurring shortly after mid-century. Before the stereopticon, the screen had been strongly associated with the phantasmagoria's mystery and magic.'[40] As Musser suggests, projected photographs introduced a lifelike quality to the screen image that generated increasingly spectacular visual effects, both in the context of popular scientific demonstrations and in more narrative-driven genres such as

[39] *A Guide to Cromwell's Stereopticon*, introduction by A. C. Wheeler (New York, c.1869), 8; cited in Charles Musser, *The Emergence of Cinema: The American Screen to 1907*, 10 vols. (New York: Scribners, 1990), i. 31–2. [40] Ibid. 32.

the travel lecture. But by the mid-1870s the novelty had worn off and the need for new selective patterns and formal juxtapositions had translated into a proto-cinematic emphasis on the visual continuity that characterized lantern shows such as Wilson's. As one commentator observed:

The continuous plan is liked best. By that we mean the arranging of your exhibition into one or more parts, and so connecting the pictures that they are made to illustrate some one subject continuously. The old-fashioned spasmodic, hitchy way, of showing first a view of Paris, say, then a comic slide, and then a scripture scene, and then another Paris view, and so on, is without interest. You should interest your audience at once, and then keep up their interest. You would grow very tired if you were travelling, and had to jump out and change cars every mile or two. You want to keep on—the scene to change, yet all the time working towards the completion of some interesting story or journey.[41]

This need to manage the potential exhaustion induced by seeing too much too quickly resonates with both contemporary accounts of train travel and Georg Simmel's account of the development of urban perception. 'Lasting impressions', Simmel argued, 'which take a regular and habitual course and show regular and habitual contrasts— all these use up, so to speak, less consciousness than does the rapid crowding of changing images, the sharp discontinuity in the grasp of a single glance and the unexpectedness of onrushing impressions'.[42] Wilson's lantern shows, in particular, suggest an interest in managing the shocks of modern visual experience Simmel describes. Like the above critic, Wilson concentrated on manipulating the perceptual apparatus of the photographic sequence to create an uninterrupted journey between lasting impressions; a journey that used Scott's poetry to suppress the necessary dislocations, distractions, and disruptions of the travel experience and of photography itself.

Wilson proved especially adept at the techniques that would become standard features of the travel lecture format and emerging documentary tradition—the location of the traveller/observer within the space created by the narrative, the intermixing of panoramic overviews and close-ups, as well as exterior and interior views, and

[41] *Magic Lantern Journal* (February 1875), 7; cited in Musser, *The Emergence of Cinema*, i. 38–9.
[42] Georg Simmel, *The Sociology of Georg Simmel*, ed. Kurt M. Wolff (New York: Macmillan, 1964), 410.

rhetorical enactments of foot, carriage, and railway travel. This was partly due to skills he developed illustrating poems such as *The Lady of the Lake* and *The Lay of the Last Minstrel*, an experience that eased the transition from book to lantern-show format. In fact, in some instances Wilson simply transported illustrative sequences that he had used before into his lantern shows. This was the case, for example, with the illustrations he provided for Scott's evocative description of Melrose Abbey in the second canto of *The Lay of the Last Minstrel*. These were reproduced in a variety of publishing contexts, including Wilson's lantern show *Sir Walter Scott and His Country*. [43]

Wilson was not alone, of course, in his interest in photographing Melrose. The Abbey had long been a site of pilgrimage for early photographers, beginning with photography's inventor William Henry Fox Talbot, who photographed the Abbey in the early 1840s, and including some of Victorian photography's most prominent figures, such as Frederick Scott Archer, the inventor of the wet collodion process, Roger Fenton, the famous Crimean photographer, Philip Delamotte, and Joseph Cundall, the latter best known for his confronting photographs of maimed Crimean veterans. But what distinguishes the reproduction and dissemination of Wilson's photographs is the increasingly elaborate use of framing devices, which can be traced, as the remainder of this chapter will do, from the Howitts's *Ruined Abbeys and Castles* to a photographically illustrated version of the poem in a collected edition of Scott's verse illustrated by Wilson, published in the 1870s, to its incarnation as a projected vignette in *Sir Walter Scott and His Country*. In each instance the textual apparatus works in conjunction with the photograph to transform individual moments into lasting impressions, effectively fusing nostalgia for an idealized medieval Scotland with self-consciously modern, yet equally nostalgic, models of attentive reading.

In the Howitts's volume Wilson's photographs follow a similar pattern to Sedgfield's Tintern illustrations discussed in the previous chapter. The first provides an overview shot of Melrose, although not in the same panoramic style as Sedgfield's view from Chapel Hill, and the second focuses on the architectural detail of the abbey's nave. This visual focus is then reinforced by the Howitts's framing

[43] George Washington Wilson, *Sir Walter Scott and His Country: A Reading, Descriptive of a Series of Lantern Slides* (Aberdeen: G. W. W. Registered, 1889; printed by John Avery).

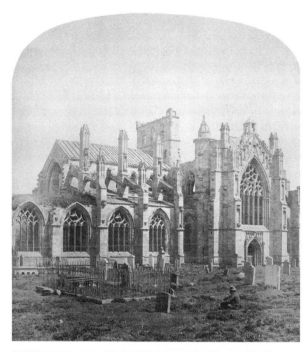

13. George
Washington Wilson,
Melrose from the
south west

14. George
Washington Wilson,
Melrose Abbey nave

description, which in summoning the ghosts of Scotland's medieval craftsmen inevitably inspires associations with the middle-class progressivism of Ruskin's theorization of the social dimension of art. There are particular affinities with *The Stones of Venice* (1851–2), which had, theoretically, offered Victorians 'of all classes' a powerful defence of 'the survival of great art as a propulsive force for collective renewal', to quote Paul Sawyer.[44] Yet ironically, the Howitts chose to amplify their defence with the aid of an illustrative form which Ruskin, after a first rush of enthusiasm, would come to identify as an intrinsically desecrating mechanistic device. Reading the Howitts's adaptation of Wilson's images through the lens of the democratizing drive of Ruskin's early aesthetics however, highlights an implicit tension in Wilson's work—its often reactionary inclinations and resistance to change, as opposed to its preoccupation with unofficial histories and the unknowable contingencies of individual memory and perceptual experience. As Elizabeth K. Helsinger observes in a statement that could equally apply to Wilson, the intrinsic elitism of Ruskin's aesthetics should never be forgotten in any defence of its democratizing inclinations, but nor should the radical implications of his notion of 'excursive sight' as a socially acquired way of seeing, not a divinely bestowed gift restricted to members of an aesthetic elite.[45] It was this decidedly anti-hierarchical position that prompted Ruskin to address the *Stones of Venice* to the 'least learned' and 'most desultory readers' and to continually stress the agency of their developing aesthetic sensibilities: 'I shall endeavour so to lead the reader forward from the foundation upwards, as that he may find out for himself the best way of doing everything . . . I shall use no influence with him whatever, except to counteract previous prejudices, and leave him, as far as he may be, free.'[46]

The antithesis to this organicist vision of individual liberty was, of course, any impression garnered at speed. Much like Rossetti and Bergson, Ruskin was inclined to shut his eyes in the interests of creating a space apart from the velocity of impressions that characterized modern perceptual experience. But again, the resulting visual experience derived its rhetorical force from the 'machine ensemble' it resisted, as the following piece of helpful advice to his desultory readers

[44] Paul L. Sawyer, *Ruskin's Poetic Argument: The Design of the Major Works* (Ithaca, NY: Cornell University Press, 1985), 103.

[45] Elizabeth K. Helsinger, *Ruskin and the Art of the Beholder* (Cambridge, Mass.: Harvard University Press, 1982), 128, 206.

[46] John Ruskin, *The Stones of Venice*, in *The Works of John Ruskin*, ix. 9, 73.

suggests: 'I say, first, to be content with as little change as possible. If the attention is awake, and the feelings in proper train, a turn of a country road, with a cottage beside it, which we have not seen before, is as much as we need for refreshment; if we hurry past it, and take two cottages at a time, it is already too much: hence to any person who has all his senses about him, a quiet walk along not more than ten or twelve miles of road a day, is the most amusing of all travelling; and all travelling becomes dull in exact proportion to its rapidity.'[47] Ruskin's equation of deceleration with attention is haunted by the stress and displacement that train travel induced. Yet it also inspires unexpected photographic analogies in its emphasis on isolating impressions and reflective sequencing. Rather than being on the side of the shock-induced inertia synonymous with modern travel, the arrest of the photographic image accords with the pauses that genteel perambulations down village streets allowed—a symmetry which Wilson, along with so many of his contemporaries, was quick to capitalize upon.

Ruskin's address to his intended desultory readers would not have been out of place in either *Ruined Abbeys and Castles* or Wilson's various illustrative enterprises, although it is possibly more applicable to the explicit didacticism of Wilson's lantern shows than the elaborate gift edition of Scott's *Poetical Works* published in 1872 by the Edinburgh publishers Adam and Charles Black.[48] Bound in wood with an inscription at the base of the cover informing the reader that it had been grown on the lands of Abbotsford, the latter volume was an elaborate aesthetic artefact designed to be appreciated in the privacy of one's already overstocked library, rather than as a practical guide in the manner of *Ruined Abbeys and Castles*. Mounted in the centre of the cover was a photograph of Scott's monument with a carriage driving away, while people sitting at the base of a nearby lamp look on. Resolutely modern, yet nostalgic in mood, this image dramatizes the intersection between the present experience of the audience and the ancient world of the text that the editors intended to cultivate throughout the volume. Like the monument itself, Wilson's illustrations are intended to reinforce a sense of temporal continuity, whilst also reminding the reader of the irrevocable passage of time. The surrounding images of Melrose, Dryburgh, Jedburgh, and Kelso Abbeys stencilled into the text's wooden binding further amplified

[47] Ruskin, *The Works of John Ruskin*, v. 370.
[48] Sir Walter Scott, Bart., *Poetical Works* (Edinburgh: Adam & Charles Black, 1872). The Black brothers were also prolific publishers of tourist guides to Scotland—see n. 22.

the overtly Gothic aesthetics of the volume. Focusing the reader's attention from the beginning on the architectural intricacies of these ruined forms, this elaborate cover also draws attention to the craft of book production, just as the Howitts's binding had done. But in this case, there was an even greater stress placed on the nexus between literary and photographic connoisseurship, again inspiring analogies with the ambiguities of Ruskin's conception of the nature of Gothic. For while Wilson and the Blacks were clearly interested in promoting a creative and accessible fusion of traditional and modern techniques of cultural production, the resulting artefact was well beyond the economic reach of many of the modern observers who may have found themselves lingering at the base of Scott's monument in the manner of Wilson's photographic centrepiece. The focus on the virtuosities of individual craftmanship that the volume's elaborate binding encouraged thus exemplifies the ambiguities of a Ruskinian counterbalancing of an elitist aesthetics with a democratizing stress on detail and particularity; a tension sustained by the subsequent illustrations which isolated moments of intricate topographical or architectural description from the narrative flow of Scott's poems.

These contradictions are especially apparent in Wilson's illustration of the opening lines of Scott's description of Melrose:

> If thou would'st view fair Melrose aright,
> Go visit it by pale moonlight;
> For the gay beams of lightsome day,
> Gild, but to flout, the ruins grey.
> When the broken arches are black in night,
> And each shafted oriel glimmers white;
> When the cold light's uncertain shower
> Streams on the ruin'd central tower;
> When buttress and buttress, alternately,
> Seem framed of ebon and ivory;
> When silver edges the imagery,
> And the scrolls that teach thee to live and die;
> When distant Tweed is heard to rave,
> And the owlet to hoot o'er the dead man's grave,
> Then go—but go alone the while—
> Then view St David's ruin'd pile;
> And, home returning, soothly swear,
> Was never scene so sad and fair![49]

⁴⁹ Scott, *Poetical Works*, 44–5.

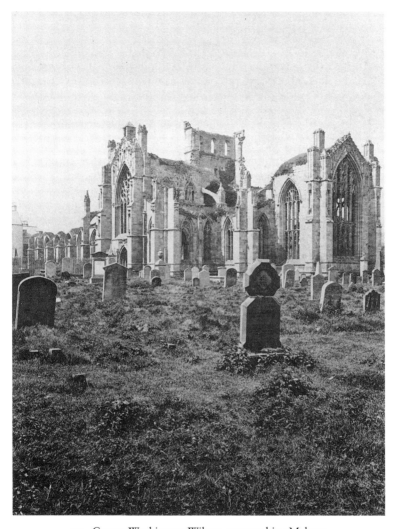

15. George Washington Wilson, approaching Melrose

Here the visual impact of Scott's exemplary Gothic description is intensified by the composition of Wilson's image conveying a sense of the observer approaching the abbey through the surrounding grave-yard. The Abbey is shot from below to emphasize its imposing scale, while the illusion of depth this creates reinforces the sense of the visitor's immobilization in a state of worshipful arrest. Like the grave-stones that memorialize those who have lived and died in the Abbey's environs, Wilson's photograph surrounds Melrose with a melan-cholic ambience. But Wilson's photographic doubling of Scott's description is not confined to registering the loss of an invented tradition. It also exemplifies the productive adaptation of a familiar text to a new self-consciously modern idealism that was attempting to literally enact the vitality of the Gothic imagination as Ruskin under-stood it: 'that restlessness of the dreaming mind, that wanders hither and thither among the niches, and flickers feverishly around the pinnacles, and frets and fades in labyrinthine knots and shadows along wall and roof, and yet is not satisfied, nor shall be satisfied'.[50]

The cultural and aesthetic ambiguities that arise from this con-vergence of the liberal optimism of high Victorian Gothic with the technological refinement of photographic illustrative techniques becomes even more explicit in the reproduction of the same illustrat-ive sequence in the context of Wilson's photographic lantern show *Sir Walter Scott and His Country*. On one level there was nothing exceptional about *Sir Walter Scott and His Country*. It was just one of many lantern shows produced by Wilson that drew on the work and lives of literary figures such as Shakespeare and Burns.[51] Indeed, by the 1890s Wilson and Co.'s empire extended far beyond Scotland and England, to America, Australia, New Zealand, and Canada, and their

[50] Ruskin, *The Stones of Venice*, x. 214.
[51] George Washington Wilson & Co. was an extensive family business that pro-duced a range of photographic products—including separate images as well as slide sets. Wilson's catalogues advertised individual lantern slides at 1s. each, coloured slides at 2s. each, lantern readings at 6s., and grooved boxes to store the slides in both card-board and wood; the latter of which were capable of storing up to 100 slides. For those who had the means to pay cash, the entire set of fifty-two slides, including a descriptive lecture, could be purchased for £2. 12s. While these prices were high, the shows them-selves were clearly designed to take place in communal spaces such as church halls and living rooms. Examples of slide sets include: *Modern Babylon: A Trip to London*—complete set 52 slides; reading 6d.; *The Shakespeare Country*—complete set 42 slides, reading 6d.; *Robert Burns—a series of portraits of the poet and his contemporaries, views of the land of his birth and life, and illustrations of his poems and songs—the most complete set of the sort yet issued!*—complete set 134 slides, reading 6d.

lantern shows were becoming increasingly formulaic to match the demand. In the descriptive lists of slides and lectures that Wilson's company produced the sheer scale of this operation becomes particularly apparent. Puffed up with testimonials, endorsements, and lists of prizes and awards given 'at Exhibitions in every part of the world', these lists could be purchased on receipt of a 6*d.* stamp from interested consumers.[52] In addition, there was also a demystifying aspect to Wilson's catalogues that encouraged consumers to play an active part in the process of assembling their own shows; an attitude that reflects how familiar Victorians had become with the format of the literary magic lantern show by the 1880s when Wilson expanded into this area.[53]

This counterbalancing of demystification and wonder that characterized the cultural construction of the magic lantern experience in the latter decades of the nineteenth century is much in evidence in Wilson's *Sir Walter Scott and His Country*. But so too is the desire to bring static images to life through the animating force of literary and historical description. Although, the text of the lecture combined lengthy quotations from Scott with the formulaic didacticism of the tour guide, Wilson's combination of moments of high literary drama with projected slides clearly flirted with the possibility of transforming textual into moving images. This is particularly true of the illustration of Scott's description of Melrose, which unlike its reproduction in book form could replicate the experience of visiting Melrose at night. At this point it is important to imagine the darkened room where the audience would have listened to Scott's text whilst looking at Wilson's image. In this performative context Scott's words were clearly intended to animate the Abbey's decaying façade, focusing the audience's gaze on the interplay between light and shadow as the sun moves across the surface of its crumbling buttresses and traceries, a dramatic illusion that had been set up by the lecture's introductory invitation to the audience to suspend disbelief and project its own experiences into the frame of the show. From the opening paragraphs the audience was addressed as if physically in Scotland, walking along the street, stopping to take in a view, or stepping onto

[52] *Descriptive List of Sets of Lantern Slides made and published by G. W. Wilson & Co, LD*, St Swithin Street, Aberdeen, Scotland (Aberdeen: G. W. W. Registered, 1898).

[53] Steve Humphries provides an accessible history of the magic lantern in Victorian England in *Victorian Britain through the Magic Lantern* (London: Sidgwick & Jackson, 1989).

a coach to embark on the next stage of the journey. The solicitous instructions of Scott's minstrel thus provided a poetic echo of Wilson's guidebook prose, whilst also animating the uncanny stasis of Wilson's image with memories of one of the most dramatic scenes from the poem.

Combining the familiar techniques of literary and photographic collage, which volumes such as *Ruined Abbeys and Castles* had pioneered, with an extensive marketing structure and slide holdings that numbered in the millions, it is easy to see why what would become Wilson & Co. in the 1880s and 1890s was such a financial success. Although the market for tourist literature was already overcrowded with guides, travel memoirs, and public slide lectures, Wilson and Co. made a virtue out of ploughing the well-worn tracks of Victorian sentimentalizations of Celtic culture, hence the recurring presence of the Melrose sequence in a range of formats. Produced in decades defined by cultural destabilization and transformation, Wilson's shows exemplify some of the more regressive aspects of late-Victorian literary nostalgia. They asserted the imaginative hegemony of the English domestic space, the ideal performative context for Wilson's shows, as the site where the continuing cultural relevance and value, not only of Scott's works, but of Scotland as a desirable tourist destination, could be endlessly reconsidered. Yet again, these shows were not simply transparent mediations of a dominant colonial ideology. There were just too many variables set in play by the heterogeneity of the format of the shows themselves, not the least of which was the participatory aspect of the form, which actively encouraged consumers to shape the lantern-show format to suit their own versions of Scott's country. Always destabilizing the effort to orchestrate fluidly the cultural memories of the observer, the format simply failed to achieve aesthetic coherence. The technologies for controlling the wandering attention of the audience were too obtrusive and the multiple aspects of the performative context, which demanded the seamless co-ordination of lantern, slide, lecture, and audience response, were potentially too chaotic. As with *Ruined Abbeys and Castles*, or Bennett and Wall's didactic efforts to shape the aesthetic sensibilities of their audience, therefore, the effort to combine photographic and poetic descriptive techniques resulted in the production, rather than the resolution, of cultural and aesthetic differences. The flawed apparatus of photographic illustration simultaneously exposes its failure to homogenize the collective experience

of Victorian observers at precisely the moment when it appears most visibly coercive and standardizing. What these examples of early photographic illustration ultimately have in common, therefore, is their transitional nature. They are truly hybrid forms, caught between the desire to perpetuate a 'nostalgic myth of contact and presence', to quote Susan Stewart, and a self-consciously modern fascination with the particularities of experience and the contingencies of perception.[54]

[54] Stewart, *On Longing*, 133.

CHAPTER FIVE

Elizabeth Barrett Browning, Photography, and the Afterlife of Poetry

This is why the event of photography is necessarily anterior to any history of photography—photography does not belong to history; it offers history. It delivers history to its destiny. It tells us that the truth of history is to this day nothing but photography. Nevertheless, the photograph—as what is never itself and therefore always passing into history—asks us to think the remains of what cannot come under a present. How can an event that appears only in its disappearance leave something behind that opens history? How can the photographed guard a trace of itself and inaugurate history?

Eduardo Cadava, *Words of Light*[1]

In her preface to an edition of Elizabeth Barrett Browning's *Casa Guidi Windows* published in 1901 by Bodley Head, the poet Agnes Mary Frances Robinson asked her readers to locate a poem typically associated with sentimentalized or sensationalized versions of the Brownings' romance in its historical and political context.[2] It was the public and the political, not the domestic and intimate that interested Robinson. Possibly inadvertently, but no less effectively, the edition's photographic frontispiece of the façade of Casa Guidi reinforces this emphasis, providing a clue but no solution to the mystery behind the decade that passed between Robinson's penning of the preface in 1891 and its eventual publication in 1901. Suggesting a resistance to

[1] Eduardo Cadava, *Words of Light. Theses on the Photography of History* (Princeton: Princeton University Press, 1997), 128.

[2] Agnes Mary Frances Robinson, Preface to Elizabeth Barrett Browning, *Casa Guidi Windows with Introduction by A. Mary F. Robinson* (London: Bodley Head, 1891), p. vii.

the commerce in celebrity portraits and biographical criticism, there is clearly an effort on the part of both Robinson and the publishers to raise the standard, while still availing themselves of new technologies of publication and publicity. But the only evidence we have in this case is the successful combination of authenticating effects that both image and text provide as the editorial apparatus for one of Barrett Browning's most difficult and elusive poems. Focusing the reader's attention on the site where Barrett Browning looked out at the events of 1848, it offers some biographical insight into the private world of the Brownings. But like the preface that follows, it encourages the reader to focus only on those events immediately related to Elizabeth Barrett Browning's work (see Fig. 16). Confronted with a close-up of the building's façade, the observer is still removed from the scene. Standing across the street, having arrived forty years or more too late, all that remains is to register the passage of time. The events of history have taken place and moved on to some other street, city, country, leaving Casa Guidi as a memorial to otherwise forgotten scenes of carnage and the jettisoned ideals of a poet confronted for the first time with the potentially silencing truth that poetry doesn't matter.

In the context of the edition, however, this photograph opens up a new history for Barrett Browning's poem that argues otherwise. In her preface Robinson calls for a more rigorous form of close reading. She insists that it takes 'a practised ear' to hear the resonances that connected Barrett Browning to an Italian poetic tradition that in the manner of Dante pierced through the 'complicated show of things' political to the 'secret pulse' of the Italian people. Once tuned to the right frequency, the reader would begin to comprehend the depth of Barrett Browning's political insight:

Mrs Browning will not speak of her Italians with the affectionate contempt of the Anglo-Saxon, nor regard them only with her Protestant simplicity of glance. She will behold, as no other writer of our age has beheld, the Latin nations, or at least among them the Italian and the French, in all their admirable complexity, and in the very truth of their substance. For Mrs Browning was above all things gifted in the psychology of the races. Except Victor Hugo, no poet of the nineteenth century has echoed so deeply the voice of political passion. What a nation is, what it wants, to what it tends, were secrets that she read with the eye of a seer. She saw the present; but she had the sense and the passion of the future. It is her rarest gift.[3]

[3] Robinson, Preface to Browning, *Casa Guidi Windows*, pp. vii–ix.

16. Frontispiece, Elizabeth Barrett Browning, *Case Guidi Windows*

Here Robinson uses a visually charged rhetoric to invest Barrett Browning's historical vision with seer-like properties. The poem that follows does not inhabit the realm of the glance like the tourists who now find their way to Casa Guidi to uncover the traces of the Browning mythology. Rather, Barrett Browning beheld the truth, fixing the substance of Italian culture in a poetic form that uncovered the secrets of the visible with an insight that turned history into prophecy. For Robinson, the activity of writing the poem is in itself akin to the photographic process—an arresting illumination that generates the potentially infinite revisitations of future readings and pilgrimages. She thus proves herself to be the poem's ideal reader, nostalgically rehearsing and legitimating Barrett Browning's uncanny visual rhetoric in the inherently citational structure of the editorial preface. Borrowing terms from the poem's photosensitive language, Robinson's preface thus evocatively foreshadows the poetic interrogation of the wilful idealism of nostalgic desire that follows. As Eduardo Cadava observes:

Like the small window that lets in the morning light or the aperture of a camera that gives way to images, the preface allows us to experience a kind of light. This light is a condition and matter of presentation. It casts a future tense on the significance of what has already been written. Like the photographic negative that can only be developed later, it traces the imprint of what is to come.[4]

The following chapter will examine the ways in which Barrett Browning's efforts to forge a self-consciously modern visual poetics provided the blueprint for the form of nostalgic close reading Robinson's preface encourages. Inspired by new ways of seeing that the daguerreotype embodied and what some critics at the time condemned as Carlyle's alienating photographic poetics, *Casa Guidi Windows* enacted the difficulties of writing poetry in the increasingly indifferent and complex visual culture that the previous chapters have mapped. The poem's resemblance to a sequence of photographic mementos is uncanny, if implicit, memorializing Barrett Browning's profound alienation from the culture that the events of 1848 had inspired her to reform. Feeling belated, redundant, and removed from the everyday lives of the mass readership she longed to reach, Barrett Browning's work registers the crises and ambiguities of a

[4] Cadava, *Words of Light*, p. xvii.

romantic liberal humanism that refused to take refuge in the defiant obscurity of 'art for art's sake'. That Bodley Head thought of publishing an edition of this particular poem in the 1890s therefore, at a time when Barrett Browning's poetry was a long-distant memory to many, aptly mirrors the idiosyncratic mix of nostalgia and beleaguered optimism that the poem itself enacts.

Casa Guidi Windows is preoccupied with the relation between memory and perception, history and stasis. Mourning the failure of the 1848 Revolutions, the poem's speaker turns her back on both the present and the future. Instead, she chooses to wander through the topography of memory, returning to paths not taken and lingering amongst the ruins of the political ideals she had once believed were realizable. Part One describes the hopes that the upheavals and disturbances of 1848 initially inspired. The belief that all earlier political and social hierarchies would be permanently swept away and that in their place a new civic society would emerge in which people for the first time would confront, to quote Marx, 'the real conditions of their lives and their relations with their fellow beings'.[5] But by Part Two, written three years later in the year of the Crystal Palace Exhibition, Barrett Browning realized that rather than embracing their freedom from the corrupt power structures of the past, Europeans were willingly enslaving themselves to yet another false idol. Seduced by the phantasmagoric world of commodities, society—and particularly English society—appeared to be surrendering voluntarily to a new economy in which money, rather than ethics, determined the fleeting relations between people and the objects they fetishized. Disillusioned, Barrett Browning initially turns away from this grim spectacle and finds solace from within, an about-face that results in the poem's conflicted resolution. Ultimately, the poem offers nostalgia as a route back from the alienating expansive powers of commodification that the Crystal Palace materialized. Yet this nostalgic resolution ironically privileges the commodity culture Barrett Browning condemned as the catalyst for the definitively modern poetry she aspired to write. Like Dante Gabriel Rossetti's train passenger and Wilson's consumers, Barrett Browning draws inspiration from precisely the perceptual and conceptual shocks that her poetry

[5] Karl Marx 'The Communist Manifesto', *The Revolutions of 1848* (Harmondsworth: Penguin, 1973), 70–3.

is ostensibly resisting. Moreover, Barrett Browning chooses to enact this process in a self-consciously impressionistic form that substantiates Wolfgang Schivelbusch's claim that one of the most inspirational materializations of nineteenth-century impressionistic style, 'as a codification of a certain nineteenth-century perception of an evanescence', was the ferrovitreous architecture of the Great Exhibition itself.[6]

In her prefatory advertisement for the first edition of the poem Barrett Browning attributed the inspiration for her impressionistic responses to an earlier disillusioning moment that had radically altered her understanding of spectacles of human progress such as the Great Exhibition and the poetry she wrote from that point on:

This poem contains the impressions of the writer upon events in Tuscany of which she was a witness. 'From a window,' the critic may demur. She bows to the objection in the very title of her work. No continuous narrative or exposition of political philosophy is attempted by her. It is a simple story of personal impressions, whose only value is in the intensity with which they are received, as proving her warm affection for a beautiful and unfortunate country, and the sincerity with which they are related, as indicating her own good faith and freedom from partisanship.[7]

Impressionistic style becomes synonymous with authenticity and a value that transcends commodification in Barrett Browning's assertion of the disinterestedness of her work. Unlike the increasingly commodified 'continuous narrative' of the Victorian novel, she claims that her poem refuses escapism. Her impressions are designed to elicit intense responses from her readers, to confront, enlighten, and hold their attention. Their value lies in their afterlife in the imagination of the reader who recognizes the process and consequently understands reading itself as an act of remembering.

Yet using the form of an advertisement to create a space for poetry that transcends the illusory continuities of commerce ironically reinforces the inherent ambiguities of such a stance. In asserting her aesthetic sovereignty to promote her work and reputation, Barrett

[6] Schivelbusch, *The Railway Journey*, 55.
[7] Elizabeth Barrett Browning, Advertisement to the First Edition, *Casa Guidi Windows*, ed. Julia Markus (New York: The Browning Institute, 1977), p. xli. All further references are to this edition unless specified.

Browning exposed both her complicity and powerlessness in the literary field and the field of power. As Bourdieu writes of similar doubts that haunted Flaubert after 1848: 'What if the power that the writer appropriates for himself through writing were only the imaginary inversion of powerlessness? What if intellectual ambition were only the imaginary inversion of temporal ambitions?'[8] According to Bourdieu, the political positions occupied by intellectuals at this time were in turn condemned to reproduce their dominated relationship to those with intellectual and economic power both within and beyond the literary field. In stressing the tenuous authority of her 'impressions' therefore, Barrett Browning acknowledges this powerlessness in the face of events beyond her control. Not only is she a poet, she is also English and a woman exiled from home by her own private pursuit of desire over duty. And yet, conversely, this self-effacing gesture is also precisely that in this context, a performative strategy that signifies Barrett Browning's willingness to exploit her fame to promote the Italian Republican cause, just as Byron had done for Greece.

After the publication of the 1850 *Poems*, which had inspired Henry Chorley's calls for her to be appointed Poet Laureate in the wake of Wordsworth's death in April of that year, Barrett Browning was at the height of her literary fame.[9] Published only eight months later, *Casa Guidi Windows*, as Dorothy Mermin has observed, marks a significant shift in Barrett Browning's career, 'because the liberation she had accomplished for herself seemed to prefigure that toward which Italy was struggling, she found for the first time in her poetic career that she could, like her male contemporaries, generalize her own experience to that of the age'.[10] The dubious lustre of literary celebrity is, therefore, the security on which Barrett Browning buys her way into the consecrated sphere of literary prophecy. Viewed through this lens, her isolated arresting impressions veer dangerously close to the alienated form of the commodities exchanged under the glass of the Crystal Palace which she savagely ironizes, in the final sections of the poem:

[8] Bourdieu, *The Field of Cultural Production*, 172.
[9] Chorley made this suggestion in the *Athenaeum* (30 November 1850), 1243, 1244.
[10] Dorothy Mermin, *Elizabeth Barrett Browning: The Origins of a New Poetry* (Chicago: University of Chicago Press, 1989), 164.

All trailing in their splendours through the door
Of the gorgeous Crystal Palace. Every nation,
To every other nation strange of yore,
Gives face to face the civic salutation,
And holds up in a proud right hand before
That congress, the best work which she can fashion
By her best means. 'These corals, will you please
To match against your oaks? They grow as fast
Within my wilderness of purple seas.'—
'This diamond stared upon me as I passed
(As a live god's eye from a marble frieze)
Along a dark of diamonds. Is it classed?'—
'I wove these stuffs so subtly that the gold
Swims to the surface of the silk like cream,
And curdles to fair patterns. Ye behold!'—
'These delicatest muslins rather seem
Than be, you think? Nay, touch them and be bold,
Though such veiled Chakhi's face in Hafiz' dream.'—
'These carpets—you walk slow on them like kings,
Inaudible like spirits, while your foot
Dips deep in velvet roses and such things.'[11]

In describing the phantasmagoria of the exhibition space, where the intrinsic value of cultural products is eclipsed by the levelling relentlessness of exchange, Barrett Browning risks reproducing the exhibition's dynamics of display—its claim to reproduce a representative copy of all nations in a form that annihilated both space and time. As one reporter in *The Times* wrote: 'Just now we are an objective people . . . We want to place everything we can lay our hands on under glass, and stare to our fill.'[12] Barrett Browning's accumulation of one luxury after another reproduces this voracious appetite to see all exposed under one glass. Objectifying and exoticizing one culture after another to produce a strong impression intended to inspire aversion not attraction, she rhetorically enacts what she supposedly reviles. This has an abstracting effect that is further reinforced by the digressive role this descriptive passage plays in the concluding stages of the poem, which is mainly consumed with Barrett Browning's reflections on the death of Italy's struggle for liberty. Rather than

[11] Barrett Browning, *Casa Guidi Windows*, Pt. 2. 586–606.
[12] *The Times* (13 October 1851), cited in Andrew Miller, *Novels behind Glass* (Cambridge: Cambridge University Press, 1995), 52.

being part of a sequence that condemns the ravages of English commodity culture, it is compositionally isolated in a single stanza intended to set forth in spectacular form all that was wrong with a culture so distracted by the pleasures of domestic consumption that it could no longer see beyond the borders of its own luxurious interior. Significantly, this emphasis on producing indelible impressions at the expense of historical sequence was a technique that the American critic James Russell Lowell compared to the fractured illuminations offered by a series of photographs in his analysis of the Carlylean historicism upon which Barrett Browning so adeptly drew:

He sees history, as it were, by flashes of lightning. A single scene, whether a landscape or an interior, a single figure or a wild mob of men, whatever may be snatched by the eye in that instant of intense illumination, is minutely photographed upon the memory. Every tree and stone, almost every blade of grass; every article of furniture in a room; the attitude or expression, nay, the very buttons and shoe-ties of a principle figure; the gestures of momentary passion in a wild throng,—everything leaps into vision under that sudden glare with a painful distinctness that leaves the retina quivering. The intervals are absolute darkness. Mr Carlyle makes us acquainted with an isolated spot where we happen to be when the flash comes, as if by actual eyesight, but there is no possibility of a comprehensive view. No other writer compares with him for vividness. He is himself a witness, and makes us witnesses of whatever he describes. This is genius beyond question, but it is not history . . . Mr Carlyle's method is accordingly altogether pictorial . . . wonderful prose poems, full of picture, incident, humour, and character.[13]

Lowell associates photography with Carlyle's poetic genius for capturing a single scene in vivid detail, for isolating a moment from the continuous flow of historical time, and for resequencing those moments of intense and instant illumination into 'wonderful prose poems'. Yet he also clearly relishes Carlyle's poetic gift for capturing the vivid and particular with such a force that it leaves the retina of the reader quivering. The sheer force of Carlyle's genius is precisely the reason that his vision is not historical in Lowell's view, since it impedes his capacity to forge stabilizing and clarifying continuities between past and present events. Accordingly, Carlyle's historicism belongs to the realm of poetry, to the contingencies of random visual effects and to the subjective vagaries of memory. Reinforcing his

[13] James Russell Lowell, *My Study Windows* (London, 1871), 102.

critique, Lowell then equates the fixing of images that he found in Carlyle's essays with the modern preference for parts over wholes, sensation and shock over restraint; an intrinsically desensitizing aesthetics that he argued resulted in an inhumane passionless elitism. Photography serves a double purpose in Lowell's poetics. On the one hand it is aligned with poetry as a technique for transforming life into literature, history into art—a constructive and creative agent, rather than a desecrating device. But on the other, it is synonymous with Carlyle's fragmentation of history into a sequence of aesthetic effects that distances readers/observers from the events of history, rendering them passive witnesses of the spectacle being enacted before their eyes.

It is telling in this context to read Barrett Browning's equally visually charged account of Carlyle's particular genius:

That Mr Carlyle is one of the men of genius thus referred to, and that he has knocked out his window from the blind wall of his century, we may add without any fear of contradiction. We may say too that it is a window to the east,—and that some men complain of a certain bleakness in the wind which enters at it, when they should rather congratulate themselves and him on the aspect of the new sun beheld through it,—the orient hope of which, he has discovered to their eyes. And let us take occasion to observe here, and to bear in memory through every subsequent remark we may be called upon to make,—that it has not been his object to discover to us any specific prospect—not the mountain to the right, nor the oak-wood to the left, nor the river which runs down between,—but the SUN, which renders visible all these.[14]

What Barrett Browning praises in Carlyle's work is precisely what Lowell fears—a method of historical illumination that renders the audience passive in the face of its brilliance. Saturated in the light of genius the landscape pales in comparison to the wonder of being swept up in a vision they could never have had for themselves. Whether the observer looks right or left is a matter of indifference, Carlyle's vision alienates preconceptions and masters the visual field in the heroic style of the men of genius he celebrated. This idealized model of isolating illuminations like Carlyle's photographic focus is what Barrett Browning adapts to suit her own foray into prophecy.

[14] Cited in William Robertson Nicoll and Thomas Wise, *Literary Anecdotes of the Nineteenth Century: Contributions towards the Literary History of the Period*, 2 vols. (London: Hodder & Stoughton, 1895), ii, 110.

Translated into a sequence of Carlylean moments, the history of the 1848 Revolutions in Italy becomes a series of descriptive flashes that seize upon a single upturned face in a crowd, a discarded flower hurled into the air in a moment of ecstatic optimism, a sunlit wave as the Arno rushes by, the curve of a street, a hand struggling free from the mass of bodies in the crowd below, until pleasure turns to pain and the poem's speaker turns away from the window, shuts her eyes, and escapes into the camera obscura of memory to resequence what she has just seen.

CAMERA FLASHES

Anyone can see that the duration for which we are exposed to impressions has no bearing on their fate in memory. Nothing prevents our keeping rooms where we spent twenty-four hours more or less clearly in our memory, and forgetting entirely where we passed months. Thus it is certainly not owing to an all too short exposure time if no image appears on the plate of remembrance. More frequent, perhaps, are the cases when the twilight of habit denies the plate the necessary light for years, until one day, from alien sources, it flashes as if from burning magnesium powder, and now a snapshot transfixes the room's image onto the plate. But it is always we ourselves who stand at the center of these rare images. And this is not so enigmatic, since such moments of sudden exposure are at the same time moments when we are beside ourselves, and while our waking, habitual, everyday (*taggerechtes*) self involves itself actively or passively in what is happening, our deeper self rests in another place and is touched by shock, like the little heap of magnesium powder by the flame of the match. It is to this sacrifice of our deepest self in shock that our memory owes its most indelible images.

Walter Benjamin, *A Berlin Chronicle*[15]

In this evocative reflection Benjamin captures the selective nature of memory and its random illumination of one moment over another and one room over another, as well as its infinite capacity to

[15] Walter Benjamin, *Reflections. Essays, Aphorisms, Autobiographical Writings*, ed. Peter Demetz (New York: Schocken Books, 1978), 56–7.

resequence and reinvent the past. The 12th September 1847 was just such a day for Elizabeth Barrett Browning and the living room of Casa Guidi was the room with which it would forever be associated. On that day Barrett Browning witnessed an ecstatic political demonstration. Looking down from the windows of the palazzo where she was living she witnessed the Florentines marching towards the courtyard of the Palazzo Pitti to thank their leader Grand Duke Leopold II of Tuscany for granting them the right to form their own militia; a reform that they interpreted as a sign of their future liberation from Austro-Hungarian rule and the ultimate unification of Italy. These events had been set in motion by the appointment of a new Pope, Pius IX—Pio Nono—who began his rule by granting freedom of the press for the first time in centuries and releasing political prisoners. The optimism that these reforms inspired is captured in a series of exuberant, yet uneasy impressions in the first part of *Casa Guidi Windows*; an unease that the time lapse between the two parts of the poem intensifies. By 1851 the hopes of the Italian Risorgimento lay in ruins, and there was a grim return to the oppression of Austro-Hungarian rule that Barrett Browning captures in a description of another very different political demonstration that passed in front of the windows of Casa Guidi. Written after the defeat of the Italians at Novara in 1849, Barrett Browning describes the return of the exiled and politically compromised Grand Duke to Florence. In the place of the jubilant Florentines that filled the streets in the first part of the poem, the grim insensible order of Austro-Hungarian soldiers marches by, brutally extinguishing the hopes of all who have gathered to witness their return.

Filled with expectations still to be disappointed, *Casa Guidi Windows* begins in darkness with a memory of a child's voice singing as it wanders along the street below: 'Neath Casa Guidi windows, by the church, | *O bella liberta, O bella!*':

> A little child, too, who not long had been
> By mother's finger steadied on his feet,
> And still *O bella liberta* he sang.

Consoling though this sound is, it takes the poem's speaker further into the privations of darkness and the solitude of her role as keeper of the memory of unheard voices. Lying alone in the dark she rails against the strategic forgetting that the aesthetic veiling of human suffering encourages:

> From congregated wrong and heaped despair
> Of men and women writhing under blow,
> Harrowed and hideous in a filthy lair,
> Some personating Image, wherein woe
> Was wrapt in beauty from offending much,
> They call it Cybele, or Niobe,
> Or laid it corpse-like on a bier for such,
> Where all the world might drop for Italy
> Those cadenced tears which burn not where they
> Touch, (Pt. I. 28–36)

This fervent declaration of war on the invisibility of suffering also identifies Barrett Browning's poetic technique with the making visible of what lies behind 'personating' images that veil rather than expose; a desire to illuminate synonymous with the need to remember which the following stanza dramatizes with prophetic Carlylean assurance:

> I can but muse in hope upon this shore
> Of golden Arno as it shoots away
> Through Florence' heart beneath her bridges four!
> Bent bridges, seeming to strain off like blows,
> And tremble while the arrowy undertide
> Shoots on and cleaves the marble as it goes,
> And strikes up palace-walls on either side,
> And froths the cornice out in glittering rows,
> With doors and windows quaintly multiplied,
> And terrace-sweeps, and gazers upon all,
> By whom if flower or kerchief were thrown out
> From any lattice there, the same would fall
> Into the river underneath no doubt,
> It runs so close and fast'twixt wall and wall. (Pt. I. 49–65)

In the light of day, Barrett Browning takes a vivid snapshot of the scene outside her window, saturated to the point of over-exposure by illuminating visual effects. Light plays across the surface of the water fracturing visual planes and loosening the eye's hold on the difference between semblance and reality. Windows multiply, cornices break apart in glittering rows on the water's uneven surface, bridges strain and tremble and marble surfaces 'cleave' to the passing waves hewn away from 'palace-walls' by the sheer force of the Arno's flow. Then into the midst of this image an imagined hand throws a 'flower or kerchief', a casual gesture intended to leave the reader's retina quivering, which also effectively creates the illusion of depth. This gesture

recalls Barthes's notion of the photograph's *punctum*—'the sting, speck, cut, little hole', the 'cast of the dice', 'the accident which pricks me (but also bruises me, is poignant to me)'.[16] Flitting down towards the Arno, it registers the frailty of a human presence, made even more tenuous and poignant by being a self-conscious invention. It is an after-effect that disturbs what Barthes would call the image's *studium*—the observer/reader's 'application to a thing, taste for someone, a kind of general, enthusiastic commitment' that shapes the desire to 'participate in the figures, the faces, the gestures, the settings, the actions'.[17]

Reinforcing the indelibility of this first impression, Barrett Browning returns to the scene to fill in more details, once she has taken the reader through a sequence of edited highlights from Italy's political and cultural history:

> How we gazed
> From Casa Guidi windows, while, in trains
> Of orderly procession—banners raised,
> And intermittent burst of martial strains
> Which died upon the shout, as if amazed
> By gladness beyond music—they passed on!
> The Magistracy, with insignia passed,—
> And all the people shouted in the sun,
> And all the thousand windows which had cast
> A ripple of silks, in blue and scarlet, down,
> (As if the houses overflowed at last,)
> [. . .]
> . . . the very house-walls seemed to bend;
> The very windows, up from door to roof,
> Flashed out a rapture of bright heads, to mend
> With passionate looks, the gestures whirling off
> A hurricane of leaves. Three hours did end
> While all these passed; (Pt. I. 470–80, 518–23)

This new impression resembles the blurred traces of movement on the surface of a daguerreotype. Walls seem to bend, light flashes, gestures whirl, and leaves flurry, as they move in and out of focus. Indeed, identification is forged out of the alienation of the lyric subject from the object world she witnesses. All that remains in effect is her capacity to register linguistically the elusive presence

[16] Barthes, *Camera Lucida*, 27. [17] Ibid. 26.

of outer stimuli, a focal transference to the dynamics of expression that Adorno identifies as specific to the lyric genre: 'a subjectivity that turns to objectivity, is tied to the priority of linguistic form in the lyric . . . Hence the highest lyric works are those in which the subject, with no remaining trace of mere matter, sounds forth in language until language itself acquires a voice.' Accordingly, Adorno stresses that this 'is why the lyric reveals itself to be most deeply grounded in society when it does not chime in with society, when it communicates nothing, when, instead, the subject whose expression is successful reaches an accord with language itself, with the inherent tendency of language.'[18] The resonances and contrasts between Adorno's formalism and Barrett Browning's lyric technique are telling here. On one level, Adorno's account accords with Barrett Browning's Carlylean proclivity for the spectacular illuminations that Lowell identified with the passionless elitism of photographic style. And yet, while Barrett Browning is clearly interested in exploiting poetry's estranging effects, the formal resistances that make language visible in her work are always guided by the compulsion to communicate something—a compulsion that inevitably returns to the reifying aesthetics that Adorno's ideal lyric poet resists. In fact, this is what leads Barrett Browning towards the prose poem and away from the limited temporal enunciations of the lyric form, as she asserted so strenuously in *Aurora Leigh*:

> Ay, but every age
> Appears to souls who live in't (ask Carlyle)
> Most unheroic. Ours, for instance, ours:
> The thinkers scout it, and the poets abound
> Who scorn to touch it with a finger-tip:
> A pewter age,—mixed metal, silver-washed;
> An age of scum, spooned off the richer past,
> An age of patches for old gaberdines,
> An age of mere transition, meaning nought
> Except that what succeeds must shame it quite
> If God please. That's wrong thinking, to my mind,
> And wrong thoughts make poor poems.
> . . .

[18] Theodor Adorno, 'On Lyric Poetry and Society', in *Notes to Literature*, ed. Rolf Tiedemann, trans. Shierry Weber Nicholsen, 2 vols. (New York: Columbia University Press, 1991–2), i. 37–54.

> . . . But poets should
> Exert a double vision; should have eyes
> To see near things as comprehensively
> As if afar they took their point of sight,
> And distant things as intimately deep
> As if they touched them. Let us strive for this.[19]

Aurora outlines the contours of a new poetry guided by a desire for proximity here, a rhetorical effect achieved through *deixis* in its classical Greek sense, with which Barrett Browning would have been familiar, meaning: 'to show forth, point, display, bring to light, hail, exhibit, reveal'.[20] As Susan Stewart has recently argued, deixis compels us 'to identify the relations between objects and persons as relational and mutual, but not in indeterminate ways. The articulation of proximity, of edges and interiors, and the use of prepositions such as *at*, *on*, and *in* thrust us toward the presence or absence of dimensionality, bounded or unbounded space, and surface.'[21] This location of poetry in time and space is integral to both Barrett Browning's sense of poetic double vision and the impression-istic technique of *Casa Guidi Windows*. In both contexts, poetic vision is a relational device that links interior and exterior spaces, while gesturing towards the utopian possibility of suspending time in the interests of forging a more recursive reflective articulation of the relation between memory and perception. Moreover, Stewart's sense of deixis as an aesthetic manipulation of everyday objects to counter the rigidity of 'the performative, pragmatic, and instrumental func-tions of discourse and gesture' with 'the utopian possibilities of repetition and simultaneity' parallels the sense of poetic memory that Barrett Browning was pressing towards in her advertisement for *Casa Guidi Windows*.[22] By using this technique, the poem reproduces images that invite repeat viewings and readings, by substituting intimate insights for official versions of what took place.

Reinforcing this linguistic sense of relation and proximity, Barrett Browning's conception of poetic double vision echoes the visual

[19] Elizabeth Barrett Browning, *Aurora Leigh*, ed. Cora Kaplan (London: Women's Press, 1978), Bk. 5. 155–66, 185–90.

[20] Liddell and Scott's Greek lexicon, cited in Susan Stewart, *Poetry and the Fate of the Senses* (Chicago: University of Chicago Press, 2002), 150.

[21] Stewart, *Poetry and the Fate of the Senses*, 155.

[22] Ibid.

experience of looking through a stereoscope at a stereographic daguerreotype or photograph. Stereoscopic space, like the poet's double vision, intensifies the illusory simultaneity of perspectival space, allowing both background and foreground to be experienced with the same degree of intensity. Like the visual effect Barrett Browning creates with the gesture of the flower or kerchief flitting down towards the Arno, or the walls of the Florentines' houses appearing to bend with the glittering banners streaming down to meet them from the windows above, the visual impact of the stereoscopic image lies in the observer's awareness of the physical sensation of focusing—of scanning the image from what is nearest at hand, to the middle ground and to the farthest plane. As Rosalind Krauss observes: 'As one moves, visually, through the stereoscopic tunnel from inspecting the nearest ground to attending to an object in the middle distance, one has the sensation of refocusing one's eyes. And then again, into the farthest plane, another effort is made, and felt, to refocus.'[23]

Viewed through the lens of nineteenth-century conceptions of stereoscopic vision, however, the unmistakable flaw in Barrett Browning's humanist ideal of a socially progressive cultural poetics with the power to arrest the attention of a distracted modern audience becomes starkly visible. As Jonathan Crary's suggestive account of the development of the stereoscope demonstrates, the visual techniques on which Barrett Browning relied to forge her distinctively modern vision were part of 'a new arrangement of knowledge about the body and the constitutive relation of that knowledge to social power' that standardized visual imagery and remade subjective visual experience into something abstract, measurable, and exchangeable.[24] In adapting her poetic vision to engage a modern readership, Barrett Browning thus reproduced modern techniques for managing visual consumption that had, in turn, found one of their most iconic manifestations in the spectacular glass halls of the Crystal Palace. In effect, her struggle to forge an aesthetic out of her resistance to a new world economy in which history is forgotten is equally guilty of privileging beauty and private interests over public duty. Her impressionistic technique, which so evocatively transformed two pivotal events in the history of Italian republicanism,

[23] Krauss, 'Photography's Discursive Spaces', 137.
[24] Crary, *Techniques of the Observer*, 17.

gives way to the same desire for simultaneity and the elevation of sight over touch that Crary argues allowed 'the new objects of vision (whether commodities, photographs, or the act of perception itself) to assume a mystified and abstract identity, sundered from any relation to the observer's position within a cognitively unified field'.[25] And yet, what makes a poem such as *Casa Guidi Windows* so conceptually complex is that it also provides us with the evidence to argue against the history of the standardization of visual experience that Crary elaborates. For Barrett Browning's privileging of the local and the particularities of affect was expressly intended to expose the illusory coherence of official images and accounts of such events. Her concern was with the private face, the interior, the destabilizing exception, and the other side of the paradox which her fascination with modern ideas of perceptual mediation involved: the various and individual cultural histories, in other words, that each observer brought to the viewing apparatus which they chose to raise to their eyes. For Barrett Browning it was only in the nexus between memory and a definitively modern perceptual scepticism that a truly modern poetry could take form, a poetry with the power to see what had come before with the same resolution and immediacy as the events unfolding before her eyes.

POETIC AFTERLIVES

> The image wanders ghostlike through the present. Ghostly apparitions occur only in places where a terrible deed has been committed. The photograph becomes a ghost because the costume doll lived . . . This ghostlike reality is *unredeemed* . . . A shudder goes through the viewer of old photographs for they do not illustrate the recognition of the original but rather the spatial configuration of a moment; it is not the person who appears in his photograph, but the sum of what is to be deducted from him. It annihilates the person by portraying him, and were he to converge with it, he would not exist.
>
> Siegfried Kracauer, 'Photography'[26]

[25] Ibid. 19.
[26] Siegfried Kracauer, 'Photography', in *The Mass Ornament: Weimar Essays*, trans. and ed. Thomas Y. Levin (Cambridge, Mass.: Harvard University Press, 1995), 56.

In an editorial preface to a photographically illustrated edition of Barrett Browning's poems published in 1866, Theodore Tilton reproduced Mary Russell Mitford's portrait of her friend: 'A slight, delicate figure, with a shower of dark curls falling on either side of a most expressive face—large, tender eyes, fringed with dark lashes—and a smile like a sunbeam.' He then compared Mitford's portrait with the photographic portrait that served as the first volume's frontispiece:

This description of twenty five years ago is true, every word, of a photograph now lying on our table, copied from Macaire's original, made at Havre in 1856, and which Robert Browning esteems a faithful likeness of his wife. The three quarter length shows (what photographs sometimes fail to show) the comparative stature of the figure—which here is so delicate and diminutive that we can easily imagine how the story came to be told (although not true) that her husband drew this same portrait in the *Flight of the Duchess* when he sketched—the smallest lady alive—But the one striking feature of the picture is the intellectual and spiritual expression of the face and head; for here, borne up by pillars of curls on either side, is just such an arch as she saw in the *Vision of Poets*:

'A forehead royal with the truth!'

A photograph, taken in Rome only a month before she died, wears a not greatly changed expression, except in an added pallor to cheeks always pale; foretokening the near coming of the shadow of death.[27]

Tilton describes the death of the subject that the photograph both memorializes and eludes. Its power to evoke what is no longer there in a ghostlike image that haunts the present; an image that as Kracauer notes does not recognize 'the original but rather the spatial configuration of a moment'. In lingering over Barrett Browning's photograph Tilton thus enacts photography's impact on, to quote Benjamin, 'the history of how a person *lives on*, and precisely how this afterlife, with its own history is embedded in life'.[28] Her diminutive stature, her abundant curls, her commanding features that inspire

[27] Theodore Tilton, 'Memorial Essay', in Elizabeth Barrett Browning, *Poems*, 5 vols. (New York: James Miller, 1866), iv. 18–19. The same photographic portrait by Macaire, taken in Le Havre in 1856 appears in another 5-vol. edition of the works published by Smith, Elder & Co. in 1880. A vignetted version of this portrait was also sold by Eliot and Fry.

[28] Walter Benjamin, *The Correspondence of Walter Benjamin, 1910–1940*, ed. Gershom Scholem and Theodor W. Adorno (Chicago: University of Chicago Press, 1994), 149.

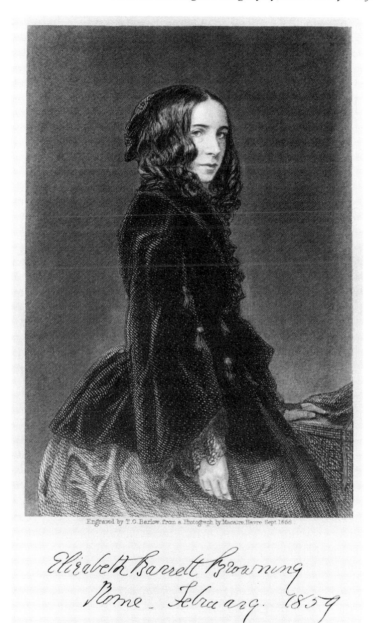

Engraved by T. O. Barlow, from a Photograph by Macaire Havre Sept 1858

17. Macaire portrait of Elizabeth Barrett Browning

suitably worshipful poetic analogies, elicits a Pygmalion-like desire in Tilton to bring this mystified 'costume doll' back to life. And to assist in this revivification he turns to a series of photographs of the interior of Casa Guidi.[29] First he guides his readers through an ante-room decorated with medallion-style portraits of Tennyson, Carlyle, and Robert Browning. He then moves into the drawing room which he claims poets had turned into a shrine long before Barrett Browning's death: 'But the glory of all and that which sanctified all, near the door. A small table, strewn with writing-materials, books and newspapers, was always by her side.'[30] Then, to further authen-ticate this description he turns to another photograph: '. . . we have this description still more vividly drawn in a photograph of the favourite room in which she often sat, taken after she had quitted it forever. If the reader could look over our shoulder, he would be welcome to see the picture; but there is hardly need to add more by mere words to those already given.'[31]

In contrast to Robinson's stress on the public and political context of Barrett Browning's work, Tilton is fascinated by private moments, interiors and faces in the manner of the celebrity profiles that would become the standard fare of late nineteenth-century photojournal-ism. His physiognomic reading of the Macaire photograph repro-duces the conventional elision of poet and poem, overlaying Barrett Browning's idealized vision of the face of poetic genius onto her own, whilst stressing her overt femininity—her pillars of curls and small stature. Yet both Robinson and Tilton's prefaces also share the com-mon nostalgia of photographic souveniring; a heightening of the tem-poral and psychological senses of nostalgia, which Jean Starobinski has identified as peculiar to nineteenth-century permutations of the original pathological sense of nostalgia.[32] Both draw their readers back in time to Casa Guidi; Tilton simply operated in a different reg-ister. Less concerned with Barrett Browning's canonical status, he writes in the spirit of a relic hunter lovingly restoring the details of an otherwise forgotten scene and in the process enacting his own sense of homelessness by creating a literary shrine that illuminates the impos-sibility of return. The medallion portraits that adorn the anteroom

[29] Tilton discusses but does not reproduce these images.
[30] Tilton, *Poems*, iv. 32. [31] Ibid.
[32] Jean Starobinski analyses the derivation of the concept from its initial coining by Johannes Hofer in 1688 to describe exiles wasting away while absent from their native homeland, in 'The Idea of Nostalgia', 81–103.

transform Tennyson, Carlyle, and Browning into acolytes gathered
to worship at the altar of the writing scene where Barrett Browning's
desk lies cluttered with the detritus of inspiration.

In this context, the living room of Casa Guidi becomes a space
calculated to generate dreams of intimacy and identification in the
manner of Benjamin's dream of visiting Goethe's study in *One-Way
Street*:

In a dream I saw myself in Goethe's study. It bore no resemblance to the one
in Weimar. Above all, it was very small and had only one window. The side
of the writing desk abutted on the wall opposite the window. Sitting and
writing at it was the poet, in extreme old age. I was standing to one side when
he broke off to give me a small vase, an urn from antiquity, as a present. I
turned it between my hands. An immense heat filled the room. Goethe rose to
his feet and accompanied me to an adjoining chamber, where a table was set
for my relatives. It seemed prepared, however, for many more than their
number. Doubtless there were places for my ancestors, too. At the end, on
the right, I sat down beside Goethe. When the meal was over, he rose with
difficulty, and by gesturing I sought leave to support him. Touching his
elbow, I began to weep with emotion.[33]

Sleep releases a dream sequence that blurs the involuntary memory
of an actual visit to Goethe's house with a fantasy of contact and inti-
macy that haunts all such pilgrimages. Instructed by the curator to
sign the visitors' book before entering, Benjamin discovers his 'name
already entered in big, unruly, childish characters'. Then, once inside,
Goethe himself singles him out for attention. Indeed, rather than
being drawn into Goethe's world, he draws Goethe into his own
domestic history, so close at hand that he can reciprocate the great
man's recognition with an offer of support—an intimate exchange
so effecting he is reduced to tears. Benjamin's grief reinforces the
childlike nostalgia of his dreaming. Like Tilton's lingering over the
photograph of the drawing room of Casa Guidi taken after Barrett
Browning 'had quitted it forever', and his invitation to his readers
to look over his shoulder and do likewise, this dream expresses a
longing for a domestic scene that never took place. Tilton simply
translates his version of the dream into the material form of a photo-
graphically illustrated book in which the dynamism of Barrett
Browning's verse and photography's uncanny effects are combined
to draw the poet back to the table.

[33] Benjamin, *One-Way Street*, 47.

Another photographically illustrated version of fragments of *Casa Guidi Windows* published in 1904 confirms the general and lasting appeal of this style of nostalgic revivification. In this edition, which combined poems by both Brownings, poems and photographs are enlisted to provide an intimate knowledge of Florence and the inner workings of the minds of both poets. Illustrated by full-page photographic illustrations, the dynamics of literary tourism shapes the reading experience in the manner of Wilson's magic lantern shows, smoothing out semantic difficulties and the disruptions of travel in the interests of handing the consumer a fluid sequence of cultural artefacts to furnish their imaginative and domestic interiors. Of Browning's *Old Pictures of Florence*, the volume's editor, Anna Benneson McMahan, informed her readers that photography would provide the historical knowledge that would give the poem the accessibility of a 'guide-book': '. . . the present work aims to set before the eye pictures of the places or persons mentioned, so that each reader may see Florence for himself as nearly as possible as the two poets saw it, may approach, as closely as ever is possible to an outsider, the sources of poetical inspiration'. She then expands her reflections to include Barrett Browning, citing the opening lines from *Casa Guidi Windows* when the poet overhears the child in the street below, which McMahan interprets as a gesture of intimacy towards the reader: 'Indeed, both poets at times seem to have invited us into the inner sanctuary of their minds, by stating distinctly the circumstances which led to poetical creation.'[34] Each photograph then extends this invitation still further, helpfully eliding the space and time between the creative and reading process, according to McMahan. Both reading and viewing in this context take place simultaneously in a ritualized display of the Brownings's poetry under the glass of the camera's lens, a display not far removed from the assemblage of cultural artefacts in the glass cases that lined the spectacular halls of the Crystal Palace.

Here again therefore, it can be argued that Barrett Browning's fascination with fixing moments and the dynamics of illumination foreshadowed these later photographic adaptations of her work. Reinforcing this affinity, Barrett Browning's own description of the wonders of daguerreotype shared the optimism that characterized MacMahan, Tilton, and Robinson's volumes. The letter to Mary

[34] McMahan (ed.), *Florence in the Poetry of the Brownings*, 14–15.

Russell Mitford with which this book began is worth quoting again in this context, not only because it reveals Barrett Browning's active engagement with the rhetoric of early photographic discourse, but also because it resonates suggestively with the evocative convergence between memory and perception in *Casa Guidi Windows*, which would continue to haunt its readers well into the twentieth century:

My dearest Miss Mitford, do you know anything about that wonderful invention of the day, called the Daguerrotype? [*sic*]—that is, have you seen any portraits produced by means of it? Think of a man sitting down in the sun & leaving his facsimile in all its full completion of outline & shadow, stedfast [*sic*] on a plate, at the end of a minute & a half!! The Mesmeric disembodiment of spirits strikes one as a degree less marvellous. And several of these wonderful portraits . . . like engravings—only exquisite and delicate beyond the work of graver—have I seen lately—longing to have such a memorial of every Being dear to me in the world. It is not merely the likeness which is precious in such cases but the association, & the sense of nearness involved in the thing . . . the fact of the very shadow of the person lying there fixed for ever!—It is the very sanctification of portraits I think—and it is not at all monstrous in me to say what my brothers cry out against so vehemently . . . that I would rather have such a memorial of one I dearly loved, than the noblest Artist's work ever produced.[35]

The resonances between the rhetoric Elizabeth Barrett Browning uses here and the earliest announcements of photography are remarkable. Published on the same page in the *Athenaeum* as Barrett Browning's eulogy to Letitia Landon, the first announcement of Daguerre's invention appeared on 26 January 1839 proclaiming that the

long researches made by M. Daguerre, to produce the wonderful effects of light and shadow which he exhibits in his dioramas, have ended in his present invention. Briefly to explain it: it enables him to combine with the *camera obscura* an *engraving power*—that is, by an apparatus, at once to receive the reflection of the scene without, and to fix its forms and tints indelibly on metal in *chiaroscuro*.[36]

Then, only a fortnight later the *Athenaeum* published William Henry Fox Talbot's address to the Royal Society, 'Some account of the art of photogenic drawing, or the process by which natural objects may be

[35] *The Letters of Elizabeth Barrett Browning to Mary Russell Mitford 1836–1854*, ii. 357–8. [36] 'Foreign Correspondence', *Athenaeum* (26 January 1839), 69.

made to delineate themselves without the aid of the artist's pencil', in which he described his invention as the 'Art of fixing a Shadow':

> The phenomenon which I have now briefly mentioned appears to me to partake of the character of the marvellous, almost as much as any fact which physical investigation has yet brought to our knowledge. The most transitory of things, a shadow, the proverbial emblem of all that is fleeting and momentary, may be fettered by the spells of our 'natural magic,' and may be fixed forever in the position which it seemed only destined for a single instant to occupy.[37]

Noting the similarities between both Daguerre's and Talbot's inventions, the framing commentary then described both in terms that Barrett Browning's letter recalls:

> When we consider the means employed, and the limited time—the moment in time, which is often sufficient—the effects produced are perfectly magical. The most fleeting of all things—a shadow, is fixed and made permanent; and the minute truth of many of the objects, the exquisite delicacy of the pencilling, if we may be allowed the phrase, can only be discovered by a magnifying glass.[38]

Read in this context Barrett Browning's occult analogies echo Talbot's own description of his invention as 'natural magic'.[39] However, her classical interests might have played a part in her perception of the daguerreotype as an indelible trace of a film-like layer of the spirit of the sitter; an idea that resembles the atomistic theory of eidola radiating out from all visible objects only to be caught up in the trajectory of the observer's gaze.[40] What is also of significance here is that Barrett Browning's mystifying response captures the sheer novelty of

[37] William Henry Fox Talbot, 'Some Account of the Art of Photogenic Drawing and the Process by which Natural Objects May Be Made to Delineate Themselves without the Aid of the Art of a Pencil', *Athenaeum* (9 February 1839), 114.

[38] 'Our Weekly Gossip', *Athenaeum* (2 February 1839), 96.

[39] Alison Winter locates Barrett Browning's response in the broader context of Mesmeric practice in *Mesmerized: Powers of the Mind in Victorian Britain* (Chicago: University of Chicago Press, 1998).

[40] Lucretius, for example, explained the behaviour of eidola, which he called *simulacra*, in the following terms: 'amongst visible things many throw off bodies, sometimes loosely diffused abroad, as wood throws off smoke and fire heat; sometimes more close-knit and condensed, as often when cicalas [i.e. cicadas] drop their thin coats in summer, and when calves at birth throw off the caul from their outermost surface, and also when the slippery serpent casts off his vesture among the thorns'. Titus, Lucretius Carus, *De rerum natura*, trans. W. H. D. Rouse (London: Loeb Classical Library, 1937), iv. 54–61.

the daguerreotype in the early 1840s, as well as its truly 'original' form. Each daguerreotype was a one-off silver image fixed on a small gilded copper plate, in contrast to the multiple copies produced by Talbot's invention. It was, therefore, far easier to assimilate into a Romantic discourse of originality, or what Allan Sekula has described as a 'bourgeois aesthetic mysticism', which attributed these small gold-tinted images with a 'primitive value' usually associated with more naturalized technologies, such as the aeolian harp.[41]

Barrett Browning's description of the debate between herself and her brothers about this new style of portraiture also evokes a domestic scene that could serve as a paradigm for the dramatic and various ways in which photography reshaped Victorian ideas of memory and perception. That Barrett Browning failed to convince her more sceptical brothers of the aesthetic merits of the daguerreotype in no way diminishes its impact on their lives. Rather, their disagreement exemplifies the constant interplay between resistance and fascination that characterized Victorian debates about the nature of the photograph and daguerreotype. The latter, as Barrett Browning's anecdote exemplifies, could signify very different things, depending on who was doing the looking. In Barrett Browning's case, the daguerreotype was free of the spectre of mass reproduction that alarmed many of her contemporaries. Her use of theologically resonant terms, such as 'sanctification', invested Daguerre's invention with a cultural value that set it apart from the mechanics of its production and the materiality of its distribution and consumption. In this idealized form it resembled an intense impression that fixed the spirit of a moment forever, an ideal which, as we have seen, she would then shape into the poetic sequence of *Casa Guidi Windows* only five years later.

Browning too was fascinated by photography's mesmeric powers. Like Barrett Browning, he was photographed on a number of occasions, most notably by Julia Margaret Cameron, and there are also photographically illustrated editions of his work. His interest in the idea of photography in poems such as 'Mesmerism', however, took a more macabre and playful approach to the medium's arresting powers. In 'Mesmerism', the calotype, like the mesmerist's art, materializes the speaker's unhealthy desire for absolute and eternal possession of another:

[41] Allan Sekula, 'On the Invention of Photographic Meaning', in Victor Burgin (ed.), *Thinking Photography* (London: Macmillan, 1982), 84–109 (98).

All I believed is true!
I am able yet
All I want to get
By a method as strange as new:
Dare I trust the same to you?
 . . .
Have and hold, then and there,
Her, from head to foot,
Breathing and mute,
Passive and yet aware,
In the grasp of my steady stare—

Hold and have, there and then,
All her body and soul
That contemplates my Whole,
All that women add to men,
In the clutch of my steady ken—

Having and holding, till
I imprint her fast
On the void at last
As the sun does whom he will
By the calotypist's skill—[42]

In this grotesque scenario the calotype becomes an extension of a fantasy of incorporation, in which the likeness of the frustratingly absent lover is mortified and encrypted. The deathlike touch of the photographer's art puts her body on display, her frozen form momentarily appeasing the longing that the felt absence between them had induced. Materializing the projection of his crazed jealousy, the calotype, like Barrett Browning's daguerreotype, is endowed with value at the moment it captures the image from its referent. No longer enslaved to the transformations and instabilities of the present, the death of photography has, as Cadava observes in the epigraph to this chapter, inaugurated a new history in which the poem's absent subject exists only as part of the mesmerist's paranoid nightmare of possession and loss; a nightmare that also haunts the melancholic landscape of the final sections of *Casa Guidi Windows*.

[42] Robert Browning, *Men and Women* (Oxford: Oxford University Press, 1972), 71–2.

DARKNESS AND NOSTALGIC AFTER-IMAGES

After witnessing the grim spectacle of the return of the 'armament of Austria' and the once-jubilant Tuscans' constrained and silent response, Barrett Browning escaped from the brutal light of day into the comforting darkness of the drawing room of Casa Guidi:

> But wherefore should we look out any more
> From Casa Guidi Windows? Shut them straight,
> And let us sit down by the folded door,
> And veil our saddened faces, and, so, wait
> What next the judgment-heavens make ready for.
> I have grown too weary of these windows. Sights
> Come thick enough and clear enough in thought,
> Without the sunshine; souls have inner lights.
> And since the Grand-duke has come back and brought
> This army of the North which thus requites
> His filial South, we leave him to be taught.
> His South, too, has learnt something certainly,
> Whereof the practice will bring profit soon;
> And peradventure other eyes may see,
> From Casa Guidi windows, what is done
> Or undone. (Pt. II. 425–41)

This is where the logic of the poem breaks down. Unable to bear the horror on the other side of the window, the speaker turns away, veils her face, and shuts her eyes. Only in the darkness of the poetic imagination can forms take shape out of the afterlife of the reality she can no longer bear to face. Poetic invention here becomes a self-conscious reconstruction of moments souvenired, a distancing gesture that collapses the external world into a series of 'Sights' that come 'thick enough and clear enough in thought'. As Susan Stewart observes, the souvenir 'contracts the world in order to expand the personal', an emblematic device that materializes the nostalgic longing for origin that all narrative reveals.[43] In this context, Barrett Browning's use of 'Sights' reinforces the souveniring sensibility of her poetic style. Like a Victorian tourist thumbing through a sequence of stereoscopic postcards, her mind isolates, collects, and sequences 'the sights' of Florence into a comprehensible narrative that reassures and legitimates

[43] Stewart, *On Longing*, p. xii.

her world-view. Yet, there is something pathological about this desire to objectify, which resembles Browning's crazed mesmerist. The everyday lives of the Florentines that continue on the other side of the window are obscured by her longing for an ideal of Italian aesthetic and political liberty that can never measure up to reality or appease her desire, born of homelessness, for a worthy cultural origin—a home of poetry, art, history, and cultural values with the power to transcend the avaricious ambitions of commerce and politics.

Barrett Browning ultimately discovers that the only way she can maintain the value of what she has seen, or any degree of pleasure in the memory, is to shut down her senses and restore her inner equilibrium—a survival strategy that frees her to indulge in the safe poetic pleasures of repetition that affirms constancy and stasis at all costs. The resemblance to the mental apparatus of the pleasure principle are too apparent to go unremarked here, and especially Benjamin's reflections that arose from his reading of the pleasure principle alongside the lyric poetry of Valéry and Baudelaire.[44] In particular, Barrett Browning's poetic technique resonates with Benjamin's reading of Valéry's capacity to reconcile an interest in the 'special function of psychic mechanisms under present-day conditions' with his exclusively lyric poetic practice.[45] To prove his point Benjamin cites Valéry's account of this process, an account that could equally apply to Barrett Browning's poem: 'The impressions and sense perceptions of man, actually belong in the category of surprises; they are evidence of an insufficiency in man . . . Recollection is . . . an elemental phenomenon which aims at giving us the time for organising the reception of stimuli which we initially lacked.'[46] Benjamin takes this to mean that Valéry places the training of the sensibility to manage and sequence the impact of shocks at the centre of his poetic practice, as Baudelaire had done: 'That the shock is thus cushioned, parried by consciousness, would lend the incident that occasions it the character of having been lived in the strict sense. If it were incorporated directly in the registry of conscious memory, it would sterilize this incident for poetic experience.'[47] The ethical responsibility of the lyric poet here becomes a balancing act that

[44] Sigmund Freud, 'Beyond the Pleasure Principle', in *On Metapsychology: The Theory of Psychoanalysis*, The Pelican Freud Library, 11 (London: Penguin, 1964), 275–338. [45] Benjamin, *Charles Baudelaire*, 116.

[46] Paul Valéry, *Œuvres*, ii. 741; cited in Benjamin, *Charles Baudelaire*, 116.

[47] Benjamin, *Charles Baudelaire*, 116.

offsets self-preservation against maintaining the integrity of the contents of the impressions that still manage to pierce through the defence mechanisms of consciousness.

Unfortunately, the final lyrical impressions that bring the second part of *Casa Guidi Windows* to a close reveal Barrett Browning's failure to maintain this balance:

> The sun strikes, through the windows, up the floor;
> Stand out in it, my own young Florentine,
> Not two years old, and let me see thee more!
> It grows along thy amber curls, to shine
> Brighter than elsewhere. Now, look straight before,
> And fix thy brave blue English eyes on mine,
> And from thy soul, which front the future so,
> With unabashed and unabated gaze,
> Teach me to hope for, what the angels know
> When they smile clear as thou dost. Down God's ways
> With just alighted feet, between the snow
> And snowdrops, where a little lamb may graze,
> Thou has no fear, my lamb, about the road,
> Albeit in our vain glory we assume
> That, less than we have, thou has learnt of God.
> Stand out, my blue-eyed prophet!—thou, to whom
> The earliest world-day light that ever flowed,
> Through Casa Guidi windows, chanced to come! (Pt. II. 742–67)

Casa Guidi Windows ends as it began with an image of a child. Consoled as she had been by the hope and innocence in the voice of a Florentine boy, she looks into the face of her own 'young Florentine' and sees the future. Lacking the aesthetic focus of her previous impressions, this final resolving image lapses into the cloying sentimentalism of poetic cliché. Sentiment and optimism cannot mask the ideological contradictions inherent in the substitution of the blue eyes and golden locks, for the swarthy features of the offspring of those child-like 'oil-eaters, with large, live mobile mouths! Agape for maccaroni' (Pt. I. 200–1). An unmistakable cultural chauvinism underlies this transformation of the illuminated features of an angelic English boy into an arresting image of a Carlylean-style heroic future, which again recalls Lowell's critique of the ethical dangers of this poetic technique.

Moreover, this exchange of faces inadvertently reproduces the culturally imperialistic exchange of one unlike thing for another

that Barrett Browning had previously exposed as the lie at the heart of the narrative of cultural progress being acted out beneath the monumental glass contours of the Crystal Palace:

> O Magi of the east and the west,
> Your incense, gold, and myrrh are excellent!—
> What gifts for Christ, then, bring ye with the rest?
> Your hands have worked well. Is your courage spent
> In handwork only? Have you nothing best,
> Which generous souls may perfect and present,
> And He shall thank the givers for? no light
> Of teaching, liberal nations, for the poor,
> Who sit in darkness when it is not night?
> No cure for wicked children? Christ,—no cure!
> No help for women, sobbing out of sight
> Because men made the laws? no brothel-lure
> Burnt out by popular lightnings?—Hast thou found
> No remedy, my England, for such woes?
> No outlet, Austria, for the scourged and bound,
> No entrance for the exiled? No repose,
> Russia, for knouted Poles worked underground,
> And gentle ladies bleached among the snows?—
> No mercy for the slave, America?—
> No hope for Rome, free France, chivalric France?—
> Alas, great nations have great shames, I say. (Pt. II. 627–48)

In 'leaving other eyes to see' what is going on on the other side of the window while she loses herself in the pleasures of poetry and motherhood, Barrett Browning absolves herself of the responsibility of having to take direct action—the sin that she accuses the great nations of the world of committing. She too wants to forget and this desire ultimately reduces the political impact of the poem which mistakenly looks to a model of Carlylean charismatic leadership as the answer to the woes of Europe's republican sympathizers.

This model, as Robinson astutely observes in her preface to the Bodley Head edition of the poem, results in a misguided focus on Louis Napoleon as the idealized public face of the Bonapartist restoration in France and the saviour of the hopes destroyed by Italy's corrupted version of heroic leadership:

In 1850 Mrs Browning is looking for a hero. In 1852 her expectant attention is rewarded. She is in Paris in the December of that year, and in reading her letters we see the Deliverer slowly taking shape before her eyes, and, to our

amazement, he is Louis-Napoleon, the hero of the Coup d'Etat. Yet there is nothing illogical in our Muse's aberration. Both the Browning's prized above all things an act of will, the effort of an individual to impress himself upon his age, and shape it to an end of his imagining. The political crime of the Deux Decembre appeared in Mrs Browning's eyes such a taking possession of the place suited to a large activity. Pathetically ignorant of evil, shielded by her delicate and almost dying condition from all news too painful for an invalid, she never wholly grasped the situation, never saw the night-side of that treacherous plot, nor heard its sinister echoes of political murder, of unwarrantable exile, of confiscation and violated freedom. The Second Empire in its early years was in fact a genteel and frivolous Terror with a gag in the mouth of Free Speech, which was no less a gag for being brilliantly electroplated. Mrs Browning saw the other side of the Bonapartist restoration (which is just as true)—the people in their millions acclaiming a Saviour of Society; the prince, a poet and a dreamer, impenetrably wrapt in a heroic vision, aloof from all that is narrow, selfish, or vulgar in national politics. She saw in him the Perseus of her imprisoned Italy; and she acclaimed the Emperor of the French the apostle of Liberty.[48]

What Robinson focuses on here is the dissociative aspects of the Carlylean ideology that shaped the belief of both Brownings in the culturally transformative power of the individual will and imagination. She also illuminates the flaw in the glass that fractures the transparent simplicity of the poetic resolution of *Casa Guidi Windows*. Focusing on brilliant figures—whether it be the innocent face of a child or the imagined virtuosity of a poet-politician bespeaks a politics underwritten by a fundamental horror of the crowd, a politics that privileges beauty and singularity above all else. What falls away from this vision is the details of suffering that Barrett Browning had pledged to expose when the poem began. The murders, betrayals, and lives lived in fear going on in the street below are forgotten as Barrett Browning contemplates the idealized portrait of yet another mistaken political saviour—blind and deaf to those who sob 'out of sight'. Her only defence as she wrote to her friend John Kenyon on 15 February 1852 was that she never claimed that her vision was anything other than the subjective testimony of a knowingly perverse idealist:

As it was in the beginning, from 'Casa Guidi Windows', so it is now from the Avenue des Champs-Elysees. I am most humanly liable, of course to make

[48] Robinson, Preface, in Barrett Browning, *Casa Guidi Windows* (1891), pp. xi–xii.

mistakes, and am by temperament perhaps over hopeful and sanguine. But I do see with my own eyes and feel with my own spirit, and not with other people's eyes and spirits, though they should happen to be the dearest—and that's the very best of me, be certain, so don't quarrel with it too much.[49]

This letter also recalls another Barrett Browning wrote to her sister Henrietta five years earlier at the height of her hopes for the Florentine uprisings:

The windows dropping down their glittering draperies seemed to grow larger with the multitude of pretty heads, & of hands which threw out flowers & waved white handkerchiefs—There was not an inch of wall, not alive, if the eye might judge—Clouds of flowers & laurel leaves came fluttering down on the advancing procession—and the clapping of hands, & the frenetic shouting, and the music which came in gushes, & then seemed to go out with so much joy, and the exulting faces, and the kisses given for very exultation between man & man, and the mixing of elegant women in all that crowd & turbulence with the sort of smile which proved how little cause there was for fear . . . all these features of the scene made it peculiar, & memorable & most beautiful to look at & to look back upon. We went to a window in our palazzo which had a full view, and I had a throne of cushions piled up on a chair, but was dreadfully tired, before it was all over, in spite of them, as you may suppose from the excitement of such a scene. And then Robert & I waved our handkerchiefs till my wrist ached, I will answer for mine. At night there was an illumination, and we walked just to the Arno to have a sight of it.[50]

In the top left-hand corner of the first page of this letter Barrett Browning sketched the parade as she saw it, marking the place where she had stood. With the excitement of a tourist she blends wonder with a desire for authentic experience. The parallels with the impressions that fill the first part of *Casa Guidi Windows* are also obvious here. It is the details of the scene—glittering draperies, white handkerchiefs, flowers, and laurel leaves—that make it peculiar, beautiful, and memorable. The accumulation of detail upon detail, listed off in a series of extraordinary and marvellous sights or

[49] Cited by Markus, Preface, in Barrett Browning, *Casa Guidi Windows* (1977), p. xl.

[50] Elizabeth Barrett Browning to Henrietta Barrett, 13 September 1847, cited by Markus, Appendix, in Barrett Browning, *Casa Guidi Windows* (1977). 66. Jane Markus notes that the above date is ascribed to this letter by Leonard Huxley, the editor of the 1929 ed. of the letters to Henrietta Barrett; the actual letter is undated—although it is clearly written in the white heat of first impressions gleaned.

impressions, similarly mirrors the accumulative style of not only the earlier impressions of the Tuscan's ecstatic celebrations, but the later attack on the Crystal Palace's museal appropriations and consumerist ideology. Reinforcing this spectacularizing of events, the stress Barrett Browning places on recursive looking, and the generation of memorable images that it necessitates contain the seeds of the nostalgic aesthetics that is both the strength and the weakness of *Casa Guidi Windows*.

Robinson's preface acknowledges both these aspects of Barrett Browning's nostalgic aesthetics, whilst also tracing and exemplifying the ambiguities that this nostalgic style created for the ongoing reception of *Casa Guidi Windows*. In her struggle to be modern Barrett Browning became ensnared in the inherent temporal paradox of keeping time in lyric form. Her version of the very real suffering of the Florentines takes place elsewhere, under the artificial illumination of the poetic imagination. Her craft for making vivid sense-like impressions uses the pleasurable deferrals of lyric sequencing to create a consoling space where politics can be cleansed of the stain of violence and betrayal. Comfort comes in the form of repetition that circles back against the grain of chronological time. Yet each repetition inevitably falls on a different point in the historical sequence of events to which the poem refers. Indeed, the cultural significance of the recursive insights the poem offers is predicated on their referencing of a historical progression that fills the speaker with an equal mixture of hope and alarm. In the particularized and personal model of time that the poem ultimately privileges, moreover, lies the potential for its nostalgic assimilation into the ongoing mythologizing of the Brownings' romance that has so effectively diminished the literary status of Barrett Browning's work in both the nineteenth and twentieth centuries.[51] Even Robinson falls prey to the attractions of summoning the ghosts of the Brownings' domestic life. Whilst refusing to idealize Barrett Browning, her earnest analysis of the flaws and strengths of *Casa Guidi Windows* does begin with a quick detour into the Brownings' correspondence in an effort to convey the rhythms of their everyday lives:

[51] Tricia Lootens provides an exhaustive and rigorous account of how the politics of canonization has worked against the critical recognition of Barrett Browning's work in *Lost Saints: Silence, Gender, and Victorian Literary Canonization* (Charlottesville: University Press of Virginia, 1996).

The Brownings had been married not quite a year when, being forced to spend a month of August in Florence, one hot summer day 'Robert went out to find cool rooms if possible, and make the best of the position . . .' 'So here we are settled,' Mrs Browning goes on to say, 'and we are indeed settled magnificently in this Palazzo Guidi, on a first floor in an apartment which *looks* quite beyond our means, and *would be*, except in quite the dead part of the season: a suite of spacious rooms opening on a little terrace, cool, and in a delightful situation.' In the spring of the following year (1848), undeterred by rumours of Revolution, the Brownings took the same pleasant suite unfurnished, filling gradually the lofty tessellated palace rooms with antique furniture, worthy of the place, with grave and faded pictures by the earlier Pre-Raphaelites, with lengths of tapestry, all familiar to many of us in later days when these dear Tuscan wares were transferred to London. But from 1848 to 1861, that is to say for the remainder of Mrs Browning's life, although the poet-couple spent more than one winter in Rome and more than one season in Paris, travelling also every summer to the Appenines, to the seashore or even to distant London, yet ever in their minds was Casa Guidi when they thought of home.[52]

Robinson's nostalgic desire for absolute presence fills the space behind the photograph of the façade of the Casa Guidi with the details of personal anecdote and the lush interior decoration that the Brownings gathered around them to domesticate its palatial rooms. That said, as I have argued throughout this chapter, Robinson still resists the sentimentalizing excesses of either Tilton or McMahan. Instead she chooses to echo and memorialize Barrett Browning's own uneasy balance of private and public registers. Enlisting intimate associations and images to achieve intellectual ends, she transforms the architecture of Casa Guidi into a materialization of the always tenuous boundary between the personal and the political in Barrett Browning's poetics.

Aptly, this tension is embodied in the frontispiece (Fig. 16) reproduced near the beginning of the chapter. On the one hand, this photograph memorializes the very public historical context that shaped *Casa Guidi Windows*, but also, on the other, wittingly plays with the curiosity of the reader to know more, to summon the ghosts of the Brownings to fill in the absence between present and past, reader and text, image and referent. In putting the lavish interior of Casa Guidi on display therefore, Robinson caters to this desire for elusive

objects. Like the Crystal Palace, Casa Guidi contains unattainable luxuries, further mystified by their location in a space invested with the cultural significance of a literary shrine. Ultimately then, Robinson's efforts to humanize and contextualize *Casa Guidi Windows* further distance the poet from the everyday world of her readers, inadvertently reinforcing the cultural alienation that the poem itself mourns. Looking back through photographs, her readers are forever on the other side of the window looking into a world that is only accessible through nostalgic fantasy. Like Benjamin's dream of revisiting Goethe's study, or Barrett Browning's obsessive return to the memory of how she had felt on that day in September when she had first looked out from the windows of Casa Guidi, all the reader can do is try to return to the place where it all began through the recreation of ever more distorted versions of a scene that possibly never took place.

CHAPTER SIX

Cameron, Tennyson, and the Luxury of Reminiscing

The scent of sweet brier, the odd acrid flavour of collodion, the door that was never shut, the parcels on the lawn, the echo of the Mistress's voice calling to her maids, that of the Master's voice reciting Homer aloud in the sunny forenoons, all comes back to one; and at the same time rise visionary glimpses of figures strangely robed and vestured, issuing from the glass house at the back of the place where the photographs were taken.

Anne Thackeray Ritchie, *Lord Tennyson and his Friends*[1]

Two years after the publication of Robinson's edition of *Casa Guidi Windows*, Anne Thackeray Ritchie's anecdotal reminiscences in *Lord Tennyson and His Friends* drew Tennyson, Cameron, and their milieu back to the table, in the manner of Benjamin's dream of Goethe. Ritchie's memories of the gardens and homes of Tennyson and Cameron are designed to inspire curiosity and nostalgia. Her anecdotes resemble a sequence of photo opportunities that isolate, illuminate, and display the pleasures and idiosyncrasies of the extraordinary lives of her subjects. Far removed from the everyday banalities of modern life they drift from room to room reciting Homer, or wander out to the glasshouse beyond to join the cast of Cameron's whimsical medieval tableaux. But unlike Benjamin's dream, there is no trace of critique in Ritchie's reminiscences. Nor is there any trace of the earnest political sensibility that shaped Robinson's reframing of Barrett Browning's political and poetic insights. Ritchie speaks as if she is addressing a circle of intimates,

[1] Anne Thackeray Ritchie, *Lord Tennyson and His Friends*. A Series of 25 Portraits and Frontispieces in Photogravure from the Negatives of Mrs Julia Margaret Cameron and H. H. H. Cameron (London: T. Fisher Unwin, 1893), 10.

looking over her shoulder in the manner of Tilton's reflections on Barrett Browning's portrait:

As one turns each page one sees them again, perhaps with the happy illumina-tion of youth to enshrine them. Their presence once more; by moonlight, by sunlight, in the friendly radiance of the great hearth at Farringford, and times and seasons return to one's mind. . . . When I go over the list of portraits which are here given to the world, the little dark room at the back of the dining-room opens once more to admit the sitters in succession, Lord Tennyson coming down half reluctant, half willing to take part in this shadowy presentment

and other still more illustrious figures follow on.[2] The only overt reference to the meaning the reader might derive from dwelling on this procession of notable figures is the advantages to be gained from turning everyday life into art as Cameron had done. The denizens of the art world of 1890s London possess enough originality 'to destroy old traditions' Ritchie mourns, but 'not enough to withstand the meretricious drift of taste and fashion' as her subjects had done.

Ritchie's reminiscences exemplify the nostalgic mode in which Cameron's work is often read, a nostalgia that nicely echoes Cameron's own style, yet necessarily veils the more prosaic proven-ance of her adaptations of Tennyson's mythic narratives of home and hearth as illustrations for a cabinet edition of the poet's works that was explicitly designed for the 'working men' of England.[3] This chapter's analysis of this first extensive publication of Cameron's images, therefore, illuminates not only the protean nature of photo-graphic illustration at this time, but also the commercial anxieties and creative disavowals that the idea of mass-production inspired in both Cameron and Tennyson. For despite Cameron's well-known disappointment with the mass-produced engravings of her photo-graphs that appeared in this edition, the fact remains that this is the context and form in which her photographs reached an audience far beyond the privileged urban and colonial milieus where they

[2] Ibid. 13. Ritchie was in fact addressing a very limited circle, if the number in this edition can be read as an indication of its intended circulation. This edition was limited to 400, of which 150 were available for sale in America.

[3] Alfred Lord Tennyson, *The Works of Alfred Tennyson*, 10 vols. (London: Henry. S. King, 1874–7). Charles Millard also briefly analyses this process as the context for a detailed examination of Cameron's subsequent volumes of illustrations in 'Julia Margaret Cameron and Tennyson's *Idylls of the King*', *Harvard Library Bulletin*, 21 (2 April 1973), 187–201.

predominantly circulated during her lifetime and beyond. Further-
more, focusing on this less-discussed chapter in the production his-
tory of these now canonical images provides a timely corrective to the
more general cultural nostalgia that has played such a decisive role in
twentieth-century critical and market re-evaluations of Cameron's
images.

Recently, Jennifer Green-Lewis has suggested that there has been
'a general classificatory shift of the found photograph from a bit of a
thing (junk) to an icon or part of a thing (antique)'; a shift that she
argues has facilitated contemporary or postmodern culture's tak-
ing of Victorian photographs 'to market as conveyors of identity
and authenticity'.[4] Cameron's photographs are at the top of Green-
Lewis's list of 'currently popular photographs', which also includes
Thomas Annan's photographs of Scottish closes, Lewis Carroll's
Alice as beggar maid, Hugh Diamond's photographs of insane female
patients, Roger Fenton's haunting Crimean image of the 'Valley of
Death', Clementina Hawarden's domestic interiors, Rejlander's
'The Two Ways of Life', and Robinson's 'Fading Away'.[5] This reveal-
ing shopping list tells us much more about postmodern investments
in what is Victorian, than the Victorian culture that these images
supposedly authenticate or represent. So while it is undoubtedly
tempting to indulge in the nostalgic mode of looking encouraged by
the seemingly infinite supply of Victorian images of elegantly tragic
women, prepubescent girls, cherubic children, idyllic pastoral scenes,
imperial landscapes, and fanciful dressings up, the history behind
their production often tells a far less romantic, yet no less compelling,
tale of ambition, commerce, and conflicting interests that disturbs the
quiet of Anne Thackeray Ritchie's garden scene with the more dis-
cordant cries of the Victorian cultural marketplace. It is this cultural
memory which will be restored here through a close consideration of
the cultural and critical implications of the far less palatable version
of Cameron's photographs that appeared in the cabinet edition.
Conventionally these engraved versions of Cameron's images are
seen as a desecration of her art, which they undoubtedly were, but
they are also a register of a distinctively Victorian conception of the
evolving relation between photography and literary culture that is
not commensurate with the proto-cinematic narratives or feminist

 [4] Green-Lewis, 'At Home in the Nineteenth Century', *Victorian Afterlife*, 29.
 [5] Ibid. 38.

readings that have informed recent critical accounts of the relation-
ship between Tennyson's poetry and Cameron's photographs.

In her reading of Cameron's *Illustrations to Tennyson's Idylls of
the King and Other Poems*, Carol Armstrong, for example, contrasts
Cameron's illustration of Tennyson's poems with those of Words-
worth and Scott. Emphasizing the latter's preoccupation with place
and biography, she argues that Cameron's volumes more closely
resemble 'books illustrated with wood-engravings', a form of visual
sequencing that 'approximates the filmic imaginary' rather than the
fragmentary visual souveniring of a mass-produced Bennett or
Wilson publication. Yet significantly, Armstrong continues to stress
their affinity with still rather than moving images:

As stills, rather than moving pictures, it is appropriate that Cameron's photo-
graphs should still motion so insistently; that they should treat narrative
sequence as a frozen, repetitive series, reducing the effect of motion that soon
would be achieved in film to a kind of ghostly stutter, and that they should
concentrate on their own status as isolate frames, rather than attempting to
translate the movement of the text into a flow of images.[6]

Cameron's immobilization of figures and plot, as Armstrong notes,
does reveal a fascination with the temporal dimension of photo-
graphy. But the idealism that informed Cameron's mystification of
the photograph as a materialization of spirit is more of the order
of memorializing homage than ironizing animation and appropria-
tion. And while it is true that Cameron's photographic techniques
depart from the conventions of positivist description, and there are
resonances with the directorial appropriation that occurs in cinematic
adaptations of literary texts, the fantasies they realize are of a very
different visual and temporal order. They are, as Cameron herself
vigorously argued, self-consciously poetic in their slowing down
of time and fascination with duration. In the context of the cabinet
edition moreover, the original images failed Tennyson, and Cameron
herself in their fundamental illegibility to a mass audience; a failure
that is not necessarily a sign of Cameron's resistance to the high
Victorian hagiographic style that the edition demanded.

This was not the result that either Tennyson or his publisher Henry
S. King had expected. Although mediated through Cameron's often
effusive correspondence, Tennyson's first request was clearly for

[6] Armstrong, *Scenes in a Library*, 421.

conventional illustrations that would help to sell the people's or cabinet edition of his poems. The prosaic terms of the initial contract are even detectable in the sentimentalized description Cameron wrote to her friend Edward Ryan, 'About three months ago Alfred Tennyson walked into my room saying, "Will you think it a trouble to illustrate my Idylls for me?" I answered laughingly, "Now you know Alfred that I know that it is immortality to me to be bound up with you that altho' I bully you I have a corner of worship for you in my heart and so I *consented*".'[7] Written in 1874, this letter foreshadows the conflict of interests that would shape the production of both the cabinet edition and the subsequent two volumes of Cameron's illustrations. Casting herself as the difficult, yet ultimately submissive, love interest in this romantic scenario, Cameron reveals both her ambition and her commercial *naïveté*. While immediately grasping the Carlylean-style hero-worship the edition was intended to inspire, she misunderstood the pragmatism of mass production that motivated both Tennyson and King. Their interest lay in the economics and politics of publicity, not in the promotion of Cameron's profile as a photographic virtuoso. What concerned King, in particular, was the photographic portrait's power to illuminate Tennyson's works with the lustre of celebrity, to popularize his image and literally transform him into the people's poet.

Quarto-sized and modestly bound, the cabinet edition was intended to be both functional and accessible to an audience extending far beyond the conventional niche market for lavishly illustrated books. Both King and Tennyson had agreed that an illustrative frontispiece would enhance each volume, and it was with this idea in mind that the latter approached Cameron to see whether she would take some photographs to serve as models for an engraver's designs. Unfortunately for Cameron, somewhere in the midst of these negotiations she lost hold of the humble nature of her original commission. Instead, she hurried around Freshwater enlisting the services of members of the household as well as local residents and visitors whose faces caught her eye. Fitted out in costumes Cameron designed or rented herself, they were then instructed to perform their designated roles in front of the camera, standing still for interminable sittings, whilst negative after negative was taken. Such sacrifices on the part of

[7] Letter from Cameron to Sir Edward Ryan, 29 November 1874. Cited in Helmut Gernsheim, *Julia Margaret Cameron* (London: Gordon Fraser, 1975), 57.

herself and her sitters were justified she felt by the 'high task' she had undertaken.[8] But these hopes were quickly disappointed when she discovered that the publishers had reduced her 'beautiful large photographs' to cabinet-size wood-cuts. Appalled by Tom Lewin's engravings, she resolved to produce 'a beautiful Xmas Gift Book or Wedding Gift Book' that would preserve the integrity of her images; an explicitly commercial ambition that resulted in the ill-fated two-volume *Illustrations to Tennyson's Idylls of the King and Other Poems* published later that year.[9] The Victorian public, it seemed, agreed with King and Tennyson that Cameron's originals defied easy consumption. Amateurish and elusive, they disrupted rather than facilitated fantastic identification with Tennyson's medievalized English types by making photography itself visible through the use of self-consciously aesthetic techniques.

Significantly, the three images that King selected for the cabinet edition were simple close-ups, rather than tableaux. Cameron's portrayal of Elaine of Astolat serves as the frontispiece for the sixth volume, her portrait of a Tennysonian-like Arthur begins the seventh, and her romantic rendition of a winsome adolescent Maud begins the ninth. In all three cases, Lewin's engravings erased the ambiguities of Cameron's focal effects, the only trace of her signature style remained in the legend below the image which drew the reader's attention to a photograph that was not a photograph, a reproduction in which her distinctive style was flattened out by the standardizing machinery of mass production. What the cabinet edition did, in effect, was to reinforce the structural possibility inherent not only in photography but also in poetry; the possibility of reproducibility, which both Cameron and Tennyson disavowed when convenient and exploited when the means of control was in their hands. Cameron's identification of her work with the rhetoric of inspiration, originality, and genius was undoubtedly antithetical to the idea of modes of reproduction fundamentally altering the 'structure of the art-work itself'.[10] Yet she herself placed her negatives in the hands of the Ealing-based Autotype Company, which ironically provided the photographic reproduction of Thomas Woolner's bust of the poet for the cabinet edition. And while she did try to withdraw them when she realized

[8] Ibid. [9] Ibid.
[10] Benjamin, 'The Work of Art in the Age of Mechanical Reproduction', *Illuminations*, 212.

that a 40 per cent commission was charged on every photograph the Autotype Company printed, she also insisted that the portrait of Tennyson which they reproduced 'ought alone to make the fortune' of whoever chose to reproduce it in a form that would remain true to the 'very straight eyes, a little drooping eyelids, bearing the weight of thought, a massive brow and an Elizabethan character in the whole man as if he were sharing the Kingdom of the world with Shakespeare'.[11] Similarly, the illustration of the cabinet edition would also confront Tennyson with the necessary relationship between profits and publicity; a reciprocity that the mass circulation of commercial studio portraits took onto a whole new level of visibility that he would find increasingly difficult to accept.

So while Cameron and Tennyson offered images of an unattainable world to their consumers, a world of lush gardens and luxurious interiors filled with mythic figures and beautiful faces, a world that supposedly transcended the endless circulation of the marketplace, their various commercial negotiations reveal their knowing implication in, as much as their resistance to, the economic dynamic of desire and alienation inherent in Victorian literary mythmaking—a symbolic economy in which exhibition value and literary value had become inextricably entangled. What Cameron failed to manipulate to her advantage was the transformative power of the marketplace, a power that Tennyson had successfully, albeit ambivalently, harnessed by 1874. Writing to William Allingham in 1869 he asked: 'Why am I popular? I don't write vulgarly.'[12] A telling question that encapsulates Tennyson's uneasy relation to the public from whom he increasingly sought validation, in pointed opposition to the new generation of alienated poets whose slogans he dismissed in 1869 with the following angry epithet: 'Art for Art's sake! Hail, truest lord of Hell!'[13] Drawing attention to these tensions and ambiguities in his 1986 study of Tennyson, Alan Sinfield argued for the political necessity of reading back through Tennyson's œuvre through the lens of vigilant suspicion. Resisting a formalist hermeneutics that stressed paradox, indirection, multivalency, and polyphony but left the myth

[11] Letter from Cameron to Blanche Cornish, cited in Gernsheim, *Julia Margaret Cameron*, 53. Cameron also disapproved of the cabinet or *carte de visite* format that the Autotype Company used to reproduce her images and market them in both individual gilt frames and album-style selections.

[12] Cited by Alan Sinfield, *Alfred Tennyson* (Oxford: Basil Blackwell, 1986), 166.

[13] Cited ibid.

of the sage intact, Sinfield called for a 'criticism from below' that would resist the translation of ideological strategies and unresolvable contradictions into critical narratives of aesthetic coherence and sagacious mastery.[14] Sinfield's seminal critique thus continues to remind us not only of the formative role of the dynamics of the cultural marketplace in Tennyson's complex negotiations with publicity, but also of the need to resist our own nostalgic reading for signs of resistance and difference where interested identification and implication often prevailed.

This nostalgic desire is particularly evident in recent feminist radicalizations of Cameron's images and their sceptical interaction with Tennyson's strenuously patriarchal vision. Lindsay Smith, for example, gives a political coherence to Cameron's work as a systematic visual critique of Victorian domestic ideology:

Cameron's photographs redefine the literal space of hearth by manipulation of focus. In Cameron there is not a sense that the private (as depicted photographically) is unquestionably defined as public. There is a celebration of hearth inseparable from a contestation of photographic focus, which cannot be read as complicitous with a division of spheres, with a polarity in which one term is invariably and unproblematically privileged over the other. Cameron as a woman photographer redefines that supposedly 'feminine' domain.[15]

While Cameron's images undoubtedly blurred lines between public and private, the extent to which her work can be read as a sustained visual destabilization of Victorian domestic ideology is more difficult to establish. Sinfield's critique of the occlusions and misrecognitions of a formalist hermeneutics that stresses paradox, indirection, multivalency, and polyphony, but leaves the myth of the sage intact is especially pertinent here. For Smith's subtle reading of the relativizing effects of Cameron's focal techniques self-consciously creates a canonizing myth of her subject as a masterful demystifier of establishment fantasies of familial and social cohesion; a sympathetic reading which reveals the intrinsic nostalgia of such revisionary thumbings through the archive for historical likenesses.

Carol Mavor takes a similar approach to Cameron's Madonna pictures, stressing her subversive proto-feminist revisionings of gender stereotypes:

[14] Ibid. 182–4.
[15] Lindsay Smith, *The Politics of Focus: Women, Children and Nineteenth-Century Photography* (Manchester: Manchester University Press, 1998), 37.

Cameron not only subverted the image of the Victorian woman through her *performed* life but also subverted its representation . . . at first glance, Cameron's images of the Virgin Mary appear to conform with the expectations of a Victorian woman. Using Christian typology, the pictures properly contain woman's sexuality within a space of holy motherhood. Yet upon closer investigation, the pictures manage to bleed through the plastered walls of confinement that encircled the period's 'angel in the house.' The images, which are often literally blurred, move metaphorically between categories, smearing the lines between sexual and not-sexual, male and female, earthly and heavenly. They move like an apparition, leaving the viewer perplexed about what has been seen.[16]

Tellingly, Anne Thackeray Ritchie's reminiscences of the pleasures of delicious breakfasts and exotic dressing up serves as the prelude to this reflection on Cameron's masterful unconventionality:

I cannot tell you how much we enjoy it all; of a morning the sun comes blazing up so cheerfully, and the sea sparkles, and there is a far-away hill all green, and a cottage which takes one's breath it looks so pretty in the morning mists. Then we go to the down top. Then comes eggs and bacon. Then we have tea and look out the window, then we pay little visits, then we dine off eggs and bacon, and of an evening Minny and Emmy, robed in picturesque Indian shawls, sit by the fire, and Miss Stephen and I stroll about in the moonlight.[17]

Such delectable scenes are left to speak for themselves in Mavor's text. Like the photographs she reads through the lens of performativity and Levinas's notion of the caress as a register of alterity, the dynamics of pleasure transcends the constraints and banalities of ideology and commerce. In such a nurturing environment Cameron metamorphoses into an exotic bird, subversive, colourful, and free, to quote Mavor:

A woman of unexpected contradictions, Cameron subverted the representation of the Victorian bourgeois woman (who was metaphorically confined like a fine bird in an elaborate cage of domestic order), even if she was not consciously critiquing its image. Cameron ruffled her feathers, decorated herself with red plumes, covered her cage with white sheets, and left the

[16] Mavor, *Pleasures Taken*, 47.

[17] Anne Thackeray, letter from Freshwater to Walter Senior, Easter 1865, reproduced in *Thackeray and His Daughter: The Letters and Journals of Anne Thackeray, with Many Letters of William Makepeace Thackeray*, ed. Hester Thackeray Ritchie (London: Harper Bros., 1924), 138. Cited Mavor, *Pleasures Taken*, 46.

tiny wrought-iron door slightly ajar, so that she could fly both in and out, or simply perch herself on the threshold of confinement.[18]

As delightful as these anecdotes are, however, what they ultimately demonstrate is that Cameron's work presents just as many challenges to feminist revisionist critique as it presented to Tennyson and King. Morever, as Joanne Lukitsh has recently demonstrated in her reading of Cameron's Sri Lankan photographs, the idealization of Cameron as an eccentric aesthete in influential readings by Gernsheim, Woolf, and others has also resulted in a critical misrecognition, or omission, of the subtle complexities of the colonial ideology that shaped her final haunting images of Sri Lankan subjects and scenes.[19]

Ironically then, even though King's response to her mystification of her Tennysonian subjects was far more instrumentalist than the responses of Cameron's many twentieth-century critics, it was ultimately more akin to her hagiographic sentimental style. By flattening out and reducing the visual focus of Cameron's images his edition provided intimate close-ups designed to inspire identification with an idealized, yet unattainable, public subject—the heroic man of letters. This was a practice, as the next chapter will argue, to which late nineteenth-century photo-journalism would give more explicit form in celebrity profiles and interviews that explicitly traded in a collective longing for the lost intimacy of face to face contact. But, more significantly still, what both these forms of celebrity portraiture exemplify is the nexus between literary consumption and the Victorian taste for searching the face for signs of affinity; a convergence of hermeneutic practices that increasingly combined emerging expressive theories with long-standing models of physiognomic encoding. This discursive convergence has been well documented, most recently in critical work on G.-B. Duchenne de Boulogne's *The Mechanism of Human Facial Expression* and Darwin's *The Expression of the Emotions of Man and Animals*.[20] The parallels

[18] Mavor, *Pleasures Taken*, 47.

[19] Joanne Lukitsh, '"Simply Pictures of Peasants": Artistry, Authorship, and Ideology in Julia Margaret Cameron's Photography in Sri Lanka, 1875–1879', *Yale Journal of Criticism*, 9/2 (1996), 283–308.

[20] The recent translation of Duchenne's influential adaptation of Nadar's photography to substantiate his theorization of expression has contributed to this growing area of scholarship; G.-B. Duchenne de Bologne, *The Mechanism of Human Facial Expression*, ed. and trans. R. Andrew Cuthbertson (Cambridge: Cambridge

between the dynamics of illustration in editions such as King's and the equally experimental approaches to illustration of Duchenne and Darwin, however, have received less critical attention. Darwin's commissioning of the famous art photographer Oskar Rejlander further reinforces this affinity. Rejlander (who may even have been introduced to Darwin by Cameron) contributed the majority of the photographs that illustrated Darwin's volume, which were combined with the work of other photographers and engravings—a format that King's edition also used.[21] This mixture of illustrative modes locates both enterprises not only within a history of transformations of illustrative practices, but more specifically as instances of the very early stages of the legitimation of photography as an empirical means of illuminating and sequencing what had previously eluded the limits of human perception and memory. Now a flicker of a gesture, an eye movement, the confluence of line and expression, the flash of personality, or spirit (to use Cameron's theocentric terms) could be captured and framed as 'objective' by an authorizing text. As Darwin observed, in his introduction to *The Expressions*, it was easy 'to be misguided by our imagination' when looking at photographs without the empirical anchor of explanatory frameworks.[22] Adapted to suit King's edition, moreover, this principle reveals how Tennyson's poetry was transformed into the temporal anchor that tethered the visual apparatus of the book to the chronological arc of the poet's life, further reinforcing the empirical assumptions and nostalgic proclivities of Victorian biographical reading practices.

University Press, 1990). In this context also see Robert A. Sobieszek's discussion of Duchenne in *Ghost in the Shell: Photography and the Human Soul 1850–2000* (Cambridge, Mass.: MIT and LA County Museum of Art, 2000). Paul Ekman's definitive edition of Darwin's study also exemplifies this recent critical focus; Charles Darwin, *The Expression of the Emotions in Man and Animals*, with an introduction, afterword, and commentaries by Paul Ekman (London: Harper Collins, 1998). Phillip Prodger's appendix on the role of photography in the edition provides a detailed history of photographic techniques, Darwin's interaction with photographers, and photography's intersection with changing conceptions of the human face; 'Photography and *The Expression of the Emotions*', 399–410.

[21] Darwin may have also simply crossed the street on his arrival in London from Downe, Kent, as Rejlander's Albert Mansions studio was adjacent to Victoria Station.

[22] Darwin, Introduction to the First Edition, *The Expression of the Emotions in Man and Animals*, 21.

FACE TO FACE

> Had we such portraits of Shakespeare and of Milton, we should
> know more of their own selves. We should have better commen-
> taries on Hamlet and on Comus than we now possess, even as
> you have secured to us a better commentary on *Maud* and *In
> Memoriam* than all our critics have given us or ever will give us.
>
> F. D. Maurice to J. M. Cameron[23]

Like King, Frederick Denison Maurice focuses on Cameron's por-
traits rather than her tableaux in the letter cited above. Not only do
Cameron's luminous faces make the previously invisible visible, her
images promise the possibility of infinite returns to an unchanging
and irrefutable origin. This fascination with tracing back to origins
resonates with Barthes's account of the dynamics of photographic
authenticity: 'What the photograph reproduces to infinity has
occurred only once: the Photograph mechanically repeats what
could never be repeated existentially. In the Photograph, the event
is never transcended for the sake of something else: the Photo-
graph always leads the corpus I need back to the body I see; it is the
absolute Particular, the sovereign Contingency . . . the Occasion,
the Encounter, the Real, in its indefatigable expression.'[24] Interest-
ingly, however, locating Barthes's reading of photographs alongside
that of Maurice illuminates the mythic nature of both. Maurice,
like Barthes, ascribes an authenticity to the photographic event that
naturalizes its mediating powers—an ideal of transparency, which
the tricks and artifice of Rejlander and others knowingly destab-
ilized. And yet Maurice's stress on reading Tennyson's 'corpus'
through photographs echoes Rejlander's literary style, as much as it
contrasts with Barthes's insistence on photography's fundamental
invisibility:

Photography is unclassifiable because there is no reason to *mark* this or that
of its occurrences; it aspires, perhaps, to become as crude, as certain, as noble
as a sign, which would afford it access to the dignity of a language: but for
there to be a sign there must be a mark; deprived of a principle of marking,
photographs are signs which don't *take*, which *turn*, as milk does. Whatever

[23] Cited in H. H. Hay Cameron's introduction to Anne Thackeray Ritchie, *Lord
Tennyson and His Friends*, 7. [24] Barthes, *Camera Lucida*, 4.

it grants to vision and whatever its manner, a photograph is always invisible: it is not it that we see.[25]

Conversely, what fascinated Maurice, as much as it frustrated King, was that Cameron's images made photography itself visible—they left a mark no matter how blurred or ethereal. To quote Cameron's familiar defence of her technique to John Herschel:

> I believe in other than mere conventional topographic photography—map-making and skeleton rendering of feature and form without the roundness and fulness of force and feature, that modelling of flesh and limb, which the focus I use can only give, tho' called and condemned as 'out of focus.' What is focus—and who has a right to say what focus is legitimate focus? My aspirations are to ennoble photography and to secure for it the character and uses of High art by combining the real and ideal and sacrificing nothing of Truth by all possible devotion to Poetry and beauty.[26]

No one could just see through a Cameron image, as Cameron and Maurice's descriptions suggest. Cameron's photographs, to use Maurice's terms, are a 'commentary'—which in its rarest sense means a notebook and more commonly a memoir. Not only does Maurice see marks on a page, he identifies an implicit sequence that animates the sitter's face—ordering expression, feature, and gesture into a series of comments on the original.

Maurice's observations also register a sense of familiarity with both photography and the well-established physiognomic assumptions that shaped the consumption of both commercial and art portraiture. In this context, Cameron's peremptory dismissal of the more commercial incarnations of her art can also be read as what Bourdieu terms the 'practical negations' on which the art world's trade 'in things that have no price' thrives.[27] Vigilantly protecting the consecrating power of her signature style to increase the symbolic capital of her images in her letters to Tennyson, as well as to various publishers, editors, and critics, Cameron was in the business of playing the market, just like Tennyson and King. The only difference lay in what they were selling. For Cameron it was photography itself, its uncanny presence, its extraordinary markings on the page, rather than simply its infinite capacity to 'turn' itself into something else.

[25] Barthes, *Camera Lucida*, 6.
[26] Cited in Gernsheim, *Julia Margaret Cameron*, 14.
[27] Bourdieu, 'The Production of Belief: Contribution to an Economy of Symbolic Goods', *The Field of Cultural Production*, 74–5.

According to Cameron, her photography was poetry, a text to be read over and over until a deeper sense emerged from between the lines on the page. Whereas for King, the photographic illustration was merely an aspect of the commodity he was selling—an attraction that could be advertised and endorsed by the authorizing brand name that appeared beneath each of Cameron's images: 'From a photographic study by Julia Margaret Cameron.'

In her incomplete autobiographical fragment, *Annals of My Glass House*, first published in the exhibition catalogue of Cameron's photographs at the Camera Gallery in London in April 1889, Cameron anthropomorphizes and eroticizes the body of the camera: 'from the first moment I handled my lens with a tender ardour, and it has become to be as a living thing, with voice and memory and creative vigour'.[28] Invested with human-like agency, the camera speaks, remembers, and creates with a force and focus that transcends the photographer's conscious will. And, like all romantic accounts of poetic inspiration and the travails of the unrecognized avant-garde, the truth that emerges is valued by a like-minded, yet restricted, community of artists and shunned by a rule-driven cultural field whose ultimate approval is nevertheless sought above all:

I exhibited as early as May '65. I sent some photographs to Scotland—a head of Henry Taylor, with the light illuminating the countenance in a way that cannot be described; a Raphaelesque Madonna, called 'La Madonna Aspettante.' These photographs still exist, and I think they cannot be surpassed. They did not receive the prize. The picture that did receive the prize, called 'Brendan,' clearly proved to me that detail of table-cover, chair and crinoline skirt were essential to the judges of the art, which was then in its infancy. Since that miserable specimen, the author of 'Brendan' (Peach Robinson) has so greatly improved that I am content to compete with him and content that those who value fidelity and manipulation should find me still behind him. Artists, however, immediately crowned me with laurels, and though 'Fame' is pronounced 'The last infirmity of noble minds,' I must confess that when those whose judgment I revered have valued and praised my works, 'my heart has leapt up like a rainbow in the sky,' and I have renewed all my zeal.[29]

In this typical piece of self-promotional sophistry, Cameron not only distinguished her work from Peach Robinson and his Pre-Raphaelite

[28] Cameron, *Annals of My Glass House* (1874); rpt. in Appendix A, Gernsheim, *Julia Margaret Cameron*, 180. [29] Ibid. 181.

particularism, but also from all commerce in the fidelity and mani-
pulation that had become synonymous with Rejlander. These tech-
niques are implicitly opposed to the 'Artists' who saw the true value
of her work and awarded her with the symbolic capital she desired—
even if the remuneration of the photographic establishment would
continue to elude her grasp.

Part of the fall-out of the cabinet edition can also be traced through
Cameron's strenuous efforts to get her work reviewed in *The Times*.
Stressing that the photographs she provided for Tennyson's cabinet
edition had been given, not sold, Cameron initially wrote to Sir
Edward Ryan, who had contacts at *The Times*, asking him to press
her case with the paper's assistant editor, George Webb Dasent:

I have worked for three months putting all my zeal and energy to my high
task. But my beautiful large photographs are reduced to cabinet size for his
people's edition and the first illustration is transferred to wood cut and
appears now today when 12,000 copies are issued. I do it for friendship not
that I would not gladly have consented to profit if profit had been offered.
Dore got a fortune for his *drawn* fancy illustrations of these Idylls. Now
one of my large photographs, the one for instance illustrating Elaine . . . at
her best would excite more sensation and interest than all the drawings of
Dore—and therefore I am producing a volume of these large photographs
to illustrate the Idylls—12 in number all differing (with portrait of Alfred
Tennyson) in a handsome half morocco volume priced six guineas—I could
not make it under for it to pay at all. . . . It will make a beautiful Xmas Book
or Wedding Gift Book—The Elaine of May Prinsep and the Enid of another
lovely girl are as all agree *not* to be surpassed as Poems and Pictures and the
King Arthur all say is magnificent mystic mythical, a real embodiment of
conscience with piercing eyes and a spiritual air.[30]

Again the machinery of photography is made visible and the faces
that embody the ideals of Tennyson's poetry are self-consciously
positioned behind the glass of a display case that insists on its
own spectacular qualities as a mediating device. Yet Cameron's
photography is constructed as anything but transparent. Like the
evanescent curved glass of the Crystal Palace, it draws attention
to itself as a naturalized form of technological illumination that
surpassed all traditional forms of mediation. Dore's drawings and
Lewin's engraved woodcuts appear small and mechanical in this

[30] Cameron to Sir Edward Ryan, 29 November 1874, cited in Gernsheim, *Julia
Margaret Cameron*, 44.

account, in contrast to the grandeur and luminosity of the images Cameron offers to her consumers. Unlike the Crystal Palace, however, the price of abandoning oneself to wonder and impressionistic reverie in Cameron's world was prohibitively expensive, unless, of course, one was privileged to circulate inside the gift economy of the Cameron and Tennyson milieu.

Yet if the sonnet written in honour of Cameron by one of Tennyson's brothers, Charles Turner Tennyson, was to be believed, no price was too high:

> Lo! Modern Beauty lends her lips and eyes
> To tell an Ancient Story! Thou hast brought
> Into thy picture, all our fancy sought
> In that old time; with skilful art and wise
> The Sun obeys thy gestures and allows
> Thy guiding hand, when'er thou hast a mind
> To turn his passive light upon mankind,
> And set his seal and thine upon chosen brows.
> Thou lov'st all loveliness! And many a face
> On thine immortal charts to take its place
> While near at hand the jealous ocean roars
> His noblest Tritons would thy subjects be,
> And all his fairest Nereids sit to thee.[31]

Emerging from these overwrought lines is something akin to Benjamin's account of photography's revelatory powers: the power of the photograph to slow motion, illuminate, and make the observer aware of what had previously eluded perception. Turner Tennyson simply gives this phenomenon a legible literary and market value, advertising its attractions through illustrious classical associations. And again, it is photography's power to impress and sequence that is stressed. The poem emphasizes that the noble physiognomies that Cameron's art immortalizes are perceived through the storytelling device of the camera's lens, while Cameron herself is nostalgically reinvented as one part muse, one part romantic heroine, one part handmaid; hardly a rebellious pose, and one that we can assume Cameron sanctioned given that Turner Tennyson's sonnet was accorded pride of place in the first volume of her *Illustrations*.

When her volumes were finally reviewed, using language suspiciously like Cameron's own account of her work in the various letters

[31] Cited in Gernsheim, *Julia Margaret Cameron*, 48.

she had sent to influential acquaintances, it was in *The Morning Post* and not in *The Times* as she had hoped. Here also, the technology of photography—the time taken to produce the volumes, the intensive labour, and the number of prints—was prioritized:

Mrs Cameron is said to have spent 3 months of unceasing care upon the preparation of this volume of photographs and at what cost of time and toil they have attained, their excellence may be inferred from the fact that, in order to produce even so small a collection, she has had to take quite 200 studies. For one scene alone—that descriptive of the 'parting between Lancelot and Guinevere'—she took forty-two. It is only the zeal that beguiles labour, the passionate zeal which is the soul of art, could have carried her triumphantly through so many and such harassing ordeals. Nor is it difficult to understand how rare and arduous must be the conditions of success in studies such as these, which presuppose high artistic feeling not only in the governing mind which has the regulating of light and shade, the positioning and grouping of figures, and the general arranging of the whole composition, but also in the 'sitters', who must be no mere models in the ordinary sense of the words, but men and women of peculiar types, combining with fine physique high mental culture as well, and abundantly imbued with the poetic spirit of the themes they cooperate in illustrating. They must be people who understand the significance of the action and gesture, and the impact of dramatic expression. In this regard Mrs Cameron has been particularly fortunate, the representatives of her dramatic personae being evidently individuals who, thus highly qualified, partake her inspiration and lend themselves to the realisation of her poetic conceptions.[32]

This passage reveals the strain involved in holding the balance between labour and value in an economy and in a material form predicated on their alienation. The unabashed bias of the account also lends credibility to Helmut Gernsheim's theory that Cameron wrote it, or at least played a part in its authorship. But there are other issues at stake in this review which intersect with both Carol Armstrong's cinematic analogy and Barthes's theorization of the unique temporality of photography, and in particular, with the distinction made in *Camera Lucida* between still and moving images. Barthes describes the cinema in terms of a 'continuous voracity' that refuses the temporal lag of exegetic or textual framing: 'Do I add to the images in

[32] 'Mrs Cameron's Photographs', *Morning Post* (11 January 1875). This particular copy is pasted in the back of the second volume of Cameron's illustrations in the Gernsheim Collection, Harry Ransom Humanities Research Center, University of Texas, Austin.

movies? I don't think so; I don't have time: in front of the screen, I am not free to shut my eyes, opening them again, I would not discover the same image; I am constrained to a continuous voracity; a host of other qualities, but not pensiveness.'[33] He responds to this visual experience by resistance and a self-restraint that he compares to the arresting effect of poetic form:

Resistance to cinema: the signifier itself is always, by nature, continuous here, whatever the rhetoric of frames and shots; without remission, a continuum of images. The film (our French word for it, *pellicule*, is highly appropriate: a skin without puncture or perforation) *follows*, like a garrulous ribbon: statutory impossibility of the fragment, of the haiku. Constraints of representation (analogous to the obligatory rubrics of language) make it necessary to receive everything . . .[34]

Facing such an onslaught of images is only bearable if the residual possibility of stasis, and of poetry that slows down the garrulous freneticism of film, can be kept alive in the mind of the pulverized observer.

Thus, as so many of his Victorian predecessors had done before him, Barthes merges photographic and poetic form in a nostalgic drive to dissipate the inescapable pathos of attempting to hold onto substance in a world of flux and shifting surfaces. This brings the figure of Rossetti's train traveller to mind, shutting his eyes against the speed of framed images passing by so that just a few frames can be salvaged and transformed into poetry. Like Barthes and Rossetti, Cameron pointedly aligned the technological apparatus of the camera with a form that did not talk back easily—a haiku, a lyric, a poetic fragment, that breaks the associative continuity of the observer; a self-consciously anti-cinematic form that is nevertheless haunted by its antithesis. For Cameron, calling her photographs poetry removed them as far as possible from the fairground attractions of commercial photography, an interested distinction which many of her late twentieth-century critics have been more than happy to preserve. Mike Weaver, for example, argues in his introductory essay to the *Whisper of the Muse* that this was Cameron's 'special contribution to photography': 'never before in the history of art have ontology and epistemology been embodied in a single medium. The historical and the devotional are one to Mrs Cameron. Thus in her work we find the

[33] Barthes, *Camera Lucida*, 55. [34] Ibid. 54.

embodiment of the ideas of Keble and Newman. Hers is a poetry of photography.'[35] But the citations from Keble and Newman that Weaver enlists to substantiate his claim reveal the deeply felt nostalgia that guides his own generous mystification of his subject as the muse and mediator of the Oxford Movement's mythic sense of poetic form as spirit embodied. To substantiate his legitimation of Cameron, for example, Weaver also cites what he describes as Keble's embrace of the 'possibility of a poetry of everyday objects, events, and persons':

> Be it addressed to the eyes, ear or mind only; be it a song of Handel, a painting of Reynolds, or a verse of Shakespeare; if it 'transports our minds beyond the ignorant present', if it fills us with consciousness of immortality, or the pride of knowing right from wrong, it is to us, to all intents and purposes, poetry. Nor is it uncommon in language to hear of the poetry of sculpture, the poetry of painting.[36]

By enlisting this passage to function as legitimizing historical context, Weaver effectively sanctions its idealism in the interests of canonizing Cameron's work as the ultimate materialization of Keble's poetics.

Similarly, Weaver invokes Newman's 1829 essay on 'Poetry' to stress both the Christian and philosophical coherence of Cameron's aesthetics: 'With Christians, a poetical view of things is a duty—we are bid to colour all things with the hues of faith, to see a divine meaning in every event and a Superhuman tendency. Even our friends, around are invested with unearthly brightness—no longer imperfect man, but beings taken into Divine favour, stamped with His seal, and in training for future happiness.'[37] Exploring the cultural implications of Newman's Christian aesthetics, Weaver's subtle typological interpretation then traces the undeniable and profound Christian influence on Cameron's iconographic style—an invaluable reading of Cameron's own volumes, yet one that the production history of

[35] Mike Weaver, *The Whisper of the Muse: The Overstone Album and Other Photography by Julia Margaret Cameron* (Malibu, Calif.: The J. Paul Getty Museum, 1986), 24.

[36] Other photographers and publishers were more explicit in their homage to Keble, producing photographically illustrated editions of the popular *The Christian Year* and illustrated guides to his home and haunts. These publications, which are cited in full in the second chapter, included John Frewen Moor's *The Birth-Place, Home, Churches and Other Places Connected with the Author of 'The Christian Year'*.

[37] Cited in Weaver, *The Whisper of the Muse*, 24.

the cabinet edition complicates. For despite the illustrious associations made by Victorian and contemporary critics alike, images of the vulgar fleshiness of Madame Tussaud's waxworks haunt Cameron's prose, perversely tethering her ethereal figures to the popular Victorian trade in uncanny likenesses, as well as its postmodern incarnations. In this context her calls for distinction mattered little. The ultimate marketability of her images depended upon the popular taste for celebrity likenesses, which had ensured the success of attractions such as Madame Tussauds. Here also, Cameron's correspondence promoting her edition is revealing. Addressing an unidentified acquaintance connected with the Bristol Art Society Cameron wrote: 'Our great Laureate Alfred Tennyson himself is very much pleased with this ideal representation of his Idylls and his own Portrait is the one he most likes, indeed it is like one of the Prophets of old. The hollow oak in Merlin came off the Poet's own grounds.'[38] Revealing her deep investment in the Victorian culture of celebrity, Cameron shamelessly trades on her connections with the Laureate here, whilst also explicitly catering to the touristic desire for literary memorabilia of which the *cartes de visite* portraits that she scorned so intensely were the staple currency.[39]

WAXWORKS, FAIRGROUND LIKENESSES, AND VULGAR FASHIONS

> I took another immortal head, that of Alfred Tennyson, and the result was that profile portrait which he himself designates as the 'Dirty Monk'. It is a fit representation of Isaiah or of Jeremiah, and Henry Taylor said the picture was as fine as Alfred Tennyson's finest poem. The Laureate has since said of it that he liked it better than any photograph that has been taken of him *except* one by Mayall, that *except* speaks for itself. The comparison seems too comical. It is rather like comparing one of Madame Tussaud's waxwork heads to one of Woolner's ideal heroic busts.
>
> Julia Margaret Cameron, *Annals of My Glass House*[40]

[38] Cited in Gernsheim, *Julia Margaret Cameron*, 48.
[39] In contrast, Mike Weaver argues that 'Mrs Cameron was maligned as a lion-hunter when she was, more correctly, a true hero-worshipper', in *The Whisper of the Muse*, 55. [40] Cameron, *Annals of My Glass House*, 183.

It is no coincidence that the Mayall portrait, to which Cameron refers above, is the portrait that serves as the frontispiece of the first volume of King's cabinet edition. Desperate to distinguish her work from her far more successful commercial contemporary, Cameron overstates the case and reveals her hand.[41] Yet while her complaints rehearse the familiar strains of misunderstood genius, there is a more implicit argument about different modes of photographic time being made here. Cameron's fixation on that '*except*' registers her outrage that Tennyson has valued the ephemera produced by Mayall's commercial studio over her own immortalizing poetic images. Moving dangerously close to the vulgar world of spectacle, a world of transience, dissociation, distraction, opacity, and illusion, Tennyson's misguided taste for Mayall's photographs threatens Cameron's mythic alignment of photography and poetry with another far more powerful and profitable alignment of photography and publicity. Moreover, Cameron's reference to Thomas Woolner's bust of Tennyson only serves to reinforce the suppressed critique of the cabinet edition in this passage, as well as registering the sustained impact of this disappointing experience on Cameron's vehement resistance to any blurring of the lines between the grubby secularity of commercial photography and the sacred production of belief in which she insisted her photographs traded.

Although he would ultimately remain indifferent to her particular investment in protecting the integrity of her images, Tennyson shared many of Cameron's concerns about the role of illustration in the cabinet edition. From the very early stages of the cabinet edition, Tennyson had been in conflict with his publishers. Indeed, over a decade passed between Tennyson's initial idea of issuing a selection of his more popular poems in sixpenny parts for the working men of

[41] Mayall made his photographic reputation in the 1840s with a series of allegorical genre daguerreotypes, including a series inspired by the Lord's Prayer (1845) and an illustrative sequence based on Thomas Campbell's poem *The Soldier's Dream* (1848). He also exhibited seventy-two daguerreotypes at the Crystal Palace, submitted images to the *Illustrated London News* and the ill-fated *Illustrated News of the World & Drawing Room Portrait Gallery of Eminent Personages*. He made his fortune in 1860, however, with a series of fourteen *cartes de visite* portraits of Queen Victoria. Called the *Royal Album*, this collection sold in the thousands, establishing Mayall's profile as a celebrity photographer; a profile that he capitalized upon, producing the countless portraits and portrait books of eminent Victorians that are discussed in context in Ch. 1 above.

England and its eventual publication in 1874. That it was published at all has as much to with the affable and entrepreneurial skills of King, who took over from Moxon as Tennyson's publisher in the 1870s. King took a more pragmatic and populist approach to the publication of Tennyson's poems, of which the people's edition would become an integral part. Although no publishing records survive, the reputed scale of the edition is a sign of King's ambition. According to June Steffensen Hagen, King printed twelve thousand copies of each volume in its first year and the edition must have been relatively profitable given that King subsequently published a multi-volume author's edition a year later, followed by a new edition of the seven-volume imperial library edition in 1877.[42]

Photographic illustration also seems to have been a pivotal aspect of King's and later Kegan Paul's vision for promoting their difficult client. And even though Tennyson would continue to resist the demands of his hero-worshipping audience, he was equally happy to profit from the sales of such popular editions. The conflicts over illustration between Kegan Paul and Tennyson, however, would prove to be particularly heated. During one exchange Paul even threatened to take matters into his own hands by reminding Tennyson that illustrations could hardly 'be considered other than a publisher's question'.[43] On a more conciliatory note, in a letter dated 5 August 1874, Paul tried to cajole Hallam Tennyson into permitting him to reproduce a facsimile of a manuscript page; a practice that he claimed to 'dislike as much as anyone', insisting that 'anything like over curiosity about a man's private life' was an impertinence. Yet it was one that he evidently felt was worth indulging, as he continued: 'I must say that a desire to possess the *ipsissima verba*, or as near them as may be of one we love and respect seems to be a blameless little bit of the instinctive worship we pay to those we love.'[44] Significantly, concern about exposure and publicity defines these arguments. Even Cameron herself was charged with transforming the Laureate into a readily identifiable public personality, albeit good-naturedly, by Tennyson himself; a somewhat unfair charge given that Rejlander's and Mayall's portraits would have been far more responsible for this unnerving phenomenon than Cameron.

[42] June Steffensen Hagen, *Tennyson and His Publishers* (London: Macmillan, 1979), 138. [43] Ibid. 139–40.
[44] Ibid.

Suiting the biographical emphasis that both King and Kegan Paul intended for the edition, Mayall's portrait began life as a *carte de visite*. In this guise it epitomized the inventor A. A. Disderi's notion of the form as visual biography. Disderi insisted in a published manual that 'One must be able to deduce who the subject is, to deduce spontaneously his character, his intimate life, his habits.' In addition, he continued, the photographer must capture 'the language of the physiognomy, the expression of the look' and, as a result, 'must do more than photograph, he must biograph'.[45] Cropped and illuminated to accentuate the Laureate's imposing forehead and unusually pristine beard and collar, Mayall's image conforms to both the conventions of celebrity portraiture and the conventional syllogisms of physiognomic description. The face dominates, forcing the eye to focus on the lines that surround the deep-set and searching eyes of the poet and the high and noble forehead that curves down to meet his nose. Lines such as these around an imposing nose had particular significance for physiognomists such as Lavater who argued that: 'A nose physiognomically good is of unspeakable weight in the balance of physiognomy: it can be outweighed by nothing whatever. It is the sum of the forehead, and the root of the underpart of the countenance. Without gentle archings, slight indentations, or conspicuous undulations, there are no noses which are physiognomically good, or intellectually great.'[46] Likewise, the high curved forehead that Mayall's studio lighting accentuated was also of great significance in Lavater's system: 'The forehead, height, arching, proportion, obliquity, and passion of the skull or bone of the forehead, show the propensity, degree of power, thought, and sensibility of man. The covering, or skin, of the forehead, its position, colour, wrinkles, and tension, denote the passions and present state of the mind.—The bones give the internal quantity, and their covering the application of power.'[47] And while it is important not to overplay the role Lavater's particular principles of physiognomy may have had in the Victorian consumption of Mayall's image, in this case they also clearly parallel the typological preoccupation with embodying psychological states or Christian ideals which was so central to Cameron's aesthetics. Furthermore,

[45] Cited in Elizabeth McCauley, *A. A. E. Disderi and the Carte de Visite Portrait Photograph* (New Haven: Yale University Press, 1985), 41.

[46] J. C. Lavater, *Essays on Physiognomy, Designed to Promote the Knowledge and the Love of Mankind*. Illustrated by more than eight hundred engravings accurately copied and some duplicates from originals; trans. H. Hunter (Zurich, 1775–7; London, 1789–98); i. 471.　　[47] Ibid. i. 379–80.

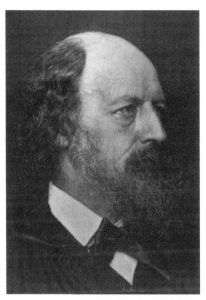

18. John Mayall portrait
of Alfred Tennyson

19. Julia Margaret
Cameron portrait of
Tennyson as 'The Dirty
Monk'

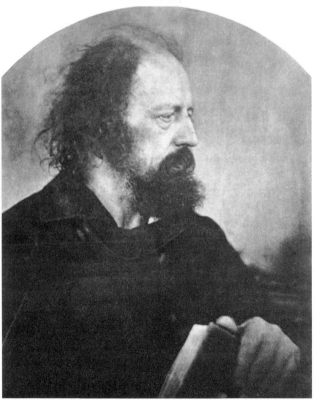

Lavater's framework suggests a possible explanation for both Tennyson's preference for Mayall's portrait over Cameron's, and King's preference for Lewin's engraved stylizations of Cameron's images in general.

In contrast to Mayall's representation of Tennyson as the public man, Cameron's portrait, which served as the frontispiece for her own two-volume edition, presents a more private, flawed persona. Rather than occupying the central foreground of the image, the poet's face recedes into the background; a visual effect that emphasizes his reclusiveness rather than his modernity and connection to his readers. Painterly in composition and cropped to include the upper part of his body, Tennyson is swathed in a dark cloak that conceals his modern clothing, while the noble brow that Mayall accentuates is surrounded by a tangle of dirty hair. Thus, while both portraits are concerned with the revelation of personality, Mayall's image offered a commentary more commensurate with King's commercial aspirations and Lavaterian convention. But, it must be stressed, one that was no less concerned with the reciprocity between photographic and poetic myth-making than Cameron's. Where the conceptual significance of the background tension and contrasts between Mayall's and Cameron's portraits lies, therefore, is not in the latter's resistance to the patriarchal politics of either Tennyson's mode of public presentation or the marketplace that she had happily consented to enter when she agreed to produce photographs for the edition, but rather as a register of the protean nature of early photographic practices and their engagement with the more commercial aspects of Victorian literary culture.

These tensions become even more apparent in Lewin's translation of Cameron's image of 'Lancelot and Elaine'. As Cameron's own underlined textual framing of the two images in her subsequent *Illustrations* reveals, her photographs specifically adapted the following fragments from Tennyson's poem:

> Elaine the fair, Elaine the loveable,
> Elaine, the lily maid of Astolat,
> High in her chamber up a tower to the east
> Guarded the sacred shield of Lancelot;
> Which first she placed where morning's earliest ray
> Might strike it, and awake her with the gleam;
> Then fearing rust or soilure fashion'd for it
> A case of silk, and braided thereupon

All the devices blazon'd on the shield
In their own tinct, and added, of her wit,
A border fantasy of branch and flower,
And yellow-throated nestling in the nest.
. . .
So in her tower alone the maiden sat:
His very shield was gone; only the case,
Her own poor work, her empty labour, left.
. . .
And in those days she made a little song,
And called her song 'The Song of Love and Death,'
And sang it: sweetly could she make and sing.[48]

In her reading of Cameron's adaptations of the poem, Carol
Armstrong argues that the above underlinings 'ask the reader to
attend twice to a female act of fashioning, of accoutrement and its
detail, and slight modifications from one image to another'.[49] Yet,
Armstrong also notes Cameron's 'rather odd' decision to emphasize
'the fashioning of the case and design of its embroidery' in the first
excerpt, rather than Elaine's solitude. But, ultimately, this does not
prevent her from concluding that this noteworthy oddity is of less
significance than the filmic qualities of Cameron's transgressive
domestication of Tennyson's original: 'It is as if she wished to remove
Elaine from Tennyson's lofty domain of doomed, obsessive love and
tragically misdirected chivalry to more finicky household matters
such as sewing; and in this way as well to convert his high author-
ship into more lowly female fashioning.'[50] But this subtle reading
risks underplaying the fetishistic representation of feminine craft
in Tennyson's original, as well as the evident symmetry between
Cameron and Tennyson's domestic evocations of Elaine. Rather
than anchoring Tennyson's lofty vision in the material world,
Cameron's 'odd' underlining stresses the affinity that her image has
with Tennyson's domestic idealization of Elaine; an emphasis which
implicitly promotes the textuality of her craft in an effort to elevate
herself to Tennyson's lofty domain, rather than to draw his poetry
into the everyday time of household rituals.

Significantly, the stress on the deathly convergence of erotic
obsession and the compulsion to materialize that obsession that

[48] Cameron, *Illustrations To Tennyson's Idylls of the King, and Other Poems*,
i. n.p. [49] Armstrong, *Scenes in a Library*, 400.
[50] Ibid.

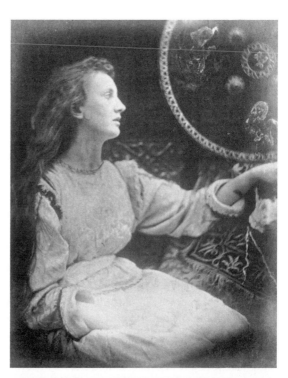

20. Julia Margaret Cameron, *Elaine*

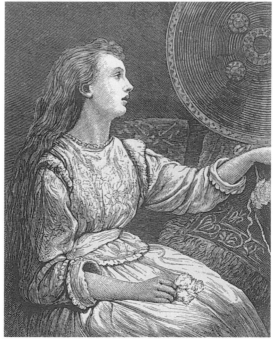

21. Thomas Lewin's engraving of Cameron's *Elaine*

characterizes both Cameron's and Tennyson's versions of the Elaine and Lancelot myth is the feature that Lewin's engraving brings into focus. Lewin makes details on the shield, which are barely visible in Cameron's original, into a featured aspect of the image. This metonymic rendering of Elaine's will to materialize Lancelot's absent presence would also seem to emphasize precisely the aspects of the poem that Cameron had chosen as her focus. Again, therefore, the basis of Cameron's engagement not only with Tennyson's poem, but with the cabinet edition as whole devolves into diverging conceptions of their proximity to the original; a creative tension over the technology of reproduction that lacks the political frisson that Armstrong's evocative reading suggests.

Lewin's next engraving of Cameron's 'photographic study' of Arthur echoes the contraction of focus and intensification of expressive details that characterized his version of Elaine. More significantly still, his intensification of the planes of light on Arthur's face and heightening of the contours of his nose and brow creates such a striking parallel with Mayall's portrait that it is almost impossible to imagine these formal echoes to be unintentional on the part of either King and Paul, or Lewin himself. The evident symmetry between Arthur and Tennyson in King's edition, however, is even more apparent in the first of Cameron's volumes, which began with her portrait of Tennyson and concluded with the image at Fig. 23 and a second three-quarter profile portraying Arthur in the act of drawing Excalibur before embracing death (Fig. 24). This symmetry is then further reinforced by the fragments that Cameron cites and underlines from 'Guinevere' and 'The Passing of Arthur' respectively:

And while he spake to these his helm was lower'd,
To which for crest the golden dragon clung
Of Britain; so she did not see the face,
Which then was an angel's, but she saw,
Wet with the mists and smitten by the lights
The Dragon of the great Pendragonship
Blaze, making all the night a steam of fire.
And even then he turn'd; and more and more
The moony vapour rolling round the King,
Who seem'd the phantom of a Giant in it,
Enwound him fold by fold, and made him gray
And grayer, till himself became as mist
Before her, moving ghostlike to his doom. ('Guinevere', 589–601)

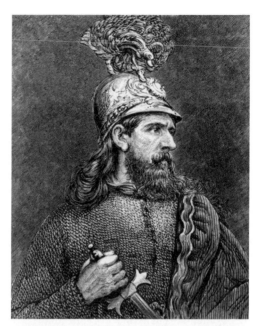

22. Thomas Lewin's engraving of Cameron's *Arthur*

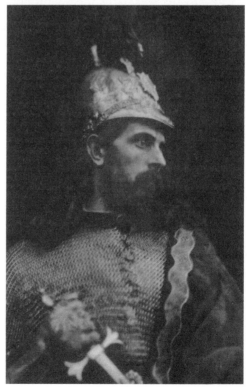

23. Julia Margaret Cameron, *Arthur*

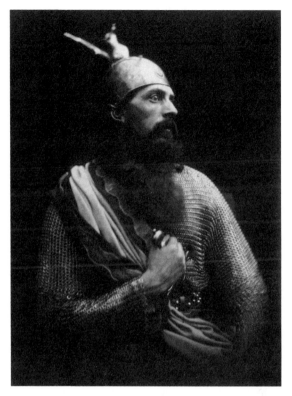

24. Julia Margaret Cameron, *Arthur drawing Excalibur*

Then spake the King: 'My house hath been my doom.
But call not thou this traitor of my house
Who hath but dwelt beneath one roof with me.
My house are rather they who sware my vows,
Yea, even while they break them, own'd me King.
And well for thee, saying in my dark hour,
When all the purport of my throne hath fail'd,
That quick or dead thou holdest me for King.
<u>King am I, whatsoever be their cry;</u>
And Lone last act of kinghood shalt thou see
Yet, ere I pass.' And uttering this the King
Made at the man ('The Passing of Arthur', 154–65)

In the case of both extracts and their relation to Cameron's photo-
graphs the underlining reveals not only what Gerhard Joseph has

described as Cameron's photographic mirroring of the formal 'optics of Tennyson's poetry', but, even more significantly still in this context, a knowing amplification of the poem's conservative ideological message to Victorian readers that the interests of monarchy and empire must be preserved above all else.[51] In both extracts Cameron's underlining invites the reader to relate the revelation and survival of Arthur's imposing spirit to the equally imposing presence of its contemporary mediator, the poet himself. As Carol Armstrong observes of the first underlined extract and illustration: 'With this illustration she returns the reader to Tennyson and his text, linking the figure of Arthur to the opening features of the poet, and asserting the connection between one 'Giant' and the other.'[52] Seen through Guinevere's tainted eyes, Arthur is resurrected as a medieval incarnation of Christ, a typological genealogy into which both Tennyson's portrait and the contemporary emissaries of the British Empire are implicitly assimilated. Yet again, while it is true that Cameron's selection of Guinevere as mediator locates a female observer at the centre of the drama, the effect is ultimately reverential rather than subversive; a dynamic that Lewin's engraving appropriately amplified to suit the civilizing mission of the cabinet edition.

This ideological and aesthetic convergence is even more apparent in Lewin's engraving of Cameron's illustration of Tennyson's *Maud*, the ninth frontispiece in the cabinet edition. Cameron's decision to illustrate a politically controversial poem such as *Maud* with a portrait of a winsome adolescent girl immersed in her own private reverie could also be read as a form of transgressive adaptation. But this reading is only convincing if one argues that Cameron's intention was to supplant rather than supplement Tennyson's text. For while the dramatic contrast between Cameron's soft-focused portrait and the cold 'clear cut face, icily regular' and 'splendidly null' of Tennyson's original only further undermines the authority of the poem's speaker, the extent to which this divergence can be read as strategic depends on how one interprets the poet's biographical relation to the ravings of his monomaniacal subject.[53] Many of

[51] Gerhard Joseph, *Tennyson and the Text: The Weaver's Shuttle* (Cambridge: Cambridge University Press, 1992), esp. Ch. 4.

[52] Armstrong, *Scenes in a Library*, 416.

[53] All references to Tennyson's poems, unless otherwise specified, will be according to *The Poems of Tennyson*, ed. Christopher Ricks, 3 vols. (London: Longman, 1987).

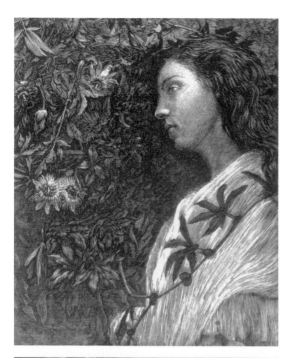

25. Thomas Lewin's engraving of Cameron's *Maud*

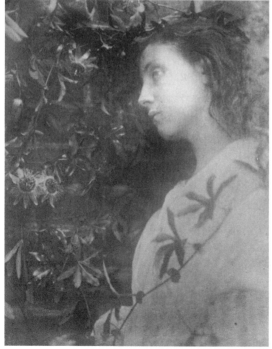

26. Julia Margaret Cameron, *Maud*

Tennyson's contemporaries, such as W. C. Bennett who penned the 1855 satirical pastiche 'Anti-Maud' by a 'Poet of the People', assumed that this identification was as unambiguous as it was repellant. But, as Isobel Armstrong convincingly argues, the dangerous fusion of eroticism and violence that converges in the speaker's manic idealization of Maud is itself destabilized by a portrayal of madness that resolves itself into the energetic nihilism of a Schopenhauer-like affirmation of will. According to Armstrong, the poem's ascription of 'the responsibility for madness to an ever-widening circle of agencies' works systematically to destabilize conventional dichotomies between rational and irrational, insiders and outsiders, love and hate, war and peace: '*Maud's* project is to negotiate contradictions of a structural kind which occur when madness and the norm merge into one another and become conflated. Questions of agency and choice become paramount as the madman becomes painfully responsible for the madness which is at the same time society's madness.'[54] In Armstrong's reading the poem constructs war as simply another manifestation, like the hauntingly vacuous beauty of Maud, of Victorian society's crazed degeneration of the once vital bonds of family, love, and selfless action; a reading that differs dramatically from interpretations of the conclusion of the poem as Tennyson's therapeutic restoration of the speaker's sanity through the embrace of the purifying violence of war.

If they chose to confront the destabilization of reason, gender, family, economy, and society in *Maud* that Isobel Armstrong describes, Victorian critics typically used terms such as 'morbid', 'grotesque', or 'effeminate' to register their disapproval.[55] Or, an alternative response was to simply disavow the more disturbing implications of *Maud* by focusing on genre and praising the poem's dramatic strengths. This approach is exemplified by the cabinet edition, which reinforces parallels with the dramatic idyll *Enoch Arden* that had initially caused critics to dub Tennyson the 'poet of the people' and was the catalyst for the idea of producing an edition for the working men

[54] Isobel Armstrong, 'Tennyson in the 1850s: From Geology to Pathology— *In Memoriam* (1850) to *Maud* (1855)', *Tennyson: Seven Essays*, ed. Philip Collins (London: Macmillan, 1992), 126.

[55] Herbert Tucker's analysis of morbidity in Tennyson's poetry offers an early account of this reception and such themes, in *Tennyson and the Doom of Romanticism* (Cambridge, Mass.: Harvard University Press, 1988).

of England. The coupling of *Maud* and *Enoch Arden* on the ninth volume's title page effectively counterbalanced one of the least successful of Tennyson's poems with one of the most popular. In this context, Lewin's engraving merely amplified this emphasis on the subtleties of form and beauty. But, again, this adaptation of Tennyson's vision was not so far removed from Cameron's image as her disappointed response might suggest. Revealingly, the lines Cameron's original illustrated are from the final two stanzas of Part I:

> There has fallen a splendid tear
> From the passion-flower at the gate.
> She is coming, my life, my fate;
> . . .
> She is coming, my own, my sweet;
> Were it ever so airy a tread,
> My heart would hear her and beat,
> Were it earth in an earthy bed;
> Had I lain for a century dead;
> Would start and tremble under her feet,
> And blossom in purple and red.

Spoken in a state of romantic reverie, these stanzas provide a nostalgic counterpoint to the increasingly frenetic monologic drive of the speaker. They reflect on a moment taken out of time, an idyllic scene that reveals Cameron's own investment in the romantic and lyrical aspects of the poem. But read in a broader cultural context of the poem, Cameron's encouragement of her audience to identify with the speaker's recursive contemplation of the luminous beauty of Maud merely reinforces his reactionary politics and evocation of an interiority deeply at odds with the world on the other side of the garden wall.

This is the aspect of Cameron's work that Roger Fry seized upon in his own interested and nostalgic version of what went on behind the garden walls of Farringford to nurture the romantic individualism that Cameron and Tennyson's idylls celebrated. Arguing that photography had still not established itself as an 'independent art' by 1926, when the collection of Cameron's photographs that he co-introduced with Virginia Woolf was published, he constructs his essay as the catalyst for a major reconsideration of why photography 'has never managed to get its Muse or any proper representation on

Parnassus'.[56] According to Fry, the 1860s and 1870s were an exceptional period in which the fixation on personality, combined with the new freedom of individual expression that Cameron's work epitomized, was transmitted by the modern wonder of photography to the broader public beyond the garden wall. Yet, as his essay unfolds, Fry's highly ironic treatment of both Cameron and her subjects destabilizes his ultimately positively disposed assessment of photography as an art. Contrasting with Anne Thackeray Ritchie's recollections of the protected environs of Farringford with which this chapter began, Fry's wit transforms the language of gardening into a withering satirical tool: 'In that walled-in garden of solid respectability, sheltered by its rigid sexual morality from the storms of passion and by its secluded elevation from the shafts of ridicule, that pervading seriousness provided an atmosphere wherein great men could be grown to perfection—or rather in which men of distinction could be forced into great men.'[57] Unable to resist the bathetic potential of this wordplay, he then proceeds in a similar vein:

In that protected garden of culture women grew to strange beauty, and the men—how lush and rank are their growths! How they abound in the sense of their own personalities! There is Sir Joseph Hooker, a learned and celebrated botanist, but no earth-shaking genius—how superbly he has sprouted in that mild and humid air. Then there was no need to grow defences, no apologies were expected, no deprecating ironies; these men could safely flaunt all their idiosyncrasies on one condition only, that of staying within the magic circle of conventional morality. Browning alone seems to take no advantage of the situation. Was it a deeper sense of life, a knowledge of character, which went behind the façades and undermined his own security? He is the least naïve of all. But the Poet Laureate flames out all the more, by comparison, with his too ambrosial locks. How he basks in the genial warmth.[58]

Proving himself to be an archetypal modernist, Fry dispenses with his Victorian forebears' eccentric anachronisms and mediocrity here, singling out Tennyson for particularly harsh treatment. And although he does remark on the earnestly felt sense of public identity and celebrity that profoundly distinguished Victorians from Modernists, the cultural significance of this distinction is lost on him. He simply notes in passing how curious it was that writers and artists

[56] Roger Fry, 'Mrs Cameron's Photographs', Introduction to Cameron, *Victorian Photographs of Famous Men and Fair Women by Julia Margaret Cameron*, 9.
[57] Ibid. 10. [58] Ibid. 11.

were so much on show and how 'anxious they are to keep it up to the required pitch'.[59]

As Fry develops his argument, however, significant parallels begin to emerge with the romanticism of early photographic discourse. This is particularly evident in his concluding discussion of Victorian portraiture and the unknowable contingencies of the photographic event. Praising the expressive qualities of Victorian photography and condemning the caricaturish style of modern commercial photography, Fry concluded with an appeal for less rigid distinctions between the creative and mechanical arts. And a crucial aspect of this opening up of aesthetic possibilities, according to Fry, was to disentangle notions of intimacy and contact from the creative process:

The importance usually attributed to manual skill in pictorial art has, I think, prevented hitherto a fair discussion of the position of photography as a possible branch of visual art. We have a natural tendency to put aside any work in which mechanism replaces that nervous control of the hand which alone seems capable of transmitting the artist's feeling to us. We are, I think, quite right to esteem this quality of works of art very highly, but we are wrong to consider it a sine qua non of all artistic expression. With the inevitable growth of mechanical processes in the modern world we shall probably become increasingly able to concentrate our attention on those elements of artistic expression which do not depend upon this intimate contact at every point of the work . . . Other qualities undoubtedly remain, such, for instance, as the general organization of the forms within a given rectangle, the balance of movements throughout the whole structure, the incidence, intensity, and quality of the light . . .[60]

Fry's argument is an interesting one in the context of early celebrations of the autographic aspects of photography and the role intention and inspiration play in the arrangement and framing of objects, movement, and light. His flirtation with separating artistic creation from the intimate touch and variations that result from the 'nervous control of the hand', tentatively gestures towards an understanding of art no longer tethered to the sanctified tools of pen or brush. But the intersection of Fry's observations with the work of poets in the 1880s and 1890s, such as Augusta Webster and Agnes Mary Frances Robinson, whose work will be the focus of the final chapter of this study, are equally compelling. Fry's subtle move towards abstract arrangements of forms and light and away from more reproducible

[59] Ibid. [60] Ibid. 14.

standardized photographic practices such as commercial portraiture is a move that Chapter 7 charts through the responses of Webster and Robinson to the idea of the mass-produced image. Like Fry, both Webster and Robinson engage with photography, although in a form that Fry derides—their own commercial portraits which were then sold and reproduced in *Harper's New Monthly Magazine*. Whether Webster or Robinson approved of this process is unknown. But the fact that this mode of photographic mediation was an aspect of their literary careers remains as a formative context for the fascination with the limits of automatism and illusion that informs their work. A fundamental change in the structural logic of image production that is evident in Fry, and is more generally ascribed to modernist and particularly surrealist aesthetic practice by Rosalind Krauss and others, emerges in the comparative sensibility of both these poets; a sensibility moreover, that is inseparable from the increasingly photographic conditions not only of literary culture, but of the everyday lives of Victorian consumers.[61]

[61] Rosalind Krauss, 'The Photographic Conditions of Surrealism,' *The Originality of the Avant-Garde and Other Modernist Myths*, 87–118.

Literary Ephemera and the Timeless Image in Late Nineteenth-Century Literary Culture

The American author whose ancestral instinct has led him to England . . . has found the domain of letters a republic, and this through the instant and impartial brother hood accorded him by those who now, in the glow and vigour of their prime, stand for English literature and song . . . He reads the writings of his welcomers, and sees new meaning between the lines: and in looking afterward upon their likenesses he thanks the camera for making life heartier for us than it could have been in the most golden of former times. I have a group of photographs, some of them the portraits of those ribboned seniors whose features are long familiar, others of the younger clansmen of Arcady in London. From these, and chiefly from the latter class, let me select a few for reproduction here. In doing this, and in giving some brief notice of their originals . . . I shall not be a critic, but a recounter: just for once venturing upon literary tea-gossip, half afraid by some awkwardness of speech to mar a good intent, yet hoping otherwise, and certainly meaning, in each instance, to offer nothing beyond the details which those who esteem a poet claim the traditional right to know of his walk and talk.

<div align="right">

Edmund Clarence Stedman,
'Some London Poets' (1882)[1]

</div>

[1] Edmund Clarence Stedman, 'Some London Poets', *Harper's New Monthly Magazine*, 64/384 (May 1882), 875.

With the above convivial words the American literary critic and poet Edmund Clarence Stedman introduced a selection of London Poets to the readers of *Harper's New Monthly Magazine* in 1882. Adopting the guise of a disinterested raconteur, Stedman conveyed an image of London as a literary arcady open to all who wished to enter. In this utopian literary world, writers welcomed strangers and nurtured their own; a sense of community which Stedman promised his readers would be extended to them through the sequence of intimate portraits and photographs that followed. Photographs, according to Stedman, made 'life heartier', a heart-warming idea designed to appeal directly to the desire for intimacy and presence that he assumed would motivate his audience to read on. And yet this rhetoric of disclosure is complicated by Stedman's anxiety that his ultimately high-minded enterprise might be mistaken for the more vulgar intrusions of celebrity gossip. Carefully maintaining the line between his brand of popularizing criticism and the more salacious proclivities of the lower end of the journalistic market, Stedman stressed his own inclusion in the poetry circles that he described. Friendship and the privileges that intimacy brings, he claimed, were the currency that allowed him to circulate between worlds, while carefully preserving the distinction between inside and outside.

Beginning with a close analysis of the dynamics of photographic illustration in Stedman's essay this chapter will explore this convergence of the rhetoric of intimacy with the desire for distinction, as well as the broader cultural implications of the Victorian fascination with eminent individuals that illustrated magazines such as *Harper's* were so quick to capitalize upon. While the impact of this new culture of publicity on canonical figures such as Wilde and James has been the subject of recent studies, the impact on lesser-known writers such as Augusta Webster and Agnes Mary Frances Robinson—the latter of whom Stedman proclaimed would have a significant influence on the future direction of English poetry—were equally profound. Webster and Robinson's various negotiations with the public spaces where Wilde and James moved with relative ease will then be analysed in the final part of this chapter in the context of a broader interrogation of the profound and pervasive tension between the growing market for literary ephemera and the increasing marginality of those who saw it as their duty to defend the timeless value of the poetic imagination.

What Stedman failed to take account of in his self-consciously modern literary travelogue was the inherently alienating effects of

enlisting photography to capture the spirit of London's poetry scene. Rather than offering a privileged insight into each of the selected poets' lives, each photograph had a memorializing effect, reminding the reader of the distance between themselves and the faces of poets whose work was either familiar or unknown to them. This distancing effect was further amplified by Stedman's biographical portraits, which moved from thumbnail sketches to longer reflective passages on the grim state of late-Victorian literary culture. Like his intended readers, Stedman seems to be searching each face for meaning or signs of life. But the objects of his curiosity remain elusive, reminding him and his readers that their guide is ultimately a stranger in this world just like themselves. A boundary figure at best, Stedman wanders on the periphery of the literary world that politely includes him, collecting literary artefacts and anecdotes that mystify rather than reveal. His presentation of scenes from literary London is therefore closer to a window display designed to seduce the consumer to purchase the luxury goods within, a familiar dynamic to his predominantly urban readers who would have recognized the format and selectively sampled whatever appealed to their literary tastes.

The significance of Stedman's essay, however, extends beyond the assimilation of advertising into the process of literary consumption. For ultimately Stedman's poetics is closer to the earnestness of Robinson's reading of *Casa Guidi Windows* than to McMahan's souveniring approach to the Brownings' representations of Italian culture or the wistful nostalgia of Anne Thackeray Ritchie. Against the grain of many of the aesthetes he admired, Stedman believed that art could still be art and be popular and he was prepared to use whatever means was necessary to achieve that end, including commercial portrait photography, which many felt was the ultimate 'vulgarization of art'.[2] This did not mean that Stedman refused to engage with the perennial anxieties that photography raised. These are evident throughout his essay, which is one of its major points of critical interest. Exemplifying the mixture of anxiety and familiarity with which his generation of writers responded to the emergence of a mass

[2] Oscar Wilde, 'The Soul of Man under Socialism', in *The Complete Works of Oscar Wilde*, ed. Robert Ross (Boston: Wyman-Fogg, 1908), ix. 247. The phrase 'vulgarization of art' is taken from the title of Linda Dowling's analysis of these debates in *The Vulgarization of Art: The Victorians and Aesthetic Democracy* (Charlottesville: University Press of Virginia, 1996).

audience and visual culture, Stedman's essay allows us to chart a more ambiguous and vexed history of complicity and resistance between late-Victorian literary culture and the marketplace. In contrast to many of his peers, Stedman was interested in reaching a wider audience and uncovering a new generation of poets, who he genuinely believed were just waiting to have the secrets of poetry explained to them. A firm advocate of self-culture, he promoted education as the only means of keeping the spirit of beauty alive in an age of escalating philistinism—an ideal that the continuing success of his survey of Victorian poetry on both sides of the Atlantic suggested was not beyond the realms of possibility. Originally published in 1876, Stedman's *Victorian Poets* had gone through thirteen editions by the end of the 1880s. These sales indicated to Stedman that, unlike many of the literary elite whom he admired, his work was actually having an impact on how ordinary Victorian readers read poetry and located it within an identifiable English literary tradition. Significantly for poets such as Webster and Robinson, Stedman's account also included a considerable number of women, although it was Elizabeth Barrett Browning who was singled out for particular attention. Not content to celebrate the superiority of her work in comparison with her male peers, Stedman chivalrously proclaimed that she was 'the representative of her sex in the Victorian era'.[3]

Conforming to this proselytizing vision, Stedman contextualized his introduction of a new generation of London poets to the readers of *Harper's* with a brief outline of the history of English prosody that positioned his subjects as the culmination of a great tradition. Then beginning with R. H. Horne, Stedman progressed through a sequence of photographically illustrated portraits that moved from uncritical celebration in the case of Swinburne to more measured assessments of poets such as Augusta Webster and Agnes Mary Frances Robinson. Yet no matter how animated Stedman's prose, the ultimate effect of the photographs he included is not a 'hearty' sense of potential dialogue and identification, but a more melancholic awareness of the necessarily ephemeral nature of any literary career or tradition. Stedman seems to be writing against time, preserving a literary culture that he feared was on the wane for a future generation of readers, while at the same time insisting on its continuing survival, if not in the Old World, then definitely in the New.

[3] Edmund Clarence Stedman, *Victorian Poets* (London, 1876), 148.

This melancholic tone was in many ways an inevitable side effect of the convergence of biographical and photographic portraiture in a culture preoccupied with recording itself for posterity. The increasing popularity of both forms reflected a need to touch, to possess, and to know both the past and present that was inflected with a similar sense of absence and loss to that which haunts Stedman's efforts to both animate and preserve London's poetic tradition. This longing for contact is what Richard Sennett has described as a shift in Victorian concepts of intimacy and public culture. Sennett argues that the late nineteenth-century fixation with personalities was an articulation of the need to preserve a sphere of intimacy at a time when impersonality appeared to be in the ascendancy. Rather than offering a refuge from the exigencies of modern life Sennett suggests that this fixation on personalities was a product of the culture it was resisting.[4] The pervasive expression of the need for a more memorable and personalized literary experience thus reinforced, rather than diminished, the impression that literary culture was in a state of decline. To survive, as the denizens of late-Victorian literary culture were only too well aware, involved the careful editing and presentation of one's own public image. Byron may have set a powerful precedent for the poet as celebrity, but photography and an expanding illustrated media raised the stakes immeasurably, offering two equally unpalatable alternatives—mass exposure or resolute marginality. The latter, however, was only a practical option for those with private incomes or Oxbridge sinecures to bankroll their talents. Poets such as Augusta Webster and Agnes Mary Frances Robinson who had to live by their pens could not afford to be so selective. Indeed Webster's career was characterized by a continual movement between journalistic and poetic spheres, making her even more likely than most to recognize the practical and creative implications of the increasing visibility of poets to their publics. And, if she was in any doubt, the prevalence of images of the Laureate himself would have proved an unavoidable and enlightening instance of the exigencies as well as the advantages of being visible to one's public.

The contemptuous responses of high-profile literary figures such as James, Wilde, and Arnold to the sea of ink spilt by a scandal-hungry press still remains one of the most powerful registers of the literary world's unease with this new culture of publicity. Arnold even coined

[4] Sennett, *The Fall of Public Man*, 259–68.

the term the 'New Journalism' to encapsulate his contempt.[5] Yet, as Richard Salmon has recently argued, James himself was not above feeding the public appetite for insights into either his own life, or the lives of famous literary personalities, writing essays for *The Century* on Du Maurier and other literary celebrities which were illustrated by prominent photographers such as Nadar.[6] Moreover, voluble critics of the press such as Wilde would also prove to be among its more effective manipulators. During the 1880s there was a veritable explosion of new forms of self-promotion and display. As Regenia Gagnier argues, the social conditions in the London of the 1880s were ripe for posing.[7] It was the beginning of the age of modern advertising and a time when the press was easily accessible to those with the linguistic power and networks to realize their ambitions. It was also a time when business, professional, and bureaucratic interests were being consolidated in the hands of an urban elite whose taste for pleasurable diversion converged with the more flamboyant marketing of literary experience that writers such as Wilde embodied.

In this new publicity-conscious literary culture the role of photography was assured. The sheer volume of prints that could be made from one negative distinguished photography from other forms of memorializing the lives of the nation's poets—such as statuary or painted portraits. Photographing signatures was also a popular aspect of this trade in 'authentic' mementos, as was the now thoroughly industrialized production of *cartes de visite* by the London-based A. Marion & Co. and Elliott & Fry. The latter provided Stedman with his portrait of Swinburne, and had images of poets such as Jean Ingelow, Elizabeth Barrett Browning, Christina Rossetti, and Mary Howitt on its books ready to be sold to journalists, biographers, or publishers interested in exploiting the unique intimacy effect that only a photographic portrait could provide. Ingelow's portrait, for example, was reproduced along with other Elliott & Fry images in another earlier photographically illustrated

[5] Matthew Arnold, 'Up to Easter', in *The Complete Prose Works of Matthew Arnold*, ed. R. H. Super, 11 vols. (Ann Arbor: University of Michigan Press, 1960–77), ix. 202. Arnold's designation was negatively intended as a response to the salacious style of W. T. Stead's notorious editorship of the *Pall Mall Gazette*.

[6] These included Eliot & Fry, which supplied many of Stedman's images. Richard Salmon analyses James's engagement with and manipulation of publicity in *Henry James and the Culture of Publicity* (Cambridge: Cambridge University Press, 1997).

[7] Regenia Gagnier, *Idylls of the Marketplace: Oscar Wilde and the Victorian Public* (Aldershot: Scolar Press, 1986), 14.

article on 'London as a Literary Centre' published in *Harper's*.[8] Likewise, Elliott & Fry sold a vignetted reproduction of the Macaire portrait of Elizabeth Barrett Browning that Tilton dwells upon in his preface to the American edition of the poet's works.

The sheer extent of this trade in photographic portraits and autographs makes the history behind particular articles and images difficult to trace. But what can be traced are the anxious reverberations that the growing market for literary ephemera created in the work of writers such as Webster and Robinson. One obvious symptom was a heightened stress on the timelessness of the literary imagination and its necessarily intransigent relation to these new forms of public communication. In practice, however, these distinctions were far more difficult to maintain. This is exemplified by the reproduction of the portraits and signatures of Robinson and Webster in Stedman's essay. While no surviving correspondence records whether either woman approved of the reproduction of their images in this format, the fact remains that the considerable circulation of *Harper's* offered unprecedented publicity that could have only benefited two writers who relied on their writing as a major source of income. In this context the profits to be made would have far outweighed the risks of perpetuating the elision of life and work that typically plagued the framing of the work of women poets with decorative portraiture; a practice exemplified by the characteristically fatuous sentiments of Hartley Coleridge: 'when we venture to lift a pen against women, straightway . . . the weapon drops pointless on the marked passage . . . whilst the mind is bent on praise or censure of the poem, the eye swims too deep in tears and mist over the poetess herself on the frontispiece, to let it see the way to either.'[9]

While undoubtedly critical of the impact of mass visual culture on literary practice, both Webster and Robinson also felt compelled to engage with the ethics of visuality in their work. This is particularly evident in their various translations of Ancient Greek texts and their consistent critique of the illusory distractions of the material world in poems that adapted the tenets of classical idealism to suit a

[8] R. R. Bowker, 'London as a Literary Centre', *Harper's New Monthly Magazine*, 76/456 (May 1888), 822. Bowker, who was also one of the magazine's European editors, illustrated his article with twenty-eight photographic portraits principally from the books of Elliott & Fry.

[9] Hartley Coleridge, 'Modern English Poetesses', *Quarterly Review*, 66 (1840), 374–5.

contemporary context. Indeed Robinson was one of the first women to study Classics at the newly formed University College of London, where she remained for seven years. This common interest in classical literature left a deeply Platonic imprint on the aesthetics of both women that resulted in a mutual scepticism towards the inherent inauthenticity of contemporary visual culture. In the case of Webster this scepticism inspired a poetry that stripped away cultural stereotypes and asserted the critical purpose of aesthetic practice, while Robinson pursued a more lean philosophical style that translated classical optical tropes into searching reflections on the limitations of individual acts of perception and memory. Yet it would be naïve to argue that this mutual fascination with classical literature was a disinterested choice made by two women who set themselves apart from the commerce in art and fame that defined the contours of the literary marketplace. Given the fetishized status of all aspects of Hellenic art and philosophy in late nineteenth-century literary culture, the recurrence of classical themes in their work clearly indicates a desire for legitimation and recognition. Registering the tensions and contradictions involved in striking a balance between making a living and making a reputation, Robinson's and Webster's work nicely parallels Stedman's interest in protecting the timeless value of art in a culture in which time itself was increasingly perceived as the enemy of tradition and memory.

INTIMATE INSIGHTS

The portrait Stedman reproduces of Webster is by an Italian studio photographer, which could be read as a sign that she sent her portrait directly to the critic, given that two footnotes to Webster's poems reveal that she was in Italy during 1881 and 1882.[10] And indeed, there would have been little cause for Webster to resist Stedman, as he had already proved himself a loyal, if measured, supporter in a previous biographical profile in *Victorian Poets*. While reiterating her conventional inclusion in the 'Browning School', Stedman had praised her unusual 'dramatic faculty', 'versatile range', and 'penetrative thought' and positively distinguished her work from

[10] Angela Leighton, *Victorian Women Poets: Writing against the Heart* (Hemel Hempstead: Harvester Wheatsheaf, 1992), 164–6.

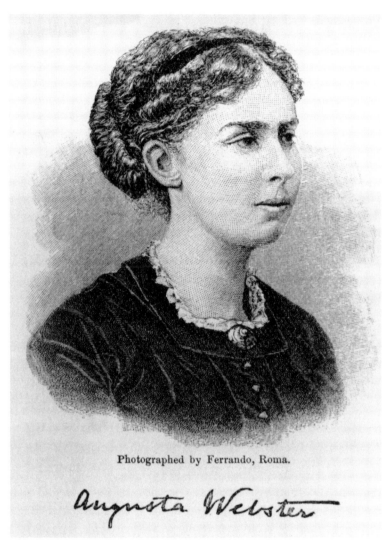

Photographed by Ferrando, Roma.

27. Portrait of Augusta Webster

Browning's, stressing its less rugged obscurity and resistance to current fashions.[11]

Webster is simply attired in this portrait and her three-quarter profile pose sensibly eschews the fashionable artifice or coy expression that Barrett Browning adopted in the Macaire portrait. This pragmatic approach to being photographed is reinforced by Stedman's physiognomically derived elision of her work and literary character:

That Mrs Webster has a professional rather than a popular reputation is perhaps evident from the fact that her several volumes have not been brought together in a single book for general reading. But those not familiar with her writings will be glad to look at her portrait—of a refined and purely English type, and plainly marked by intellect and sensibility. She is not only a poet, but also a ready and practical thinker.

Recalling the previously analysed photographic illustration of Wordsworth, Scott, Tennyson, and others, Stedman exploits the visual curiosity of the reader to encourage further reading here, while the work itself becomes an intimation of an affinity and identification between reader and writer that goes beyond words. Stedman's reference to his profile of Webster in *Victorian Poets* also implicitly encourages readers to make the leap from 'literary tea gossip' to reading more ambitious poetry and criticism; a didactic gesture that constructs this article as an extension of the more expansive cultural mission of *Victorian Poets*. There Stedman had outlined his mission in the opening chapter as an effort to restore 'the poet's hold upon the youthful mind and sentimental popular emotion' at precisely the moment when 'there never were more outlets to the imagination, serving to distract public attention from the efforts of the poets, than are afforded in this age of prose-romance and journalism'.[12] Victorian consumers, he insisted, craved guidance to achieve a 'more dramatic, spontaneous utterance'—a modern poetic mode that would lure, to invoke his own sensational phrasing, 'school girls and spinsters' away from the charms of Darwin, Huxley, and Spencer towards a new way of studying 'life, dialect and feeling'.[13]

Stedman's promotion of both his critical reputation and cultural agenda becomes even more explicit in his profile of Robinson:

There seem to be, in the new generation of Englishwomen, few maidens whose thoughts are fixed upon the succession to these gentle palm-bearers

[11] Stedman, *Victorian Poets*, 281. [12] Ibid. 23. [13] Ibid. 13, 31.

Photographed by Geruzet Frères, Bruxelles.

28. Portrait of Agnes Mary Frances Robinson

whom I have named. Possibly the artistic sensibilities of English girls find due expression in their appeal to the sense of vision, in their taste for dress and decoration, and in the pursuing of aesthetic devices that are the modern extension of those which fashioned the tea cup times of Anne. The spring, however, always returns, and I should say that there never was a fairer opportunity than the present for the wholesome welcome and speedy rise to fame of a new English poetess. . . . it was my good hap to meet, first with her sister in the parlors of Mrs Gosse, and afterward in her father's home, the young songstress who of all seemed to be most hopefully and gallantly regarded by her fellow poets, and the surest among new aspirants to fulfill the predictions made for her. The portrait here given will at once be recognized by her acquaintances, but the photographer has contrived to retain a likeness while very poorly expressing the youth and grace which belong to the original. . . . Were I permitted to make any suggestion to her, it would be that . . . Trained as she has been in the atmosphere of London, its tendencies may too strongly influence her Muse. Her lyrics that express her own moods, or that take hold of some essentially English theme, with the home color and feeling, are original and effective. If she will look still more in their direction, and sing for the English people, she will touch their hearts . . .[14]

Here Stedman constructs Robinson as a blushing literary maiden in need of rescue and the intellectual ministrations of a more worldly champion. Chivalrous rhetoric, which simply rehearses the standard clichés of contemporaries, such as his host Edmund Gosse, who had taken it upon themselves to defend the virtue of women poets.[15] These affinities are particularly apparent if one reads Stedman's portrait of Robinson alongside the criticism of such contemporary anthologists as Frederic Rowton, whose *The Female Poets of Great Britain* (1848) had recently been republished, or Eric Robertson's sentimental framings of the work of Robinson and others in *English Poetesses* (1883).[16] And yet there is a fundamental difference

[14] Stedman, 'Some London Poets', 887.

[15] Edmund Gosse's well-known dismissal of women poets in his profile of Christina Rossetti is exemplary of this critical style. Gosse claimed that women 'in order to succeed in poetry, must be brief, personal and concentrated'. Edmund Gosse (1882), 'Christina Rossetti', *Critical Kit-Kats* (London, 1896), 136.

[16] Eric Robertson's introduction to his series of critical biographies of women poets took this paternalistic attitude to a more chivalrous extreme, demanding of his readers: 'What woman would not have been Niobe rather than the artist who carved Niobe?' Eric Robertson, *English Poetesses: A Series of Critical Biographies with Illustrative Extracts* (London, 1883). Frederic Rowton, *The Female Poets of Great Britain* (1848) was reissued as *The Cyclopaedia of Female Poets* in 1875 to cater to this interest amongst American readers.

between Stedman and these peers. For while the latter's paternalistic framings of women's poetry enjoyed a fairly limited circulation, Stedman's essay was intended to reach a considerable international audience interested in cultivating their knowledge and appreciation of English literary culture.

Harper's New Monthly Magazine was a lushly illustrated, deeply Anglophilic publication which was enthusiastically embraced by an extensive transatlantic family audience.[17] Indeed, it proved to be so successful that an English edition of the magazine was published from 1880—a move intended to forge even stronger ties between American and European culture. Promoted aggressively as an alternative to competitors such as *The Century* and the English *Illustrated Magazine*, it soon outsold both in England by promising its readership a combination of accessible content and the highest quality illustrations that current technology was capable of producing. Daily newspapers, its advertisers proclaimed, may provide the 'skeleton of an occurrence', but the monthly magazine would bring people and events to life, giving them flesh, blood, and movement.[18] This desire to transform life and art into an easily consumed form also made *Harper's* just the type of publication of which the critics of the New Journalism were so dismissive. Compounding its numerous offences, the endless fascination with middlebrow ephemera that the illustrated magazine exemplified to many typified the continuing degenerative feminization of culture; an invidious association for the women poets who sought recognition through its pages, especially given the already long history of the negative construction of women as the purveyors and consumers of 'light literature' and illustrated publications.[19]

[17] According to Laurel Brake, *Harper's* circulation rose to 110,000 per month in the first sixteen years of its publication, 1850–1865. It had always been conceived as promoting closer cultural ties between England and America, a connection that was reinforced by the decision in 1880 to produce a European or English edition as well as an American one. Laurel Brake, '*Harper's New Monthly Magazine*: American Censorship, European Decadence and the Periodicals Market in the 1890s', *Subjugated Knowledges: Journalism, Gender and Literature in the Nineteenth Century* (London: Macmillan, 1994), 104–24.

[18] Anon., 'The Making of a Great Magazine. Being an inquiry into the past and the future of HARPER'S MAGAZINE' (London and New York, 1889). Cited in Brake, *Subjugated Knowledges*, 116.

[19] Andreas Huyssen describes the legacy, if not the ambiguities, of this late nineteenth-century equation of feminization with mass culture in *After the Great Divide: Modernism, Mass Culture, and Post Modernism* (Houndmills: Macmillan, 1988).

All these factors accentuate the ideological work that the rhetoric of gender was required to do in Stedman's essay. Stedman was clearly on a mission to save not only poetry, but also late-Victorian womanhood from the glittering distractions of London's arcades and department stores. He assumed that this immersion in an unwholesome world governed by the pursuit of visual pleasure and unrestrained consumption had potentially stifled the voices of the nation's future women poets. Developing a taste for poetry thus becomes the perfect antidote to the unsavoury effects of modern mass culture, a wholesome cure leading to a resurgence of a healthy feminine influence in an age of sterile mass production and consumption. In this context, Robinson's photograph, despite Stedman's protests that it fails to do her justice, functions both as a visual lure to catch the distracted attention of a new generation of female consumers and as visual proof that beauty and genius can co-exist in the same elegant vessel.

Although we can never know what Christina Rossetti, whose letter appeared in the correspondence pages of this volume, would have thought of this portrayal of her generation, and of the future of English women's poetry more generally, we can assume that while she may have agreed with Stedman's condemnation of commodity culture, his stereotypical characterizations would have struck a disappointingly familiar chord.[20] Rossetti's correspondence and work testifies to a subtle awareness of the destructive elision of poet- and woman-worship that had shaped the reception of her own work and that of Barrett Browning, with whom she was consistently compared.[21] And, if she was in any need of reminding, she could have read Stedman's typically diminishing comparison of her work with Barrett Browning's in his introduction to the profiles of Webster and Robinson:

The British sisterhood of song appears to be relatively less numerous than our own, but there are always in England and Scotland a few contralto voices of a rare order. It seems to me that no female poet of modern times has fairly equalled Mrs Browning, having in mind her constant, spontaneous wealth of

[20] Rossetti's letter concerns the profile of her brother Dante Gabriel that had been published in a preceding edition. She thanks the editors for the profile and in a typically fastidious manner draws their attention to factual errors in the piece: *Harper's New Monthly Magazine*, 959.

[21] Lootens, *Lost Saints: Silence, Gender, and Victorian Literary Canonization*, 45–77.

production, her learning, her broad humanity, the fervour and exaltation of her spirit, and lastly, the imagination and individuality which made us tolerate the carelessness that unquestionably marred her work. Christina Rossetti often is subtler, deeper, more suggestive; her hold is more upon certain minds, and those are not far wrong who draw a neat distinction, and say that whoever has been the greatest, Miss Rossetti has been the finest of English poetesses.[22]

While this brief sketch is less sentimental than Stedman's characterization of Robinson, the mixture of excessive praise with critical censure implies that these exceptional 'poetesses' still wrote from the heart rather than the head. In the case of Barrett Browning, her fervour and spontaneity indicated a poetic sensibility in need of discipline, while Rossetti's overly refined sensibility limited her capacity to appeal to a wider audience. In itself this distinction was not new; in fact Rossetti herself had made a similar point in the preface to her recently published sonnet sequence *Monna Innominata*. Where Stedman patronized and flattered, however, Rossetti wrote in the spirit of dialogue and critique driven by a struggle for authority and recognition between equals.[23]

Stedman's gender stereotypes become even more apparent in the profile of Swinburne that immediately follows Robinson's. Discarding his didactic tone, Stedman resumed the role of tourist guide describing his visit to Swinburne's house at Henley-on-Thames in excited detail. But in contrast to his profiles of Webster and Robinson, he portrays the poet at work and makes no reference to the Elliott & Fry portrait that illustrates the profile. It merely functions as a visual supplement to an account of the great mind that has opened himself up to his public's curious gaze:

The poet was working in his bedroom, a chamber plainly furnished, but with a glorious view from the windows—the Swinburne lawn, with fine old trees sloping from the foreground. A wooden table was covered with the manuscript sheets of a poem that he had been writing with the speed that is transferred to his galloping anapests. It was the long, melodious, haunting

[22] Stedman, 'Some London Poets', 884.

[23] Although the date of composition is unknown according to Rebecca Crump, *Monna Innominata* was first published in *A Pageant and Other Poems* (1881). See Crump's editorial history of the poem in *The Complete Poems of Christina Rossetti*, ed. R. W. Crump, 3 vols. (Baton Rouge: Louisiana State University Press, 1979–90), ii. 307.

piece 'On the Cliffs,' consecrated to the memory and Muse of Sappho. . . . Except for a chronic nervousness, or what I should call over possession of his body by his mind, he was in health, voice, and spirits, and he read me what was completed of the poem. . . . He read his lyrical rhapsody with a free chanting cadence, like the poet he is, and as such verbal music should be read. At lunch, and in our long walk after it, for he insisted on guiding me to the station, we talked of much which it is not my province to repeat. His conversation is as noteworthy as his written text—a flood of wit, humor, learning, often enthusiastic, more rich with epigram and pithy comment than other men.[24]

The personal tone of this interview was typical of the intimate style cultivated by publications such as *Harper's*, and of the emerging genre of celebrity interviewing more generally.[25] There is no attempt to maintain the neutrality of an anonymous critic. Rather, to quote a review of journalistic trends published only a few years later, Stedman attempts to reproduce a 'photograph of the outward man'.[26] He details Swinburne's mannerisms, his mode of writing and speaking, relishing every domestic detail that could be read as an outward manifestation of the writer's personality. Stedman also puts himself in the frame revealing his bias for Swinburne's work in the manner of a literary tourist who cannot quite believe his good fortune. Like his contemporary Edmund Yates, the prolific author of over three hundred separate profiles of various celebrities published in his weekly newspaper *The World*, Stedman also insists on the distinction between inferior modes of literary tourism driven by idle curiosity and his own respectful pilgrimages. Note the resemblance, for example, between Stedman's conspiratorial anxiety concerning the privacy of his subjects in the above passage and Yates's description of one of his own pilgrimages to Tennyson's refuge from the voracious curiosity of his public at Haslemere:

Like the better known house at Farringford, whence the poet has been almost driven by the vulgar curiosity of mobs of tourists, this at Haslemere stands close to the ridge of a noble down, and there are groves of pine on either hand; but instead of forming a vantage point where, by the aid of telescopes,

[24] Stedman, 'Some London Poets', 890.
[25] Although it differed from the later mode of transcripted dialogue published in magazines such as *The Idler*. Richard Salmon discusses these distinctions between modes of celebrity interviewing in 'Signs of Intimacy: The Literary Celebrity in the "Age of Interviewing"', *Victorian Literature and Culture*, 159–77.
[26] T. P. Connor, 'The New Journalism', *The New Review*, 1/5 (1889), 423.

the poet might be seen wandering in the careless-ordered garden, these groves dip suddenly down into deep gorges.[27]

Disavowing his own complicity in the culture of publicity he condemns, Yates, whose profiles were 'discreet to the point of dullness', constructs himself as a boundary figure in a similar fashion to Stedman.[28] Neither inside nor outside, he trades in the rhetoric of intimacy whilst perpetuating the mythic construction of Tennyson's legendary refusal of publicity.

DISTINCTIONS AND PARADOXES

Women poets, such as Webster and Robinson, however, were as familiar with, as they were dismissive of, Stedman's conventional critical stereotypes. Webster, as Stedman himself notes, was both resourceful and strategic in her negotiations with the demands of her profession and the social conventions that constrained the everyday lives of Victorian women. Her essays in *The Examiner* suggest a knowing, often playful approach to a wide selection of topics ranging from fashion, household shopping, the increasing excesses of funeral and mourning rites, and gossip. But Webster did not confine herself to this entertaining mode. She also wrote earnest and confrontational pieces on women's right to higher education, on domestic violence, and on the need to preserve aesthetic standards in an age unhealthily distracted by ephemeral images. In the latter, photography did not fare well. As pragmatic as she was about the need to engage with new cultural forms, Webster's optimism failed her when it came to the commercial photographs that Stedman strategically adapted to his critical agenda. Exemplifying her concerns, Webster's essay on 'Portraits' dismissed photography as a mechanical form of illustration bereft of the imaginative insight of a poem or a painting,[29] although it is also important to note that her argument refused to lapse into an uncritical nostalgia for the superior culture of times gone by:

[27] Edmund Yates, *Celebrities at Home*, 3 vols. (London: Office of *The World*, 1877–9), i. 24.

[28] Richard Altick, *Lives and Letters: A History of Literary Biography in England and America* (Westport, Conn.: Greenwood Press, 1965), 133.

[29] Augusta Webster, 'Portraits', *A Housewife's Opinions* (London, 1879), 168–72.

The common explanation of this triteness of our contemporary portrait painting is a sufficient one—if true. We are all alike in these days, it is said, all Philistine, all respectable, all smug, all Mrs Grundy-ized, therefore the painters who make our likenesses have through a thousand faces but one mind to pourtray [*sic*]. That sounds superior and aesthetic, and we can say it, in whatever words, with an agreeable feeling of being ourselves exceptional, removed from the commonplace herd and able to walk ungregarious and criticizing beside the simultaneous multitude. But is it true? First, has human life, in portrait-painting times, ever been free from the authority of common precedent? . . . In the best, as in the worst, days of portrait painting, education was chiefly a training to be like the rest of the world, and the artist's true work was to see the unlikeness through the likeness and to render both.

This is much to ask of any man. For it is the secret of genius. It is the poet's secret like the painter's, the sculptor's like the musician's.[30]

Webster draws attention to the inherently standardizing effects of aesthetic convention in whatever form it takes in this essay, while still maintaining the importance of the original insight of genius. Refusing to simply rehearse an Arnoldian-style attack on the philistine cult of 'Doing as One Likes', Webster focuses on the continuing potential for moments of genius and insight that reside in the difference between seemingly identical copies.[31] She encourages her readers to look closely for these signs of difference, rather than grouping all contemporary forms of portraiture into the same derivative style; an interesting argument given her own condemnation of photography. Resisting the location of works of genius on a far loftier ground, Webster suggests that signs of inspiration can be found in that most prosaic of places, the commercial artist's studio. All one needed was the happy coincidence of talent and opportunity, an argument that inadvertently allows for the possibility that this could equally apply to the most modern of portraitists, the commercial photographer.

It would therefore be a mistake to assume that Webster's antipathy towards the standardizing effects of late nineteenth-century visual culture was yet another instance, and not a particularly distinguished one at that, of the widening chasm between high and mass culture at that time. In contrast, as Frederic Jameson and others have argued, the increasingly articulated distinction between high and mass culture in the latter decades of the nineteenth century is a sign of the entangled history of their discursive formation, rather than an

[30] Augusta Webster, 'Portraits', *A Housewife's Opinions* (London, 1879), 169–70.
[31] Matthew Arnold, *Culture and Anarchy* in *Prose Works*, v. 87–256 (150).

indication of their radical divergence.[32] This complicity is much in evidence in Webster's criticism of the nullifying complacency of bourgeois aesthetic taste and her belief that poetry, painting, and sculpture contained the seeds of a more general cultural redemption. Rather than claiming a position of triumphant marginalization for those with the genius to perceive difference in an ocean of sameness, her argument pushes artists back towards the cultural centre; a critical strategy that echoes the reformist arguments of contemporaries such as Ruskin, Morris, and even Wilde. There is, for example, a parallel between Webster's essay and Wilde's paradoxical assertion that art could only survive the vulgarity of mass society by resisting popularity and demanding that the public should aestheticize itself instead.[33] Yet this parallel only further exposes the intrinsic flaw in such valorizations of an aristocratic sensibility that was inherently antithetical to the practical realization of the 'aristocracy of everyone', as Linda Dowling has recently argued.[34] For while she may never have gone to Wilde's rhetorical extremes, Webster's valiant efforts to strike a balance between aesthetic and social responsibility inevitably fell prey to the same paralysing moral contradiction. In her fight to preserve the aesthetic value of portraiture, Webster effectively misrecognized the interests of an intellectual elite for the interests of the majority, while simultaneously reducing the latter to stereotypes with the help of the familiar slogans of anti-bourgeois rhetoric.

This resistance to the ascendancy of a philistine orthodoxy in Victorian visual culture is equally evident in Webster's poetry. In poem after poem, her narrators dismantle the stereotypical construction of women and assert their alienation from a social sphere which insists on their commodification. Finding themselves alone in rooms while life takes place elsewhere, they address mirrors and write in diaries, transforming their solitude into a space where they can enact unspoken desires and interrogate the cultural stereotyping that consigned their voices to the private and domestic sphere. In 'By the Looking Glass' Webster's speaker takes refuge from 'the glitter

[32] Frederic Jameson, *The Political Unconscious: Narrative as a Socially Symbolic Act* (London: Routledge, 1989), 206–8.

[33] Oscar Wilde, 'The Soul of Man under Socialism', in *The Artist as Critic: Critical Writings of Oscar Wilde*, ed. Richard Ellmann (New York: Random House, 1968), 60–72. [34] Dowling, *The Vulgarization of Art*, p. xiv.

and din' of a ball to reflect on the gulf between how others see her and how she sees herself.[35] Exhausted by social expectations, she is plagued by self-doubt and disappointed by love, and yet a defiant tone still inflects her melancholy. For unlike those around her, her isolation comes with the privilege of insight, even if the truth that is revealed is even greater cause for suffering. This is a continual theme in Webster's work and one to which she returns in one of her more explicitly political monologues, 'A Castaway'. Spoken in the voice of a prostitute, this poem uses the conventional conceit of the mirror as a device for exposing the hypocrisies of Victorian sexual morality. Defying physiognomic conventions, Webster demands that her readers see through the clichés that constructed 'the fallen woman' as a race apart:

> And what is that? My looking-glass
> Answers it passably; a woman sure,
> No fiend, no slimy thing out of the pools,
> A woman with a ripe and smiling lip
> That has no venom in its touch I think,
> With a white brow on which there is no brand;
> . . .
> And, for me,
> I say let no one be above her trade;
> I own my kindredship with any drab
> Who sells herself as I, although she crouch
> In fetid garretts and I have a home
> All velvet and marqueterie and pastilles,
> Although she hide her skeleton in rags
> And I set fashions and wear cobweb lace:
> The difference lies but in my choicer ware,
> That I sell beauty and she ugliness;
> Our traffic's one—I'm no sweet slaver-tongue
> To gloze upon it and explain myself
> A sort of fractious angel misconceived—
> Our traffic's one: I own it. And what then?
> I know of worse that are called honourable.
> Our lawyers, who with noble eloquence
> And virtuous outbursts lie to hang a man,
> Or lie to save him, which way goes the fee:
> Our preachers, gloating on your future hell
> For not believing what they doubt themselves:

[35] Augusta Webster, *Dramatic Studies* (London, 1866), 149–60.

Our doctors, who sort poisons out by chance
And wonder how they'll answer, and grow rich:
Our journalists, whose business is to fib
And juggle truths and falsehoods to and fro:
Our tradesman, who must keep unspotted names
And cheat the least like stealing that they can:
Our—all of them, the virtuous worthy men
Who feed on the world's follies, vices, wants,
And do their business of lies and shams
Honestly, reputably, while the world
Claps hands and cries 'good luck,' which of their trades,
Their honourable trades, barefaced like mine,
All secrets brazened out, would shew more white?[36]

This confronting poem exemplifies Webster's strength as an observer of the complicity and conventions that bound perceived cultural polarities together. In this case the distinctions between prostitution and the bastions of respectability gradually dissolve as Webster unravels the myths associated with both and exposes the economic conditions that perpetuated the mutual oppression of prostitutes and wives in a society governed by the interests of men. As with her journalism, popular images and stereotypes are summarily dismissed in preference for a more subtle and layered mode of cultural description. And yet the realist techniques that Webster preferred also positioned her work in direct opposition to many of her aestheticist contemporaries. Pater, in particular, had associated realism with the desecrating tendencies of bourgeois taste in essays such as 'The School of Giorgione', where he explicitly rejected social realism arguing that art must always strive 'to be independent of mere intelligence, to become a matter of pure perception, to get rid of its responsibilities to its subject or Material'.[37] In contrast, Webster, as Angela Leighton has argued, recognized 'external reality as the basic matrix, of all perception. Hers is, in a sense, a poetry of the market'.[38] And it is precisely this aspect of her work that drove Webster to assert such a profound division between the middlebrow art of photography and the high arts of painting and poetry. Unlike Pater, Webster did not have the privilege of assuming a disinterested pose. Despite her aesthetic aspirations, she felt responsible to the audience

[36] Augusta Webster, 'A Castaway', in *Portraits* (London, 1870), 26–31, 65–97.
[37] Walter Pater, 'The School of Giorgone', in *The Works of Walter Pater*, 10 vols. (1873; London: Macmillan, 1910), i. 138.
[38] Leighton, *Victorian Women Poets*, 174.

her work addressed; a sense of duty intensified on a practical level by a passionate commitment to public service and political issues such as the higher education of women and the rights of the politically and economically disenfranchised.

Considering Webster's scepticism towards photography, one wonders what she would have thought of the parallels between her own work and that of her contemporary, the photographer Lady Clementina Hawarden. Like Webster, Hawarden experimented with the techniques of portraiture and yet she chose to do so in a medium that Webster argued was the antithesis of imaginative originality. In her photographs of women alone in domestic spaces Hawarden transformed the camera's lens into a hall of mirrors that reflected the nuances and subtle power struggles that took place in the distinctively feminine world of private pleasure and intimate reverie that also preoccupied Webster.

The woman in the photograph (Fig. 29) observes while being observed. Luxuriously attired and surrounded by personal mementos,

29. Lady Clementina Hawarden, *Untitled*

she takes possession of her surroundings in a manner that positions the spectator as an intruder or interloper; a visual effect that echoes Webster's interest in transforming the language of intimacy, of affect, into a source of aesthetic power and critique. As in Webster's poems, the self-sufficient posture of the woman in Hawarden's image enacts the tension between agency and complicity involved in surrendering herself to the curious gaze of the photographer and the visual pleasure of her implied audience.

Hawarden and Webster's mutual interest in the ambiguous play between power and subjection also revealingly contrasts with Stedman's reading of the portrait of Robinson. Although very different in style and intent, Robinson's confident posture is not too dissimilar from that of Hawarden's more artfully posed sitter. In both images women confront the camera in a manner that destabilizes, while seeming to reinforce, conventional divisions between private and public, interiority and exteriority. As Stedman himself observed, there is something missing from Robinson's portrait, a lack that he attributes to the photographer's focus on producing a mechanical likeness, rather than on 'expressing the youth and grace that belong to the original'. A less interested reading, however, suggests a different interpretation that destabilizes Stedman's insistence on his own superior intimacy with the subject. In contrast to his portrayal of her as a naïve ingénue with mistaken political and social beliefs, Robinson's stern gaze into the camera's lens conveys an impression of authority and self-possession; a commanding posture that suggests that Robinson was far more in control of her own public image than Stedman's profile implied.

Indeed Robinson's awareness of the prejudices and inequities of literary celebrity more generally found expression in her own foray into literary biography. In her introduction to a biography of Emily Brontë, which was published in John Ingram's 'Eminent Women Series', Robinson described the biographer's task in terms of a necessary dismantling of the popular myths surrounding her subject:

Would that I could show her as she was!—not the austere and violent poetess who, cuckoo-fashion, has usurped her place; but brave to fate and timid of man; stern to herself, forbearing to all weak and erring things; silent, yet sometimes sparkling with happy sallies. For to represent her as she was would be her noblest and most fitting monument.[39]

[39] Agnes Mary Frances Robinson, *Emily Bronte* (London: W. H. Allen, 1883), 7.

And this is exactly what Robinson proceeded to do. She located Brontë's work in its cultural context by tracing both its strengths and weaknesses back to specific social and economic conditions, while systematically interrogating the sentimental formulations which ensured that women poets such as Brontë or Barrett Browning would forever be associated with the men they either did or did not marry, rather than with the intellectual and imaginative preoccupations that shaped their work. As Robinson observed in her preface to the photographically illustrated edition of *Casa Guidi Windows* discussed earlier, the explicitly political content of the work of women writers such as Barrett Browning demanded historical contextualization and critical evaluation based on literary merit alone.

ALTERNATIVE REALITIES

Consistent with her praise of Barrett Browning's political commitment, Robinson insisted, in a sonnet first published in *A Handful of Honeysuckle* (1878), that poetry should engage with the world through a productive resistance to its 'harsh and unlovely' realities and prosperous boors:

> God sent a poet to reform His earth.
> But when he came and found it cold and poor,
> Harsh and unlovely, where each prosperous boor
> Held poets light for all their heavenly birth,
> He thought—Myself can make one better worth
> The living in than this— . . .
> But when at last he came to die, his soul
> Saw earth (flying past to Heaven) with new love,
> And all the unused passion in him cried:
> O God, your Heaven I know and weary of.
> Give me this world to work in and make whole,
> God spoke: Therein, fool, thou hast lived and died![40]

As this salutary tale of wasted genius illustrates, Robinson's desire for dialogue was always a deeply ambivalent one. Seclusion may not have been an option, but neither was a naïve embrace of the utilitarian

[40] Agnes Mary Frances Robinson, 'Sonnet', reproduced in *Lyrics Selected from the Works of A. M. F. Robinson (Madame James Darmesteter)* (London: Fisher & Unwin, 1923), 28.

vulgarity of a public insensible to the sublimity of poetic insight. Robinson wanted public recognition for poetry and poets, but like Wilde, she felt recognition would be of value only if poets such as herself had, in turn, shaped the sensibility of their audience. Until that happened, Robinson argued, the public would continue to be enslaved by the rampant appetite for tasteless ephemera that Ruskin had condemned in one of his more splenetic outbursts as 'the gelid putrescence' of a 'modern infidel imagination, amusing itself with destruction of the body, and busying itself with the aberration of the mind'.[41] Like Ruskin, Robinson believed in the humanizing power of the poetic imagination and dramatized that ideal in lyric celebrations of an individual imaginative experience that was the antithesis of the ready-made images she believed had mesmerized and paralysed the modern consumer. Resonating not only with Ruskin's cultural project, but with the individualistic hellenism of Arnold and Wilde, her classically informed poetics provides an illuminating concluding case study of the ways in which an ambitious woman poet struggled to assert the aesthetic autonomy of her work at a time when the avenues for cultural consecration and the publics to which one could appeal were rapidly expanding and diversifying.[42]

The apparent contradiction between the promotion of her work in an essay such as Stedman's on the one hand and her celebration of a pure poetic form that was by definition 'out of time' with the market on the other also returns us to Sennett's interpretation of the heightened stress on authenticity and intimacy as symptoms of the increasing impersonality of a market-governed public sphere. But Bourdieu's analysis of the necessary and productive tension between what he terms the 'field of restricted production'—the production of cultural goods for a public of producers of cultural goods—and the 'field of large-scale production'—which produces goods for a public at large—is even more pertinent here.[43] For although the nuances of Robinson's interrogation of the limits of the visible cannot be simply reduced to Bourdieu's sociological formula, many of her rhetorical

[41] John Ruskin, *The Genius of John Ruskin*, ed. John D. Rosenberg (Cambridge, Mass.: Harvard University Press, 1980), 444.

[42] Wilde, 'The Soul of Man under Socialism', 72.

[43] Bourdieu elaborates the relationship between restricted and expanded fields of practice in a variety of his works. It is, however, succinctly elucidated in 'The Market of Symbolic Goods', *The Field of Cultural Production*, 112–44.

strategies exemplify his analysis of the ways in which the restricted field of late nineteenth-century literary culture generated its own criteria for evaluating and legitimating its products in opposition to a broader reading public. In this context the often sophisticated archaism of Robinson's verse emerges quite simply as an appeal to the aesthetic nostalgia of an elite class of readers. And yet, ironically, it is precisely these seemingly highbrow aspirations that attracted Stedman's admiration and led to his consequent promotion of her work to the decidedly middlebrow audience of *Harper's*. As his critique of mass consumption in his profile of her suggests, Stedman clearly saw Robinson as an exemplary figure who could inspire other women to cultivate a taste for lyric poetry, rather than a talent for interior decoration. What Stedman valued, therefore, in many ways conformed to what Robinson hoped her readers would recognize, that her work was a continuation not only of an English poetic tradition, but of the classical lyrical lineage on which she so adeptly drew.

Like Barrett Browning therefore, Robinson's Neoplatonic ideals were forged out of a desire for truth and authenticity in what both women feared was an age distracted by spectacle and deluded by the false mastery of surface perception. Yet, paradoxically, this resistance to the political passivity that they associated with an unhealthy bourgeois fascination with the visible and the ephemeral inspired both women to engage with rather than ignore the ideological power of visual concepts, both old—in the case of the camera obscura, and new—in the case of photography. There were, as we have seen, profound resonances between Barrett Browning's embrace of the daguerreotype as a visualization of the essence of a moment in time and her interrogation of the fraught relationship between vision and memory in *Casa Guidi Windows*. Similarly, Robinson's fascination with the trope of the camera obscura as a materialization of an interiority freed from the fragmentary effects of real time intersected in provocative ways with anxieties about photography's fragmenting effects, and in particular with concerns expressed by Henri Bergson, whom she would read in later life. Robinson's career, like Barrett Browning's before her, thus testifies to the rich conceptual context that bound Victorian poetic practice to the visual culture of which photography was such a powerful iconic manifestation; a discursive entanglement that meant that photography could never be simply dismissed as another instance of modernity's embrace of progress

and effacement of the past. Photography was, in contrast, as Barrett Browning herself acknowledged, an incarnation of the troubled relationship between the past and the present. But in the intervening decades between Barrett Browning's early engagement with the cultural meaning of the daguerreotype and the publication of Robinson's first volume of poetry, the meaning of photography had shifted. The idea and practice of photography had effectively become part of the visual vernacular of everyday life in the years when Robinson was establishing her career, providing a frame of reference that she would implicitly oppose to the unifying perceptions of a more phenomenologically attuned and ethically responsible consciousness.

One of Robinson's more extraordinary poems, 'In the Barn', exemplifies the ways in which these concerns unfold in her work through a subtle interplay of optical metaphors:

> I sought refuge from the skies of June.
> The barn with yawning doors announced the boon
> Of shade and coolness, rest and fragrant hay;
> So there I stayed the livelong afternoon.
> I closed the mossy gates; full-length I lay
> And let the torrid daytime melt away—
> One wall was cleft, and where the cranny was
> I spied the world without: how vast and gay!
> Against the sky the mountain's dazzling mass,
> Flawed by the sudden chasm of a pass;
> Below, the river's long and liquid line
> Winding about the greenness of the grass.
>
> How bright the woods of aspen quake and shine!
> Look on the nearer hill, the flowering vine!
> How far and vivid through how mere a chink
> I see this vast and various world of mine.
> . . .
> So, in our twilight cavern of the Soul,
> We spy the brilliant vision of the whole,
> As near, as real, but incomplete and strange:
> The river flows with neither fount nor goal.
>
> O Time, why measure such a narrow range?
> Hast thou, in all thine infinite change
> Nothing but Now, Hereafter, and the Past?
> 'Nay, blame the serried crevice of the grange!'
> O Space, thou too art fettered hard and fast

> Of all the myriad forms thou surely hast
> Nothing but Three, O Space, nothing but three?
> 'The limits of the vision are not vast.'
>
> O moving life, O world immense and free
> Circling all round in magic mystery,
> When down my wall at last shall crash and fall,
> Grant I may rear a fearless front, and see![44]

In the opening stanzas, the barn provides a dark refuge from 'the torrid daytime' in which the observer can lie, eye pressed up against a chink in the wall, and watch the myriad spectacle of natural phenomena scroll by. Like a spectator in a camera obscura, she relishes the dark intimacy of the room that surrounds her, as well as the privileged perspective of seeing without being seen. In the dark world of the barn she has complete control over the world she views. Rather than being immersed in the chaotic flux and beauty on the other side of the wall, she views the world from a self-protective distance. Here she can 'spy' on its vastness, and with the privilege of distance order 'the mountain's dazzling mass' and 'the river's long and liquid line' into an evocative impressionistic sequence. She then takes another step back into a more removed and darker room—the 'twilight cavern of the Soul'. Divorcing herself from immediate visual stimuli, she confronts the shadowy essences of material phenomena, as Barrett Browning had done in the final stages of *Casa Guidi Windows* when she turned her back on the window, shut her eyes, and uttered the following plaintive words: 'But wherefore should we look out any more | From Casa Guidi windows? Shut them straight, | And let us sit down by the folded door, | And veil our saddened faces'.[45] Like Barrett Browning, Robinson uses a dramatic iconophobic gesture to create an inner space where truth and poetry can be divorced from illusion. Inside her own imaginative camera obscura Robinson's persona begins to understand that the river flows 'with neither fount nor goal' and that the temporal sequence of 'Now, Hereafter, and the Past' is an arbitrary construction dreamt up by those still trapped inside the machinery of corporeal perception. Her dramatic withdrawal then culminates with an ambiguous closing image. What

[44] Agnes Mary Frances Robinson (Madame Mary Duclaux), *The Return to Nature. Songs and Symbols* (London: Chapman & Hall, 1904), 57–8.

[45] Barrett Browning, *Casa Guidi Windows*, ed. Julia Markus, Book II, lines 425–8, p. 52.

one wonders are we too make of the image of the circling panorama of 'moving life' and 'magic mystery' that surrounds the little black box where the poem's speaker has confined herself? Surely when the walls that protect her from this luminous and varied spectacle break down, the release itself will be deeply traumatic and possibly even life-threatening? But maybe this is the ultimate point of Robinson's poem; an assertion of poetry as a temporal fold in which the shocks and destabilization of the present can be resolved outside the illusory dialectics of rational perception and selective historical chronologies. This reading also returns us to her edition of *Casa Guidi Windows*, a poem and an edition that use photographic techniques to create a poetic counter-memory, resonances that suggest a deeper philosophical rationale behind Robinson's interest in Barrett Browning's work.

This conception of a non-successive existence free of all dualisms recurs throughout Robinson's œuvre, more implicitly in her paean to Zeno, and more explicitly in a lyric entitled *The Idea*, which asserts the existence of the 'Eternal Mind', beyond 'the sense that we inherit . . . dim and undefined . . . unconscious and unseeing'.[46] It also emerges in her critical prose. In an introduction to a much later volume of essays and reviews of twentieth-century writers, for example, Robinson associated a similar idea with the work of Henri Bergson amongst others, arguing that his method tended towards the 'condition of music'; a condition of 'movement and liberty rather than Art; freedom of rhythm rather than classic determinism and classic constraint' to which she claims she also aspired.[47] This conception of Bergson also provides an alternative perspective on the final ambiguous stanza of 'In the Barn', suggesting that Robinson was pressing beyond a conventional Platonic eschewal of the reflections and phantasms of representation towards a more phenomenological conception of unmediated vision. If we read the final image of the walls crashing and falling as a liberation of the subject from the introspective dynamic of the camera obscura, this suggests that Robinson was pressing towards a new way of seeing, unconstrained by the will to know and master everything before it had happened. It is also

[46] Agnes Mary Frances Robinson (Madame Mary Duclaux), *Retrospect and Other Poems* (London: Fisher & Unwin, 1893), 19; and *Songs, Ballads and a Garden Play* (London: T. Fisher & Unwin, 1888), 36.

[47] Agnes Mary Frances Robinson (Madame Mary Duclaux), *Twentieth Century French Writers: Reviews and Reminiscences* (London: Collins, 1919), pp. v–vi.

at this point that the more subtle affinities between Robinson's re-
flections on the nature of perception and time and those of Bergson
also begin to emerge. Robinson's embrace of movement and the
irreducibility of present experience resonates with Bergson's privileg-
ing of the qualitative heterogeneity of experienced time. Likewise,
Robinson shared a similar scepticism towards what Bergson would
describe in *Matter and Memory* as modernity's fixation with 'ready-
made motionless images, of which the apparent fixity is hardly
anything else but the outward reflection of the stability of our lower
needs'.[48]

That Robinson should have been familiar with the work of
Bergson is unsurprising, given her longtime residence in France
and her interest in promoting French writers to English readers.
There are, however, also specific ethical affinities that locate this iden-
tification within a more general context of the conflicting models
of temporality and visuality that this chapter and this study more
generally has explored. As the previously discussed affinity between
Bergson's concept of duration and Dante Gabriel Rossetti's reflec-
tions on speed and perception also suggests, there is a common
anxiety that unites the Victorian construction of poetry as a temporal
form that allows for an interplay between differences and Bergson's
conception of a model of time in opposition to the mechanized time
of modern industrial culture. In contrast to the homogeneity of stan-
dardized models of time, Bergson's concept of temporality was pred-
icated on a 'qualitative heterogeneity', that was not so far removed
from Rossetti or Robinson's poetic dramatizations of the possibility
of an unmediated experience free of the hegemony of rational per-
ception.[49] Robinson's work, moreover, reveals a profound distrust
of vision which accords with what Martin Jay has identified as the
systematic denigration of vision in Bergson's equation of the spatial-
ization of time with the hegemony of sight, which was first expressed
in his 1889 doctoral thesis *Time and Free Will: An Essay on the
Immediate Data of Consciousness*.[50] Haunting Bergson's assertion
that the brain was an instrument of action and not of representation

[48] Henri Bergson, *Matter and Memory*, trans. N. M. Paul and W. S. Palmer (New York: Zone Books, 1991), 219.
[49] Henri Bergson, *Time and Free Will: An Essay on the Immediate Data of Consciousness*, trans. F. L. Pogson (1889; London: Allen & Unwin, 1950), 95.
[50] Martin Jay, *Downcast Eyes. The Denigration of Vision in Twentieth-Century Thought* (Berkeley: University of California Press, 1994), 149–211.

was an implicitly negative association of any form of representation with the mechanization and seemingly infinite multiplication of images that photography and other new visual technologies had made possible.[51] But the spectre of mass production was not so easily exorcized. Like Robinson and Webster, Bergson's work bears the traces of the visual culture it was resisting, while manifesting a post-Kantian resistance to the models of passive sensation that had been sustained by Carlyle's influential insistence on the need for a new spiritual optics and the visionary Neoplatonism of critics such as Ruskin.

The speed with which Victorians embraced photography suggests, however, that this interest in the relation between time and image was not confined to poets and philosophers. Transforming the landscape of what Bourdieu describes as middlebrow culture, photography, as this study has demonstrated, played an integral role in the transformation of literary consumption into a self-conscious device for slowing down time and creating a space for reflecting on the survival and value of an increasingly visible literary heritage. Whether one chose, in the words of Henry James, to use literature as the lens through which 'to catch the colour, the relief, the expression, the surface, the substance of the human spectacle', or a series of stereoscopic photographs interspersed with inspiring fragments of verse, these instructive pleasures took place in a time and space outside the relentlessly prosaic rhythms of everyday life.[52] As middlebrow as the more commercially produced forms of photographic illustration were, therefore, they nevertheless register the growing diversity of a cultural sphere where it was increasingly difficult to maintain distinctions between forms of literary consumption beyond a very limited literary elite. Critical criteria for maintaining hierarchies between high brow, middlebrow, and lowbrow culture may have held enormous sway in the restricted field of artistic practice, but they had little or no influence over the growing market for forms of literary tourism that were helping to ensure the cultural afterlife of poets such as Cowper, Wordsworth, Scott, and others. Nor could they claim to have driven a wedge between more general concepts of the moral value of literature and the discourse of self-culture that

[51] Bergson, *Matter and Memory*, 74.
[52] Henry James, 'The Art of Fiction', in *Literary Criticism* (New York: Library of America, 1984), 53.

had readily assimilated photography into its aesthetic repertoire. Concepts of literary experience were unavoidably, and not always negatively, inflected by the increasing voyeurism of a mass culture that now had access to the technological means to see and know worlds that were far removed from the everyday life of the average middle-class consumer; an expanded visual field that correspondingly extended the debate over the relation between truth and representation and the relative value of images produced by hand or machine. Any consumer who could afford to purchase a daguerreotype, a stereoscope, a photograph, and increasingly their own camera was necessarily immersed, even if only at the most basic level, in a reflective process that measured the limitations of human perception and memory against what could now be seen and transformed into an everlasting image with the aid of technology. And it is here that the rationale lies for the assortment of analogies between poetry and photography that this book has discussed. Whether individual poets or critics believed in the aesthetic merits of photography, the idea of this frozen yet evanescent image proved to be an infinitely compelling and endlessly adaptable one. A photographic image, as these various illustrative forms reveal, could be read as a sign of the loss of memory or its saviour, as art or as an augury of its immanent demise, or it could quite simply be cherished as a personal *memento mori* of an otherwise private or forgotten moment when time itself had seemed to stand still.

Afterword

The aim of the illustrated newspapers is the complete reproduc-
tion of the world accessible to the photographic apparatus.
They record the spatial impressions of people, conditions, and
events from every possible perspective. This method corres-
ponds to that of the weekly newsreel, which is nothing but a
collection of photographs . . . Never before has an age been so
informed about itself, if being informed means having an image
of objects that resembles them in a photographic sense. . . . In
reality, however, the weekly photographic ration does not at all
mean to refer to these objects or ur-images. If it were offering
itself as an aid to memory, then memory would have to deter-
mine the selection. But the flood of photos sweeps away the
dams of memory. . . . The *contiguity* of these images systemati-
cally excludes their contextual framework. The 'image-idea'
drives away the idea. The blizzard of photographs betrays an
indifference toward what things mean. . . . For the world itself
has taken on a 'photographic face'; it can be photographed
because it strives to be absorbed into the spatial continuum
which yields itself to snapshots.

<div align="right">Siegfried Kracauer, 'Photography'[1]</div>

Published over three decades after the last photographically illus-
trated form discussed here, Siegfried Kracauer's grim reflections on
photographic illustration contrast dramatically with the optimistic
words of Victorians such as Elizabeth Barrett Browning and David
Brewster with which this book began. The uncanny verisimilitude
that had caused so many Victorians to marvel inspired Kracauer with
thoughts of a world of images that had replaced truth with illusion
and authentic memories with the posed artifice of the snapshot.
Where Kracauer is haunted by the fear of absence and cultic amnesia,
Victorians imagined the possibility of capturing the presence or the
soul of the sitter on the surface of an image, or the equally marvellous

[1] Siegfried Kracauer, 'Photography', 58–9.

possibility of writing a complete history of the world in which no moment need be forgotten. Similarly, rather than producing an indifference to what things meant, photography not only inspired Victorians with a desire to clarify the purpose of art, it extended the terms of debates about public taste and aesthetic value into the unknown territory of mass production and mass culture. To quote John Leighton's contribution to a debate that addressed these concerns in the *Journal of the Photographic Society* in 1853: 'by rendering us more familiar with nature's infinite beauty, and educat[ing] the eye by presenting her transient forms and effects in all their variety, imprinted by her own hand without fear or favour' photography caused 'true art to be better appreciated and more widely understood'.[2] This belief in photography's power to capture the sheer variety of the transient phenomena of life and transform them into a meaningful sequence—to create literature out of nature, in other words, would prove to be a powerful creative catalyst. For the medium's early practitioners, photography not only recorded the differences between forms and effects, it illuminated them in a way that trained the eye of the observer to do likewise. This conception of photography could not be further removed from Kracauer's nightmare of passive vision. And for precisely this reason, the equal emphasis Leighton places on photography's power to arrest time and the creative possibilities that arise from that idea reinforces how important it is to use Victorian rather than modernist paradigms to unravel the historical impact of photography on nineteenth-century 'image-ideas'.

Integral to Kracauer's vision is the idea of a culture that predated the photographic inauthenticity of the present of early twentieth-century mass culture; a time when the senses of the observer were not rendered inert by an inundation of images ultimately signifying nothing. Chronologically, this locates this ideal society as coming to an end with the beginning of the mass visual culture that photography would come to epitomize. But this mythic origin, as the work of Geoff Batchen has shown, is difficult to pin down.[3] Does it begin in the early decades of the nineteenth century with the first experiments of Davy and Wedgwood? Or in the late 1830s when the first sensational reactions to Daguerre and Fox Talbot's inventions

[2] John Leighton, 'On Photography' [Abstract], *Journal of the Photographic Society*, 1 (21 June 1853), 74.
[3] Batchen, *Burning with Desire*, esp. 24–53.

were registered? Or in the mid-1850s when the *cartes de visite* craze took off? Or with the invention of the half-tone process in the 1880s which led to the rapid expansion of the illustrated press that Kracauer condemns? And, likewise, when do the symptoms of the mass disenchantment that Kracauer describes first appear? At easily identifiable moments such as the Great Exhibition of 1851, as Elizabeth Barrett Browning feared? Or when consumers failed to distinguish between a *carte de visite* portrait and an art-photograph as Julia Margaret Cameron argued? As this list demonstrates, Kracauer's nostalgia for a pre-photographic world generates more questions than it resolves.

Ultimately therefore, like the narratives of his Victorian predecessors, Kracauer's influential efforts to describe photography's unique affective power exemplifies its destabilization, rather than standardization, of concepts of visual experience. Responding to the uncertainty of modern culture with a declinist theory of affect, Kracauer simply takes up one of a range of positions that had been mapped out by Victorians before him. And in so doing he illuminates the photographic conditions of his own perception. His desire for an image that would engage the imagination of the observer and for a visual culture that would accurately convey the complexity of historical experience expresses a decidedly post-photographic will to authenticity which can also be traced through the early discursive transformations of photography into literature that this book has discussed. Like Kracauer, the concern of these volumes was to give expression to an inherently nostalgic desire for authentic experience in an age when many felt the dematerializing effects of capital and commerce had triumphed. The difference between the optimism of the latter and Kracauer's more nihilistic view merely proves the fact that photography generated as many dreams as nightmares about the shifting nature of time itself. Haunted by the possibility of enlightenment that photography made possible, both negative and positive incarnations of the photographic image register a distinctively modern conception of time as the still point at the core of the process of representation, a compelling yet elusive idea which the Victorian photographically illustrated book struggled to give both linguistic and visual form.

Bibliography

ADAMS, JAMES ELI, 'The Hero as Spectacle: Carlyle and the Persistence of Dandyism', in Carol T. Christ and John O. Jordan (eds.), *Victorian Literature and the Victorian Visual Imagination* (Berkeley: University of California Press, 1995), 213–32.

ADORNO, THEODOR, 'On Lyric Poetry and Society', *Notes to Literature*, ed. Rolf Tiedemann, trans. Shierry Weber Nicholsen, 2 vols. (New York: Columbia University Press, 1991–2), i. 37–54.

ALTICK, RICHARD, *The English Common Reader* (Chicago: University of Chicago Press, 1957).

—— *Lives and Letters: A History of Literary Biography in England and America* (Westport, Conn.: Greenwood Press, 1965).

—— *The Shows of London* (Cambridge, Mass.: Belknap Press, 1978).

ANDERSON, PATRICIA, *The Printed Image and the Transformation of Popular Culture 1790–1860* (Oxford: Clarendon Press, 1991).

ARMSTRONG, CAROL, *Scenes in a Library: Reading the Photograph in the Book, 1843–1875* (Cambridge, Mass.: MIT Press, 1998).

ARMSTRONG, ISOBEL, 'Tennyson in the 1850s: From Geology to Pathology —*In Memoriam* (1850) to *Maud* (1855)', in *Tennyson: Seven Essays*, ed. Philip Collins (London: Macmillan, 1992), 102–40.

—— *Victorian Poetry. Poetry, Poetics and Politics* (London: Routledge, 1993).

ARMSTRONG, NANCY, 'Emily's Ghost: The Cultural Politics of Victorian Fiction, Folklore, and Photography', *Novel* (Spring 1992), 245–66.

—— *Fiction in the Age of Photography: The Legacy of British Realism* (Cambridge, Mass.: Harvard University Press, 1999).

ARNOLD, MATTHEW, 'The Buried Life', in Walter E. Houghton and G. Robert Stange (eds.), *Victorian Poetry and Poetics* (New York: Houghton Mifflin, 1968), 446–7.

—— *The Complete Prose Works of Matthew Arnold*, ed. R. H. Super, 11 vols. (Ann Arbor: University of Michigan Press, 1960–77).

BALL, DOUGLAS, *Victorian Publisher's Bindings* (London: Scolar, 1985).

BARRELL, JOHN, *The Idea of Landscape and the Sense of Place, 1730–1840* (Cambridge: Cambridge University Press, 1972).

—— 'The Public Prospect and the Private View: The Politics of Taste in Eighteenth-Century Britain', in Simon Pugh (ed.), *Reading Landscape: Country–City–Capital* (Manchester: Manchester University Press, 1990), 19–40.

BARRETT BROWNING, ELIZABETH, *Poems*, 5 vols. (New York: James Miller, 1866).

—— *Casa Guidi Windows, with Introduction by A. Mary F. Robinson* (London: Bodley Head, 1901).

—— *Elizabeth Barrett to Mr Boyd: Unpublished Letters of Elizabeth Barrett Browning to Hugh Stuart Boyd*, ed. Barbara P. McCarthy (New Haven: Yale University Press, 1955).

—— *Casa Guidi Windows*, ed. and Preface by Julia Markus (New York: Browning Institute, 1977).

—— *Aurora Leigh*, ed. Cora Kaplan (London: Women's Press, 1978).

—— *The Letters of Elizabeth Barrett Browning to Mary Russell Mitford 1836–1854*, ed. Meredith B. Raymond and Mary Rose Sullivan, 3 vols. (Winfield, Kan.: Armstrong Browning Library of Baylor University, The Browning Institute, Wedgestone Press, and Wellesley College, 1983).

BARTHES, ROLAND, *Image—Music—Text*, trans. Stephen Heath (New York: Noonday Press, 1977).

—— *Camera Lucida. Reflections on Photography*, trans. Richard Howard (1980; New York: Hill & Wang, 1998).

BARTRAM, MICHAEL, *The Pre-Raphaelite Camera: Aspects of Victorian Photography* (London: Weidenfield & Nicolson, 1985).

BATCHEN, GEOFF, *Burning with Desire: The Conception of Photography* (Cambridge, Mass.: MIT Press, 1997).

BEER, GILLIAN, *Darwin's Plots: Evolutionary Narrative in Darwin, George Eliot and Nineteenth Century Fiction* (London: Ark Paperbacks, 1985).

—— *Open Fields: Science in Cultural Encounter* (Oxford: Clarendon Press, 1996).

BENJAMIN, WALTER, *Charles Baudelaire: A Lyric Poet in the Era of High Capitalism*, trans. H. Zohn (London: Verso, 1997).

—— *Reflections. Essays, Aphorisms, Autobiographical Writings*, ed. Peter Demetz (New York: Schocken Books, 1978).

—— *One-Way Street*, trans. Edmund Jephcott and Kingsley Shorter (London: Verso, 1979).

—— *Illuminations*, ed. Hannah Arendt (London: Fontana Press, 1992).

—— *The Correspondence of Walter Benjamin, 1910–1940*, ed. Gershom Scholem and Theodor W. Adorno, trans. Manfred R. Jacobson and Evelyn M. Jacobson (Chicago: University of Chicago Press, 1994).

BERGSON, HENRI, *Creative Evolution*, trans. Arthur Mitchell (London: Macmillan, 1913).

—— *Time and Free Will: An Essay on the Immediate Data of Consciousness*, trans. F. L. Pogson (1889; London: Allen & Unwin, 1950).

—— *Matter and Memory*, trans. Nancy M. Paul and W. Scott Palmer (New York: Zone Books, 1991).

Black's Picturesque Guide to Scotland (Edinburgh: Adam & Charles Black, 1852).

Black's Picturesque Guide to the Trossachs (Edinburgh: Adam & Charles Black, 1866).

Black's Picturesque Tourist of Scotland (Edinburgh: Adam & Charles Black, 1844).

BLATHWAYT, RAYMOND, 'How Celebrities Have Been Photographed', *The Windsor Magazine*, 2 (1895), 639–48.

BOURDIEU, PIERRE, *The Field of Cultural Production: Essays on Art and Literature*, ed. Randal Johnson (New York: Columbia University Press, 1993), 161–75.

BOWKER, R. R., 'London as a Literary Centre', *Harper's Monthly*, 76/456 (May 1888), 814–26.

BRAKE, LAUREL, '*Harper's New Monthly Magazine*: American Censorship, European Decadence and the Periodicals Market in the 1890s', *Subjugated Knowledges: Journalism, Gender and Literature in the Nineteenth Century* (London: Macmillan, 1994), 104–24.

BRAUDY, LEO, *The Frenzy of Renown: Fame and Its History* (Oxford: Oxford University Press, 1986).

BREWSTER, DAVID, *Letters on Natural Magic. Addressed to Sir Walter Scott, Bart.* New edition with introduction and chapters on the being and faculties of man, and additional phenomena of natural magic (1824; London: William Trigg, 1868).

—— *The Stereoscope: Its History, Theory and Construction* (London: John Murray, 1856).

BROWNING, ROBERT, *Men and Women* (Oxford: Oxford University Press, 1972).

BUCKLAND, GAIL, *Fox Talbot and the Invention of Photography* (London: Scolar Press, 1980).

BUZARD, JAMES, *The Beaten Track: European Tourism, Literature, and the Ways to 'Culture' 1800–1918* (Oxford: Clarendon Press, 1993).

—— 'Translation and Tourism: Scott's *Waverley* and the Rendering of Culture', *Yale Journal of Criticism*, 8/2 (1995), 31–59.

CADAVA, EDUARDO, 'Words of Light: Theses on the Photography of History', *Fugitive Images: From Photography to Video*, ed. Patrice Petro (Bloomington: Indiana University Press, 1995), 221–45.

—— *Words of Light: Theses on the Photography of History* (Princeton: Princeton University Press, 1997).

CAMERON, JULIA MARGARET, *Illustrations to Tennyson's Idylls of the King, and Other Poems*, 2 vols. (London: Henry S. King, 1875). Gernsheim Collection, Harry Ransom Humanities Research Center, University of Texas, Austin.

—— *Victorian Photographs of Famous Men and Fair Women by Julia Margaret Cameron. With Introductions by Virginia Woolf and Roger Fry* (London: Hogarth Press, 1926).

CARLYLE, THOMAS, *Collected Works*, 34 vols. (London: Chapman & Hall, 1870–87).

—— *Past and Present*, ed. Edwin Mims (New York: Charles Scribner's Sons, 1918).

—— *Thomas Carlyle: Selected Writings*, ed. Alan Shelston (London: Penguin, 1971).

CARROLL, LEWIS, 'Photography Extraordinary', reproduced in Helmut Gernsheim, *Lewis Carroll, Photographer* (New York: Dover, 1969), 110–13.

—— *Phantasmagoria and Other Poems*, illus. Arthur B. Frost (London: Macmillan, 1911).

—— *The Letters of Lewis Carroll*, ed. Morton N. Cohen, 2 vols. (London: Macmillan, 1979).

CHADWICK, W. J., *The Magic Lantern Manual. With One Hundred Practical Illustrations* (London, 1878). Gernsheim Collection, Harry Ransom Humanities Research Center, University of Texas, Austin.

CHRIST, CAROL T., *The Finer Optic: The Aesthetic Particularity in Victorian Poetry* (New Haven: Yale University Press, 1975).

COHEN, MORTON N., *Lewis Carroll, Photographer of Children: Four Nude Studies* (New York: Potter, 1978).

COLERIDGE, HARTLEY, 'Modern English Poetesses', *Quarterly Review*, 66 (1840), 347–89.

COLERIDGE, SAMUEL TAYLOR, *Coleridge's Miscellaneous Criticism*, ed. Thomas Middleton Raysor (London: Constable, 1936).

—— *Collected Letters*, ed. Earl Leslie Griggs, 6 vols. (Oxford: Oxford University Press, 1956–71).

—— *Biographia Literaria*, ed. George Watson (New York: Dutton, 1971).

—— *Poems*, ed. John Beer (London: Dent, 1974).

COLLEY, LINDA, *Britons. Forging the Nation 1707–1837* (London: Pimlico, 1992).

CONNOR, T. P., 'The New Journalism', *The New Review*, 1/5 (1889), 423–34.

'Correspondence', *Athenaeum*, 606 (June 1839), 435–6.

COWLING, MARY, *The Artist as Anthropologist: The Representation of Type and Character in Victorian Art* (Cambridge: Cambridge University Press, 1989).

CRARY, JONATHAN, *Techniques of the Observer: On Vision and Modernity in the Nineteenth Century* (Cambridge, Mass.: MIT Press, 1992).

—— *Suspensions of Perception: Attention, Spectacle and Modern Culture* (Cambridge, Mass.: MIT Press, 1999).

CRAWFORD, WILLIAM, *The Keepers of Light: A History and Working Guide to Early Photographic Processes* (New York: Morgan & Morgan, 1979).

CURRAN, STUART, *Poetic Form and British Romanticism* (Oxford: Oxford University Press, 1986).

DAGUERRE, JACQUES MANDE, *History and Practice of Photogenic Drawing on the True Principles of the Daguerreotype with the new method of Dioramic Painting; secrets purchased by the French Government, and*

by their command published for the benefit of the arts and manufactures: by the inventor L. J. M. Daguerre, trans. J. S. Memes (London: Smith & Elder, 1839).

DARRAH, WILLIAM C., *Cartes de Visite in Nineteenth Century Photography* (Gettysburg, Pa.: W. C. Darrah, 1981).

DARWIN, CHARLES, *The Expression of the Emotions in Man and Animals*. Introduction, afterword, and commentaries by Paul Ekman (London: Harper Collins, 1998).

DILLON, STEVE and KATHERINE FRANK, 'Defenestrations of the Eye: Flow, Fire, and Sacrifice in *Casa Guidi Windows*', *Victorian Poetry*, 35/4 (Winter 1997), 471–92.

DOWLING, LINDA, *Hellenism and Homosexuality in Victorian England* (Ithaca: Cornell University Press, 1994).

—— *The Vulgarization of Art: The Victorians and Aesthetic Democracy* (Charlottesville: University Press of Virginia, 1996).

DUCHENNE DE BOULOGNE, G.-B., *The Mechanism of Human Facial Expression*, ed. and trans. R. Andrew Cuthbertson (Cambridge: Cambridge University Press, 1990).

DUGAS, KRISTIN, Introduction, *The White Doe of Rylstone; or The Fate of the Nortons* by William Wordsworth, ed. Kristine Dugas (Ithaca: Cornell University Press, 1988), 3–65.

EASTLAKE, LADY ELIZABETH, 'Photography', *Classical Essays in Photography*, ed. Alan Trachtenberg (New Haven, Conn.: Leete's Island Books, 1980), 39–68.

ELFENBEIN, ANDREW, *Byron and the Victorians* (Cambridge: Cambridge University Press, 1995).

EMERSON, PETER HENRY, *Naturalistic Photography for Students of the Art* (London, 1889).

FLINT, KATE, *The Woman Reader 1837–1914* (Oxford: Clarendon Press, 1993).

—— *The Victorian Visual Imagination* (Oxford: Oxford University Press, 2000).

'Foreign Correspondence', *Athenaeum* (26 January 1839), 69.

FOSTER, MARGARET, *Elizabeth Barrett Browning: A Biography* (London: Flamingo/Harper Collins, 1993).

FOUCAULT, MICHEL, *Language, Counter-Memory, Practice: Selected Essays and Interviews by Michel Foucault* (Ithaca, NY: Cornell University Press, 1977).

—— *The Order of Things: An Archaeology of the Human Sciences* (London: Routledge, 1989).

FREUD, SIGMUND, *On Metapsychology: The Theory of Psychoanalysis*, The Pelican Freud Library, II (London: Penguin, 1964).

FREUND, GISELE, *Photography and Society* (Boston: David R. Godine, 1980).

FREWEN MOOR, JOHN, *The Birth-Place, Home, Churches and Other Places Connected with the Author of 'The Christian Year'*, including thirty-two mounted photographs by William Savage (Winchester: Savage; London: Parker, 1867).

FRISWELL, J. HAIN, *Life Portraits of William Shakespeare*, including eight photographs and one photographic vignette (London: Sampson, Low, Son & Marston, 1861).

GAGNIER, REGENIA, *Idylls of the Marketplace: Oscar Wilde and the Victorian Public* (Aldershot: Scolar Press, 1986).

GALPERIN, WILLIAM H., *The Return of the Visible in British Romanticism* (Baltimore, Md.: Johns Hopkins University Press, 1993).

GALTON, FRANCIS, *Inquiries into Human Faculty and Its Development* (London, 1883).

GAMER, MICHAEL C., 'Marketing a Masculine Romance: Scott, Antiquarianism and the Gothic', *Studies in Romanticism* (Winter 1993), 523–49.

GAUDREAULT, ANDRE, 'Showing and Telling: Image and World in Early Cinema', in Thomas Elsaesser with Adam Barker (eds.), *Early Cinema: Space, Frame, Narrative* (London: BFI Publishing, 1990), 274–81.

GEARY, CHRISTAUD M., and VIRGINIA LEE WEBB (eds.), *Delivering Views: Distant Cultures in Early Postcards* (Washington, DC: Smithsonian Institute Press, 1998).

GERNSHEIM, HELMUT, *Lewis Carroll: Photographer* (New York: Dover, 1969).

—— *Julia Margaret Cameron: Her Life and Photographic Work* (London: Gordon Fraser, 1975).

—— *Incunabula of British Photographic Literature: A Bibliography of British Photographic Literature, 1839–75* (London: Scolar Press, 1984).

GERNSHEIM, HELMUT and ALISON, *Roger Fenton: Photographer of the Crimean War* (London: Secker & Warburg, 1954).

—— *L. J. M. Daguerre: The History of the Diorama and the Daguerreotype* (New York: Dover, 1968).

GILL, STEPHEN, 'Copyright and the Publishing of Wordsworth 1850–1900', in John O. Jordan and Robert L. Patten (eds.), *Literature in the Marketplace: Nineteenth-Century British Publishing and Reading Practices* (Cambridge: Cambridge University Press, 1995), 74–92.

—— *Wordsworth and the Victorians* (Oxford: Clarendon Press, 1998).

GILMAN, SANDER (ed.), *The Face of Madness: Hugh W. Diamond and the Origin of Psychiatric Photography* (New York: Bruner/Mazel, 1976).

GLENDENING, JOHN, *The High Road: Romantic Tourism, Scotland, and Literature 1720–1820* (London: Macmillan, 1997).

GOLDMAN, PAUL, *Victorian Illustrated Books 1850–1870: The Heyday of Wood-Engraving* (London: Scolar, 1994).

GOLDSMITH, LUCIEN, and WESTON J. NAEF, *The Truthful Lens: A Survey of the Photographically Illustrated Books 1844–1914* (New York: The Grolier Club, 1980).

GORDON, CATHERINE, 'The Illustration of Sir Walter Scott: Nineteenth-Century Enthusiasm and Adaptation', *Journal of the Warburg and Courtauld Institutes*, 34 (1971), 297–317.

GOSSE, EDMUND, *Critical Kit-Kats* (London, 1896).

GOSTWICK, JOSEPH, *English Poets*, twelve essays illustrated by nine photographs after paintings (New York: Appleton, 1875).

GREEN-LEWIS, JENNIFER, *Framing the Victorians: Photography and the Culture of Realism* (Ithaca, NY: Cornell University Press, 1996).

——— 'At Home in the Nineteenth Century: Photography, Nostalgia, and the Will to Authenticity', *Victorian Afterlife: Postmodern Culture Rewrites the Nineteenth Century* (Minneapolis: University of Minnesota Press, 2000), 29–48.

GRUNDY, WILLIAM MORRIS, *Sunshine in the Country: A Book of Rural Poetry Embellished with Photographs from Nature* (London: Richard Griffin, 1861).

GUILLORY, JOHN, *Cultural Capital: The Problem of Literary Canon Formation* (Chicago: University of Chicago Press, 1993).

GUNNING, TOM, 'Phantom Images and Modern Manifestations: Spirit Photography, Magic Theater, Trick Films, and Photography's Uncanny', in Patrice Petro (ed.), *Fugitive Images: From Photography to Video* (Bloomington: Indiana University Press, 1995), 42–71.

HABERMAS, JURGEN, *The Philosophical Discourse of Modernity*, trans. Frederick Lawrence (Cambridge, Mass.: MIT Press, 1987).

HAGEN, JUNE STEFFENSEN, *Tennyson and His Publishers* (London: Macmillan, 1979).

HAGSTRUM, JEAN, *The Sister Arts: The Tradition of Literary Pictorialism and English Poetry from Dryden to Gray* (Chicago: University of Chicago Press, 1958).

HANKINS, THOMAS L., and ROBERT J. SILVERMAN, *Instruments and the Imagination* (Princeton: Princeton University Press, 1995).

HECHTER, MICHAEL, *Internal Colonialism: The Celtic Fringe in British National Development, 1536–1966* (1975; New Brunswick: Transaction Publishers, 1999).

HEIDEGGER, MARTIN, *Being and Time*, trans. John Macquarie and Edward Robinson (Oxford: Basil Blackwell, 1962).

HELSINGER, ELIZABETH K., *Ruskin and the Art of the Beholder* (Cambridge, Mass.: Harvard University Press, 1982).

——— 'Ruskin and the Politics of Viewing: Constructing National Subjects', *Nineteenth Century Contexts*, 18 (September 1994), 125–46.

HOBSBAWM, E. J., *The Age of Capital 1848–1875* (New York: Meridian, 1984).

HOBSBAWM, ERIC, and TERENCE RANGER (eds.), *The Invention of Tradition* (Cambridge: Cambridge University Press, 1992).

HOLMES, OLIVER WENDELL, 'The Stereoscope and the Stereograph', *Atlantic Monthly*, 3 (June 1859), 738–48.

—— 'Sun-Painting and Sun-Sculpture', *Atlantic Monthly*, VIII (July 1861), 14–15.

—— 'Doings of the Sunbeam', *Atlantic Monthly*, XII (July 1863), 1–15.

HOWITT, MARGARET, *Life of Mary Howitt* (London, 1889).

HOWITT, WILLIAM, *Homes and Haunts of the Most Eminent British Poets*, 2 vols. (London, 1847).

HOWITT, MARY and WILLIAM, *Ruined Abbeys and Castles of Great Britain*, Photographic Illustrations by Francis Bedford, Russell Sedgfield, George Washington Wilson, Roger Fenton, and others (London: A. W. Bennett, 1862).

HUGGETT, FRANK E., *Victorian England As Seen by Punch* (London: Sidgwick & Jackson, 1978).

HUMPHRIES, STEVE, *Victorian Britain through the Magic Lantern* (London: Sidgwick & Jackson, 1989).

HUYSSEN, ANDREAS, *After the Great Divide: Modernism, Mass Culture, and Post Modernism* (Houndmills: Macmillan, 1988).

—— 'Monument and Memory in a Postmodern Age', *Yale Journal of Criticism*, 62 (1993), 249–61.

IVINS, WILLIAM M., *Prints and Visual Communication* (Cambridge, Mass.: MIT Press, 1969).

JAMES, HENRY, *Literary Criticism* (New York: Library of America, 1984).

JAMESON, FREDERIC, *The Political Unconscious: Narrative as a Socially Symbolic Act* (London: Routledge, 1989).

—— *Signatures of the Visible* (New York: Routledge, 1990).

—— *Post-Modernism, or, the Cultural Logic of Late Capitalism* (Durham, NC: Duke University Press, 1991).

JANOWITZ, ANNE, *England's Ruins: Poetic Purpose and the National Landscape* (Oxford: Basil Blackwell, 1990).

JAY, BILL, *Victorian Cameraman: Francis Frith's Views of Rural England* (Newton Abbott: David & Charles, 1973).

JAY, MARTIN, 'Scopic Regimes of Modernity', in Hal Foster (ed.), *Vision and Visuality* (Seattle: Bay Press, 1988).

—— *Downcast Eyes: The Denigration of Vision in Twentieth-Century Thought* (Berkeley: University of California Press, 1994).

JEPHSON, JOHN MOUNTENEY, *Shakespeare: His Birthplace, Home and Grave; a Pilgrimage to Stratford on Avon in the Autumn of 1863, with Photographic Illustrations by Ernest Edwards* (London: Lovell Reeve, 1864).

—— *The Shakespeare Gallery: A Reproduction for the Tercentenary Anniversary of the Poet's Birth, MDCCCLXIV* (London: L. Booth & S. Ayling, 1864).

JOHNSON, EDGAR, *Sir Walter Scott: The Great Unknown* (New York: Macmillan, 1970).

JOHNSON, WILLIAM S., *Nineteenth-Century Photography: An Annotated Bibliography 1839–1879* (Boston, Mass.: G. K. Hall, 1990).

JOSEPH, GERHARD, *Tennyson and the Text: The Weaver's Shuttle* (Cambridge: Cambridge University Press, 1992).

JUMP, JOHN. D. (ed.), *Tennyson: The Critical Heritage* (London: Routledge, 1967).

JUSSIM, ESTELLE, *Visual Communication and the Graphic Arts: Photographic Technologies in the Nineteenth Century* (New York: R. R. Bowker, 1974).

KEATS, JOHN, *Poems* (London: Everyman's Library, 1974).

Kelley, THERESA M., *Wordsworth's Revisionary Aesthetics* (Cambridge: Cambridge University Press, 1988).

KEMP, WOLFGANG, 'Images of Decay: Photography in the Picturesque Tradition', *October*, 54 (Fall 1990), 103–34.

KINGSLEY, CHARLES, *Yeast* (London: Macmillan, 1891).

—— *The Life and Works of Charles Kingsley*, 19 vols. (London: Macmillan, 1901).

KIRBY, LYNN, *Parallel Tracks, Railroad and Silent Cinema* (Durham: Duke University, 1997).

KRACAUER, SIEGFRIED, 'Photography', *The Mass Ornament: Weimar Essays*, trans. and ed. Thomas Y. Levin (Cambridge, Mass.: Harvard University Press, 1995), 47–63.

KRAUSS, ROSALIND, *The Originality of the Avant-Garde and Other Modernist Myths* (Cambridge, Mass.: MIT Press, 1986).

LALVANI, SUREN, *Photography, Vision, and the Production of Modern Bodies* (New York: State University of New York Press, 1996).

LAMB, CHARLES and MARY, *Tales from Shakespeare*, with twelve illustrations in permanent photography from the Boydell Gallery (London: Bickers, 1876).

LAVATER, J. C., *Essays on Physiognomy, Designed to Promote the Knowledge and the Love of Mankind. Illustrated by more than eight hundred engravings accurately copied and some duplicates from originals*, trans. from the French by H. Hunter, 3 vols. (Zurich, 1775–7; London, 1789–98).

LEIGHTON, ANGELA, *Victorian Women Poets: Writing against the Heart* (Hemel Hempstead: Harvester Wheatsheaf, 1992).

LEIGHTON, JOHN, 'On Photography' [Abstract], *Journal of the Photographic Society*, 1 (21 June 1853).

LEWES, GEORGE HENRY, *The Physiology of Common Life*, 2 vols. (London: Blackwoods, 1860).

—— 'Principles of Success in Literature', *Fortnightly Review*, I (1865), 572–9, 585–8.

LINDBERG, DAVID C., *Theories of Vision from Al-Kindi to Kepler* (Chicago: University of Chicago Press, 1976).

LIU, ALAN, *Wordsworth: The Sense of History* (Stanford, Calif.: Stanford University Press, 1989).

LLOYD, GENEVIEVE, *Being in Time: Selves and Narrators in Philosophy and Literature* (London: Routledge, 1993).

LOOTENS, TRICIA, *Lost Saints: Silence, Gender, and Victorian Literary Canonization* (Charlottesville: University Press of Virginia, 1996).

LOVELL REEVE, AUGUSTUS, *Portraits of Men of Eminence in Literature, Science, and Art, with Biographic Memoirs*, 2 vols. (London: Lovell Reeve, 1863–4).

LOWELL, JAMES RUSSELL, *My Study Windows* (London, 1871).

LUKITSH, JOANNE, 'Simply Pictures of Peasants: Artistry, Authorship, and Ideology in Julia Margaret Cameron's Photography in Sri Lanka, 1875–1879', *Yale Journal of Criticism*, 9/2 (1996), 283–308.

MACCANNELL, DEAN, *The Tourist: A New Theory of the Leisure Class* (New York: Schocken, 1989).

MCCAULEY, ELIZABETH, A. A. E. *Disderi and the Carte de Visite Portrait Photograph* (New Haven: Yale University Press, 1985).

MCLACHLAN, LACHLAN, 'A National Photographic Portrait Gallery', *British Journal of Photography* (15 August 1863), 333.

MCMAHAN, ANNA BENNESON (ed.), *Florence in the Poetry of the Brownings. Being a Selection of the Poems of Robert and Elizabeth Barrett Browning which have to do with the History, the Scenery and the Art of Florence* (Chicago: A. C. McClurg, 1904).

MANTRELL, GIDEON, *The Wonders of Geology*, 2 vols. (London, 1839).

MANDELBAUM, MAURICE, *History, Man and Reason: A Study of Nineteenth-Century Thought* (Baltimore: Johns Hopkins University Press, 1974).

MARIEN, MARY WARNER, *Photography and Its Critics: A Cultural History 1839–1900* (Cambridge: Cambridge University Press, 1997).

MARVIN, CAROLYN, *When Old Technologies Were New* (Oxford: Oxford University Press, 1988).

MARX, KARL, *The Revolutions of 1848* (Harmondsworth: Penguin, 1973).

MAVOR, CAROL, *Pleasures Taken: Performances of Sexuality and Loss in Victorian Photographs* (Durham: Duke University Press, 1995).

MAYALL, JOHN P., *New Series of Photographic Portraits of Eminent and Illustrious Persons* (London: Mavor & Son, 1864).

—— *Celebrities of the London Stage* (London, 1860).

—— *Artists at Home*, ed. with biographical notices and descriptions by F. G. Stephens (New York, 1884).

MEISEL, MARTIN, *Realizations. Narrative, Pictorial, and Theatrical Arts in Nineteenth-Century England* (Princeton, NJ: Princeton University Press, 1983).

MELLOR, ANNE K., *Romanticism and Gender* (London: Routledge, 1993).

MERMIN, DOROTHY, *Elizabeth Barrett Browning: The Origins of a New Poetry* (Chicago: University of Chicago Press, 1989).

MICHAEL, IAN, *The Teaching of English: From the Sixteenth Century to 1870* (Cambridge: Cambridge University Press, 1987).

MILL, JOHN STUART, *Literary Essays*, ed. Edward Alexander (Indianapolis: Bobbs-Merrill, 1967).

—— 'On Liberty', *On Liberty and Other Essays* (New York: Oxford University Press, 1991), 5–128.

MILLARD, CHARLES W., 'Julia Margaret Cameron and Tennyson's *Idylls of the King*', *Harvard Library Bulletin*, 21 (2 April 1973), 187–201.

MILLER, ANDREW H., *Novels behind Glass: Commodity Culture and Victorian Narrative* (Cambridge: Cambridge University Press, 1995).

MILLER, ANGELA, 'The Panorama, the Cinema, and the Emergence of the Spectacular', *Wide Angle*, 18 (April 1996), 34–69.

MITCHELL, W. J. T., 'Visible Language: Blake's Wond'rous Art of Writing', in Morris Eaves and Michael Fischer (eds.), *Romanticism and Contemporary Criticism* (Ithaca: Cornell University Press, 1986), 46–95.

—— *Iconology: Image, Text, Ideology* (Chicago: University of Chicago Press, 1986).

—— *Picture Theory: Essays on Verbal and Visual Representation* (Chicago: University of Chicago Press, 1994).

'Mrs Cameron's Photographs', *Morning Post* (11 January 1875). Pasted in the back of the second volume of Cameron's illustrations in the Gernsheim Collection, Harry Ransom Humanities Research Center, University of Texas, Austin.

'Mr Wilson's Scottish Gems', *British Journal of Photography* (15 January 1860), 23.

MUNICH, ADRIENNE, *Queen Victoria's Secrets* (New York: Columbia University Press, 1996).

MUSSER, CHARLES, *The Emergence of Cinema: The American Screen to 1907*, 10 vols. (New York: Scribners, 1990).

NEWHALL, BEAUMONT (ed.), *Photography: Essays & Images: Illustrated Readings in the History of Photography* (London: Secker & Warburg, 1981).

NEWHALL, NANCY, *Peter Henry Emerson: The Fight for Photography As a Fine Art* (New York: Aperture, 1975).

NICOLL, WILLIAM ROBERTSON, and THOMAS J. WISE (eds.), *Literary Anecdotes of the Nineteenth Century: Contributions towards a Literary History of the Period*, 2 vols. (London: Hodder & Stoughton, 1895).

NIETZSCHE, FRIEDRICH, *The Gay Science*, trans. Walter Kaufmann (New York: Vintage Press, 1974).

'Our Weekly Gossip', *Athenaeum* (2 February 1839), 96.

PALGRAVE, FRANCIS. 'The Fine Arts in Florence', *Quarterly Review*, 66 (1840), 321–6.

PALGRAVE, FRANCIS TURNER, *The Golden Treasury of the Best Songs and Lyrical Poems in the English Language* (Cambridge, 1863).

PATER, WALTER, *The Works of Walter Pater*, 10 vols. (1873; London: Macmillan, 1910).

'Photographic Society', *Athenaeum* (29 May 1858), 692.

Photographic Portraits of Living Celebrities, executed by Maull and Polyblank with biographical notices by E. Walford (London: Messrs Mall & Polyblank, 1859).

PICK, DANIEL, *Face of Degeneration: A European Disorder, c.1848–c.1918* (Cambridge: Cambridge University Press, 1989).

POE, EDGAR ALLAN, 'The Daguerreotype', *Classical Essays in Photography*, ed. Alan Trachtenberg (New Haven, Conn.: Leete's Island Books, 1980), 37–8.

PRICE, UVEDALE, *Essays on the Picturesque, As Compared with the Sublime and the Beautiful; and, on the Use of Studying Pictures, for the Purpose of Improving Real Landscape*, 3 vols. (London, 1810).

QUEEN VICTORIA, *Leaves from the Journal of Our Life in the Highlands from 1848 to 1861*, ed. Arthur Helps (New York: Harper Bros., 1868).

RABB, JANE M. (ed.), *Literature & Photography Interactions, 1840–1990: A Critical Anthology* (Albuquerque: University of New Mexico Press, 1995).

Review of Annual Exhibition of the London Photographic Society, *Photographic Journal* (21 February 1857), 217.

Review of Annual Exhibition of the Photographic Society of London, *Photographic News* (London, 1864), 266.

Review of Annual Exhibition of the Photographic Society of London, *Illustrated London News*, rpt. in *Photographic Journal* (July 1865), 117.

Review of Fine Arts, *Athenaeum* (17 April 1847), 416.

Review of Modern Light Literature—Poetry, *Blackwood's Edinburgh Magazine*, 79 (February 1856), 125–40.

Review of Photographic Publications, *Photographic News* (8 August 1862), 375.

Review of Photographic Society of London, Annual Exhibition 1864, *Photographic Notes*, 9 (London, 1864), 171.

Review of William Henry Fox Talbot, *The Pencil of Nature*, Part III, *Athenaeum* (14 June 1846), 592–3.

Review of William Morris Grundy, *Sunshine in the Country*, *The Art-Journal* (1 February 1861), 48.

RICKS, CHRISTOPHER, *Tennyson* (London: Macmillan, 1989).

RITCHIE, ANN THACKERAY, *Lord Tennyson and His Friends* (London: T. Fisher Unwin, 1893).

ROBERTSON, ERIC, *English Poetesses: A Series of Critical Biographies with Illustrative Extracts* (London, 1883).

ROBERTSON, FIONA, *Legitimate Histories: Scott, Gothic, and the Authorities of Fiction* (Oxford: Clarendon Press, 1994).

ROBINSON, AGNES MARY FRANCES, *Emily Bronte*, Eminent Women Series, ed. John H. Ingram (London: W. H. Allen, 1883).

—— *Songs, Ballads and a Garden Play* (London: T. Fisher & Unwin, 1888).

ROBINSON, AGNES MARY FRANCES, Preface to Elizabeth Barrett Browning, *Casa Guidi Windows with Introduction by A. Mary F. Robinson* (London: Bodley Head, 1891), pp. v–xiv.

—— (Madame Mary Duclaux), *Retrospect and Other Poems* (London: Fisher & Unwin, 1893).

—— (Madame Mary Duclaux), *The Return to Nature: Songs and Symbols* (London: Chapman & Hall, 1904).

—— (Madame Mary Duclaux), *Twentieth Century French Writers: Reviews and Reminiscences* (London: Collins, 1919).

—— (Madame James Darmesteter), *Lyrics Selected from the Works of A. M. F. Robinson* (London: Fisher & Unwin, 1923).

ROBINSON, HENRY PEACH, *Pictorial Effect in Photography: Being hints on construction and chiaroscuro for photographers. To which is added a chapter on combination printing* (London: Piper & Carter, 1869).

—— *Letter on Landscape Photography* (New York: Scovill Manufacturing Co., 1888).

ROSENBERG, JOHN D., *The Fall of Camelot: A Study of Tennyson's 'Idylls of the King'* (Cambridge, Mass.: Belknap Press, 1973).

ROSS, ALEXANDER M., *The Imprint of the Picturesque on Nineteenth Century Fiction* (Waterloo: Wilfred Laurier University Press, 1986).

ROSSETTI, CHRISTINA, *The Complete Poems of Christina Rossetti*, ed. R. W. Crump, 3 vols. (Baton Rouge: Louisiana State University Press, 1979–90).

ROSSETTI, DANTE GABRIEL, *The Essential Rossetti*, ed. John Hollander (New York: Ecco Press, 1985).

ROWTON, FREDERIC, *The Female Poets of Great Britain* (London, 1848).

RUSKIN, JOHN, *The Works of John Ruskin*, ed. E. T. Cook and Alexander Wedderburn, 39 vols. (London: George Allen, 1903–12).

—— *The Genius of John Ruskin*, ed. John D. Rosenberg (Cambridge, Mass.: Harvard University Press, 1980).

SALMON, RICHARD, 'Signs of Intimacy: The Literary Celebrity in the Age of Interviewing', *Victorian Literature and Culture*, 25/1 (1997), 159–77.

—— *Henry James and the Culture of Publicity* (Cambridge: Cambridge University Press, 1997).

SAMUEL, RAPHAEL, *Theatres of Memory*, 2 vols. (London: Verso, 1994).

SAWYER, PAUL L., *Ruskin's Poetic Argument: The Design of the Major Works* (Ithaca, NY: Cornell University Press, 1985).

SCHAAF, LARRY J., *Out of the Shadows: Herschel, Talbot, and the Invention of Photography* (New Haven: Yale University Press, 1992).

SCHIVELBUSCH, WOLFGANG, *The Railway Journey: The Industrialization of Time and Space in the Nineteenth Century* (Oxford: Basil Blackwell, 1977).

SCOTT, WALTER, *The Lady of the Lake*, illustrated by George Washington Wilson (London: A. W. Bennett, 1862).

—— *The Lady of the Lake: Illustrated by Birket Foster and John Gilbert with Photographs by George Washington Wilson* (Edinburgh: Adam & Charles Black, 1863).

—— *The Lay of the Last Minstrel, with Photographic Illustrations by Russell Sedgfield* (London: Provost & Co., 1872).

—— *Poetical Works*, illustrated by George Washington Wilson (Edinburgh: Adam & Charles Black, 1872).

—— *Minstrelsy of the Scottish Border*, ed. T. F. Henderson, 4 vols. (Edinburgh: William Blackwood & Sons, 1902).

—— *The Poems and Plays of Sir Walter Scott*, 2 vols. (London: Dent, 1911).

—— *The Letters of Sir Walter Scott*, ed. H. J. C. Grierson, 12 vols. (London: Constable, 1932–7).

SEDGWICK, EVE KOSOFSKY, *Between Men: English Literature and Male Homosocial Desire* (New York: Columbia University Press, 1985).

SEIBERLING, GRACE, *Amateurs, Photography, and the Mid-Victorian Imagination* (Chicago: University of Chicago Press, 1986).

SEKULA, ALLAN, 'On the Invention of Photographic Meaning', in Victor Burgin (ed.) *Thinking Photography* (London: Macmillan, 1982), 84–109.

—— 'The Traffic in Photographs', *Photography against the Grain: Essays and Photo Works 1973–1983* (Halifax: Press of the Nova Scotia College of Art and Design, 1984), 78–91.

—— 'The Body and the Archive', *October*, 39 (Winter 1986), 1–19.

SENNETT, RICHARD, *The Fall of Public Man* (London: Faber & Faber, 1986).

SIMMEL, GEORG, *The Sociology of Georg Simmel*, ed. Kurt M. Wolff (New York: Macmillan, 1964).

SINFIELD, ALAN, *Alfred Tennyson* (Oxford: Basil Blackwell, 1986).

SMITH, LINDSAY, 'The Elusive Depth of Field: Stereoscopy and the Pre-Raphaelites', in Marcia Pointon *Pre-Raphaelites Re-viewed* (Manchester: Manchester University Press, 1989), 83–99.

—— *Victorian Photography, Painting, and Poetry: The Enigma of Visibility in Ruskin, Morris, and the Pre-Raphaelites* (Cambridge: Cambridge University Press, 1995).

—— *The Politics of Focus: Women, Children and Nineteenth-Century Photography* (Manchester: Manchester University Press, 1998).

SOBIESZEK, ROBERT A., *Ghost in the Shell: Photography and the Human Soul 1850–2000* (Cambridge, Mass.: MIT and LA County Museum of Art, 2000).

SOLOMON-GODEAU, ABIGAIL, *Photography at the Dock: Essays on Photographic History, Institutions, and Practices* (Minneapolis: University of Minnesota Press, 1991).

SONTAG, SUSAN, *On Photography* (New York: Anchor Books, 1990).

SPIRA, S. F., 'Carroll's Camera', *History of Photography*, 8 (July–September 1984), 175–7.

STAFFORD, BARBARA MARIA, *Voyage into Substance: Art, Science, Nature, and the Illustrated Travel Account, 1760–1840* (Cambridge, Mass.: MIT Press, 1984).

—— *Visual Analogy; Consciousness and the Art of Connecting* (Cambridge, Mass.: MIT Press, 1999).

STAROBINSKI, JEAN, 'The Idea of Nostalgia', *Diogenes*, 54 (1966), 81–103.

STAUNTON, HOWARD (ed.), *Memorials of Shakespeare* (London: Day & Son, 1864).

STEDMAN, EDMUND CLARENCE, *Victorian Poets* (London, 1876).

—— 'Some London Poets', *Harper's New Monthly Magazine*, 64/384 (May 1882), 874–92.

STEWART, GARRETT, 'Photo-gravure: Death, Photography and Film Narrative', *Wide Angle*, 91 (1987), 11–31.

STEWART, SUSAN, *On Longing: Narrative of the Miniature, the Gigantic, the Souvenir, the Collection* (Durham: Duke University Press, 1993).

—— *Poetry and the Fate of the Senses* (Chicago: University of Chicago Press, 2002).

TAGG, JOHN, *The Burden of Representation: Essays on Photographies and Histories* (London: Macmillan, 1988).

TALBOT, WILLIAM HENRY FOX, 'Some Account of the Art of Photogenic Drawing and the Process by which Natural Objects May Be Made to Delineate Themselves without the Aid of the Art of a Pencil', *Athenaeum* (9 February 1839), 112–15.

—— *The Pencil of Nature*, Anniversary Facsimile, ed. Larry J. Schaaf, 7 vols. (New York: Hans P. Krauss, 1989).

TAYLOR, JOHN, 'The Alphabetic Universe: Photography and the Picturesque Landscape', in Simon Pugh (ed.), *Reading Landscape: Country–City–Capital* (Manchester: Manchester University Press, 1990).

TAYLOR, ROGER, *George Washington Wilson: Artist and Photographer 1832–93* (Aberdeen: Aberdeen University Press, 1981).

TENNYSON, ALFRED LORD, *The Works of Alfred Tennyson*, 10 vols. (London: Henry S. King, 1874–1877).

—— *The Letters of Alfred Lord Tennyson*, ed. Cecil Y. Lang and Edgar F. Shannon, Jr., 3 vols. (London, 1897).

—— *The Poems of Tennyson*, ed. Christopher Ricks, 3 vols. (London: Longman, 1987).

TENNYSON, HALLAM, *Alfred, Lord Tennyson: A Memoir*, 2 vols. (London: Macmillan, 1898).

—— *Materials for a Life of A. T.* (privately printed, n.d.).

TERDIMAN, RICHARD, *Present Past: Modernity and the Memory Crisis* (Ithaca, NY: Cornell University Press, 1993).

THACKERAY, ANNE, *Thackeray and his Daughter: The Letters and Journals of Anne Thackeray, with Many Letters of William Makepeace Thackeray*, ed. Hester Thackeray Ritchie (London: Harper Bros., 1924).

'The Daguerreotype', *The Spectator* (22 February 1845), 4.

'The Railway', *Quarterly Review*, 63 (November 1839), 22.

'The Talbotype—Sun Pictures', *The Art Union Monthly Journal of the Fine Arts and the Arts, Decorative, Ornamental*, 8 (1 June 1846), 143–4.

THOMAS, NICHOLAS, *Entangled Objects: Exchange, Material Culture and Colonialism in the Pacific* (Cambridge, Mass.: Harvard University Press, 1991).

THOMPSON, STEPHEN, 'On Portraits and Portraiture', *British Journal of Photography* (15 January 1862), 21–2.

—— 'Photography in its Application to Book Illustration', *British Journal of Photography* (1 March 1862), 88–9.

—— 'The Commercial Aspects of Photography', *British Journal of Photography* (1 November 1862), 406–7.

TILTON, THEODORE, 'Memorial Essay', Elizabeth Barrett Browning, *Poems*, 5 vols. (New York: James Miller, 1866), iv. 13–75.

TUCKER, HERBERT, 'From Monomania to Monologue: "St Simeon Stylites" and the Rise of the Victorian Dramatic Monologue', *Victorian Poetry*, 22 (1984), 125–45.

—— *Tennyson and the Doom of Romanticism* (Cambridge, Mass.: Harvard University Press, 1988).

TURNLEY, JOSEPH, *The Language of the Eye: The Importance and Dignity of the Eye as Indicative of General Character, Female Beauty, and Manly Genius* (London, 1856).

WAKEMAN, GEOFFREY, *Victorian Book Illustration: The Technical Revolution* (Newton Abbot: David & Charles, 1973).

WALFORD, EDWARD, *Photographic Portraits of Living Celebrities* (London: Messrs Maull & Polyblank, 1859).

—— *Representative Men in Literature, Science and Art* (London: A. W. Bennett, 1868).

WALL, ALFRED, H., 'An Artist's Letters to a Young Photographer. On Landscape. Tone: Its Importance in Relationship with the Artistic Expression of Light, Air, and Space', *British Journal of Photography* (15 January 1862), 29–30.

—— 'An Artist's Letters to a Young Photographer. On Landscape. Sentiment—Introductory Considerations—Is the Highest Art True or False to Nature?—Sir Joshua Reynold's Art-Creed and His Photographic Disciples—Hazlitt and Ruskin versus Reynolds—Witnesses Examined on Either Side, and Their Evidence Given in a Series of Brief Extracts from "Modern Painters," the "Athenaeum," "Blackwood's Magazine," the "Guardian," &c.', *British Journal of Photography* (1 February 1862), 47–8.

WALL, ALFRED, H., 'An Artist's Letter to a Young Photographer, On Landscape. Sentiment (*continued*)—The False and the Ugly *versus* The True and The Beautiful in Art—On the Various Kinds of Expression

Peculiar to Various Scenes, &c.—How To Look At Nature', *British Journal of Photography* (15 February 1862), 68–70.

WALLACE, ANNE D., *Walking, Literature, and English Culture: The Origins and Uses of Peripatetics in the Nineteenth Century* (Oxford: Clarendon, 1993).

WARNER, MICHAEL, 'The Mass Public and the Mass Subject', in Craig Calhoun (ed.), *Habermas and the Public Sphere* (Cambridge, Mass.: MIT Press, 1992), 377–401.

WEAVER, MIKE, *Whisper of the Muse: The Overstone Album and Other Photography by Julia Margaret Cameron* (Malibu, Calif.: J. Paul Getty Museum, 1986).

—— (ed.), *The Art of Photography 1839–1989* (New Haven: Yale University Press, 1989).

WEBSTER, AUGUSTA, *Dramatic Studies* (London, 1866).

—— *Portraits* (London, 1870).

—— *A Housewife's Opinions* (London, 1879).

WHITE, HAYDEN, *Tropics of Discourse: Essays in Cultural Criticism* (Baltimore: Johns Hopkins University Press, 1978).

WIENER, MARTIN, *English Culture and the Decline of the Industrial Spirit 1850–1980* (Harmondsworth: Penguin, 1985).

WILDE, OSCAR, *The Complete Works of Oscar Wilde*, ed. Robert Ross, 10 vols. (Boston: Wyman-Fogg, 1908).

—— *The Artist as Critic: Critical Writings of Oscar Wilde*, ed. Richard Ellmann (New York: Random House, 1968).

WILLIAMS, RAYMOND, *Keywords: A Vocabulary of Culture and Society* (London: Fontana, 1976).

WILSON, DEREK, *Francis Frith's Travels: A Photographic Journey through Victorian England* (London: J. M. Dent, 1985).

WILSON, GEORGE WASHINGTON, 'A Voice from the Hills: Mr Wilson at Home', *British Journal of Photography* (16 September 1864), 375–6.

—— 'Photography in the Field', *British Journal Photographic Almanac* (September 1866), 67.

—— *Sir Walter Scott and His Country: A Reading, Descriptive of a Series of Lantern Slides* (Aberdeen: G. W. W. Registered, 1889). Gernsheim Collection, Harry Ransom Humanities Research Center, University of Texas, Austin.

—— *Descriptive List of Sets of Lantern Slides Made and Published by G. W. Wilson & Co, L.D. 2 St Swithins Street, Aberdeen, Scotland* (Aberdeen: G. W. W. Registered, 1898). Gernsheim Collection, Harry Ransom Humanities Research Center, University of Texas, Austin.

WINTER, ALISON, *Mesmerized: Powers of the Mind in Victorian Britain* (Chicago: University of Chicago Press, 1998).

WISHER, ANN, 'Photography and Literature: The First Seventy Years', *History of Photography* (July 1978), 230–42.

WORDSWORTH, WILLIAM, *Our English Lakes, Mountains, and Waterfalls. As Seen by William Wordsworth*, with photographic illustrations by Thomas Ogle, 4th edn. (London: A. W. Bennett, 1862; London: Provost & Co., 1870).

—— *The Poetical Works of Wordsworth*, ed. Thomas Hutchison (Oxford: Oxford University Press, 1923).

—— *The Prelude or Growth of a Poet's Mind* (Text of 1805), ed. Ernest de Selincourt (Oxford: Oxford University Press, 1970).

—— *The Prose Works of William Wordsworth*, eds. W. J. B. Owen and Jane W. Smyser, 3 vols. (Oxford: Clarendon Press, 1974).

—— William Wordsworth, ed. Stephen Gill (Oxford: Oxford University Press, 1984).

—— 'Preface 1800 Version (with 1802 Variants)', *Lyrical Ballads: The Text of the 1798 Edition with the Additional 1800 Poems and the Prefaces*, ed. R. L. Brett and A. R. Jones (London: Routledge, 1991), 241–73.

WRIGHT, WILLIAM SAMUEL, *The Loved Haunts of Cowper; the Photographic Remembrancer of Olney and Weston; Being Photographs of Buildings and Rural Scenes Immortalized by the Poet; with Historical and Descriptive Sketches* (compiled and published by William Samuel Wright, 1867).

YATES, EDMUND, *Celebrities at Home*, 3 vols. (London: Office of *The World*, 1877–9).

Index